# Arab and Islamic Studies
# in Honor of Marsden Jones

# Arab and Islamic Studies
in Honor of Marsden Jones

Edited by

Thabit Abdullah

Bernard O'Kane

Hamdi Sakkut

Muhammad Serag

The American University in Cairo Press

Copyright © 1997 by
The American University in Cairo Press
113 Sharia Kasr el Aini
Cairo, Egypt

All rights reserved. No part of this publication may be reproduced,
stored in a retrieval system or transmitted in any form or by any
means, electronic, mechanical, photocopying, recording or otherwise,
without the prior written permission of the publisher.

Dar el Kutub No. 7312/96
ISBN 977 424 402 8

Printed in Egypt

# Contents

List of Contributors — vii

*Hamdi Sakkut*
Preface — ix

## Art and Architecture

*Bernard O'Kane*
The Gunbad-i Jabaliyya at Kirman and the
Development of the Domed Octagon in Iran — 1

*George T. Scanlon*
Medieval Egyptian Wooden Combs:
The Evidence from Fustat — 13

*Caroline Williams*
The Visual Image of Nineteenth-Century Cairo:
The British Discovery — 39

## History

*Thabit Abdullah*
Some Observations on the Causes of the Decline of
Basra's Trade in the Late Eighteenth Century — 53

**جورج صليبا**
الإتجاهات الحديثة في دراسة تاريخ علم الفلك العربي — ١٠٥

*Pascale Ghazaleh*
Bedouins and Mamluks in the Sinai Trade — 61

رؤوف عباس
المصريون والسلطة: رؤية تاريخية ٨٥

Peter Gran
Egypt 1760–1815: A Period of Enlightenment? 73

Arnold H. Green
Family Trees and Archival Documents: A Case Study
of Jerusalem's *Bayt* al-Dajani 95

## Islamic Jurisprudence

محمد سراج
منهج التجديد التشريعي في الأحوال الشخصية في مصر
في القرن العشرين ٧١

Bernard Weiss
Amidi on the Basis of Authority of Juristic Opinion 111

## Literature

Roger Allen
Ḥadīth ʿĪsā ibn Hishām by al-Muwaylihi:
Thirty Years Later 117

محمد مصطفى بدوي
الثوابت في الأدب العربي ٤٩

محمد بريري
نزعة الشك عند شعراء الجاهلية:
بحث في الصور الذهنية المجردة ٢١

عادل سليمان جمال
زهير بن جناب. رائد مجهول ١

حمدي السكوت
مقدمة ط

قائمة المساهمين ز

# CONTRIBUTORS

Adel Suleiman Gamal is a professor of Arabic literature at Arizona University.
Arnold H. Green is a professor of history at Brigham Young University, Utah.
Bernard O'Kane is a professor of Islamic art and architecture at the American University in Cairo.
Bernard Weiss is a professor of Arabic and Islamic studies at the Middle East Center of the University of Utah.
Caroline Williams is an adjunct lecturer at the College of William and Mary, Virginia.
George Saliba is a professor of science history at the Department of Near Eastern Languages and Culture, Columbia University.
George T. Scanlon is a professor of Islamic art and architecture at the American University in Cairo.
Hamdi Sakkut is a professor of Arabic literature at the American University in Cairo.
Muhammad Bereiri is an associate professor of Arabic literature at Cairo University, Beni Suef Branch.
Muhammad Serag is a professor of Islamic law at the Faculty of Law, Alexandria University, and visiting professor at the Department of Arabic Studies of the American University in Cairo.
Mustafa Badawi is a professor of modern Arabic literature at Oxford University.
Pascale Ghazaleh recently obtained her MA in Arabic Studies at the American University in Cairo.
Peter Gran is an associate professor of history at Temple University, Philadelphia.
Raouf Abbas is a professor of modern history and vice-dean of the Faculty of Arts, Cairo University.
Roger Allen is a professor of Arabic at the Department of Asian and Middle Eastern Studies of the University of Pennsylvania, and is also co-director of the Huntsman Program in International Studies and Business.
Thabit Abdullah is an assistant professor of Middle East studies at Oklahoma State University.

# Preface

## Hamdi Sakkut

This work contains studies on various aspects of Arab and Islamic civilization, which have been written in memory of Dr. Marsden Jones, a distinguished scholar who, as founder of the Center for Arabic Studies at the American University in Cairo and its director for many years, had a profound influence on the life of the university and on generations of younger scholars.

The diversity of the studies in this volume reflects the wide span of Dr. Jones' interests, and the contributors—Arabs, Europeans, and Americans—are representative of his many friends from different countries.

I had the opportunity to work with Dr. Jones for a quarter of a century, during which time I learned much from him and benefited from his guidance and friendship. It gives me great pleasure to have collaborated with my colleagues in bringing this memorial volume into being. It is a humble and inadequate expression of our gratitude for the services that this eminent scholar gave to the field of Arab and Islamic studies.

First of all, a few words about Dr. Jones himself. John Marsden Beaumont Jones was born on 20 December 1920 in Wales, in the United Kingdom. He received his secondary education at Gowerton Grammar School and part of his university education at the University College of Wales, Aberystwyth. However, it was at the School of Oriental and African Studies (SOAS) of the University of London that he received his B.A. with first-class honors in Arabic Studies in 1949. He received his Ph.D. from the same college in the same field and was appointed lecturer

in Arabic studies at SOAS. In 1960 he became professor of Arabic studies at the American University in Cairo, and director of what was then known as the School of Oriental Studies. He continued working at the university until his death in the summer of 1992 at the age of seventy-one.

Marsden Jones' eminent position in the field of Arabic studies rests on his contributions in three spheres: his reputation as a superb teacher, which attracted students from many parts of the world; his first-rate scholarship, as reflected in his teaching, research, books, and articles; and his valued participation in building up the academic reputation that the American University in Cairo enjoys today.

In the sphere of teaching, Dr. Jones' students will always remember his unusual skill in introducing the complex and diverse aspects of Islamic civilization. He did not rely on secondary sources, in which misunderstandings and inaccuracies are common, but on Arabic primary sources. Jones firmly believed that without mastery of these, no sound and objective understanding of the rise and development of Islamic thought and institutions could be achieved. He condemned the tendency of an increasing number of Western scholars to study Islam through secondary sources as a result of their inadequate knowledge of the Arabic primary sources.

Jones was highly successful in applying his own approach, especially with his graduate students. There is no doubt that those students who were fortunate enough to have him as their thesis supervisor will never forget his thorough knowledge, his meticulous methodology, and his constant willingness to provide help and advice whenever needed.

Jones' method in relying on Arabic primary sources was reflected not only in his teaching but also in his research and publications, which are noted for their depth and for their new insights into early Islamic history. We should also remember that Jones followed closely contemporary trends of scholarly methodology. His work in his main area of specialization—the early Islamic period—was widely acclaimed, especially his studies on the *sira* and the early development of Islamic institutions. In 1966, Oxford University Press published his edition of *Kitāb al-maghāzī* by al-Waqīdī (d. 206/821–22) in three volumes. He also published a number of articles and studies related to the Prophet's campaigns, including "The Chronology of the *Maghazi*: A Textual Survey" and "Ibn Ishaq and Al-Waqidi: The Dream of ʿAtika and the Raid to Nakhla in Relation to the Charge of Plagiarism," both published in the *Bulletin of the School of Oriental and African Studies;* the entries "Ghazwah" and "Ibn Ishaq" in the new edition of the *Encyclopedia of Islam;* "Al-Sirat Al-Nabawiyah as a Source of the Economic History at the Rise of Islam" in the *Findings of the First International Symposium on the History of Arabia* (Riyadh, 1977); and the chapter on *maghāzī* literature in the first volume of the *Cambridge History of Arabic Literature.*

Jones' scholarly activities soon expanded into other fields; he wrote the article on Egypt for the *Encyclopaedia Britannica* in collaboration with Dr. Leila el-Hamamsy, and published a study on "Al-Jabarti and the First French Proclamation" (*Findings of the 150th Anniversary Conference on al-Jabarti,* Cairo, 1974). He also made an admirable translation of Naguib Mahfouz's novel *Midaq Alley,* but as the translation by Trevor Le Gassick had already appeared, this remained unpublished. Jones and I also collaborated in the publication of four volumes of the *Leaders of Contemporary Arabic Literature in Egypt* series (*Taha Husayn,* Cairo, 1975, 2nd edn. 1982; *Ibrahim ᶜAbd al-Qadir al-Mazini,* Cairo, 1979, 2nd edn. 1985; *ᶜAbd al-Rahman Shukri,* Cairo, 1980; and *Ahmad Amin,* Cairo, 1981) and in several articles.

In the later years of his life, Jones was working on his own study of the Prophet's life, concentrating on the strategy of his campaigns, and the early development of Islamic institutions. He was also investigating the past and present history of extremist movements in Islam. Regrettably, his untimely death prevented the completion and publication of this research.

Jones' contributions to AUC university life were many. Soon after his appointment to the university in 1960, he transformed the School of Oriental Studies, which had a religious orientation, into the Center for Arabic Studies, with its modern academic programs and facilities for the study of Arabic language and literature, Arabic and Islamic history, Islamic thought, and Islamic art and architecture, its Arabic-language programs for non-native speakers, and a research unit. Qualified specialists were hired from Europe, the United States, and the Middle East to implement these programs.

Marsden Jones was elected chairman of the AUC Faculty several times, and was an influential member of the long-range planning committee, besides his service on many university committees. By virtue of his extensive knowledge of Arab civilization and Egyptian society, his penetrating mind, and his diplomatic skills, Jones was frequently consulted by the university administration during times of crisis.

In sum, Marsden Jones' contribution to the development of the American University in Cairo and the improvement of its administrative organization and academic activities is undisputed and was highly appreciated by both faculty and administrators.

Finally, I would like to thank all those friends and colleagues who contributed articles to appear in this volume, and my colleagues Drs. Thabit Abdullah, Bernard O'Kane, and Muhammad Serag for their time and effort in collecting and editing these articles. Our thanks are also due to the staff of the AUC Press, especially to its director Mr. Mark Linz and Neil Hewison, for without their advice, support, and cooperation this volume could not have appeared.

# THE GUNBAD-I JABALIYYA AT KIRMAN AND THE DEVELOPMENT OF THE DOMED OCTAGON IN IRAN

## Bernard O'Kane

One of the most imposing early Islamic mausoleums of Iran is the Gunbad-i Jabaliyya at Kirman. Ever since Eric Schroeder's first scholarly publication of the monument attributed it to the Saljuq period,[1] little has appeared in the way of dissenting viewpoints, although some have viewed the date with caution.[2] In the sixty years since Schroeder's work appeared our knowledge of early funerary architecture in Iran has been enriched by the discovery and publication of many monuments. This essay will review some of the new evidence that is available and, to anticipate its conclusions, will suggest a Buyid date for the monument. This redating will be used in turn to reexamine the role of the domed octagon in the development of Iranian funerary architecture.

The dome chamber stands isolated near a graveyard some three kilometers east of the centre of the city of Kirman (Plate 1).[3] It contained an anonymous grave which was a revered object of pilgrimage by the people of Kirman, until a flood in 1954 washed it away.[4] The building's location in a graveyard is attested in the earliest secure reference to it, in the early sixteenth-century pilgrimage guide, the *Mazārāt-i Kirmān*. It tells the story, related to the second quarter of the fourteenth century,[5] of how a pilgrim to the abode of a local holy man, Shaykh ᶜAli Qudsi, who had foretold his own death on that evening, took fright when in the evening cries and light became manifest; he retreated from the shaykh's dwelling step by step until he reached the vicinity of the Gunbad-i Jabali, where he saw the townspeople of Kirman coming with candles and lamps *(shamᶜ va fānūs)* to pay homage to the shaykh, who had just died. The shaykh's

grave was henceforth also a place of pilgrimage.[6] Some have tried to identify the Jabaliyya with the Gunbad-i Gabr (or Kabir) built by the Samanid Abu ᶜAli Ilyas in 310/922–23,[6] or the Gunbad-i Ganj built by Ardashir, the founder of the Sasanian dynasty,[8] both of which are mentioned in local Saljuq and Mongol histories, but the information in their texts, whether topographical or otherwise, is so limited that it does not permit any certainty in this respect.[9]

This being the case, we are left with the materials, the form and the decoration of the building as our dating criteria. Rubble masonry is used for most of the building, the facing stones being roughly shaped. Baked brick is employed on the dome and for the framing of the hexadecagon below it (Plate 1). As Schroeder remarks, the stonework therefore has a Sasanian character,[10] but it is one that is shared by several buildings of the Islamic period in Iran. The earliest may be the building at Sarvistan, which also displays a large brick dome on a rubble base.[11] A possibly Buyid waystation, the Zandan-i Harun near Rayy, is another early example.[12] Early mausoleums that use the same material are the series of tomb-towers at Samiran (eleventh century), Abarqu (dated 448/1056–57), and Turan Pusht (one dated to 543/1148–49).[13] However, in addition to the twelfth-century tomb-tower mentioned above, rubble was used for the Ilkhanid *ayvān* at Pir-i Bakran, and for a series of Timurid caravansarays in the second half of the fifteenth century.[14] The use of rubble masonry, although clearly weighted toward earlier periods, thus covers too wide a chronological range to be used as an accurate dating criterion.

The form of the building at first may seem to present many parallels (Figures 1, 2), but on closer inspection similar buildings are relatively few in number. Although it is one of some twenty octagonal mausoleums that have survived from pre-Mongol Iran,[15] almost all of these are tomb-towers, where the emphasis is on the overall height relative to the base, and where the elevation is on one plane as far as the springing of the dome or polyhedral roof. The Jabaliyya differs from these in that it is no taller than it is wide, and in its elaborate arrangement below the level of the dome of three receding planes, the middle one sixteen-sided, corresponding to the hexadecagon of the interior. Its capacious interior also differentiates it from tomb-towers. One feature of the interior, the autonomous sixteen-sided zone of transition with its eight windows, at first sight appears to be indicative of a late date, as its nearest analog is the *qibla* dome-chamber of the Ilkhanid Friday mosque of Varamin.[16] But the verticality of Varamin is obviously missing at the Jabaliyya. The apparent advance of the Jabaliyya in this respect over Saljuq dome-chambers recedes when it is remembered that the base of the building is octagonal and not square, and that it is its un-Saljuq massiveness (see below) that provides a safe framework for the many window openings.

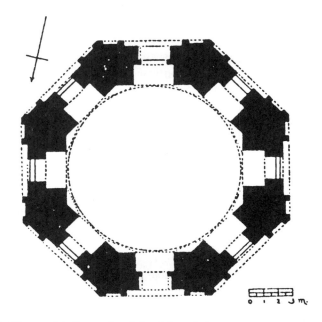

Figure 1. Kirman, Jabaliyya, plan (after Schroeder)

Figure 2. Kirman, Jabaliyya, section (after Schroeder)

The Jabaliyya also possibly differed from most of the early extant mausoleums in Iran in being a canopy-tomb. In its restored state there is no definite way of knowing how many of the entrances have been blocked. At present only one of the eight sides of the monument is open; Sykes' photograph (dating from the1890s)[17] and Schroeder's plan (Figure 1) show two entrances opposite each other. However, the lack of solid coloring on his plan for the walls that blocked the arches (of identical shape and size) on the other sides of the building may indicate that he thought that these too had originally been open. Certainly the thickness of the walls within these arches (about thirty centimeters) is so much less than that of any other part of the building as to provide support for this view. This is also suggested by a drawing in the *Mazārāt-i Kirmān*[18] that shows open doorways on two contiguous sides (all that are clearly visible in the drawing). Although this 1951 edition is obviously later than Sykes' photograph and Schroeder's plan, the reproduction could have been made from an even earlier drawing or photograph of the monument.[19]

Only two other pre–thirteenth-century Persian octagonal mausoleums have entrances on each side, the Shaburgan-Ata mausoleum near Karakul in Uzbekistan, which has been attributed to the eleventh century, and the *qibla* dome-chamber of the Natanz Friday mosque. The resemblance of the Shaburgan-Ata mausoleum to the Jabaliyya has been commented on previously by Grabar.[20] In addition to being a canopy-tomb, it does have a combination of stone and brick, although the stone is ashlar, not rubble masonry, and gives way entirely to brick in the upper half of the building. It incorporates a *pīshṭāq,* which is absent at the Jabaliyya, and has none of its receding planes.

The other surviving example of an open octagonal mausoleum, the *qibla* dome-chamber of the Natanz Friday mosque, presents some closer parallels. This is a building that was known to Schroeder, and which he actually mentions as a probable contemporary of the Jabaliyya (by which he meant late Saljuq) but of poorer design.[21] Recent uncovering of the plasterwork on the interior of the Natanz dome-chamber has revealed a date of 389/998–99. Sheila Blair's detailed study of the monument shows that its probable original form was an open octagon with a surrounding open ambulatory. On the basis of its shape, she also argues that its probable function was a mausoleum.[22] Its method of construction was very different from the Jabaliyya, consisting of bricks that in part were laid in alternate rows, vertically and horizontally. But it shares one very distinctive decorative motif with it, the moldings of the arches that loop at the top to produce an ogee (Plates 2–5). It surmounted each of the eight arches at Natanz (where another loop is made on the shoulders of the arches), and seems to have been present on each of the eight lower arches at the Jabaliyya, and on the eight arches of the hexadecagon immediately above

the lower ones (Figure 2). The significance of this motif as a dating criterion is underscored by the fact that it is found on the Natanz and Jabaliyya dome-chambers and on no other monuments.

Schroeder noted that at the time of his fieldwork some half-dozen courses of brickwork remained on one side of the dome.[23] This, together with his calculations that the piers are twice as massive as were needed to support the dome, led him to suggest that the structure was originally designed to be double-domed.[24] When he was writing in the 1930s, this would have made the Jabaliyya the earliest known Iranian structure with a double dome. However, it has recently been noticed that a passage from the Saljuq vizir Nizam al-Mulk's *Siyāsatnāma* describes a tenth-century Buyid tomb at Rayy as being double-domed *(bi du pūshish)*.[25] The earliest dated example that survives is the first tomb-tower at Kharraqan (460/1067–68).[26]

A comparison of the ratios of area of support to areas roofed and width to height with other early dome-chambers supports the argument that the Jabaliyya *was* originally double domed. Schroeder noted that the ratio of the area of support to the area roofed of the dome is 0.85, a very high figure when compared to either the 0.4 of the Davazdah Imam in Yazd (429/1038) or the 0.48 of the north dome-chamber of the Isfahan Friday mosque (481/1088–89).[27] The ratios of the height of the dome to the inner diameter are also revealing. For the Jabaliyya it is 1.44; for the Davazdah Imam, 1.54, for the Kharraqan II tomb-tower (486/1093–94) 1.72, and for the tomb of Sanjar (c. 1157) 2.1. Thus, compared to the double-domed chambers of the Saljuq period, the figures of the Jabaliyya are extremely conservative. We may well conclude with Schroeder that the architect was in a period of experimentation with the double dome, and wished to ensure its stability by adding a wide margin of safety. From the evidence above, the Jabaliyya was at the beginning of the series, and now with a greater number of buildings known to us than at the time Schroeder was writing, this can be put back to the Buyid period, corroborating the evidence of the decoration, and the form of the monument.

Schroeder's proposition that the monument was double-domed is therefore certainly plausible. Was it definitely unfinished, as he also thought? There is a curiously large number of early Iranian and Transoxianian mausoleums that had double domes, or an inner dome and outer polyhedral roof, whose outer shell has mostly or completely vanished. They include the Kharraqan tomb-towers, the mausoleum of Sultan Sanjar, the Gunbad-i Surkh at Maragha, the Haruniyya at Tus and the tomb of Uljaytu's son at Bistam. All of these are likely to have been finished, to judge from the state of their decoration and inscriptions, with the possible exception of the Haruniyya. Just why they should all have lost their outer covering is puzzling, although it is the one that, at least initial-

ly, received the brunt of weather damage.[28] Those responsible for maintenance may have thought that the expense of repairing an outer shell was poor value if the inner shell remained sound. In the case of the Jabaliyya it must therefore remain a possibility that the outer dome was finished, but that it deteriorated like the other examples mentioned.[29]

## The Historical Setting

Kirman in the early eleventh century was a troubled province, suffering from both the internal quarrels of the Buyids and brief occupations by Ghaznavid forces. At the time of the erection of the Natanz dome-chamber in 389/998–99 Baha' al-Dawla had just come to power. On his death in 1012 his son Sultan al-Dawla was named his successor and reigned from Shiraz, appointing his brother Qawam al-Dawla as governor of Kirman. Mahmud of Ghazna attempted to install a nominee in Kirman province in 407/1017–18. This was unsuccessful, but he won the support of Qawam al-Dawla in the following year when Sultan al-Dawla visited Iraq, and Qawam al-Dawla took advantage of his absence to attack Shiraz. The attempt was unsuccessful, and Sultan al-Dawla's forces briefly occupied Kirman in revenge. Qawam al-Dawla remained in control of the city until his death in 1028. This was reputedly caused by poison administered at the behest of Sultan al-Dawla's eldest son, Abu Kalijar, who since the death of his father in 1024 had been vying for control of the Buyid empire with another brother of Sultan al-Dawla, Jalal al-Dawla. The Ghaznavids under Mas'ud b. Mahmud again took control of Kirman in 424/1033, but their financial exactions were so severe that the inhabitants conspired with Abu Kalijar's forces, who retook the city after a few months. For a brief period after the death of Jalal al-Dawla in 1044 Abu Kalijar reunited the territories of Iran and Iraq under one ruler. However, he had to repulse one Saljuq attack on Kirman in 434/1041–42, and following his death in 1048 the governor of Kirman surrendered to the Saljuq forces without a fight.[30]

Schroeder attributed the unfinished character of the building to the Ghuzz invasions of 1187, when the city was ravaged and temporarily deserted as a result. If the building was indeed unfinished—although, as we have seen, this is far from certain—there are certainly sufficient incidents of sieges and transfers of power also in the first half of the eleventh century to account for this. Does the above summary of this period of history in Kirman point to any possible patron? When discussing the Natanz dome-chamber, Sheila Blair noted that textual information mentions that contemporary mausoleums were built for members of the Prophet's family, and for Buyid rulers and their families and vizirs.[31] We have no knowledge of prominent religious figures who may have been buried in the area at the time, and it might be surmised that the present anonymity of the tomb points to a secular rather than a religious patron. Qawam al-Dawla's

rank and strong ties with Kirman, which he ruled from 1012 to 1028, make him a plausible candidate, but this can only be speculation.

## The Domed Octagon

With the redating of the Jabaliyya to the Buyid period we are in a somewhat better position to put in perspective the development of the domed octagon in Iran. Should it be viewed as an independent entity, as a variation of the tomb-tower,[32] or as a derivation of the domed square?[33]

Although a distinction between octagonal tomb-towers and domed octagons is not always easy to make,[34] some of the major differences between the Jabaliyya and tomb-towers have been outlined above. Its lack of verticality, its succession of receding planes, and its commodious and articulated interior effectively eliminate it from the category of tomb-tower. It clearly has little in common with the earliest octagonal tomb-towers, for instance, the Gunbad-i ᶜAli at Abarqu and those of Kharraqan.[35]

It has also been argued that the Iranian domed octagon was derived from the domed square in a natural process of development of the radiating centralized plan, which "best combined the requirements of a central focus—usually provided by a sarcophagus—with those of the maximum space for circumambulation *(ṭawāf)* and the maximum scope for spatial and other architectural experiments."[36] While the primacy of the domed square in extant examples of Iranian and Central Asian architecture is undeniable, we are unfortunately lacking the vital evidence needed to substantiate whether one developed from the other, namely the forms that mausoleums erected under Buyid rule took. It is curious, for instance, that only one domed-square funerary building, the Davazdah Imam in Yazd (429/1038), is known from pre-Saljuq Central Iran as opposed to the more numerous examples from Samanid Central Asia. Is it possible that it was the domed octagon rather than the square that was the standard plan for Buyid mausoleums? Hillenbrand's mention of the *ṭawāf* in combination with the octagonal plan is surely significant. The earliest Islamic mausoleums were built over the graves of prophets and the descendants of Muhammad, eventually attracting pilgrims "in large and enthusiastic crowds,"[37] and circumambulation of the tomb was the normal form of devotion by pilgrims.[38]

The very first Islamic commemorative monument, the Dome of the Rock in Jerusalem, has a plan with two octagonal ambulatories surrounding a central dome. There is still disagreement among scholars as to what it commemorates, but the form of the monument seems obviously designed to accommodate pilgrims. Most modern scholars have tended to discredit the reports of some ninth-century historians that ᶜAbd al-Malik built it in an attempt to divert the hajj from Mecca to Jerusalem,[39] although

recently it has been strenuously argued that more credence should be given to them.[40] Whatever the truth of the matter,[41] it is at least clear that this was a common explanation for the building and its shape from the ninth century onwards, reinforcing in many Muslims' minds a connection between the ṭawāf and the octagonal plan.[42] The next surviving commemorative monument, the mausoleum known as the Qubbat al-Sulaybiyya at Samarra, also has an octagonal ambulatory.[43] The tomb of ᶜAli at Najaf was rebuilt by the Hamdanid prince Abu'l-Hayja' ᶜAbd Allah (d. 317/929–30) as a dome (qubba) supported on piers (arkān) on all sides in which were portals (abwāb). This probably refers to an annular building, possibly to an octagonal one, and definitely to a canopy-tomb.[44] Unfortunately other textual references to no-longer-extant Buyid mausoleums give no indication of their form.

Paltry as this evidence is, it suggests that there is no reason why the form of the Buyid octagonal mausoleums at Natanz and Kirman need necessarily be related to earlier domed squares or tomb-towers—the domed octagon itself may have been the preferred form of the mausoleum under the ᶜAbbasids and Buyids. The reverence of the Buyids for the Shiᶜi martyrs buried in territory within their sphere of influence is exemplified by ᶜAdud al-Dawla's restoration of the tombs of ᶜAli and Husayn.[45] The Buyid rulers were themselves amongst the hordes of pilgrims to these sites, and their possibly octagonal shape may have inspired the mausoleums at Natanz and Kirman.

At least the quality of the building is not in question. Schroeder lauded "the vast and slow movement of its receding planes," while admiring the deceptions used by the architect to impart a sense of lightness to it.[46] To this one may add its significance as a rare example of a Buyid mausoleum, and as the earliest extant building designed to have a masonry double dome.

## Notes

1 Eric Schroeder, "The Jabal-i Sang, Kerman," in *IIIe Congrès International d'Art et d'Archéologie Iraniens. Mémoires. Leningrad, September 1935* (Moscow, 1939), 230–35; and "Islamic Architecture. F. Seljuq Period," in *A Survey of Persian Art from Prehistoric Times to the Present*, ed. Arthur Upham Pope and Phyllis Ackerman (London and New York, 1939).

2 A Saljuq date has been accepted in André Godard, "Voûtes iraniennes," *Āthār-é Īrān* 4 (1949), 299; Donald N. Wilber, *The Architecture of Islamic Iran: The Il Khānid Period* (Princeton, 1955), 64; André Godard, "Les anciennes mosquées de l'Iran," *Arts Asiatiques* 3 (1956), 55; Arthur Upham Pope, *Persian Architecture* (London, 1965), 185; Anthony Hutt and Leonard Harrow, *Iran 1* (London, 1977), 43; Nusrat Allah Mishkati, *Fihrist-i bināhā-yi tārīkhī va amākin-i bāstānī-yi Īrān* (Tehran, 1247/1970), 155; Piero Sanpaolesi, "La cupola di Santa Maria del Fiore ed il mausoleo di Soltanieh,"

Mitteilungen des Kunsthistorisches Institutes in Florenz 16/3 (1972), 238; Sheila Blair, "The Octagonal Pavilion at Natanz: A Reexamination of Early Islamic Architecture in Iran," *Muqarnas* 1 (1983), 83; Robert Hillenbrand, "The Islamic Architecture of Persia," in *The Arts of Persia*, ed. R. W. Ferrier (New Haven and London, 1989), 87; Ahmad Parsa Qudus, "Sih bināhā-yi yādbūd-i sangī az daurān-i saljūqī," *Hunar u mardum* 16 (no. 184, Bahman and Isfand 2536/1977), 48–52. A late Sasanian or early Islamic date has been suggested in Sayyid Ahmad Musavi, "Gunbad-i Jabaliyya," *Hunar u mardum* 14 (no. 168, Mihr 2535/1976): 74–77; in anon., "Bināhā-yi tārīkhī-yi Kirmān," *Āgāhināma-yi Sāzmān-i Millī-yi Ḥifāẓat-i Āsār-i Bāstānī-yi Īrān* 2 (Bahman 1354/1976), 8; and in Sazman-i Milli-yi Hifazat-i Asar-i Bastani-yi Iran, *Āsār-i bāstānī-yi Kirmān*, n.d., c. 1970s, n.p., 4. A pre-Islamic origin and tenth-century repair (see note 7 below) is suggested by the editor in Ahmad ᶜAli Khan Vaziri Kirmani, *Tārīkh-i Kirmān*, ed. Muhammad Ibrahim Bastani Parizi (Tehran, 1352/1973), 129. Given the lines of argument that I pursue in the text, the fact that it is difficult to suggest any function for the building other than that of a mausoleum, and that no pre-ninth century Iranian mausoleums are known to have existed, I have not pursued the possibilities of a Sasanian or very early Islamic date further.

3  For a map showing its location relative to the city see Percy Molesworth Sykes, *Ten Thousand Miles in Persia or Eight Years in Iran* (London, 1902), "Plan of Kermán," opp. 188. The earliest published photograph of the monument is one by Sykes, which appeared in K. A. C. Creswell, "Persian Domes before 1400 A. D. (conclusion)," *The Burlington Magazine* 26 (1915), Pl. II, J. Creswell refrained from suggesting a date for the Jabaliyya, but suggested it was a prototype for sultanate tombs at Delhi, such as the tomb of Firuz Shah (ibid., p. 208). On the basis of the same photograph, Diez suggested a date of c. 1300: *Persien: Islamische Baukunst im Churâsân* (Hagen i. W., 1923), 97.

4  Musavi, "Jabaliyya," 77.

5  Earlier a visit to the shaykh by Ghiyath al-Din Muhammad, the vizir of the Ilkhanid Abu Saᶜid, is mentioned: Mihrabi Kirmani, *Mazārāt-i Kirmān*, ed. Sayyid Muhammad Hashimi Kirmani and Husayn Kuhi Kirmani (Tehran, 1330/1951), 97.

6  For the shaykh's biography see *ibid.*, 94–102; the passage that mentions the Gunbad-i Jabali is in *ibid.*, 100.

7  Two sources mention this, one the twelfth-century history of Afzal al-Din Kirmani, *Badā'iᶜ al-zamān fī vaqā'iᶜ Kirmān*; the other by the same author, *ᶜIqd al-ᶜalā li-l-mawqif al-ᶜalā* (composed in 564/1188–89) (both cited in Musavi, "Jabaliyya", 75). In the latter source Afzal al-Din locates the Gunbad-i Gabr within the Old Fort *(qalᶜa-yi kuhn)*, an attribution that Schroeder rejected ("Jabal-i Sang," 235) on the grounds that this building is likely to have been further west of the location of the Jabaliyya, closer to the center of Kirman.

8  Nasir al-Din Munshi Kirmani, *Simṭ al-alā li-l-ḥazrat al-ᶜuliyā*, cited in Musavi, "Jabaliyya," 75. It is interesting that the fifteenth-century historian Ahmad b. Husayn b. ᶜAli al-Katib, *Tārīkh-i jadīd-i Yazd*, ed. Iraj Afshar (Tehran, 1345/1966), 46, recounts that a Gunbad-i Hasht Dar, which was partially extant at the time, was reputedly one of three dome chambers erected above

wells in which were stored treasures of Yazdigird. The epithet *hasht dar*, 'eight doors,' may have referred to a dome chamber that, like the Jabaliyya, was octagonal and had an entrance on each side, although another possibility is a square building with two entrances on each side, like the 'Hasht Taq' at Takht-i Sulayman (Georgina Herrmann, *The Iranian Revival* (Oxford, 1977), 114, 118).

9  There is likewise no textual evidence for a local tradition that the building is the tomb of Sayyid Muhammad Tabashari: Sykes, *Ten Thousand Miles*, 192.
10 "The Jabal-i Sang," 230.
11 Lionel Bier, *Sarvistan: A Study in Early Iranian Architecture* (University Park, PA, and London, 1986), where it is argued that the building was a fire temple that should be dated to c. 750–950.
12 Maxime Siroux, *Caravansérails d'Iran et petites constructions routières*, Mémoires de l'Institut Francais d'Archéologie Orientale du Caire, 81 (Cairo, 1949), 103–5, Pls. XI/5–6, showing walls of rubble masonry, with a corbeled brick squinch, and a brick herring-bone pattern on the dome. Judging from the squinch, which is similar to one employed as late as the twelfth century in the Ribat-i Sharaf, Siroux's dating of the second century Hejira may be a century too early.
13 For Samiran, see Monique Kervran, "Une forteresse d'Azerbaidjan: Samiran," *Revue des Études Islamiques* 41 (1973), 71–93; for the Gunbad-i ᶜAli at Abarqu see André Godard, "Abarkūh: Le Gunbad-é ᶜAlī," *Āthār-é Īrān* 1 (1936), 49–54; for Turan Pusht see Iraj Afshar, *Yadgārhā-yi Yazd*, vol. 1 (Tehran, 1348/1969), 273–75; for the dating of the Gunbad-i Shaykh Junayd see Godard, "Voûtes iraniennes," 260, n. 2.
14 For Pir-i Bakran see Wilber, *Architecture of Islamic Iran*, Cat. no. 26; for the Timurid caravansarays see Bernard O'Kane, *Timurid Architecture in Khurasan* (Costa Mesa, 1987), Cat. no. 40.
15 For a list of these, see Blair, "Octagonal Pavilion," 83, Table 1. To her list may be added that of Rayy (Wilber, *Architecture*, Cat. no. 129, Pl. 42, dating corrected in Myron Bement Smith, review of Wilber, *Architecture*, in *Journal of the American Oriental Society* 76 [1956], 243); three eleventh- to twelfth-century examples of Mashhad-i Mistorian, and the possible eleventh-century example of Shaburgan-Ata in Uzbekistan: G. A. Pugachenkova, *Pamyatniki iskusstva Sovetskogo Soyuza. Srednaya Aziya. Spravochnik-putevoditel'* (Moscow, 1983), Figs. 130, 133–34, 341.
16 Best illustrated in Sonia P. Seherr-Thoss, *Design and Color in Islamic Architecture* (Washington, D.C., 1968), Pl. 58.
17 See note 3 above.
18 On p. 100.
19 Without mentioning his evidence for this, Sayyid Ahmad Musavi writes that the eight sides of the building were open: "Gunbad-i Jabaliyya," 75.
20 In Oleg Grabar, "The Earliest Islamic Commemorative Structures," *Ars Orientalis* 6 (1966), 31–32. Grabar mentions that Nil'sen attributes the Shaburgan-Ata mausoleum to c. 1100, rather than Pugachenkova's eleventh-century dating.
21 Schroeder, "Islamic Architecture," 1017.

22 Blair, "Natanz," 83–90.
23 In the recent restoration of the monument by the Sazman-i Milli-yi Hifazat-Asar-i Bastani-yi Iran, the National Society for the Preservation of the Historical Monuments of Iran, these brickwork courses have been rebuilt to a height of approximately one meter.
24 Schroeder, "Jabal-i Sang," 234, refers to it as the oldest double dome in masonry, considering it to be older than the mausoleum of Sultan Sanjar (c. 1157). Despite this, in *ibid.*, 235, he suggests a date of 1187 for the Jabaliyya on historical grounds.
25 Sheila Blair and Jonathan Bloom, *The Art and Architecture of Islam 1250–1800* (New Haven and London, 1994), 319, n.25.
26 Blair and Bloom, *loc. cit.*, cite the second Kharraqan tomb-tower as the earliest, but the outer shell of the first is partially intact, like that of the second.
27 "Jabal-i Sang," 233.
28 Schroeder, "Islamic Architecture," 1019, revising his earlier opinion ("Jabal-i Sang," 234) that the outer shell was of masonry, surmised that outer domes were made of wood until the fourteenth century, but this contradicts his arguments for the massiveness of the piers of the Jabaliyya. The Kharraqan tomb-towers show that masonry was indeed used for their outer shells.
29 Schroeder ("Jabal-i Sang," 234) also wrote that the almost perfect circle of the hole at the apex of the inner dome implied that the building was unfinished. This is a persuasive, although not necessarily conclusive argument. As the building was a *mazār* (place of pilgrimage) at least until the 1950s it is possible that repair works, which may have included partial restoration of the dome, were carried out at unspecified periods.
30 C. E. Bosworth, *The Ghaznavids: Their Empire in Afghanistan and Eastern Iran, 994–1040*, 2nd ed. (Beirut, 1973), 90; Ann Lambton, "Kirmān," *Encyclopaedia of Islam*, 2nd ed., 5:158; Heribert Busse, "Iran under the Būyids," in *The Cambridge History of Iran 4, The Period from the Arab Invasion to the Saljuqs*, ed. R. N. Frye (Cambridge, 1975), 296–301; C. E. Bosworth, "The Imperial Policy of the Early Ghaznawids," *Islamic Studies* 1 (1962), 7; Ibn al-Athir, *al-Kāmil fī-l-ta'rīkh*, 13 vols. (Beirut, reprint, 1966), 9: 360, 368.
31 Blair, "Octagonal Pavilion," 88–89, and *The Monumental Inscriptions from Early Islamic Iran and Transoxiana*, Studies in Islamic Art and Architecture 3 (Leiden, 1992), 58.
32 It is classified thus in Blair, "Natanz"; see note 15 above.
33 This is the viewpoint in Robert Hillenbrand, *Islamic Architecture: Form, Function and Meaning* (Edinburgh, 1994), 281.
34 *Ibid.*, 282–83.
35 Despite the misidentification of the Jabaliyya as the Gunbad-i ᶜAli in Keith Albarn et al., *The Language of Pattern* (London, 1974), 84, Fig. 1. For the Gunbad-i ᶜAli see note 12 above; for the Kharraqan towers see David Stronach and T. Cuyler Young, "Three Seljuq Tomb Towers," *Iran* 4 (1966), 1–20. The tomb-towers of Samiran have also been dated to the second half of the eleventh century: Kervran, "Samīrān," 90–93. Blair, "Natanz," 84, argues that the engaged columns and blind arcading of many of the early octagonal tomb-

towers suggest the vestige of an ambulatory. However, these features could more simply be regarded as part of the normal grammar of architectural articulation, and indeed they are frequently found on pre-Mongol domed-square mausoleums. For engaged columns see Bukhara, mausoleum of the Samanids; Tim, ᶜArab Ata; Kermina, Mir Sayyid Bahram; Kharraqan, Samiran, Astana-Baba, ᶜAlambardar; Sarakhs, Yarti Gunbad; Maragha, Gunbad-i Surkh; Imam Sahib, Baba Hatim; Tus, Haruniyya. For arcades or arcading see Bukhara, mausoleum of the Samanids; Imam Baba, mausoleum of Ahmad; Yazd, Davazdah Imam; Sarakhs, Yarti Gunbad; Sarakhs, Baba Luqman mausoleum; Maragha, Gunbad-i Surkh; Merv, Muhammad b. Saᶜid. For illustrations of these see Pugachenkova, *Pamyatniki*, Pls. 8 (ᶜAlambardar), 9 (ᶜArab Ata), 23 (Samanids), 98 (Kermina), 142 (Muhammad b. Saᶜid), 234 (Yarti Gunbad); Sheila Blair, *The Monumental Inscriptions from Early Islamic Iran and Transoxiana*, Studies in Islamic Art and Architecture 5 (Leiden, 1992), Pl. 40 (Imam Baba), Pope, *Survey*, Pls. 273A (Davazdah Imam), 341 (Gunbad-i Surkh), 380 (Haruniyya); Hutt, *Iran 1*, Pl. 128 (Baba Luqman; the original structure dates from the twelfth century, not the fourteenth, as in the caption); Régis de Valence, *La restauration de mausolée de Baba Hatim en Afghanistan* (Paris, 1982), Pls. 74, 75 (Baba Hatim).

36  Hillenbrand, *Islamic Architecture*, 281.
37  Terry Allen, "The Tombs of the ᶜAbbasid Caliphs in Baghdad," *Bulletin of the School of Oriental and African Studies* 46 (1983), 431. Inventories of early funerary monuments are found in Oleg Grabar, "The Umayyad Dome of the Rock in Jerusalem," *Ars Orientalis* 3 (1959), 35–36 and Yusuf Raġib, "Les premiers monuments funéraires de l'Islam," *Annales Islamologiques* 9 (1970), 21–36.
38  Blair, "Natanz," 86.
39  Grabar, "Dome of the Rock," 35–36.
40  Amikam Elad, "Why Did ᶜAbd al-Malik Build the Dome of the Rock? A Reexamination of the Muslim Sources," in *Bayt al-Maqdis: ᶜAbd al-Malik's Jerusalem*, part one, ed. Julian Raby and Jeremy Johns, Oxford Studies in Islamic Art, 9 (Oxford, 1992), 33–58; Josef van Ess, "'Abd al-Malik and the Dome of the Rock: An Analysis of Some Texts," in *ibid.*, 89–104.
41  If one accepts Sheila Blair's plausible theory in *ibid.*, 59–87, that the date of 72/691–92 given in its inscription refers to its commencement rather than its completion, then with ᶜAbd Allah b. Zubayr's defeat imminent (it took place in October–November 692; a year previously ᶜAbd al-Malik had defeated Musᶜab, the brother of ᶜAbd Allah b. Zubayr, in Iraq), ᶜAbd al-Malik would hardly have needed to plan for a Kaᶜba substitute.
42  Blair, "Natanz," 86, makes the same point.
43  K. A. C. Creswell, *Early Muslim Architecture*, 2 vols. (Oxford, 1969), 2:283-86. Blair, "Natanz," 86 suggests the possibility that the building should be identified as the shrine of the tenth and eleventh imams, ᶜAli Naqi and Hasan al-ᶜAskari.
44  Blair, "Natanz," 84; Allen, "Tombs," 426.
45  This is described in detail in Blair, *Monumental Inscriptions*, 44–45.
46  "Islamic Architecture," 1017–18.

# Medieval Egyptian Wooden Combs
## The Evidence from Fustat

## George T. Scanlon

The ancient Egyptians usually made high art out of their concern for the appearance and care of the hair. Paintings and hieroglyphs abound to prove this were there no artifacts; fortunately these latter abide in museums and private collections in such proliferation that styles and development are quite taken for granted. Among the most important of these objects was the comb, so simple in its utility yet fascinating in its variety and evolution.

Grooming was of paramount importance given the climatic conditions and the various types of hair to be found among the inhabitants, from the wooly helmets in Upper Sudan and Abyssinia to the sleek and sharply cut pates of the Mediterranean coast. It was incumbent on any man or woman to keep the hair free of lice, indeed of any verminous residue, and to ensure the same obtained for their children. Thus hair had to be unknotted, even 'unkinked' for a short time, before it could be cleaned more deeply and stranded. Different types of combs with teeth of varying width were employed for these processes and in sizes relative to age and disposition of the hair.

It was inevitable that someone would think of combining two sets of teeth, one more widely spaced for 'unkinking' the hair, the other more finely separated for the cleaning process. Further, the penchant for decoration noticeable on the earlier one-type combs would be applied in the space between the set; this space became the arena for developed decoration, elements of which lasted through the Arab conquest to the threshold of the thirteenth century.

Flinders Petrie believes the combination of sets of teeth was flourishing by the Ptolemaic period.[1] The decorative schema on the one hand preserved some of the earlier themes, particularly of the New Kingdom, while reflecting the newer tastes of the Alexandrian court. The vast majority were made of wood (Palestinian boxwood, sycamore, acacia, and palm; a few of imported hardwoods such as ebony, still fewer of aromatics such as cedar), and small combs were fashioned from bone.[2] Up to the Arab conquest, the most artistically rendered combs were of ivory, whose working had remained an Egyptian specialty. With Coptic combs we duplicate the decorative processes: the motifs of the earlier periods continue somewhat abated or modified, while newer designs arising from Christian iconography are pierced or engraved or carved between the sets of teeth.[3] This technical and decorative conservatism would naturally carry over into the early Islamic period; indeed some of the finest Coptic combs bodying forth Christian narratives and symbolism were made well after the Islamic conquest.

Muslim praxis put a greater premium on ritual cleanliness than had obtained before, and it was now obligatory upon the entire community. The head must be clean, hence was shorn almost to the scalp. The cutting of the hair could be once a week for the fastidious, an operation carried out in the bath-house.[4] Still, the need for so high a degree of cleanliness made mandatory the continued production of wooden combs,[5] a production that swelled as the Muslim population of Egypt soared, particularly after ca. 900.

During the excavations carried out by the Fustat Expedition of the American Research Center in Egypt between 1964 and 1981, a substanial number of wooden combs, whole or fragmented, came forth from the mounds. Most of these were surface finds, that is, they were found on the surface or within the fills of the mounds down to the *sibākh* layer, beneath which the finds were reasonably datable.[6] Because of a more securely dated context, one of the combs (Figure 15, Plate 16) can be dated but does not exhibit any decorative differences from the previous epochs, proving the decorative conservatism of the genre. However, sometime right before or immediately after 1200, with the appearance of Arabic inscriptions in the middle register of the comb, one senses a new, more idiosyncratic decorative expression, one consonant with an overall Mamluk esthetic, which dominated Egyptian Islamic art through the first half of the sixteenth century.

The following combs have been registered with the Fustat Expedition/ARCE. It was thought reasonable to attempt a typology based on decoration, though it must be used with great caution because of the chronological lacunae. The find *loci* can be identified through the field maps in the Preliminary Reports, which are termed FEPR, followed by the year and the volume in JARCE noted above.

## Catalog of Registered Wooden Combs: Fustat Expedition/ARCE

*I. Undecorated mid-panel.* In all periods these comprise the most numerous category. Plate 1 is a sample of undecorated combs from the 1972 season and is easily duplicated from the finds of the other eight seasons. Generally these are fashioned from the cheapest woods, palm planks for the larger part, and vary in size relative to the grasp of the user or the age of hair under treatment. Obviously the widely spaced side is for unknotting the hair and the more closely spaced side is for cleaning and fashioning the mane. As there is very little or sparse decoration, the category is useless for dating purposes.

A. Major portion of an undecorated comb. Pres. dim. 8.5 x 4.4 x 0.5 cm. Found in Fustat-A in quadrant VIII-11 on the surface; JARCE 4. [64.4.30; Akron Museum of Art]. Fig. 1 and Pl. 2.

B. Major portion of an undecorated comb. Pres. dim. 8.5 x 4.0 x 0.8 cm. Found in Fustat-A on the surface in quadrant VII-15; JARCE 4. [64.4.58; Akron Museum of Art]. Fig. 2 and Pl. 3.

C. Complete comb; all teeth present; two scratched parallel lines the only decoration in middle panel. Found in Fustat-B in quadrant XVI-7 near the rim of cistern F´; JARCE 5. The find spot would permit a dating of 12–13th century. Pres. dim. 7.1 x 4 .7 x 0.7 cm. [65.3.47; Princeton Museum]. Fig 3 and Pl. 4. A somewhat similar but larger comb was found at Qusayr al-Qadim in 1980 which must be of about the same vintage.[7]

*II. Rudimentary or incomplete decoration.* There is a rough asymmetrical placement of the decoration, which is rarely centered within the midpanel. The desire is to be artful while the effect is clumsy. Nevertheless one senses a move away from the utter simplicity of Type I. When the decorative theme is incomplete or incompetently handled one is at a loss to decide on chronology; all one may conjecture is that the type seems to carry on themes from the earlier periods.

A. Small fragment of comb; sufficient remains to conjecture that when complete it was close to the same dimensions as Figs. 1 and 2. The narrowly spaced teeth are all broken at about a third of the original length. The central design of contingent flattened ovoids within a slightly sunk panel is irregularly placed. Found in Fustat-A on the surface of quadrant III-23; JARCE 4. Pres. dim. 6.6 x 2.0 x 0.6 cm. [64.5.11; Akron Museum of Art]. Fig. 4 and Pl. 5. Because of the similarity of the contingent ovoids to motifs on slip painted pottery and tonged glass,[8] one is tempted to assign this fragment to the 9th or 10th century.

B. An almost complete small comb; on both sides in the center of the

mid-panel is a small, rounded, shield-like device with two bars, not quite parallel on one side, slanting at a 45° angle. Found in Fustat-B on the surface of quadrant XXI´; JARCE 18. Pres. dim. 4.0 x 4.0 x 0.5 cm. [72.10.2; Ashmolean Museum, Oxford]. Fig. 5 and Pl. 6. The shield-like device is most reminiscent of a class of Mamluk heraldic devices;[9] thus it would not seem unreasonable to place the comb ca. 1200.

*III. Concentric circles theme.* The motif of small or large concentric cirles arranged in various patterns is probably as old as Near Eastern antiquity itself. It is easy to execute and appealing in variation. It had become almost synonymous with Coptic art, as one finds its expression in practically all metiers including illuminated manuscripts.[10] That it would carry over into the Islamic period seems inevitable, which makes objects so adorned found in undatable *loci* rather difficult to date.[11] Indeed, we see the motif accompanying Arabic inscriptions on combs, below. Finally, it is noteworthy that it is the motif associated with the new miter-shaped comb.

A. Large comb, complete except for a few broken teeth on the narrow-spaced side. The mid-panel has an aligned design of three sets of large concentric circles with two sets of smaller ones intervalent, which is duplicated on the other side. Found within the top level of *sibākh* in quadrant XXI´-5/XXI-1 in Fustat-B; JARCE 18. Pres. dim. 10.2 x 8.5 x 1.0 cm. [72.9.3; Ashmolean Museum, Oxford]. Fig. 6 and Pl. 7. The find-spot would allow a tentative dating of ca. 1200, which indicates how long-lived this single motif theme was.

B. Comb complete except for some slight damage to the teeth on either side of mid-panel. The latter has a centrally decorated group of large and small concentric circled devices rather in the form of an *ansa* between two triangular grooves. The combination is repeated on the other side. Found in Fustat-B on the surface of quadrant VI-20; JARCE 11. Pres. dim. 8.0 x 7.4 x 0.5 cm. [68.10.2; Kelsey Museum, Ann Arbor]. Fig. 7 and Pl. 8. Though a surface find, this comb would seem to precede in style and expression of theme the more elaborate combs of the period after 1200. Perhaps it is wiser to cite this difference only when relative to the finer wrought decoration of that period. Conservatism continues, which might here pose questions of social and geographical distinction.

C. Major fragment of comb; some loss of teeth ends on widely-spaced side. Mid-panel decoration of large central concentric circle motif bounded at the extreme by a triangular set of concentric circles with a doubled set intervalent; arrangement repeated on the overside. Found in Fustat-A in sector III on the surface; JARCE 4. Pres. dim. 8.4 x 4.6 x 1.0 cm. [64.4.66; Princeton Museum]. Fig. 8 and Pl. 9. Again this is

a surface find, and one is aware of the conservatism of motival decoration; nevertheless one feels if it were a commissioned object it would have been made before 1200.

D. Comb fragment; most of the wide-set teeth broken off, the size of the narrow set group ascertainable. Mid-panel decoration of three concentric circle elements in triangular arrangement followed by single element to the right on the one side and this combination followed by a yet smaller element to the left on the other face. Found in Fustat-B on the surface of quadrant XVI-5; JARCE 5. Pres. dim. 4.6 x 3.0 x 0.7 cm. [65.3.9; Princeton Museum]. Fig. 9 and Pl. 10. The fact that the design is not symmetrically carved on both sides points to our fragment as a pure artisanal product for which no dating is possible other than to assume it was made after the Islamic conquest.

E. Miter-shaped comb with single set of narrow-spaced teeth, of which a few tips and left guard are broken. One side has a symmetrical design of a single large concentric circle set in the middle of the arched space, two sets of three elements differently triangulated at the ends above the teeth and a single element at the point of the arch (Fig. 10). The other side is the same except that the triangular sets are symmetrical and a doublet is placed eccentrically above the left triangle (Pl. 11). Found in Fustat-B on the surface of quadrant XXI-19; JARCE 17. Pres. dim. 7.5 x 7.6 x 1.1 cm. [71.9.26; Islamic Museum, Cairo]. As far as published examples allow the claim, this is a new shape in the world of Egyptian wooden combs. There is an example in the Islamic Museum collection that is similar but has a slightly curving top.[12] 'Abd al-Raziq in his excellent article on the wooden combs in the Louvre believes combs of this type, i. e., with a single set of narrowly spaced teeth, are for combing beards.[13] It is tempting to see the shape rather than the decoration as an Islamic contribution to the genre, which gives the miter shape a post-640 significance.

F. Miter-shaped comb; slightly smaller than the above example and with right guard and some of the narrowly set teeth broken above the half-point. Decoration of a triplet set of concentric circles at the crown and two more at either extremity above the teeth with a four-element combination between the latter. Pattern repeated on other side but with some loss of carved definition. Found in Fustat-B on the surface just outside quadrant XXI -5; JARCE 18. Pres. dim. 6.2 x 4.0 x 0.7 cm. [72.10.3; Ashmolean Museum, Oxford]. Fig. 11 and Pl. 12. As this example is again a surface find one can see it only as post-640.

*IV. Concentric circle theme in combination.* Inevitably the dominant motif of concentric circles would be coupled with other devices to make for a more diversified artistic and/or artisanal expression. But it was not until the appearance of Arabic inscriptions that it lost its dominant or equal

place in the schema of comb decoration. Our examples might be considered miscellaneous to the category III above, but strict typology demands a neater definition. Perhaps when a larger number of complete combs is subjected to stylistic analysis, our newer category may seem to beg the question. As all examples are surface finds they add little to chronological security.

A. Large fragment of comb; right guard and some of both sets of teeth missing. Mid-panel decoration of three concentric circle units arranged as an *ansa* pointing toward the center, at which a round shield with a central band is in relief. As the decor is duplicated on the other side, the completed decor would have had another triangular *ansa* at the other end of the mid-panel. Found in Fustat-B on the surface of quadrant XI-22; JARCE 10. Pres. dim. 7.9 x 5.0 x 0.7 cm. [66.4.7; Princeton Museum]. Fig. 12 and Pl. 13. There can be little doubt that the central motif is heraldic, much more distinctly so than the more roughly drawn comb in Fig. 5 and Pl. 6. Compared to those illustrated by Mayer[14] and 'Abd al-Raziq,[15] our example lacks their more complex decoration. Nevertheless it is clearly to be dated after 1200.

B. Less than half a comb, teeth intact in the preserved section of the comb. Mid-panel decoration of single small circles and concentric circle motifs in varying sizes. There is evidence that the central portion was probably pierced. Interesting variation is the engraving of the left guard, which must have been duplicated on the right. The decoration goes around the guard and is duplicated on the other side. Found in Fustat-B on the surface of quadrant XXI-2; JARCE 6. Pres. dim. 9.4 x 3.8 x 0.7 cm. [65.4.176; Princeton Museum]. Fig. 13 and Pl. 14. Though this example anticipates our next category it is interesting to see the circle theme in its single dotted form competing against the concentric form; also the three parallel-line margin. The artistic plethora of circles and the symmetry of the design when compared to the fillers in the inscription category mark this comb as artistic and made after 1200.[16]

C. Small fragment of comb; teeth intact on either side. The mid-panel contains a composition of concentric and dotted circles that differs slightly on either side of the comb. This attends a small portion of a central rectangular motif that shows parallel diagonal lines on both sides. Between the narrow-spaced teeth and the central section is a narrow horizontal margin with a wavy line that has disappeared just below the wide-spaced teeth on both sides. Found in Fustat-B in the surface fill of quadrant XVI-21´; JARCE 5. Pres. dim. 7.7 x 2.1 x 1.0 cm. [65.4.52; Princeton Museum]. Fig. 14 and Pl. 15. Because the central portion dominated the mid-panel one sees here the circles

serving as filler, which by analogy with the examples with inscriptions permits one to place this fragment as after 1200.[17]

V. *Pierced designs.* There was a technical challenge, one springing from the presence of pierced designs in ivory and bone metiers, in going beyond carving and engraving to test the temper of the wood, which, due to the pressure already rendered by carving the narrow and wide teeth, might risk cracking through further cutting. This problem was certainly solved in the wooden combs with Coptic themes, and combs of a high artistic order ensued.[18] Hence the more elaborate and intricate the pierced design the closer it will be to the Coptic models, as is the case with our Fig. 16. In the post-1200 period the piercing most approximates *mashrabiyya* work, which reached a high artistic level of production in the Mamluk period.[19]

A. A large fragment of a comb, both of whose sets of teeth have been broken but whose guard is intact, allowing for a sense of the height of the original. Oddly, but with great skill, the guard itself is pierced: five times attendant to each set of teeth and three times at the mid-panel. What remains of the latter has an intricate lattice pierced within a rectangle; this lattice was probably repeated in the central wider section.[20] Found in the undisturbed shallow pit K in quadrant XI-16 in Fustat B; JARCE 6. Pres. dim. 12.3 x 4.8 x 0.8cm. [66.5.17; Princeton Museum]. Fig. 15 and Pl. 16. Also in the fill of the pit were pieces of a carved bone inlay of the 8th–9th century (Pl. 17). Thus it becomes a firmly dated object; something rather rare in the genre. It also proves the continuity of the older, highly adroit Coptic mastery of woodcarving, which continued well into the Islamic period.

B. Two matching fragments of comb, crack goes through two pierced elements; some of the narrow-spaced teeth broken. Mid-panel design of pierced central lattice of diamond pattern attended by one single, then two, then three triangular piercings completed by a sunken roundel probably for an inlay. The guard is pierced by two sets of holes roughly marking the top and bottom of the mid-panel. Found in Fustat-B in the surface fill of quadrant VI´-9; JARCE 11. Pres. dim. 9.0 x 4.5 x 0.6 cm. [68.11.48; Kelsey Museum, Ann Arbor]. Fig. 16 and Pl. 18. This comb lacks the finesse of carving of the previous example, but the lattice work is not yet *mashrabiyya* work and the guard has been pierced. Hence it seems to us that the complete comb was certainly made before 1200, most probably around 900.[21]

VI. *Inscriptions.* Monumental *naskhī* was introduced into Egypt during the Ayyubid period and became the supreme decorative theme in all aspects of Mamluk art and architecture. Thus there can be no objection to dating all combs bearing such inscriptions as after 1200. To be more precise, one must have so particular an inscription as to be self-dating—as is the case of the sultanic comb noted immediately below. Generally the inscriptions

carry simple invocations, moral or humorous sayings, and sometimes a brief verse of the Qur'an. Ahmad Hamdi has been most solicitous in providing a number of these inscriptions on combs in the Islamic Museum, Cairo,[22] and 'Abd al-Raziq has related these to the ones in the Louvre bearing inscriptions, and the entire group to instances from other metiers, thereby joining the simple comb to other objects purveying the quintessential Mamluk esthetic.[23] The group emanating from the Fustat Expedition/ARCE discussed below should be construed in relation to these scholars' analyses and, hopefully, moving somewhat forward in understanding that esthetic.

A. Intact comb except for end blunting of a few teeth. Mid-panel contains on either side a central rectangular inscription panel bounded by sets of concentric circles acting as *ansae*, then a narrow panel containing three parallel slanting lines (similar to those noted in Fig. 14) margined by two vertical thin lines and completed around the guards by dotted circle roundels carrying inscriptions. The full inscription reads: *bi-rasm al-muwaqqar al-ajall Nāṣir al-Dīn Muḥammad* (ordered by the supreme, the highly respected Nasir al-Din Muhammad). The right roundel can be read: *'azzahu* (praise him); the left is more difficult to decipher but might carry the initials or the 'sign' of the comb-maker. Above and below the entire central design and running into the roundels is a single unsymmetrical wavy line (again similar to that in Fig. 14). Found in Fustat-B in the surface fill of XXXI-13; JARCE 6. Pres. dim. 7.8 x 9.5 x 1.2 cm [65.5.23; Islamic Museum, Cairo]. Fig. 17 and Pls. 19, 20. Considering the adjectives and the admonition to praise in the right guard, the inscription points to the sultan al-Malik al-Nasir Muhammad ibn Qala'un. As he reigned three times, an absolute dating cannot be entertained; but the combination of *al-muwaqqar* and *al-ajall* points to the third reign (1310–41), when he had consolidated his power within the Mamluk realm.[24]

B. Intact comb; a few of the narrow-spaced teeth broken immediately adjacent to the left guard. Mid-panel decoration of inscription cartouche on both sides, attended on either side by roundels containing triangles within which are carved smaller devices: on the front small triangles, on the rear by a crescent and a circle. Between these roundels and the dotted circle roundels going around the guards are a vertical arrangement of two large concentric circle devices and smaller dotted circles in the interstices. The whole panel is bordered by a number of parallel lines that are not continued around the guards and the rear panel is slightly higher than the front one. The back cartouche reads *al-ᶜāfiya* (good health) and the front one reads *al-iqbāl* (prosperity). Found in the surface fill at M in quadrant XI-15 in

Fustat-B; JARCE 5. Pres. dim. 8.2 x 7.6 x 0.7cm. [65.3.152; Princeton Museum]. Fig. 18 and Pls. 21, 22. This is a complete example of the simple wise saying: good health (by using this comb) leads to prosperity.[25] The roundels carrying the triangles are purely decorative and not heraldic. Again one must note the longevity of the concentric circle theme, but here simply as filler. Probably 14th century.

C. Fragment of a comb, less than half preserved including left guard. An inscription reading *al-iqbāl* (prosperity) goes around the guard. It is bordered on either side by a rectangular panel containing a rough polygonal shield-like device with a roundel of dotted circles in the center; this latter is attended on the comb by a pierced lattice in the *mashrabiyya* style divided into two smaller panels.[26] Above and below the whole decorative panel is bordered by straight parallel lines that go right around the guard. Found in Fustat-B on the surface of quadrant XVI-16; JARCE 5. Pres. dim. 9.0 x 3.9 x 0.75 cm. [65.2.31; Princeton Museum]. Fig. 19 and Pl. 23. This is a very subtle variation on the preceding example in that the pierced design is given primacy of place in the mid-panel while the inscription goes around the guard. On this analogy, the missing guard probably had the word *al-ᶜāfiya* (good health) going around it. For similar examples of inscription and pierced lattice cf. Petrie, *Objects*, pl. XXI, no. 42, and 'Abd al-Raziq, "Les peignes égyptiens," fig. 1. Most probably all three are of the 14th century.

D. Fragment of comb, less than half preserved including the left guard. Inscription cartouche with curved endings goes around the guard. Between it and a dotted concentric circle motif is an irregular pattern of dotted and concentric circle motifs attempting an X device. The entire mid-panel decoration is bounded by a wavy line motif that goes right around the guard. The inscription is difficult to decipher but might read *rabbī al-jabbār al-fātiḥ al-khallāq* (my Lord; [you are] the Powerful, the Conqueror, the Creator). Found in Fustat-B within the disturbed fill of U in quadrant XVI-17; JARCE 5. Pres. dim. 8.5 x 3.4 x 0.5 cm. [65.1.27; Islamic Museum, Cairo]. Fig. 20 and Pl. 24. Unlike similar inscriptions noted by Hamdi and 'Abd al-Raziq, the first word here is divided by the gist of the invocation: *ra–bbī*. This might be a characteristic of the carver's art or a fully intended artful flourish. The bounding wavy line motif and the subtle inscriptional device allow for a 14th century dating.

E. Approximately half a comb, some of the widely-spaced teeth missing. Originally the mid-panel decoration consisted of two inscription cartouches on each side, each straight-sided at the edge and curved on the opposite side. The intervening space was made up of a large

central concentric circle motif bounded by two vertically placed concentric circle units with dotted circles in the interstices. The mid-panel decoration was bounded above and below by the wavy line motif, which stops dead at the end of the comb. Found in Fustat-B in the surface fill of quadrant XI-21; JARCE 5. Pres. dim. 7.2 x 4.4 x 0.7 cm. [65.4.117; Islamic Museum, Cairo]. Fig. 21 and Pls. 25, 26. There are two puzzling aspects of this comb: first there is no guard, and then the inscription cartouches read as almost duplicate: possibly *al-riḍā mimma al-qaḍā'* (contentment comes from what has been ordained). Also in the better inscription-bearing combs the wavy line motif goes right around the guards, anchoring the mid-panel as it were; here it stops dead, which leads one to surmise there might have been more to the comb, hence more to the inscriptions, which surely would have ended in a curved line. Thus one is led to the conclusion that the guard is missing and that it no doubt carried the wavy line motif around itself. The double concentric circle motif used vertically echoes the treatment in Fig. 18 herein. Probably 14th century.

F. Small fragment of comb; height ascertainable though many teeth are broken. Mid-panel decoration of inscription band on both sides; cartouche endings missing; bounded above and below by sets of horizontal parallel lines. Found in the lowest surface fill of quadrant XXI-20 in Fustat-B; JARCE 17. Pres. dim. 9.3 x 2.5. [71.10.3; Islamic Museum, Cairo]. Fig. 22 and Pl. 27. Though the portion of the inscription band on either side is too narrow to make any sense, it no doubt carried the text of a wise saying contained within a wide cartouche on either side with appropriate filler and guards, hence very much in the tradition of Mamluk combs. Though there is nothing exactly parallel in the examples published by Hamdi and 'Abd al-Raziq, the carving seems assured; the cutting is sharp rather than deep. Dating from the find-spot would be dubious, but on stylistic grounds we would put the fragment somewhere in the 14th–15th centuries.

## Conclusion

This catalog of combs and comb fragments has fulfilled three purposes: a) it has shown the strength and continuity of pre-Islamic decorative motifs; b) it has added a considerable number of differing examples to those studied by Hamdi and 'Abd al-Raziq; and c) in two instances (Figs. 15 and 17) it has provided a better dating focus. On a less exalted level, we now have a new shape (Figs. 10 and 11) to add to the canon and can be more assured of the pervasiveness of the Mamluk esthetic to the humblest of domestic products. It becomes more interesting to note the shifts of taste (for example, from Coptic piercing designs to Mamluk *mashrabiyya*)

apparent at this level of production. However, it is disappointing that to date we have no combs undeniably from the Fatimid period, when Egyptian decoration elsewhere freed itself from Abbasid taste; and, more particularly from the archeologist's point of view, we still lack a firm dating horizon for the period before 1200, something that we now have for ceramic filters.[27] Further excavations at the site will no doubt rectify these lacunae.[28]

## Notes

1. W. Flinders Petrie, *Objects of Daily Use* (London, 1927), 26, pls. XX, XXI. The early combs in the Egyptian Museum, Cairo, are surveyed and discussed in Georges Benedite, *Objets de toilette* (Paris, 1911), pls. III–VII.
2. The continuity of producing bone objects into the early Islamic period is most fruitfully essayed in M. Ereshefsky, "Bone and Ivory Carving in Early Islamic Egypt," M. A. thesis, The American University in Cairo, 1980, 36–39, 76–89.
3. J. Strzygowski, *Koptische Kunst* (Vienna, 1904), pls. 7116–17 for ivory combs and pls. 8826–36 for wooden combs. For more particular examples see John Beckwith, *Coptic Sculpture 300–1300* (London, 1963), pl. 44 (ivory) and pl. 131 (wood). The most up-to-date discussion of the phenomenon can be found in M.-H. Rutschowscaya, "Ivory and Bone" and "Woodwork" in *The Coptic Encyclopedia* (New York, 1991).
4. There is a very fine illustration of the custom in a painting by Bihzad of the caliph al-Ma'mun being shorn during a visit to the baths: B. Gray, *Persian Painting* (London, 1977), 117.
5. Some small, generally undecorated, combs continued to be fashioned from bone, but no example has yet been published of an ivory comb fashioned for use by a Muslim. As proven by the wooden examples covered in this article, there can be little doubt that such an object would have carried an Arabic inscription. Prof. Bernard O'Kane has brought to my attention an underglaze-painted tile in the Islamic Museum, Cairo, which has a comb next to a large vase and a small rectangular panel that carries the inscription *mimmā ᶜumila bi-rasm al-qāḍī* (what has been made by order of the qadi), a phrase that also occurs on the painted wooden ceiling of the small *madrasa* of Badr al-Din al-ᶜAyni, built in 1411–12. He served as *qāḍ al-quḍāt* on a number of occasions. The comb lacks a central inscription, carrying rather a floral rinceau: Laila Ibrahim and Bernard O'Kane, "The Madrasa of Badr al-Dīn al-ᶜAynī and its Tiled Miḥrāb", *Annales Islamologiques* 24 (1988), 258, and pl. XVIa (*vice* pl. Va in the text). We reproduce the tile in Plate 28 herein.
6. This excavation routine at Fustat can best be understood from the various Preliminary Reports that appear in the following volumes of the *Journal of the American Research Center in Egypt*: 4, 5, 6, 10, 11, 13, 16, 17, 18, 19 and 21. For a more particular examination of a single mound, cf. George T. Scanlon, "Fustat Expedition: Preliminary Report 1973—Back to Fustat-A," *Annales Islamologiques* 16 (1981), 422–32.
7. Cf. J. H. Johnson and D. S. Whitcomb, *Quseir al-Qadim 1980* (Malibu, 1982), pl. 69-d. A more scientific analysis of these Red Sea combs can be found in F.

T. Hiebert, "Commercial Organization of the Egyptian Port of Quseir al-Qadim: Evidence from the Analysis of the Wooden Objects," *Archaéologie Islamique* 2 (1991), 127–59, fig. 7.

8  For the latter cf. JARCE 16, fig. 21, which from its find-spot is clearly of the 9th–10th century. For a very good approximation of our motif see A. Badawi, *Coptic Art and Architecture* (Boston, 1978), pl. 5.45 middle.

9  Cf. L. A. Mayer, *Saracenic Heraldry* (Oxford, 1933), *passim*. He illustrates a comb with a round shield containing a fleur-de-lys, an amirial device: *ibid.*, pl. V-5.

10  To cite an immediate corollary metier, its incidence on bone objects is practically endemic, cf. Strzygowski, *Koptische Kunst*, pl. XX and O. Wulff, *Altchristliche und mittelalterliche...Bildwerke* (Berlin, 1909), pls. IX–XI, XXII–XXVI. For a slightly different treatment of the motif from the al-Hira excavations, cf. G. T. Scanlon, "Ancillary Dating Materials from Fustat," *Ars Orientalis* 7 (1968), fig. 5 and text fig. 7-a.

11  That the motif could be used in a most inchoate and inartistic manner is obvious from a comb found at Qusayr al-Qadim, where it is literally spread over the mid panel and the guard riders: Johnson and Whitcomb, *Quseir*, pl. 69-a. On the other hand a more formal arrangement can be seen on a comb formerly in the Coptic Museum, Cairo, and now in the Port Said Museum: D. Benazeth and G. Gabra, "Boiseries du Musée Copte déposées au Musée National de Port-Said," *Bulletin de la Société d'Archéologie Copte*, 33 (1994), pl. VI-a.

12  Cf. Ahmad Hamdi, *Mu'iddat al-tajmīl fī mathaf al-fann al-islāmī* (Cairo, 1959), pl. 22, which is undecorated and assigned to the fifteenth century. The majority of the examples cited by Dr. Hamdi came from Fustat during the excavations carried out by Aly Bay Bahgat.

13  Ahmad 'Abd al-Raziq, "Les peignes égyptiens dans l'art de l'Islam", *Syria* 49 (1972), 399–412, figs. 6–7. It is interesting that one of his examples is denticulated on the curving top while the other has a carved crenelation of rudimentary crown. Dr. 'Abd al-Raziq most helpfully quotes al-Maqrizi to the effect that there was a comb-makers' *sūq* attendant to the al-Salihiyya madrasa in the Bayn al-Qasrayn area: *ibid.*, 412. Dr. 'Abd al-Raziq indicates that these combs were given to the Cabinet des Médailles in the Bibliotheque Nationale by Dr. Paul Balog, a long-time resident of Cairo. One may assume that most of these came from Fustat; the ebony ones (nos. 8 and 9) from the Ottoman period may not have.

14  *Saracenic Heraldry*, V-5 and another that is not illustrated, associated with the *amīr* Malaktamur (Islamic Museum #4926).

15  "Les peignes égyptiens," number 6, 409 f.

16  The medallion of small dotted circles carrying the decoration around the guard is duplicated on a comb in the Louvre: *ibid.*, pl. XXI.

17  A variation of the arrangment can be seen in a comb fragment from Qusayr al-Qadim: Johnson and Whitcomb, *Quseir*, pl. 69b. Yet another variant can be seen in Fig. 23 herein, which also shares a variant motif with Fig. 17 herein. This example is from a badly preserved fragment presently in the Princeton Museum (reg. no. 65.2.61).

18 Cf. the two combs in Rutschowscaya, "Woodwork," 2336.
19 Cf. Hamdi, *Mu'iddat al-tajmīl*, pl. 19 and 'Abd al-Raziq, "Les peignes égyptiens," fig. 1 and in Fig. 20 herein.
20 An almost complete double of ours with the central panel intact was found by Aly Bahgat at Fustat; cf. Aly Bahgat and Albert Gabriel, *Fouilles d'al Foustat* (Paris, 1921), pl. XXVII, lower photograph upper right.
21 Hamdi, *Mu'iddat al-tajmīl*, pl. 15, places its nearest congener among the published examples in the fifteenth century, whereas we would place it before 1200 for the reasons noted.
22 *Ibid.*, 60–64.
23 "Les peignes égyptiens," 406 f.
24 Though not of sultanic quality, the comb in Johnson and Whitcomb, *Quseir*, pl. 69-c, must have been especially commissioned, for the inscriptions reads in part: *mimmā 'umila bi-rasm* . . . (was made on the order of . . . ). As such it should be compared to those with this formula in Hamdi, *Mu'iddat at-tajmīl*, 64.
25 The same decorative schema but with different motifs between the inscription panel and the guards can be seen in *The Arts of Islam: Masterpieces from the Metropolitan Museum of New York* (New York, 1982), no. 61, 156–57.
26 The combination of the polygonal shield-like device and the *mashrabiyya* lattice is almost duplicated in Hamdi, *Mu'iddat al-tajmīl*, pl. 19. Another variant of this combination can be seen in Fig. 24 herein. This has a curious S-motif on either side of the piercing but lacks an inscription around the guard. This fragment is in the Princeton Museum (reg. no. 65.2.86).
27 Cf. G. T. Scanlon, *Fustat Expedition: Final Report. Volume 1, Filters* (Lake Winona, Ind., 1985), *passim*.
28 A recent publication illustrates four combs from Kom al-Dikka: Iwona Zych, "A Note on the Collection of Wooden Objects from the Polish Excavations at Kom al-Dikka in Alexandria," *Société Archaeologique d'Alexandrie*, Bulletin 45 [Alexandrian Studies in memoriam Daoud Abdu Daoud] (Alexandria 1993), 414–15, pls. XCVIII, CII. Those on the former plate mirror our Figures 1–3, 8 and 9; that on the latter plate exhibits a lovely variation on the perforated motif.

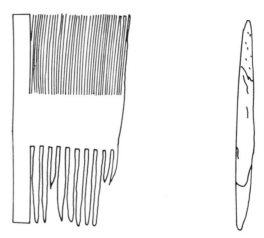

Figure 1    Note: All figures 65% actual size

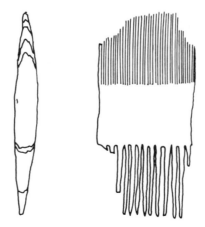

Figure 2

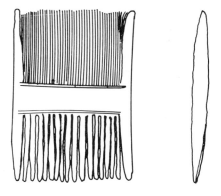

Figure 3

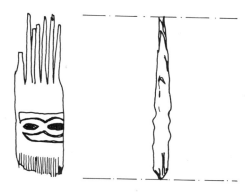

Figure 4

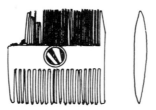

Figure 5

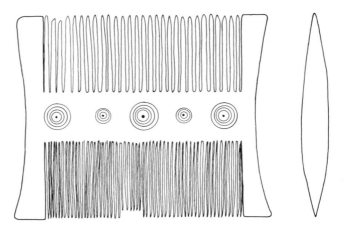

Figure 6

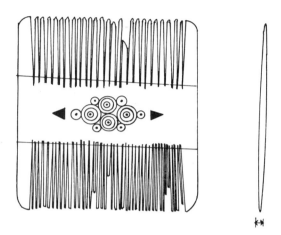

Figure 7

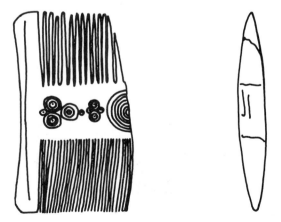

Figure 8

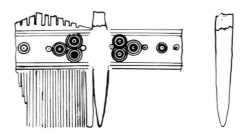

Figure 9

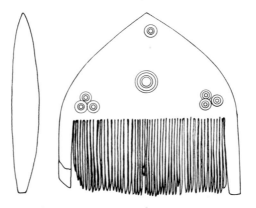

Figure 10

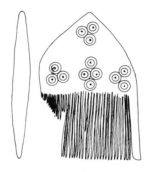

Figure 11

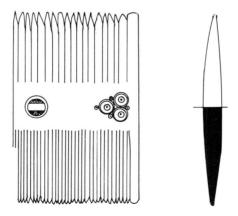

Figure 12

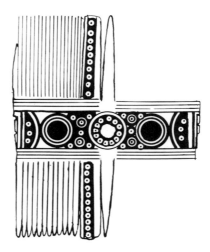

Figure 13

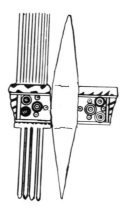

Figure 14

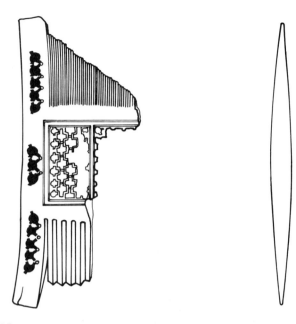

Figure 15

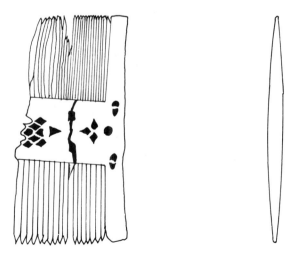

Figure 16

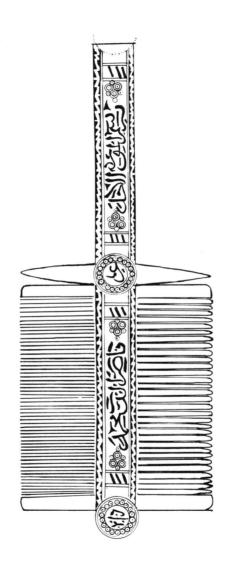

Figure 17

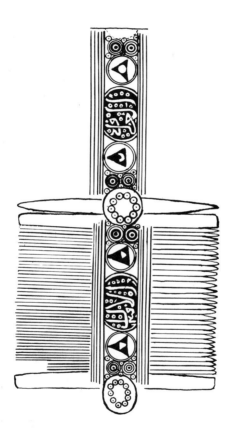

Figure 18

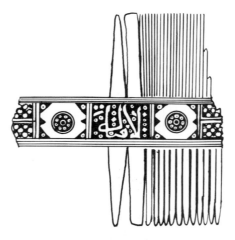

Figure 19

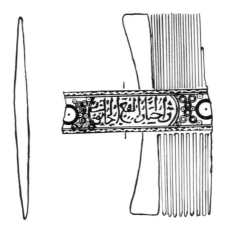

Figure 20

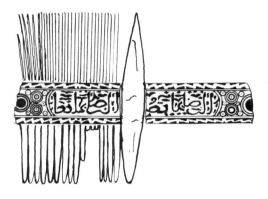

Figure 21

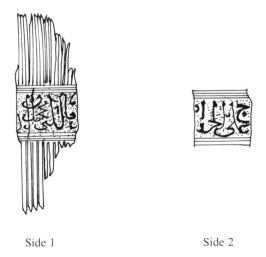

Side 1          Side 2

Figure 22

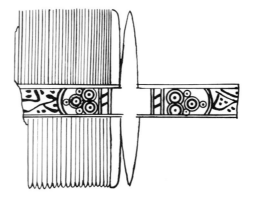

Figure 23

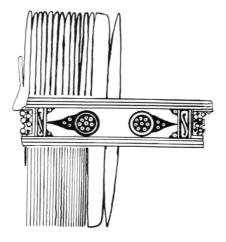

Figure 24

THE VISUAL IMAGE OF NINETEENTH-CENTURY
CAIRO: THE BRITISH DISCOVERY

Caroline Williams

Between 1830 and 1860, English artists discovered the great Islamic city of Cairo. The images they produced—topographical lithographs, genre scenes, and black-and-white photographs—have documentary and anecdotal value; they are valuable research tools and a source of visual pleasure. But in addition they are important in themselves, as part of the evolutionary way in which foreign artists described Cairo visually. These images and the men who produced them—Robert Hay, David Roberts, John Frederick Lewis, and Francis Frith—are the subject of this essay.

At the beginning of the nineteenth century medieval Egypt was awakened from its long Ottoman slumber by two young suitors: a French general and an Albanian opportunist. On July 1, 1798, Napoleon Bonaparte, commanding a French expeditionary force, disembarked near Alexandria, marched up the Nile, defeated the Mamluk army in the Battle of the Pyramids, and entered Cairo. Napoleon's military victory was short-lived, but the event marked a turning point in the history of Egypt and of Cairo. On the international level, Egypt became an area of strategic importance for England and France. On the cultural level, Egypt was revealed as a land of ancient, diverse, and exotic fascination to an ever-increasing public who were anxious to see for themselves what they read about in 'descriptions' and saw at exhibitions.[1] Logistically, the development of railroads through Europe and of steamships across the Mediterranean made Egypt a destination increasingly more feasible to reach.

In Egypt itself, the Napoleonic invasion brought to power Muhammad ᶜAli, an Albanian Ottoman military officer who had been part of the com-

bined British and Ottoman invasion that terminated the French occupation, and whose family after him ruled Egypt until 1952. In 1811, Muhammad 'Ali with a fusilade gunned down the Mamluks, the medieval power that had ruled the country for more than 550 years. As the Father of Modern Egypt, Muhammad ᶜAli turned westward for expertise and example in updating his country. He invited to Egypt talented French and Italian soldiers and technicians, whose careers in Europe had been cut short by the collapse of the Napoleonic empire, to remodel his military forces and administration, and to advise, staff, and teach in the factories and schools he was establishing. He welcomed and facilitated trade with Europe, guaranteeing security to European merchants and travelers. Official and unofficial contacts between the countries were cultivated. Thus by the 1820s the way to Egypt, physically and culturally, lay open to European explorers, adventurers, observers, and artists.

## Robert Hay (1799–1863)

Initially the artists came to Egypt as part of archaeological expeditions to authenticate the past, the world of the pharaohs, but they soon discovered a new world, that of Islam, and the interest in Egypt broadened to include its Islamic present. One patron–enthusiast was Robert Hay, Laird of Linplum and Nunraw.[2] He was part of a remarkable circle of young, British, independent scholar enthusiasts who came to "discover" and "record" Egypt. Between 1824 and 1834 he financed two expeditions to Egypt, and became a major figure in the systematic recording of pharaonic monuments. For this task he hired artists and draftsmen to make detailed drawings of reliefs and plaster-casts of the ancient sculpture. The forty-nine volumes of manuscript and drawings resulting from his expeditions still await cataloguing in the British Museum. Paradoxically, however, it is for his *Illustrations of Cairo,* published in 1840, that he is best known today. Hay lacked application and financial sense and the volume did not sell well, but for what it portrays of the new interest in contemporary Cairo it is remarkable in several ways.

The volume contains thirty lithographic plates done mostly from the drawings of Owen Browne Carter (six of the drawings were by Hay himself), an architectural draftsman from Winchester, whom Hay engaged when he returned to Egypt in 1829. The plates concentrate on the Cairene cityscape. The views are mostly topographical in nature, but they do include events that integrate the local population with the architectural backdrop such as a circumcision parade (pl. 6), merchants doing business (pls. 12, 24), a wedding procession (pl. 15), women on an outing (pl. 17), and so on. These drawings are the first accurate representations of Cairo's rich mix of people and monuments (fig. 1).

Some of the monuments are well known (for example, the Complex of

Sultan Barquq, pl. 9), which initiates an interesting sequence of comparisons of the same view with those by subsequent artists. But other plates show vistas and monuments for which these illustrations are our only records. Plate 20, drawn by Robert Hay, is of the Great Iwan on the Citadel. This is the Great Audience Hall, built by the fourteenth-century sultan al-Nasir Muhammad and destroyed in 1837 to clear the way for Muhammad ᶜAli's mosque, which is now Cairo's most conspicuous landmark. The view of Birkat al-Fil (pl. 21), the 'Lake of the Elephant,' with its pavilions, villas, and mansions, was drawn by O. B. Carter. From the fourteenth to the nineteenth century it was a famous lake and residential area of Cairo, but during the urban improvements of Muhammad ᶜAli and his dynasty it was filled in. Plates 27–28 show Bulaq, the port of entry for the city of Cairo and the point of departure for Nile excursions, as it was before the changes wrought in the later nineteenth and twentieth centuries.

Further evidence of the growing interest in the Islamic present is offered in the dedication and in the title page. Robert Hay presented the volume to his artist, agent, and friend:

> To Edward William Lane Esq.
> Author of *The Manners and Customs of the Modern Egyptians*
> This volume is Dedicated, as a Tribute of Respect for the Zeal and Fidelity he has evinced in his Literary Pursuits connected with that country . . .

Edward Lane (1801–76) also arrived in Egypt in the mid-1820s.[3] From the first moment, when at age twenty-four he approached Alexandria (as he wrote, "like an Eastern bridegroom about to lift the veil of his bride"), until his death fifty years later, Lane was involved in a lifelong, almost obsessive, dedication to a comprehensive, systematic description and explanation of Egyptian Muslim society, culture, and language.

Lane observed and collected the material for his book during two sojourns in Egypt between 1825 and 1833, just before the galloping changes introduced by Muhammad ᶜAli and his successors were to commit Egypt to an irrevocable process of westernizing 'modernization.' The book was first published in 1836. It is a classic description of Cairo as a medieval city untouched by Western influences. Lane set out to illuminate "honestly" and "correctly" the Islamic life and culture in which he had inserted himself. The microscopic accuracy of his detailed observations and record is so complete and final that the book, more than one hundred and fifty years later, is still in print and is still a basic text for historians of the Arab world, a classic for anthropologists, and a highly readable work for all others. Lane was also an artist of accuracy and skill and his textual illustrations highlight and pinpoint his verbal descriptions.

The colored title page of *Illustrations of Cairo* was designed and print-

ed by Owen Jones (1809–74). Jones, aged twenty-one, was in Cairo in 1832, and made several sketches of Cairene monuments. It was the study of these buildings that stimulated him to travel on to Constantinople and from there to Spain. Owen considered the Islamic architecture of Cairo second only to that of the Alhambra in Granada. The drawings of the Alhambra he made with his friend Jules Goury between 1823 and 1834 were published, between 1836 and 1845, as *Plans, Elevations, Sections and Details of the Alhambra.* It became the most influential book on Islamic architecture and decoration yet to appear in England.

## David Roberts (1796–1864)

The monuments of Islamic Spain also excited two other artists who came to Cairo, David Roberts and John Frederick Lewis. Their fame rested on their portrayal of Cairo, although they achieved it by very different images. Let us consider David Roberts first.[4] Born in Scotland, Roberts started his professional life as a theatrical scene-painter, in Edinburgh and then London. He painted architectural and topographical views on the side and for sale. In search of new material, he toured Spain from October 1832 to October 1833. The engravings and lithographs from his Spanish drawings, published as *Picturesque Sketches from Spain,* in 1837, gave Roberts his first real recognition as an artist, and financed his trip to Egypt and the Holy Land.

David Roberts was forty-two years old when he arrived in the Middle East, a visit that he acknowledged as the "central episode of my artistic life." As a member of the Royal Academy, Roberts was the first professional artist to come to Egypt without a patron or an archaeological expedition. From October 6 to December 21, 1838, he traveled up the Nile from Cairo to Abu Simbel and back, and afterwards spent seven weeks in Cairo sketching the Islamic monuments.

He began work in Cairo on December 26. His *Journal* records both his buoyant enthusiasm about this new subject matter, and the furious pace he set for himself. For example: "I am in a city that surpasses all that artists can conceive. I shall not lose an hour while in it to cull its beauties" (December 31); "Made two drawings of Gate Mitwalli with its minarets" (i.e., Bab Zuwayla, plates 91, 92, December 28); "Made two drawings, one of the street leading to the lunatic asylum, and another of the same street opposite. They are glorious subjects" (i.e., Monument of Sultan Qalawun, pl. 110, and Bazaar of the Coppersmiths, pl. 104, December 29) (fig. 2).

But this was not easy work, as his *Journal* also makes plain:

> No one in looking over my sketches will even think of the pain and trouble I have had to contend with in collecting them. I have stood in crowded streets jostled and stared at until I came home quite sick

[January 1]. . . . Surrounded by the most filthy and impertinent mob in existence [January 3]. . . . Just as I had finished a drawing a half-sucked orange was thrown from a window above me and struck my sketch book out of hand [Notes to Mosque El Mooristan, pl. 110]. . . . Narrow crowded streets rend it very difficult to make drawings, for in addition to the curiosity of the Arabs, you run the risk of being squeezed to a mummy by the loaded camels, who although they are picturesque in appearance are ugly customers to jostle [December 28]. . . . In mid-January, the sun so powerful it was with greatest difficulty I could sit out the day [January 16]. . . . Worked on a view of Cairo. The subject is excellent but am nearly blinded by dust, the wind being from the south [January 31]. . . . All night very ill, little or no rest, a constant diarrhoea. This may be attributed partly to the weather and partly to the excitement I have been in ever since landing. Another cause probably is the mess I get to eat, scarcely any of which I can enjoy. The only thing I am certain of getting clean or decent is my cup of tea. This and toast are my standing dishes [January 3]. . . . In order to visit the mosques I must espouse the Turkish dress. I have purchased a suit and tomorrow must divest myself of my whiskers. This is too bad, but . . . my object can be accomplished in no other way, no Christian being allowed to enter these places at all [January 2]. . . .

Despite the inconveniences and the "hazards" Roberts was "determined to make drawings in spite of all obstacles. My aim is to get these objects of a bygone age as all now are fast hastening to decay, many already in total ruin" (January 2).

Between February and May 1839 he was in Palestine. He departed for England in July 1839 with 272 drawings, a panorama of Cairo, and three full sketchbooks. He knew that his folio, "one of the richest and most interesting that ever left the East" (January 29), would make his fortune and reputation, as indeed it did.

In England his sketches were turned into lithographs by Louis Haghe and published by Francis Graham Moon in a six-volume collection as *The Holy Land, Syria, Idumea, Arabia, Egypt and Nubia* between 1842 and 1849.

Louis Haghe was a partner in the printing firm Day & Haghe, Lithographers to the Queen. Lithography, the art of printing from stone, was invented in 1796, the year of Roberts' birth, but it was not until the 1820s that it really became popular. It is a method of printing from the smooth surface of limestone. The image is drawn in reverse with a greasy crayon that attracts lithographic ink. The inked stone is then printed on paper in a special press. Lithography is a very accurate and faithful means of reproduction and almost unlimited clear copies can be made from a single stone.

In 1840 Haghe was already experienced and exposed to Islamic architecture. He had drawn one of the views in R. Hay's *Illustrations of Cairo*. He had also helped Owen Jones publish his Alhambra drawings and had drawn for Roberts's *Picturesque Views of Spain*. With *The Holy Land, Syria, Idumea, Arabia, Egypt and Nubia*, Haghe produced his finest work. For the 247 plates (including frontispieces) in these volumes, Haghe had the laborious task of redrawing all of Roberts's original sketches on stone in mirror image. Roberts worked closely with him to be sure of obtaining a faithful reproduction. Roberts wrote his own praise of Haghe's work: "Haghe has surpassed himself and all that has been done heretofore in the masterly treatment of the sketches: clear, simple, unlabored, add to which a vigour, and boldness, that only a painter like himself could transfer to stone." Louis Haghe worked on the project for nine years. He raised lithography to perhaps the highest point it had ever attained.

Francis Graham Moon, the outstanding art publisher of the day, put up £50,000 (the equivalent of more than $2,000,000 at today's value) to finance and market the venture. Moon paid Roberts £3,000 for his drawings and in 1840 held exhibitions to attract subscribers, who paid £52 each. The work was dedicated to Queen Victoria, and she headed the subscription list. It was one of the most important and elaborate ventures of nineteenth-century publishing. For Moon, the publication was the supreme accomplishment of his establishment. The 247 lithographic views of monuments, landscape, and people afforded the most complete visual record of the Middle East until then produced.

William Brockedon—traveler, artist, author, inventor—wrote the historical and descriptive commentary for *Egypt and Nubia*. He used many sources, among which were Roberts' own journals. Of the 124 drawings Roberts made for this volume, thirty-eight plates were of contemporary Egypt and Cairo.

The volumes enjoyed enormous critical and popular success. One hundred and fifty years later, reproductions of Roberts' views are everywhere: on notepaper, greeting cards, and postcards; on calendars; in new publications, and in facsimile editions. Galleries in Cairo and abroad sell prints, originals, and copies. The continuing popularity and success of Roberts' work would not have surprised him. Roberts was not a scholar of Egyptian culture, nor did he enjoy life in Cairo. On his departure for Palestine, he wrote: "I am leaving all the misery, wretchedness, and vice of Cairo behind me" (February 7, 1839). But he was a shrewd Scot and an appreciative artist. With determination and energy, speed and accuracy, he recorded the novelty and the beauty of these grand, albeit crumbling, monuments, and this despite the colorful but exasperating human scene around them. As a topographical artist with theatrical experience he sometimes took liberties with proportions and scale, but he did so to emphasize over-

all impressions otherwise not possible. He concentrated on Cairo as a great visual feast, and his colossal subjects and broad vistas are tangible reminders of the mediaeval dictum "He who does not know Cairo does not know the grandeur of Islam."

Roberts drew and recorded, and thus preserved, monuments and urban contexts that today no longer exist or stand only in skeletal form. Even in the 1830s, as he sketched, Muhammad ᶜAli had ordered the removal of the mashrabiyya (wooden lattice) screens across windows and of mastabas (stone benches) in front of shops because they posed fire and traffic hazards. Roberts' drawings also show the rich mixture of social and economic classes in the public context, and the interaction between architectural backdrop and human movement on main ceremonial and commercial ways. He has left the single best record of medieval Cairo we possess. In the 1840s Roberts' drawings appealed to an ever-widening middle-class British public eager for vicarious travel to remote places and new vistas. Today, as the architectural legacy of Cairo's traditional medieval city crumbles and disappears under the modern onslaught of population pressures, vehicular congestion, waste, and atmospheric discharges, Roberts' drawings possess undeniable anecdotal and documentary value.

### John Frederick Lewis (1805–76)

The other British artist whose fame rests primarily on paintings inspired by his stay in Cairo is John Frederick Lewis.[5] For Lewis, as for Roberts, a trip to Spain, in 1833–34, was the springboard to his eventual arrival in Cairo. His residence in Granada and travels through southern Spain produced *Sketches and Drawings of the Alhambra* (1835) and *Sketches of Spain and Spanish Character,* each with twenty-six lithographic plates, many of which he drew himself. Lewis's interest in rich color and the closeness of observation that was to characterize his mature style was also a product of his Spanish adventure.

In 1837 Lewis left England for Paris, Italy, Greece, and Istanbul, arriving in Egypt in 1841. He lived in Cairo for ten years, the first—and for a long time the only—artist to live in Egypt for an extended period. Like Roberts, it was his paintings of the Middle East that made him famous, but unlike Roberts, Lewis left few letters or journals, and of this period in his life only an outline is known. He rented a house in the Azbakiyya quarter, reputedly one that had belonged to a mamluk grandee massacred by Muhammad ᶜAli in 1811. It was here, in 1844, that he was visited by William Thackeray, on an Eastern Tour, who left an amusing description of Lewis as "an Oriental nobleman established in most complete Oriental fashion." James Wild also visited Lewis. Wild had come to Egypt in 1842 on an expedition sent out by the king of Prussia under Dr. Lepsius, but after 1845 he had stayed on in Cairo to study Arab domestic architecture

and the mosques, which, like Roberts, he wore native dress to enter. Among Wild's sketchbooks, now at the Victoria and Albert Museum, is a drawing of the main reception room of the house in which Lewis was living.[6] In 1847, Lewis married the twenty-year-old Englishwoman Marian Harper, who thereafter was frequently a model in his paintings. Lewis must have known Edward Lane, who was in Cairo between 1842 and 1849 and also living like an Arab, but there is no record of the acquaintance. In 1850 Lewis sent to the Old Watercolor Society in London *The Hhareem*.[7] It was displayed in their galleries and created a sensation. The painting made Lewis's reputation as an Orientalist artist. In 1851 he returned to England with over six hundred sketches, upon which he was to base his work for the next twenty-five years.

The attraction of the East for Lewis was not in its antiquities. In *The Temple of Edfu*,[8] one of the most beautiful Ptolemaic buildings in Egypt, Lewis shows it only as a colonnaded backdrop for a group of resting camels and their masters. Lewis's interests are in the contemporary world of people, in their doings, and in their context. Lewis preferred the intimate scale and concentrated on interior and domestic scenes. In this he parallels the literary expositions of Sir Gardner Wilkinson and Edward Lane, who wrote about the daily lives of Egyptians, ancient and modern.

In *The Hhareem* Lewis displays his talents at their most characteristic. The scene is anecdotal, descriptive, Oriental. In the left half a handsome pasha sits crosslegged on a pillow-strewn divan. A gazelle reclines to one side of him; to the other, two languid ladies lounge. A black eunuch disrobes a new concubine for his inspection. He leans forward to look. The feathered fan, the tame gazelles, the textured fabrics add to the Eastern mystique. What elevates this painting from mere sensationalism, however, is Lewis's detailed and realistic observation of texture, form, color, and light. The sun streams in through the intricate and varied lattices of the mashrabiyya window behind the pasha, and ripples out across the various fabrics to become an embellished beam connecting pasha–lady–concubine–gazelle. Lewis's extraordinary ability to depict the play of light and shadow, the overlay of one pattern upon another, and the textures and sheens of rich fabrics first demonstrated in *The Hhareem* is a constant theme in his work, and is featured many times again, as in *An Intercepted Correspondence*, 1869[9] (fig. 3) and *The Reception*, 1873.[10]

Lewis's interest in people as opposed to monuments is evident when comparing his treatment of the street area between the Sabil–Mausoleum and the Madrasa–Mosque of Sultan Qansuh al-Ghuri with a scene of the same area by David Roberts. Roberts calls his version the *Bazaar of the Silk Mercers*[11] (fig. 4). He draws the textile stalls as background against which the merchants sit, smoke, talk, and interact in various poses. But

the real star of the lithograph is the Ghuriyya itself. Two-thirds of the plate is taken up by the architecture of the buildings: the scale, the high portals, the overhanging roof, the elevated entrances. The mashrabiyya windows suggest the street's continuation beyond the little square. John Frederick Lewis's late (c. 1870) painting of the same area is entitled *The Street and Mosque of the Ghooreyah*[12] (fig. 5). The architectural context, however, although correct, serves only to frame the action taking place in the street. For Lewis it is the people who are the most interesting element of the composition, and they occupy roughly two-thirds of the total picture. This shifts the emphasis from a textile bazaar to the human drama in the left foreground, where a black-bearded shaykh seems to be predicting the future or reading a message for the two women who lean towards him in rapt attention. The main focus is not the topography, as it was for Roberts, but the humans and the color. In the lively yellow/blue/red of the women's costumes, the framing blues and greens of the men's robes on either side, and the yellows and oranges in the background, Lewis concentrates on the very aspect of Cairo that for the British visitor was its chief charm. Here is William Thackeray's description:

> There is a fortune to be made for painters in Cairo, and materials for a whole Academy of them. I never saw such a variety of architecture, of life, of picturesqueness, of brilliant colour, and light and shade. There is a picture in every street, and at every bazaar stall. Some of these, our celebrated water-colour painter, Mr. Lewis, has produced with admirable truth and exceeding minuteness and beauty; but there is room for a hundred to follow him." (p. 141)

Between the Roberts and Lewis images of Cairo, there is an implicit element that accounts for the contrast: the advent of photography. In the thirty-odd years between the Roberts and the Lewis versions of the Ghuriyya, photography had been born and had come into its own as a reproductive medium, an advance that had obvious consequences for the way artists approached their material. When David Roberts drew his *Silk Mercers* he was there, painting the scene, as he saw it. As an artist, he recorded as accurately as possible a new vista for his faraway audience. Lewis's painting was done long after he left Cairo, and was based on his sketches of Islamic life, his collection of costumes and artifacts, and access to available photographs.[13] Three decades after Roberts, when Lewis sited his painting in the same location, he was interpreting rather than recording the scene. He painted from recollection a scene that lithographs and photographs had made familiar. He did not have to 'copy' it; photographs did that. Lewis's aim was to imbue it with life, and focus on some of its drama.

## Francis Frith (1822-98)

David Roberts left Egypt in 1839; John Frederick Lewis left in 1851. These two years heralded two important developments in photography: its invention, and the wet plate process.[14] In August 1839, just after Roberts' departure from the Mediterranean, the birth of photography was announced, and in November 1839, the first image in Africa produced by mechanical means, a daguerreotype, was made of Muhammad ᶜAli's harem in Alexandria. From the start Egypt and photography were linked. Eighteen fifty-one, the year of John Frederick Lewis's return to England from Cairo, coincided with another milestone in the development of photography. In March of that year, the wet-collodion-on-glass-plate process was introduced. The chemically coated glass negative created a sharp image and enabled photographs to be mass produced. It did not take long for photography to reach a level of artistic endeavor and proficiency that caused radical change in both the availability and the quality of information about the visible world. The possibilities of this new process were immediately recognized, and photography was one of the exhibits at the Crystal Palace Exposition of 1851 in London, the first of the general exhibitions that celebrated the achievements of commerce and industry. By the 1860s over 100 million photographs a year were produced in England alone.[15]

In 1856, Francis Frith, the first professional travel photographer on an entrepreneurial scale, set sail for the Middle East. Frith may have been prompted eastward by the success of David Roberts' work. He was certainly acquainted with it.[16] Between 1856 and 1859 Frith made three trips to Egypt and Palestine—"the two most interesting lands of the globe"— where he worked from September 1856 to July 1860. When he was not in the Middle East taking photographs he was in England printing them for publication. Multiple sets of stereoscopic views, many loose photographs, and seven publications were the result. Frith went as an amateur, but the photographic views he brought back immediately established his reputation as the leading photographer of the day and as Britain's first great photographer–publisher. Charmingly written, handsomely produced, and full of exotic material, Frith's publications were the ultimate drawing-room table books. *Egypt and Palestine Photographed and Described by Francis Frith* (1858–60) had seventy-six photographs. Two thousand copies of it were made, for which Frith ran off and mounted over 150,000 prints. *Egypt, Sinai, and Palestine*, published in 1860 with a text by Mrs. Sophia Poole and Reginald Stuart Poole (the sister and nephew of Edward Lane) is the largest photographically illustrated book ever published. The prints are 48 by 38 centimeters on pages that measure 74 by 53 centimeters.

Frith was a man of great stamina and a superb craftsman. His work set

the standard for published photographic views of foreign lands. Early photographers in the Middle East rarely gave details about how their work was produced. Frith, however, wrote engagingly about the skill, resource, patience, and speed required to produce at best six pictures a day in the wet-plate collodion process.

The modern tourist, used to the ease of the 'point-and-shoot' camera, cannot imagine how cumbersome and complex was Frith's operation. He carried three cameras: the standard studio camera; a dual-lens camera for stereoscopic pictures; and an outsize camera for the 40 by 51 centimeter glass plates (the only way to produce large prints). The glass plates were packed in special boxes lined with India rubber cushions; the necessary chemicals were stored in cork-lined boxes. Because the glass plate had to be chemically coated before use, and then exposed, processed, and fixed while still moist, a portable developing tent had to be within immediate reach of the subject. These "cumbrous loads of apparatus"[17] weighed up to 55 kilograms and had to be transported by boat, mule, camel, or porters.

To these logistical ardors and procedural complexities were added compositional problems and technical limitations. Frith had to work with the scene as it was: he could not add the picturesque, or eliminate the awkward. Nor could he take his "aparatus" into crowded urban areas, such as busy streets or bazaars. Furthermore, his exposure times, in bright sunlight and broad daylight, varied from six to forty-five seconds. This meant that people could be present in the composition only if they did not move; if they did, they blurred. He photographed humans, therefore, only for accent and for scale. The slow exposure times also meant that the light inside buildings such as homes, mosques, and bazaars was not adequate. The greatest limitation, however, and the one that Frith was most aware of, was the lack of color (fig. 6).

> 'Costume' is one of the most striking and interesting features of the East. In its novelty and variety of form, and the splendour of its colours . . . an Eastern crowd rivals in brillance and variety the flowers in your garden.[18]

On the positive side, photography could be counted on to render complicated forms and complex interrelationships almost instantly. The photograph was an *aide-mémoire* of a scene or event that could be studied again at leisure. Photography, with its black-and-white realism, seemed to doom the work of the topographical/reproductive draftsman like Roberts. No sooner had *The Holy Land, etc.* volumes appeared than John Ruskin wrote: "Roberts brought home records of which the value is now forgotten in the perfect detail of photography."[19] In 1852 Louis Haghe retired from lithographic art to concentrate on his painting, giving as his reason the coming of photography, which lessened the importance of reproduc-

tive artists. When F. G. Moon retired in 1853, the unsold sets of *The Holy Land, etc.* were put to auction in December and the lithographic stones were "destroyed" in the presence of the bidders. Ironically, however, when a new edition of the multiple volumes of *The Holy Land, etc.* was brought out in 1855–56, its plates were produced by photographic means.

But photography in its black-and-white realism also created new artistic possibilities and challenges for painters. The photograph could not reproduce color or the moving scene. It was for the painter, therefore, as creator and imaginer, to concentrate on impression, on atmosphere, on color, on motion, and on human relationships, indoors and out. John Frederick Lewis, in his depiction of the anecdotal and the illustrative aspects of human relations, and the colorful and varied contexts in which they took place, focused on material that the photographers from 1840 to 1880 could not capture and which the contemporary genre artists who followed him to Egypt would pursue. In 1855 four of Lewis's paintings were exhibited at the Exposition Universelle in Paris, among them *The Hhareem*.[20] Jean-Léon Gérôme, a young French artist who was beginning his career, was represented in the same exposition by a large canvas that the French Government had commissioned from him and whose payment financed his first trip to Egypt in 1856, the same year that Francis Frith set sail for the Middle East.

Gérôme undoubtedly saw Lewis's paintings and was influenced by them. Gérôme returned to Egypt often thereafter, and, working in the manner already suggested by Lewis, from the sketches, the costumes, and artifacts he had collected while there, from the local models he posed in his Paris studio, and from the photographs available to him, he painted as many as 250 Orientalist paintings. Between 1860 and 1885 he became the leading Orientalist genre painter in France.[21] His interpretive vignettes of daily life, his concentration on colorful costumes, are as much a continuation of Lewis's style as they are a complement to the black-and-white realism of contemporary photographers.

The memory of Cairo's monuments and inhabitants as they were in the first half of the nineteenth century we owe primarily to British artists such as Robert Hay, David Roberts, Francis Frith, and John Frederick Lewis. They discovered a new city and in different ways recorded what they saw. Today their images are valuable and sought-after collectors' items. But more than that, their work as a progression offers an incomparable record of the visual encounter of one culture with another.

## Notes

Note that bibliographical entries are listed only once, but a book often contains material appropriate to more than one subject: for example, the exhibition catalogs (note 5) contain material on more than one artist.

1. *Description de l'Egypte*, 26 volumes of text, 11 volumes of prints, published 1809-29; Giovanni Belzoni, *Narrative of Recent Operations and Discoveries within the Pyramids, Temples, and Tombs, and Excavations in Egypt and Nubia* (London, 1821); Peter Clayton, *The Rediscovery of Ancient Egypt: Artists and Travellers in the Nineteenth century* (New York, 1982); Brian Fagan, *The Rape of the Nile* (London, 1975, 1992); Robert Anderson and Ibrahim Fawzy, eds., *Egypt Revealed: Scenes from Napoleon's Description de l'Egypte* (Cairo, 1987); Patrick Conner, ed., *The Inspiration of Egypt* exhibition catalog (Brighton, 1983); Sarah Searight, *The British in the Middle East* (London, 1969, 1979).
2. Jason Thompson, *Sir Gardner Wilkinson and His Circle* (Austin, 1992); Selwyn Tillett, *Egypt Itself: The Career of R. Hay, Esq.* (London, 1984); R. Hay, *Illustrations of Cairo* (London, 1840).
3. E. W. Lane, *The Manners and Customs of the Modern Egyptians* (London (Everyman's Edition), 1963); Laila Ahmed, *Edward W. Lane: A Study of his Life and of British Ideas of the Middle East in the Nineteenth Century* (London, 1978); Michael Darby, *The Islamic Perspective: An Aspect of British Architecture and Design in the Nineteenth Century* (London, 1983); Jason Thompson, "Edward William Lane as an Artist," *Gainsborough's House Review* (1993/94), 33–42.
4. Helen Guiterman and Briony Llewellyn, compilers, *David Roberts* (exhibition catalog, Barbican Art Gallery, London, 1986); John R. Abbey, *Travel in Aquatint and Lithography 1700–1860* (London, 1956–57, 1972), 2 vols; Jeremy Mass, *Victorian Painters* (New York, 1969); David Roberts, "Eastern Journal," unpublished transcript by Christine Bicknell, 2 vols., National Library of Scotland; David Roberts, *The Holy Land, Syria, Idumea, Arabia, Egypt and Nubia* (London, 1842–49), 3 vols., and *Egypt and Nubia* (London, 1846–49), 3 vols.
5. John Sweetman, *The Oriental Obsession: Islamic Inspiration in British and American Art and Architecture 1500–1920* (Cambridge, 1988); William Makepiece Thackeray, *Notes from a Journey from Cornhill to Grand Cairo* (Heathfield, 1991), 142–46; The Fine Art Society, *Eastern Encounters: Orientalist Painters of the Nineteenth Century*, exhibition catalog (London, 1978); The Fine Art Society, *Travellers Beyond the Grand Tour*, exhibition catalog (London, 1980); Donald Rosenthal, *Orientalism*, exhibition catalog (Rochester, 1982); M. A. Stevens, ed., *The Orientalists: Delacroix to Matisse*, exhibition catalog (Washington, 1984); Briony Llewellyn, *The Orient Observed: Images from the Searight Collection* (London, 1989); Sotheby's, *Important Orientalist Paintings from the Collection of Coral Petroleum*, auction May 22, 1985.
6. Victoria and Albert Museum, E. 3763-1938 and 717-877, E. 5679-1910x; Sweetman, *Obsession*, p.132.
7. Owned by Nippon Life Insurance Co., Osaka. Illustrated *Cornhill to Grand Cairo*, p.146.
8. Tate Gallery, London; Stevens, *Orientalists*, p.182.
9. Private Collection; Stevens, *Orientalists*, pl. 95, p.50; Sotheby's, *Orientalist Paintings*, #11.

10  Yale Center for British Art, New Haven; Sweetman, *Obsession*, p.138.
11  David Roberts, *Egypt and Nubia*, vol. 3, pl. 96.
12  The Forbes Magazine Collection, New York; Thackerary, *Cornhill*, p.139.
13  This composition, in its general subject and in its details, echoes paintings Lewis had done earlier. The overall scene is similar to *Scene in a Cairo Bazaar*, 1856, (Searight, *Orient*, p.131), and the ensemble of yellow gallabiyya and red-striped/blue-checkered shawl is exactly similar to that worn by the young lady in *The Arab Scribe*, 1852 (Fine Art Society, *Travellers*, p.21), and in *The Temple of Edfu* (see note 8). The man on the right looks very similar to the model for *A Memlook Bey, Egypt* in 1868 (Stevens, *Orientalists*, 94, 91).
14  Helmut and Alison Gernsheim, *The History of Photography* (London, 1955); Deborah Bull and Donald Lorimer, *Up the Nile: A Photographic Excursion: Egypt 1839–1898* (New York, 1979); *Egypt and the Holy Land in Historic Photographs: 77 Views by Francis Frith*, introduction by Julia van Haaften (New York, 1980); Bill Jay, *Victorian Cameraman* (Newton Abbot, 1973); *Egypt and Palestine Photographed and Described by Francis Frith* (London, 1858–60), 2 vols.
15  Jim Harrison, "Unimaginable Visions," *Harvard Magazine*, Nov–Dec 1989, p.25.
16  "Osiride Pillars and Fallen Colossus," *Egypt and Palestine*, I, ". . . David Roberts, in his splendid work . . ."
17  "Cleopatra's Temple at Erment," *Egypt and Palestine*, I.
18  "Portrait: Turkish Summer Costume," *Egypt and Palestine*, I.
19  Abbey, *Travel*, 2:341.
20  The others were: *The Arab Scribe, Halt in the Desert*, and *Camels in the Desert*.
21  Caroline Williams, "Jean-Léon Gérôme: A Case Study of an Orientalist Painter," in Sabra J. Webber and Margaret R. Lynd, eds., *Fantasy or Ethnography? Irony and Collusion in Subaltern Representation*, Papers in Comparative Studies 8 (1993–94), (The Ohio State University, 1996), 117–18.

# Some Observations on the Causes of the Decline of Basra's Trade in the Late Eighteenth Century

## Thabit Abdullah

Historians have known for some time now that the commercial fortunes of Ottoman Basra suffered a serious decline at the end of the eighteenth century. Sources ranging from local accounts and travelers' reports to the detailed records of the English East India Company agents all speak of a sharp reduction in the volume of trade beginning in the last quarter of the century and continuing well into the first half of the next century. Khawaja ᶜAbdul-Qadir, an Indian traveler who visited Basra in 1786, and William Heude, who visited the city in 1817, both commented at length on the ruinous state of the port's economy and its dilapidated buildings.[1] My survey of the records of the English East India Company tends to corroborate this impression. Between 1763 and 1774, for example, the annual average number of ships (above 100 tons) that docked at Basra was fifteen. This figure dropped to only two between 1784 and 1793.[2] The situation seems to have continued to be bad well into the next century, when, in 1860, the Ottoman governor asked Ahmad Nur al-Ansari, the cadi of Basra, to write a report on the state of Basra's trade and present suggestions as to how it might be revived.[3] It was not until the 1860s that, under British commercial hegemony, Basra's trade began to rapidly rise again.[4]

## Causes

While the fact that this decline took place is not in doubt, the causes of it continue to be murky. Generally, the handful of historians who have dealt with this question fall into two camps. The first prefer to see the situation in Basra—and indeed in most of the Ottoman ports—as a subset of the

broader issue of the overall decline of the empire in the seventeenth and eighteenth centuries. It is argued that Basra continued to suffer from overall Ottoman decline until the Tanzimat reforms of the mid-nineteenth century, but more importantly until British troops secured its incorporation into the world economy in 1914. The general framework of this view has been sufficiently criticized by numerous historians working on different areas of the Ottoman Empire, including André Raymond, Roger Owen, Soraya Farouqhi, and Bruce Masters. These authors have shown that the economic developments in the vast Ottoman Empire were quite different from area to area and from city to city.

The second camp has tended to place great emphasis on the role that events such as natural disasters or wars played in the destruction of premodern economies. Daniel Panzac, for example, argues that the decline of Basra's trade was due solely to the plague of 1773.[5] There is little doubt that the "plague of Abu Chafchir," as it was called, was one of the most devastating scourges that befell the city in the eighteenth century. This plague, however, was not the first to have struck Basra. An epidemic (probably cholera) ravaged the city in 1741. Nevertheless, once the disease had died down the ships returned and commercial activities resumed. The same appears to have happened with the 1773 plague, for scarcely a year after it had struck, the English traveler Mr. Parsons wrote admiringly of the port's commercial activity.[6]

Iraqi historians have usually emphasized the devastating effects of the Persian occupation of Basra of 1776–79.[7] Here again, while it is true that Karim Khan Zand's siege and subsequent occupation of the city was long and harsh, it was not a unique event in Basra's history. Previous sieges by Nadir Shah in 1733 and 1744, and tribal pillaging in 1765, were also harsh but the city managed to rebound soon after the danger had passed. Such arguments, then, are hardly sufficient to explain the causes of the decline of Basra's trade at the end of the eighteenth century.

## Problem in Method

I would suggest that a solution to this question—and indeed to most questions relating to the trade of the area—has been difficult to find not because of a lack of information but because of a problem in methodology. When dealing with the Middle East, most historians have tended to situate their subject of study within an administrative rather than an economic framework. If we take, as an example, two of the most influential works on the economic history of the modern Middle East we see how this problem is manifested. In both *The Economic History of the Middle East, 1800–1914* by Charles Issawi, and *The Middle East in the World Economy* by Roger Owen, Basra is examined within the framework of "Iraq" or "The Iraqi Provinces."[8] This view makes some sense with the

twentieth century in mind. It assumes, however, that Basra's economy can be better understood if it is studied along with Mosul rather than, say, Oman. Such an approach has led to a certain myopic view of the past. I believe that we can better understand the nature of the trade of the area if we situate our subject within an economic rather than an administrative framework. Once this is done the reasons for the decline of Basra's trade will become more evident.

## Basra's Trade Networks

In the eighteenth century, Basra sat at the center of six major commercial networks, some of which were as old as the earliest Mesopotamian civilizations. Three of these networks were maritime, while the others linked the city with its hinterland. Basra mostly played the role of an international port of transit. While the city did export some products, notably dates, it was in collecting duties on goods destined elsewhere that most of its wealth was made.[9]

The city's most important trade was with western India. Ships running this route normally rode the northeast monsoon and arrived at Basra around June, just as the winds begin to shift. This would guarantee that they did not have to wait long before returning to India on the southwest winds. The India ships brought spices, cloth, chinaware, iron, tin, lead, and various types of piece goods. The twelve largest vessels that traveled this route unloaded some one thousand bales of goods each in a normal year. The largest of these were two Surati vessels. Other large vessels included several Omani and British ships.

Our information on the second and third commercial networks to which Basra belonged is quite limited. While the history of early modern Oman is generally well-known,[10] its exact role in the trade of the region remains unclear. We know that the Ya'rubi sultans, who came to prominence in the middle of the seventeenth century, succeeded in acquiring a strong fleet built largely at the Indian port of Surat. In the mid-eighteenth century the Al Bu Sa'id seized the throne and under their able leadership Muscat's trade flourished. The most important trading commodity of the Omanis was the Mocha coffee of Yemen. An English East India Company report estimated that the Omani fleet of around fifty vessels of various sizes carried "near one half of the quantity [of coffee] annually produced in Yemeen. . . . [This was] sufficient for the full consumption thereof in the countries of Persia, Arabia Deserta, Mesopotamia, Courdistan, Armenia, Georgia and Natalia."[11] In addition to coffee, the Omanis also brought to Basra limited numbers of east African slaves.

Basra's third maritime trade network was with the several small Arab ports all along the Persian Gulf. According to one estimate the Arabs had over four hundred small vessels operating within the gulf in the eighteenth

century.[12] Throughout the century Basra remained the most important port within the Persian Gulf. Bandar ᶜAbbas, the major port of the Safavid Empire, had lost its importance after the decline and fall of the Safavids in the first decades of the century. Nadir Shah encouraged the development of Bushire as the alternative port for Persian commerce, and in cooperation with the Matarish Arabs this port did see some prosperity.[13] Also in the northern part of the gulf, the island of Kharg briefly rose to prominence in the middle of the century first under the Dutch and then under the ruthlessly ambitious Mir Muhanna. Bandar Riq and Kangan also represented minor ports on the Persian side of the gulf with which Basra had regular trade. On the Arab side of the gulf Bahrain and Qatif, both with rich pearl exports, were the most important ports. During the second half of the century, however, the ᶜUtub Arabs succeeded in transforming Kuwait and Zubara (Qatar) into two of the most thriving ports in the gulf. Each of these ports, and several other minor ones, had a fleet of small vessels. They would bring the products of these ports, most notably pearls, to one of the 'international' ports of Basra, Muscat, or, to a lesser extent, Bushire for export to India, Persia, or the Ottoman Empire.

As for Basra's inland trade, there is little doubt that the city's trade with southern Persia was of vital importance. Between December 1768 and March 1777 over 27 percent of the merchants who had dealings at the English Factory in Basra were from Persia.[14] One of these Persian merchants, Mir Muhammad al-Baqir, was considered one of the wealthiest individuals in Basra, worth 700,000–800,000 rupees.[15] Goods were sent from Basra to Isfahan or Shiraz either by small boats on the Karun river or by caravan. From southern Persia Basra received dried fruits, pistachios, saffron, tobacco, raw silk, and caps. It exported Indian spices and piece goods, Mocha coffee, English woolens, and dates.

For most of the eighteenth century Basra was under the governorship of the Ottoman wali of Baghdad. This tie was further strengthened by the extensive commerce that linked the two cities together. Most of the trade between Baghdad and Basra was carried out by a fleet of boats that made an annual trip down either the Tigris or Euphrates river. The most important cargo that these "Baghdad boats" brought to Basra for export was copper that was mined in the region of Diyarbakr.[16] Other merchandise included specie and Aleppo and Persian goods.

Lastly, Basra had a thriving caravan trade with Aleppo. During the eighteenth century, the overland route across the Euphrates valley and the Syrian desert was considered the safest, cheapest, and most direct way to transport Indian goods to Europe and visa versa. The strong commercial contacts between the two cities were underscored in 1781 when the governor of Aleppo agreed to pay half the cost of a new fleet to protect Basra's shipping.[17] At the time, the caravans that formed this trade were

among the largest and best organized in the world. While their size varied, a normal merchant caravan had about 1,500 camels, though some were known to have reached 4,000.[18] Smaller caravans would start from al-ʿUqayr in Arabia and move north toward Basra, picking up more camels around Zubara, Qatif, and Kuwait. These small caravans would assemble near the town of Zubayr, just south of Basra, forming one large caravan that would then depart for Aleppo. The merchants of Basra spent several months organizing one of the two annual Aleppo caravans. The camels, each of which could carry 200 to 300 kilograms, took the merchandise of Basra, India, southern Persia, Yemen, Muscat, and the Persian Gulf and brought back goods from Aleppo, Anatolia, and Europe. The latter included French broad cloth, Venice ware, beads, looking glasses, stained glass, silks, and brass wire. It took a large caravan between forty-five and seventy days to complete the desert crossing.

## The Question of Decline

Because of Basra's economic role as a transit port, it is preferable that we situate the city within its broader trading region when investigating any issue related to its commercial life. Basra's economy was obviously extremely sensitive to developments that might occur anywhere in this large region, which included the Persian Gulf, western India, and Yemen on the one hand, and Mesopotamia, southern Persia, and Aleppo on the other. The answer to the question of the decline of Basra's trade necessarily leads us to look at developments in these areas.

During the second half of the eighteenth century two transformations of enormous proportions affected this region. Both have been studied, but each in isolation, thus limiting the discussion on their broader impact. The first was the fall of the Zand state in southern Persia and the subsequent rise of the Qajars in the north. After the death of Karim Khan Zand in 1779, Persia entered a period of savage civil war, which led to the interruption of its trade. While this was certainly not the first time that Persia had suffered such misfortune, the outcome this time did not favor the resumption of trade with Basra. The victory of the Qajars fundamentally altered Basra's commercial relationship with southern Persia. Under Qajar rule the focus of Persia's economic activities shifted from the south around Isfahan and Shiraz, where it had been for over two centuries, to the north around Tabriz and the newly established capital of Tehran. The result was that the south, upon which much of Basra's trade depended, fell into "decay and depopulation."[19]

The second transformation is more difficult to date. Around the early seventeenth century, northern Najd witnessed a series of gradual but ultimately massive tribal migrations. For reasons that are still vague, large war-like tribes such as the Shammar and ʿAnaza moved mainly to the

north and east of Arabia. As they moved they pushed in front of them other tribes, causing a ripple-wave that affected the entire region. During the course of the eighteenth century tribal power increased, affecting not only Basra's hinterland but also its trade in the Persian Gulf. Tribes such as the Ka$^c$b, Khaza$^c$il, $^c$Ubayd, and Muntafiq became progressively bolder, flouting central authority and disrupting Basra's important trade routes with Baghdad and Aleppo. In the 1770s, for example, the city's trade with Baghdad via the Euphrates river was regularly interrupted due to the growing power of the Khaza$^c$il tribes. "The Ghesaal Arabs," wrote the English Agent in 1787, "continue to obstruct communications between Bussora and Bagdat by the river Euphrates," causing a serious reduction in the city's provisions and driving prices beyond the reach of most of its inhabitants.[20] Several attempts were made by the Ottoman wali in Baghdad to bring them to heal, but to no avail. By the end of the century their raids had virtually closed down this important route, contributing to the overall decline of Basra's economic fortunes.

Other tribes also rose against central authority and contributed to the decline of the riverine trade. In 1786 the powerful $^c$Ubayd tribe under the ambitious leadership of their shaykh Sulayman al-Shawi raised havoc around Baghdad for nearly two years before they were subdued. In the following year al-Shawi joined forces with Shaykh Thwayni of the Muntafiq and actually seized Basra, prompting the wali of Baghdad to send a large army to liberate the city.

Tribal migrations also affected Basra's maritime trade in the gulf. Tribes such as the $^c$Utub in Kuwait and Zubara, and the Hawallah and Qawasim along the Trucial coast, succeeded, in the course of the eighteenth century, in establishing their own independent shaykhdoms in these areas. As they did this they strove to channel trade away from Basra toward their own ports, often using piracy as a means. The Qawasim of Ra's al-Khayma and the Hawallah were particularly effective in their attacks against both native and European vessels destined for Basra. Further aiding the Qawasim was their alliance with the Wahhabis of Najd, whose raids on southern Iraq, culminating in their sack of Karbala' in 1801, caused much distress in Basra.

The rise of these shaykhdoms at the expense of Basra led the English agents to observe that while "a favorable change has lately taken place in the commercial interests of Muscat, Bahreen, Zebarra, and Grain [Kuwait], the commercial importance of Bussora has since the year 1773 most materially decreased."[21] Kuwait, in particular, seemed to gain the most from the decline of Basra's commerce. Commenting on this fact, the English agents wrote:

Grain [Kuwait] has always had a free communication by the desert, with Bagdad and Aleppo and very large and rich caravans . . . fre-

quently passed to and from those cities. . . . The degree of [Kuwait's] importance must ever depend on the prosperity or distress of Bussora, during the time in which the Persians were in possession of that city, Grain was the port through which that part of the produce of India proper for the Bagdad, Damascus, Alepo, Smyrna and Constantinople markets which is annually brought to Bussora, found its way to these places.[22]

If we couple these two factors—the rise of the Qajars and tribal migrations—with other less crucial ones that affected the region, the cause for the decline of Basra's trade becomes obvious. Bruce Masters has argued that by the end of the eighteenth century Aleppo's commerce declined mainly because of the development of alternative silk sources.[23] Likewise, Paul Dresch mentions that by around the same period the once thriving Mocha coffee trade began to suffer as a result of competition from Java coffee.[24] Both of these areas, as we have seen, represented important links in Basra's trade networks, and their decline certainly adversely affected Basra's commerce.

From this brief overview it is clear that the riddle of the decline of Basra's trade at the end of the eighteenth century can only be solved if we look outside the city and the area of Iraq. Once it is understood that the city was part of a much larger region tied together by trade, it becomes evident that change affecting this trade can only be explained by looking at the region as a whole. The decline of Basra's trade was certainly the result of region-wide structural changes, whose ramifications were felt for many decades after.

## Notes

1. K. Qadir, *Waqai-i Manazil-i Rum: Diary of a Journey to Constantinople* (New York, 1968), 51–52; W. Heude, *A Voyage Up the Persian Gulf and a Journey Overland from India to England in 1817* (London, 1819), 49–50.
2. *Maharashtra State Archives*, Bussora Factory Diaries nos. 193–202, and Gombroon Factory Diaries nos. 112–118; *India Office Records*, Letters from Basra nos. G/29/18–22.
3. A. al-Ansari, *al-Naṣra fī akhbār al-Baṣra* (Baghdad, 1976).
4. M. Hasan, "The Role of Foreign Trade in the Economic Development of Iraq, 1864–1964: A Study in the Growth of a Dependent Economy," in *Studies in the Economic History of the Middle East*, ed. M. Cook (Oxford, 1970), 348.
5. Daniel Panzac, "International and Domestic Maritime Trade in the Ottoman Empire During the Eighteenth Century," *International Journal of Middle East Studies* 24 (March, 1992), 190.
6. Mentioned in J. G. Lorimer, *Gazetteer of the Persian Gulf, ᶜUman and Central Arabia* (Calcutta, 1915), 1243.
7. See, for example, ᶜAli Wardi, *Lamaḥāt 'ijtimāᶜiyya min tārīkh al-ᶜIrāq al-*

hadīth, vol. 1 (Baghdad, 1969); A. al-ᶜAzawi, Tārīkh al-ᶜIrāq bayn iḥtilalayn, al-juz' al-sādis: ḥukūmat al-Mamālīk (Baghdad, 1954).

8 Charles Issawi, *The Economic History of the Middle East, 1800–1914* (Chicago, 1966); Roger Owen, *The Middle East in the World Economy, 1800–1914* (London 1981).

9 While these duties tended to change depending on time and the goods involved, generally speaking the authorities at Basra charged 3 percent on European goods and 7.5–8.5 percent on non-European goods.

10 See, for example, Patricia Risso, *Oman and Muscat: An Early Modern History* (London, 1986).

11 Samuel Manesty and Harvard Jones, *Report on the British Trade With Persia and Arabia*, India Office Records, G/29/25, 1791, folios 219–20.

12 ᶜAbd al-Malik al-Tamimi, *Ta'rīkh al-ᶜilaqāt al-tijāriyya bayn al-Hind wa manṭaqat al-khalīj al-ᶜarabī fī-l-ᶜaṣr al-ḥadīth* (Baghdad, 1986), 21.

13 For the history of Bushire in the eighteenth and nineteenth centuries see Stephen Grummon, "The Rise and Fall of the Arab Shaykhdom of Bushire: 1750–1850," Ph.D. dissertation, Johns Hopkins University, 1985.

14 *Maharashtra State Archives*, Bussora Factory Diaries nos. 199–203.

15 *Maharashtra State Archives*, Bussora Factory Diaries no. 200, folio 112.

16 See the report by William Page dated 24 February, 1797, in the *National Archives of India*, Home Department, Public Branch, Occasional Papers no. 3.

17 *India Office Records*, Letters from Basra, G/29/21, folios 396–97.

18 The description of these caravans is based primarily on Christina Grant, *The Syrian Desert, Caravans, Travel and Exploration* (London, 1937), 125–56; Ahmad Abu Hakima, *History of Eastern Arabia 1750–1800: The Rise and Development of Bahrain and Kuwait* (Beirut, 1965), 169–75; and Douglas Carruthers, *The Desert Route to India, Being the Journals of Four Travellers by the Great Desert Caravan Route Between Aleppo and Basra, 1745–1751* (London, 1929).

19 Ann Lambton, *Qajar Persia* (London, 1987), 108–9.

20 *India Office Records*, Letters from Basra, G/29/22, folio 401.

21 Manesty and Jones, *Report*, folio 235.

22 Manesty and Jones, *Report*, folio 213.

23 Bruce Masters, *The Origins of Western Economic Dominance in the Middle East: Mercantilism and the Islamic Economy in Aleppo, 1600–1750* (New York, 1988), 30–33.

24 Paul Dresch *Tribes, Government and History in Yemen* (Oxford, 1989), 200.

# BEDOUINS AND MAMLUKS IN THE SINAI TRADE, 1750–1800: THE STRUGGLE FOR SUEZ

## Pascale Ghazaleh

Before and throughout the Mamluk and Ottoman periods, the Bedouins of Egypt are mentioned, both in primary and in secondary sources, as potential troublemakers, encroaching upon the settled areas and wreaking havoc on the trade routes during political crises or famines. The frequent accounts of their looting and pillaging, found in literature from the chronicles of Ibn Iyas and al-Jabarti to Ibn Khaldun's theory of civilizational decay and renewal, testify to the perception that the Bedouins posed a threat to both trade and the stability of the central government. Most scholars discussing the Red Sea trade, in particular, have noted the importance of the Bedouins' role in transporting merchandise and protecting caravans. This role has usually been seen as a passive one: the less the Bedouins' presence was felt, the more they were appreciated. Understandably, however, the crises caused by the Bedouins have been more often emphasized; less has been written on the importance of their role in a trade crucial to the entire Ottoman Empire, involving thousands of people and hundreds of thousands of paras.

The objective of this essay is to evaluate the Bedouins' role not as a threat to central government, nor as a potential spanner in the smooth works of commerce, but as actors in their own right, who could have considerable impact on trade and politics, changing the course of events and countering the decisions of rulers and merchants. Through the analysis of one incident among many, involving a Bedouin raid along the route from Cairo to Suez, I will attempt to place the Sinai Bedouins in the context of late eighteenth-century Egypt and explain their behavior, both in this par-

ticular case and within the pattern of which it seems representative. The Cairo–Suez route was frequently used by pilgrims and merchants, who often encountered no opposition from the Bedouin tribes. But raids were by no means exceptional, and the specific raid that will provide the focus of this essay illustrates an important tendency. It shows how, in the power struggles among the Porte, the beys, and the British for the benefits of the lucrative Red Sea trade at the end of the eighteenth century, the Bedouins were able to direct the course of events to their own advantage. They did so either by actively setting the parties to the struggle against one another or by exploiting existing rivalries among ruling factions or different state institutions. By reading this incident from a new perspective, it is possible to acquire an understanding of the Bedouins' role that differs somewhat from the dominant view.

The commercial and religious life of Cairo was sustained by the trade routes that linked it to other provinces of the Ottoman Empire. Each part of the empire exchanged the goods it possessed in abundance for those found in other provinces, creating a largely self-contained economic system. Across Egypt, converging on Cairo, ran the routes from the Maghrib to the Hijaz, Syria, and beyond, as well as those from Africa to Europe. Pilgrims and merchants depended for their material and spiritual sustenance on the activities that made the capital one of the largest and most diverse cities in the Ottoman Empire.

Especially important to trade were the routes connecting Cairo to the holy cities of the Arabian peninsula and Jerusalem. Both overland and maritime routes converged on the strip of desert between Cairo and Suez. Smooth commercial interactions largely depended, therefore, on the security of this part of the trade network—a condition that was usually fulfilled. A time of crisis, during which insecurity reigned, however, will provide the focus for this study of the Bedouins' role in the Sinai trade.

The choice between the use of the route through Suez and other routes, such as that via Qusayr, generally seems to have varied according to relative political stability in Upper Egypt and the territory lying east of the Nile. Qusayr, however, had been more or less abandoned by the fifteenth century,[1] and several routes were open between Cairo and Suez. By the eighteenth century, it took relatively little time to reach one from the other. Clerget[2] noted that it took between eighteen and sixty hours to reach Cairo from Suez, and this variation is in itself extremely significant, since it suggests that various obstacles along the caravans' way—including Bedouin attacks—could almost quadruple the time spent crossing this strip of desert.

The importance of the Cairo–Suez route to merchants and the government clearly lay in its strategic relation to the empire's vast trade and pilgrimage network. European attempts to enter the Red Sea also suggest its

importance to world commerce as a whole. While the beys in Cairo were attempting to use trade as a means of establishing their own sovereignty, and therefore had a direct stake in the Cairo–Suez route, the Porte was trying to exercise at least a modicum of control over their activities; British merchants, and the British government in India, were simultaneously exerting considerable efforts to enter the Red Sea and reach Suez.

In theory, European ships were forbidden from entering the Red Sea until the eighteenth century, but incidents of British ships arriving at Suez before this despite the prohibition prompted the Porte to issue several firmans reiterating in increasingly severe terms that no European vessel was to enter the Red Sea. (The Porte cited the proximity of the holy cities as a reason for the ban, and was concerned as well with the fact that Jidda was being bypassed to the benefit of Suez.) Nevertheless, the beys and representatives of the East India Company continued to negotiate—the former in an effort to secure an independent commercial position, and the latter convinced of the potentially lucrative nature of such a trade and the crucial importance of Suez as a link with India.

In the power struggle, all parties—the Porte, the beys, and the British—had in common their need for the Bedouins, who actually controlled the route between Cairo and Suez. The Bedouins, however, were taken into account neither by the beys in Cairo, attempting to secure the trade through Suez that the Porte adamantly opposed,[3] nor by the representatives of the East India Company and the British government in India, who were also negotiating on their own behalf: the trade agreements signed between Egypt and the British government in India during the 1770s were never recognized—at least not explicitly—by the home government in London.[4]

The tribes that controlled the desert between Cairo and Suez were, to say the least, a mixed blessing for trade and central government. On one hand, they provided essential transport and security services, backing up the role of the *'amīr al-ḥajj*, which was to lead the annual pilgrimage caravan to Mecca and Medina;[5] on the other, they could—and did—exploit this role to their own advantage during times of crisis, plundering caravans instead of protecting them.

Throughout the Ottoman era an organized system of caravans transported merchandise between Cairo and Suez, ensuring that the wheels of commerce ran smoothly most of the time. Four principal tribes are mentioned in the *Description de l'Egypte* as being responsible for transport along this route: the Tarrabin, who lived south of Cairo, around Old Cairo and al-Basatin; the Hawitat, who were established in Qalyubiyya province; the ᶜArab al-Tur, from Sinai; and the ᶜA'idi, from the region of Matariyya and Birkat al-Hajj, one day east of Cairo. The Arabs provided the camels, with their equipment and drivers. Each camel usually carried

a load of six qantar, or around 250 kilograms.[6] In spring, ships bearing coffee arrived from the Hijaz and the caravans transported it on to Cairo, especially in April, May, and June.[7] There also seems to have been a fairly clear-cut division of labor, at least with respect to certain services; the ᶜArab al-Tur, notably, provided the camels at least until ᶜAjrud (twenty kilometers northwest of Suez) according to Clerget.[8]

In Sinai, as in Upper Egypt, various tribes provided protection against the others, depending on alliances with the ruling beys or with a shaykh influential among certain of the Bedouins. In many cases, this was a 'passive protection'—that is, the Bedouins would agree not to raid in return for a fee, the ᶜawa'id. The 'amīr al-ḥajj was given large sums to distribute to the Bedouins along the way; influential or respected individuals (sometimes the shaykh of the strongest tribe) were also enlisted to negotiate in face of any hostility the pilgrims might encounter.[9]

But the services provided by the Bedouins were perhaps not as lucrative as they could have been. During the seventeenth century the fees for transporting certain goods remained constant in value, and rose but little in the first half of the following century.[10] By the end of the eighteenth century, the fees were more or less the same as they had been in 1751. To the extent that they were not fully self-sufficient, the Bedouins may well have felt the pinch as the prices of other commodities rose, and the very services they provided—principally transportation and protection—could be turned to their own advantage to extract from the merchants or the government far more than they were initially willing to pay. The Bedouins could—and often did—benefit from their de facto control of the Cairo–Suez route. The chronicler ᶜAbd al-Qadir al-Ansari al-Jazari al-Hanbali saw Bedouins protect caravans in territory under their control, only to pillage it a few hours later, when it was under the responsibility of another group of nomads.[11]

During the late eighteenth century, the Bedouins had ample incentive to take more frequent advantage of the fact that their services were necessary to both rulers and merchants. The relative decline in their condition, combined with their awareness of the power struggles taking place in Cairo, explain the increase in the number of raids carried out on caravans during this time.

It would seem that, generally speaking, when the state is weak the Bedouins, among other elements opposed to central government, tend to gain strength. Revolts usually peaked during times of external aggression or political interregna.[12] Sultan al-Ghuri found the Bedouins of Sharqiyya and Gharbiyya especially troublesome, and mention of their encroachments on settled areas and the raids they carried out on caravans recurs frequently in Ibn Iyas' chronicle. In March of 1504, to cite only one of the instances recorded by Ibn Iyas, the Bedouins were wreaking such havoc

on the routes that no women were allowed to join the pilgrim caravan.¹³ The Mamluk government was plagued by Bedouin attacks during its defeat at the hands of the Ottomans: the infamous ᶜAbd al-Da'im, chief of the Sharqiyya Bedouins, had revolted during al-Ghuri's reign and gone on to ravage crops, pillage the Mamluk troops, and stop caravans on their way to Cairo from Damascus as the Ottoman army advanced.¹⁴

An alliance between Bedouins and other elements "hostile to central power," such as the fellahin, was often forged at least in part on the basis of their common animosity to the government; but the Bedouin chiefs seem to have benefited the most from revolts, which occurred mainly in the areas most distant from central power.¹⁵

Yet to posit the relative strength of Bedouins and government as diametrically opposed—the one increasing only when the other diminishes—is to assume that both the Bedouins and the government formed two monolithic, mutually antagonistic groups; nor does such an assertion take into account the fact that it was often to the advantage of both the government and the Bedouins to establish a *modus vivendi*. The relation between state and tribes was not always conflictual: the ruler could appoint the leaders of certain friendly tribes (Ibn Iyas mentions for instance that Sultan al-Ghuri renewed the appointment of Najm—who had served the Mamluk state by capturing one of the most unruly Bedouin in Sinai and sending his head to Cairo, where it was paraded through the city—as shaykh of the ᶜA'idi tribe¹⁶); rulers could cooperate with certain Bedouin tribes in order to subdue the others (and, in fact, sometimes could not afford not to do so), or have a powerful tribe settle in a certain area to offset the influence of another, more hostile group, as was most notably the case with the Hawwara of Upper Egypt; finally, the rulers in Cairo frequently fled to Upper Egypt or to Sinai (as was most notably the case during the Ottoman conquest), seeking refuge from their rivals among the most powerful tribes settled there.

The government's efforts to appease the Bedouins through grants of land or tax farms are also apparent throughout the Mamluk period. Toward the end of the fifteenth century, for instance, Ibn Iyas recorded lists of *iqtaᶜāt* assigned in whole or in part to the Bedouin chiefs. The phenomenon occurred most notably in Upper Egypt but was not unknown to the northeast, in areas bordering the Sinai desert. It is to be expected that the Bedouin tribes received *iqtaᶜāt*, since certain services were demanded of them, and this was one way of integrating them into the mechanisms of the Mamluk state; but during a time of weakness in the system, what should have been a means of control became a trap for the state itself, and the number of *iqtaᶜāt* grew out of all proportion to the services expected from the Bedouins.¹⁷

Numerous *iqtaᶜāt* were attributed to the Bedouins, therefore, both in an

attempt to integrate them into the mechanisms of government, thus giving them a vested interest in stability, and in recompense for the services they rendered, such as assuring the security of the trails, providing specifically Bedouin 'products' like horses and camels, and supplying the army with auxiliary corps and cavalry in time of war.[18]

In the arid area between Cairo and Suez, however, the Bedouins were neither sedentarized on a large scale nor transformed into landlords. This point is a crucial one, since it implies that they did not have the same kind of permanent source of revenue as their Upper Egyptian counterparts and therefore relied much more heavily on the ᶜawā'id. It seems, in fact, that the ᶜawā'id constituted the same kind of trap for the state as did the iqtaᶜ in Upper Egypt. When they were not paid, the Bedouins compensated their lost income through raids. While they usually did supply Bedouin products, and therefore were directly involved in commercial activity most of the time, they could supplement the revenue from these products in times of need with what they had obtained in a raid.

The late eighteenth century, when the state's power was greatly undermined by Mamluk infighting and the political instability it engendered, was just such a time of need. The ᶜawā'id, which in the past had served to discourage raids on caravans, were being withheld more frequently, since funds were more profitably diverted in the short term to the rivalries of the beys in Cairo. In the late eighteenth century, the Porte's officials at ᶜAqaba, who were granted extra funds in times when Arab raids occurred frequently, also began to keep most of these funds for themselves, letting the pilgrims make the return journey without escort. Only a fraction was left over for the protection and supplies of the caravans.[19] At times when the 'amīr al-ḥajj was powerful enough to fight the Bedouins, or influential enough to obtain safe passage without disbursing a para, this development did not affect trade or the pilgrimage. This is evident in al-Jabarti's account of the pilgrimage of 1760 (AH 1148), when the caravan, headed by Husayn Bey Kishkish, then 'amīr al-ḥajj, was ambushed by "Arabs" on the way to Mecca. The ᶜawā'id were demanded, but the Bedouins were outwitted by Husayn Bey, who then slaughtered the tribal chiefs and sent their heads back to Cairo.[20]

While antagonism was not always the rule, then, the importance of the 'amīr al-ḥajj, especially from the 1770s onward, seems to have been dictated mainly by conflict, and not cooperation, between the government and the Bedouins.

This seems not to have deterred the Bedouins, who escalated the scale and frequency of raids in the last quarter of the century. At a time of crisis and rapid change, the government's failure to pay the ᶜawā'id provided the Bedouins with more incentive to take advantage of the prevailing instability. The Bedouins seem to have understood and taken advantage of

the fact that internal rivalries were destabilizing the government in Cairo, and increased the frequency and severity of their attacks all along the caravan's route. The Bedouins were always vital to trade, and during this time it was possible for them to exploit the fact that all parties with a stake in the Cairo–Suez route needed them. They even tore the *mahmal* to pieces, not far from the caves of Shuᶜayb, on the pilgrimage's return in 1793 (1207).[21] This seemingly random act of destruction, from which the Bedouins can have derived no financial benefit, must be seen in context as an act of protest against the deterioration of their situation—and a reminder to the government that they meant business.

Besides the symbolic importance of controlling the Bedouins in order to establish and emphasize strong central power—reflected in ᶜAli Bey al-Kabir's efforts to subdue the most powerful and antagonistic tribes—Bedouin raids had very tangible economic repercussions, especially where the pilgrimage was concerned.[22] In the instance cited above, al-Jabarti records the unexpected arrival of the pilgrims in Cairo, and describes their pitiful state of hunger and nakedness. All the property of the *'amīr al-ḥajj* and the merchants' goods were stolen; the Bedouins also captured all the women and their goods.[23] Nor was this the only incident of its kind. In 1787, the ᶜA'idi attacked a merchandise and pilgrim caravan coming from Suez and, according to al-Jabarti, robbed the merchants of six thousand camel-loads of different goods; the pilgrims' belongings were also seized, and the women were taken captive.[24]

While the *ᶜawā'id* or, alternatively, overwhelming force, provided at least some assurance against raids, at least in times of relative political stability, it was always necessary for the government to take all possible precautions to ensure the safety of merchants and pilgrims: one year, fifteen thousand men were sent along with the pilgrim caravan.[25] By the last quarter of the eighteenth century, such protection was growing more and more inefficient, and the *ᶜawā'id* were paid less and less frequently. Muhammad Bey Abu'l-Dhahab (ᶜAli Bey al-Kabir's successor as *shaykh al-balad*) died in 1775, and power struggles among the Qazdughliyya (one of the powerful Mamluk households of the late eighteenth century) marked the next decade. Raids increased in number during this time. They had occurred sporadically throughout the century: in 1730 the Arabs had taken two thousand loads of coffee out of a total of three thousand from the caravan to Mecca; the caravan was pillaged again in 1758.[26] But from the 1770s on, Cairo was too torn by struggles between the various Mamluk houses to fulfill its side of the bargain with the Bedouins. In 1784, the Bedouins stopped the Maghribi pilgrims at ᶜAqaba and pillaged their bags; in 1786 they seized the *mahmal* and pillaged the merchandise; in 1788 they pillaged the merchants and pilgrims on their way back from Suez.[27]

While the raids may not have had a remarkably adverse effect on the

economy as a whole (since the stolen goods were usually resold), they were devastating for individual merchants, and often involved large sums of money. In other words, the Bedouins entered into direct competition with the merchants, inserting themselves as relatively gratuitous—at least from the merchants' point of view—middlemen, to supplement their normal trading activities. They could sell the booty they had seized to European merchants (there is mention in the records of the East India Company of Bedouins selling coffee plants to Venetian merchants, for example); or to the merchants or the beys in Cairo or Suez.

The latter occurred most notably in the raid of 1779, which considerably hampered European and Mamluk efforts to open Suez. This raid illustrates the ability of the Bedouins to impose their own priorities on the rulers and merchants; but incidents abound confirming this point, and this raid was in many ways typical of the pattern discussed above. In the context of a shifting balance of power, however, it had quite a profound and long-lasting impact, since it put a temporary end to Europe's efforts to enter the Red Sea. Seen within this context, it shows the extent to which the Bedouins could affect long-term historical trends, and exploit them to their own advantage. The raid is also significant because it demonstrates the extent to which all merchants—whether Ottoman subjects or East India Company dependents—could be affected by the Bedouins' activities; at the same time it provides a relatively rare blow-by-blow, eye-witness account.

By 1772, Sir Warren Hastings, British governor of Bengal, had authorized a trade agreement with Egypt. The following year, a similar one was signed between James Bruce, an East India Company employee, and Yusuf Bitar al-Halabi, the customs master at Dumyat, calling for an 8 percent Suez customs duty on all imported goods from India and a fifty tallar docking tax for each ship, and guaranteeing the safety of all English merchants and sailing captains.[28] For various reasons, however, the agreement was to be superseded by events—mainly, I would again argue, because those signing it had not realized the importance of the Bedouins.

In a letter to Lord Viscount Weymouth, dated 4 October 1779, Sir Robert Ainslie, British ambassador at Constantinople, cites a letter sent to him by George Baldwin, the East India Company agent in Cairo. The letter, Ainslie writes, contained a narrative of sundry transactions since the arrival of two English packets from India at Suez the previous April, and afterward of two merchant ships under Danish colors, with cargoes of merchandise, which, contrary to the orders of the Porte, were received and landed there. The whole of one of these cargoes was seized and carried off by the Bedouins, in the desert between Suez and Cairo.[29]

A letter from John O'Donnell, a member of the party attacked, to Robert Ainslie, dated 5 August 1779, was enclosed in the package sent to

Lord Weymouth. On 25 May the Danish ship *Nathalia*, in which O'Donnell was a passenger from Bengal, had anchored in Suez. Having obtained the pasha's permission to unload the cargo, the merchants had delivered the goods to the customs master, who in turn handed them over to the bey's own caravan, which was sent for the purpose of transporting them to the customs house in Cairo. On the evening of 15 June, O'Donnell and his companions set off with the caravan, bound for Cairo. The next day at dawn, the group was attacked by Bedouins, who seized the entire caravan, no resistance being made by the bey's people; on the contrary, exclaimed an indignant O'Donnell, the latter "rather assisted with the business." The Bedouins proceeded with the merchandise to within a quarter of a mile of Suez, on their way to al-Tur in Sinai, then sent about thirty armed men on dromedaries after O'Donnell and the other European merchants, who had evidently attempted to escape. These men soon "overtook, stripped and plundered us of our watches, clothes etc. and then threatened to cut us to pieces. Even the rascals had the inhumanity to take the shoes off our feet, the coverings off our heads and shirts from our backs."

O'Donnell managed to return to Suez, where, far from obtaining satisfaction, he found that the commandant of his ship would not even allow him on board. O'Donnell suggested that men and arms from the ship be sent to assist in the recovery of the caravan. Not only did the captain refuse, he took the additional precaution of detaining O'Donnell, who was convinced that a plot had been hatched to prevent him from retaking his property. Seven of the ten Europeans, it was subsequently revealed, had died in the desert.

In a letter to Ibrahim Bey (one of the main parties to the power struggle that followed the death of Muhammad Bey Abu'l-Dhahab, and later one of the ruling duumvirate), O'Donnell noted that the "Arabs" had made restitution of all the property belonging to the "natives," and had declared that they were at war with the English. The *Nathalia* and the other Danish ship were then seized at Suez by the very force that had been dispatched after the Bedouins to recover the caravan.

Adding insult to injury, the goods from the ships were then publicly brought into Suez by the Bedouins for sale. O'Donnell was sure that they had paid a "considerable douceur for this indulgence, otherwise they never would venture to do so, as the Bey has at this time a large party of Mamalucks there."

This incident can be seen as resulting from violent Mamluk struggles to control Egypt's resources. The all-out competition among the Mamluks would have made it impossible to dispense with the revenue from the trade until the Porte was no longer following their activities so closely.[30]

The attack on the East India Company merchants can also be seen, not

as a calculated move supported or even orchestrated by the Porte or the beys, but as one incident among many—a reflection of the disintegration of central power in the last quarter of the century. The British merchants were hardly the only ones to have suffered from the Bedouins' attacks. Still, in this instance, they seem to have lost out on the deal struck between the *multazim* (tax farmer) at the Suez customs house and the Bedouin chiefs, whereby the booty from the raid, or the revenue derived from its sale, would be shared between the two parties. Under the conditions of extreme competition among the beys, it would indeed have been difficult to pursue a long-term policy encouraging European trade against the will of the Porte; and in this case, the *multazim* in question seems to have opted for quick gain. The restitution of the "natives'" property could well have been a figment of O'Donnell's imagination, for it is equally possible that the local merchants in question bought back their own goods[31] and that the British refused to do so. The Bedouins' declaration of war on the English is equally difficult to explain conclusively on the sole basis of O'Donnell's report.

Placed in context, however, the raid appears as a continuation of the general pattern discussed above. The Bedouins seized the opportunity presented by Mamluk infighting and the Porte's opposition to the beys' policies (which implied the potential support of Istanbul for this raid in particular), to pillage yet another caravan. The attack put a temporary end to the attempts of the beys and the British to open Suez to European trade, and this result only testifies to the Bedouins' ability to make the most of the power struggle and the changing balance of international trade. Yet even this is only part of a wider struggle pitting the Bedouins against *all* the merchants who relied on the transport of their goods to Suez and further east. In the final analysis, then, until Muhammad ʿAli's succession to power, it was the Bedouins who were able to turn the short-term situation to their own advantage, benefiting from the impact on commerce of political instability in Cairo.

## Notes

1   Already in the thirteenth century Bedouin revolts and similar disturbances had bred a certain reluctance among many merchants to take the Qusayr route. Some traffic continued to pass via Qusayr throughout the sixteenth century, but the bulk of trade had shifted to the Red Sea route. Garcin, however, attributes this shift more to the Mamluks' extortions from merchants, which had intensified by the late fourteenth century, than to Bedouin pillaging. He notes: "A mamluk amir who must gather money rapidly in a temporary post does not have the same reasons to spare the merchants as a tribe that guarantees the caravans' safe passage." Jean-Claude Garcin, *Un centre musulman de la Haute-Egypte mediévale: Qus* (Cairo, 1976), 400–410, 570.

2   Marcel Clerget, *Le Caire: étude de géographie urbaine et d'histoire économique* (Cairo, 1934), 196.

3   See Peter Thompson, *Trading Politics and the Politics of Trade: The Issue of a Direct British Trade at Suez during the Last Quarter of the 18th Century,* M.A. Thesis, The American University in Cairo, 1994, for a detailed discussion of the conflicts over Suez that arose between the Porte and the beys, and a lengthy analysis of the 1779 incident in particular.
4   John W. Livingston, *ᶜAli Bey al-Kabir and the Mamluk Resurgence in Ottoman Egypt, 1760–1772,* Ph.D. Thesis, Princeton University, 1968, 107.
5   The *'amīr al-ḥajj* was sent by the Porte during the seventeenth century, but the post was given to a member of the Fiqariyya household in the early eighteenth century, when they dominated political life in Egypt, then to one or another of the leaders of the Mamluk houses at the end of the eighteenth century. A crucial post, it was usually assigned to members of the dominant political group. The *'amīr al-ḥajj* was responsible for the organization of the pilgrimage, the administration of the finances allocated to it, and the protection of the pilgrims between Cairo and the holy sites. He was "authorized to distribute costly gifts in cash and kind to the Seyhs [shaykhs] of the Arab tribes dwelling along the route of the pilgrims' caravan in order to secure protection for it against Arab raids and other hostile acts." Stanford J. Shaw, *The Financial and Administrative Organization and Development of Ottoman Egypt, 1517–1798* (Princeton, 1962), 185, 239–49, 298ff.
6   André Raymond, *Artisans et commerçants au Caire au XVIIIe siècle,* 2 vols. (Damascus, 1973–74), 123.
7   Raymond, 123.
8   Clerget, 198–99. See also Jacques Jomier, "Ageroud: un caravansérail sur la route des pèlerins de la Mekke," *Bulletin de la Société d'Etudes Historiques et Géographiques de l'Isthme de Suez* 3 (1949–50).
9   Gaston Wiet, *Journal d'un bourgeois du Caire: Chronique d'Ibn Iyas,* 2 vols. (Paris, 1955), 1:42.
10  Raymond, 124.
11  Jacques Jomier, *Le mahmal et la caravane égyptienne des pèlerins de la Mecque: XIIIe–XXe siècles* (Cairo, 1953), 93.
12  See Jean-Claude Garcin, "Note sur les rapports entre Bedouins et fellahs à l'époque mamluke," *Annales Islamologiques* 14 (1978) 146–63. Garcin's emphasis is Upper Egypt until the fifteenth century, but his conclusions are useful for a more general discussion of the relation between Bedouin tribes and central power.
13  Wiet, 1:59.
14  Wiet, 2:211.
15  Garcin, 147–48.
16  Wiet, 1:100.
17  Garcin, 155.
18  Garcin, 161.
19  Shaw, 253.
20  ᶜAbd al-Rahman al-Jabarti, *ᶜAjā'ib al-athār fī-l-tarājim wa-l-akhbār,* 3 vols. (Beirut, n.d.), 1:309.
21  Jomier, 134.
22  Muhammad Tabo Mahmud, "The Role of the Bedouin in Egyptian Politics in

the Period 1750–1850," M.A. Thesis, The American University in Cairo, 1972, 42.
23 Mahmud, 43.
24 Mahmud, 41.
25 Mahmud, 44.
26 Raymond, 128–29.
27 Raymond, 128–29.
28 Livingston, 127.
29 This incident is described at length in the records of the East India Company's India Office Records (series G/17/5 "Egypt and the Red Sea," ff. 249–50 et seq.) These documents have been underutilized generally, although Thompson dwells on the raid in some detail.
30 Thompson, 100.
31 This was not an uncommon occurrence. Al-Damurdashi cites one instance in which Bedouins raided the pilgrim caravan passing through ᶜAqaba, only to sell the merchandise back to the pilgrims a little further on. See ᶜAbd al-Wahab Badr and Daniel Crecelius, trans., *Al-Damurdashi's Chronicle of Egypt, 1688–1755: al-Durra al-musana fi akhbar al-Kinana* (Leiden, 1991), 344–45. The only plausible explanation for the Bedouins' failure to seize also the pilgrims' money, with which they must have bought back their belongings, is the fact that merchandise and beasts of burden were far easier to make off with quickly. It is also possible—although less likely—that the Bedouins intended to impress upon the pilgrims the extent to which they were under the tribes' control, and took advantage of their desperation to exact a higher price for the goods.

# Egypt, 1760–1815: A Period of Enlightenment? Reflections on the Origins of Modern Egyptian History

## Peter Gran

The period 1760–1815 in Egyptian history has been neglected by the majority of writers on modern Egypt on the grounds that it was a period that was premodern, or 'tributary,' and hence irrelevant.[1] The view is now being contested by a minority who see the period as a transition to the modernity of the later nineteenth century, one that sheds some light on the form of culture and of capitalism that came to predominate at that time. In this latter view, the period becomes one analogous to the Age of Enlightenment typical of a country such as Spain, a country whose Age of Enlightenment also came out of its medieval scholastic heritage and whose Enlightenment is quite important to an understanding of its modernity. To establish this view of Egypt, this essay is divided into three sections. The first contains a brief account of the unfolding of the social dynamics in Egypt from 1760 to 1815 to show the transition on this level; a second and longer section examines the cultural material that was produced in this period. It looks at the ways Egyptian writers shaped their world and by extension our own as well. The third and final section raises the question of why in the face of evidence such as that presented here the old paradigm of Golden Age, decline, and reawakening in 1798 by the West still dominates the field of Egyptian studies.

### Egypt, 1760–1815: An Interpretation of the Social Dynamics

In the middle of the eighteenth century, Egypt reached a watershed in its socioeconomic history. The Price Revolution of the sixteenth century had

tied the country to the Ottoman Empire, but the industrial revolution of the eighteenth century had the effect of drawing Egypt slowly but surely toward Europe, meaning toward the production of raw goods, especially foodstuffs for France. There were, however, rewards for some for doing this, and these rewards included French textiles. Thus we find in the Egyptian Delta French merchants and their commercial proxies the Syrian Christians plying these textiles, ever seeking to expand their range of privileges at the expense of the Muslim merchants and *multazimīn*, while in Cairo the dominant circles, benefiting from their growing wealth from trade, were taking a number of steps toward political independence.

Historians have noted that during the eighteenth and early nineteenth centuries, Cairo and the Delta experienced a degree of capitalist penetration, that there was a struggle over the control of trade in these areas, and that by contrast in Upper Egypt there was not. In Cairo, the Ottoman administration, as represented by the pasha and the central bureaucracy, waned in importance with the rise of offices such as the *shaykh al-balad* and *amīn al-ḥajj*. These two figures, backed by their mamluks and in loose alliance with the Egyptian middle classes through the *diwān*, began to orient their trade toward the European market, decreasing at the same time their payment of tribute *(ḥulwān)* to the sultan, and sometimes ceasing altogether to pay it. In this period, for example, the late mamluks, who invested in business and land, bypassed the registration and tax procedures of the central bureaucracy. Further, they intermarried with Egyptians and participated in the Egyptian religious and cultural life of the middle and upper classes.

The middle classes, in which were located the majority of the ulama and native Egyptian merchants, did not have the capital to buy land and to take advantage of the new opportunities for foreign sales. They had to compete on increasingly unequal terms with French mass-produced goods, and coffee from Martinique. There was no way in which they could corner the wholesale trade in these commodities, since its source was France. Their situation was one of long, slow decline, which, as the next section shows, worked itself out in the form of a religious and cultural revival.

The period from 1815 to 1837 saw a continuation of many of these trends on a formal level, but the struggle that had been waged in Cairo by the indigenous merchants and artisans had been suppressed, being pushed more into the provincial towns. New political and legal forms crystallized on a countrywide level; an era of 'reform' began. A different orientation in Islamic culture came to prevail. In the years from 1837 to the 1860s, these changes continued, modern Egypt emerging as a capitalist nation-state in the 1860s of an 'Italian' sort, 'northern' open market capitalism being played off against 'southern' 'feudalism.' To sum up, capitalism

was not born in the period we are considering, nor was it imported from Europe. Rather, by the end of this long transition period of 1760–1860 the capitalism that already existed had spread to the country as a whole, a long process culminating in the laws passed by Sa{c}id in the 1850s.

Finally, the spread of capitalism in Egypt, as in other countries, however complete or incomplete the process may have been, nonetheless created a political crisis, whose resolution ushered in the modern nation-state. In the 1860s, in the face of sharpening class conflict, a new political alliance was formed in Egypt, one that could agree on the rules of the game as it would now be played; power then was delegated to the bureaucracy, which arose in its modern form. The view that Muhammad {c}Ali Pasha performed these functions back at the beginning of the century is, of course, not correct.

## Culture, 1760–1815

*The Social Context and Juridical Outlook*

Until the twentieth century, the intellectual life of Egypt was centered in the mosque university of al-Azhar.[2] This institution has never been adequately studied. Frequently seen by scholars as the upholders of a frozen orthodoxy, the Azharites have often been simply ignored. Scholarly work on eighteenth-century Spain offers a useful perspective for a writer trying to redress the situation in Egyptian studies. Spain, like Egypt, arrived at its modern culture through its scholastic tradition and through the revival movements of various religious orders. Napoleon's invasion of Spain was rejected culturally, as it was in the case of Egypt.

If in the Enlightenment in France human rationality was manifest in the people's capacity to limit the powers of the ruler, in countries such as Egypt and Spain it reached its modern form balanced with faith; if in France autocracy was destroyed, in Spain and Egypt autocracy survived, albeit confined by laws and custom. If in France and England ethics declined as an intellectual terrain, as Filmer gave way to Bentham and his calculus of pain and pleasure, in Egypt and Spain ethics rose in importance, emerging from within religious thought and history to challenge the amoral utilitarianism of capitalism. If in France the Enlightenment undertook to destroy religion, elsewhere, it undertook to reform it. All this leads to the question: should the French model of the Enlightenment be imposed on the cases of Spain and Egypt? Should one draw out the odd figure from these countries to show the universality of the French experience? Alternatively, should one ignore the French Enlightenment?

It seems preferable to adopt a middle-ground approach, one doing less violence to the experience of countries such as Egypt, while at the same time avoiding the nominalism typical of Egyptian studies. Egypt resolved many of the same problems that France did in this period, but it reached

different solutions. Egypt's Enlightenment—like that of Spain and in fact like that of a number of other countries as well—was not the society-centered one of Louis XVI or the state-centered one of Peter the Great in Russia or of his Ottoman contemporaries, it was somewhere between them, a mixture of state and society.

In the second half of the eighteenth century, a number of leading shaykhs of al-Azhar were associated with the commercial sector, referred to above in regional terms as a part of the 'north' of Egypt (Cairo and the Delta to Alexandria). Among these shaykhs one finds most of the members of the reform-minded sufi orders of the era. And, as the main source of the period makes clear, these orders were enjoying a revival.[3] Thus one finds that while the shaykhs gave their lectures in al-Azhar in hadith and the other required subjects, research and reformist thought took place in the salons *(majālis)* of civil society. This we know about as much as anything from the work of the historian al-Jabarti, who, while not a participant, was a keen observer. Al-Jabarti's family, as an aside, was from the 'south' (Cairo, Middle and Upper Egypt; Cairo here, to clarify, being split part 'north' and part 'south' ); he retained contacts with the older, tributary side of the system, the side one could term 'anti-enlightenment.'

From al-Jabarti's accounts, we know that the most famous of these salons was that of the Wafa'iyya sufis. Second was that of the Khalwatiyya–Bakriyya. The Wafa'i *majlis* was regularly attended by the great *shaykh al-ṭarīqa* Muhammad Abu Anwar and by the greatest hadith scholar of the century, Muhammad Murtada al-Zabidi.

While rosters for the Wafa'iyya and the Khalwatiyya–Bakriyya do not exist, pieces of information about their membership do, and this serves to make the link noted above to the changing commerical scene, as well as to distinguish these two orders from each other and from the larger popular orders, which also played an important role in this period. The Wafa'iyya would meet in the homes of notables for al-Zabidi's evening lectures. Their followers included a number of local government officials. In contrast, the locus of the Khalwatiyya–Bakriyya was the rank and file of the Egyptian merchant community. Thus while the Wafa'iyya was a small, fairly simply-organized group concentrated in Cairo, the larger Khalwatiyya–Bakriyya was spread along trade routes and had a correspondingly more elaborate structure and more numerous sources of revenue. The Wafa'iyya benefited from the patronage of a few individuals who had amassed great wealth, combining capitalism with political power, giving the order an élitist tone.

The cultural outpouring from these two sufi orders between 1760 and 1790 was extraordinarily large and multifaceted. Much of the writing of books was a byproduct of studies in law. To put this in context, one needs to remember that law in orthodox Islamic centers has several different

bases, and that while theoretically these reinforce one another, reflecting different facets of the same reality, in practice writers have often used the differences to legitimate different views.[4] In this period, the study of law in Egypt was dominated by hadith, much of it carried on by sufis who were at the same time Azharite shaykhs. *Fuqahā'* were few and far between, the central state with its *qānūn* (secular) being weak.

In turning to the best-known writings in hadith, the first thing a historian might note is the inclusion of themes germane to the period in question. The struggle for control of the Egyptian market between the indigenous and the foreign merchant, one that the Egyptians were losing, was reflected in a number of hadith writing on the Battle of Badr.[5] Secondly, the sharpening class conflict in Cairo was also reflected in the hadith scholarship—the views of the popular orders, such as those of the Bayyumiyya, pitted against those of the élite orders mentioned above. Shaykhs such as ᶜAli al-Bayyumi, who threw in their lot with the artisans, were perceived by the élite as subversives. This in any case is how the élite understood al-Bayyumi's demand for brotherly solidarity among members and for loyalty to the shaykh.[6]

Was this type of conflict in the commercial sector typical of Ottoman history, or of modern history more generally? The long-term view of the subject suggests otherwise. The more conventional pattern—in the sixteenth and seventeenth centuries and then again after 1815—was one in which the dominant classes had enough of an upper hand that they could codify their beliefs through a systematic theology and could employ Aristotelian logic as a shield in argumentation. In such a context, hadith, like sufism, remained an alternative discourse, one not directly responded to by the power structure, but one that it had to tolerate to rule.

In the years following 1815, the principal social cleavage was that of lord—be it landlord or bureaucrat—and peasant. If earlier (for example, in the 1780s) one still found a complex set of relations between merchant, mamluk, and artisan, a set of relations characterized by a range of gradations, by 1800 and thereafter this was less the case. At that point, the number of day-laborers in Cairo began to grow, as the apprentice system broke down and as landless labor in the nearby countryside also grew. The fate of modern Egypt appears to have been decided in the bitter—and little studied—thirty-five years from 1780 to 1815. Looked at from 1815, a society of laborers could be discerned working for a more clearly defined class of rich merchants and large landowners; *fiqh* was enjoying a rebirth as a significant component of law. Egyptian *fuqahā'* were returning to the scene. First came the *faqīh* Muhammad 'Arafa al-Dasuqi, then Hasan al-ᶜAttar. Before al-Dasuqi, for at least one generation, Egypt had no important *fuqahā'*. Consider the best-known figure of that era, the Upper Egyptian Malikite Muhammad al-Amir, who became increasingly a sufi, known as Sidi Muhammad al-Amir.

For evidence of the changeability of the bases of Islamic jurisprudence over time, one has the biographical dictionaries and the manuscript catalogs. For example, an examination of the production of books and copies of books from *tarājim* literature and from manuscript catalogs such as those of Dar al-Kutub and al-Azhar suggests that writing, and presumably instruction, in some fields was far more evolved than it was in others. In the eighteenth century the quantity of works in some areas—such as hadith studies—had been enormous, while in others such as *fiqh*, the number of works was small and fragmentary. This leads to the conclusion not that fields were not available but that knowledge production was driven by the very history we want to understand—hence the need to study cultural history as a way to understand the society. There was nothing static or predictable about it.

Another point: the dominance of hadith and certain fields that supported hadith in eighteenth-century Egypt did not mean—as the case of the *faqīh* Muhammad al-Dasuqi makes clear—the absence of other fields for the individual who might want them. Different centers in the Ottoman Empire, by virtue of their history, tradition, and current politics, had different specialties; travel by scholars from center to center was the norm, as it had been earlier with the Peripatetics. This gives importance to the literature of accreditation still found in hadith collections such as the *ijāza*, the *thabt*, and the *samt*. It establishes the connections. Thus, for example, in the late eighteenth century, Istanbul was not producing many works in hadith, but a number of Ottoman Turks were studying hadith in Cairo, just as there were Egyptians in Istanbul studying logic and science, the latter not being available in Cairo.

The widespread reliance on hadith in Egypt gave it a uniquely important status. For the serious thinker, questions concerning hadith thus justified vast research projects that today one might term empirical research. Al-Zabidi, for instance, produced more than one hundred books, most of them outgrowths of his work on hadith. The best known of these books is his ten-volume dictionary, *Tāj al-ᶜarūs*, which, until today, is one of the most widely-used reference works in the Arab world.

From al-Zabidi's point of view, to understand the meaning of hadith required that one know the Arabic language of the period in which the hadith emerged. This meant that the entire history from the Jahiliyya through the Prophet Muhammad's lifetime (the period during which the language evolved), a subject that had not been studied in Egypt for at least a century, had to be reestablished. One approach favored by scholars such as al-Zabidi was to go to the Bedouin in Arabia. It was assumed, both in the eighteenth century and more recently, that the Bedouin had not intermingled with the world as much as other Arab peoples and that hence their speech retained its pristine purity. Another

approach to the understanding of this period was through a study of its literature.

*Literature, Philology, and History*

The great value of literature for the scholars living in this period—here to ignore for a moment the esthetic attraction—was that it offered them an alternative logic for ascertaining the meaning of texts to that provided by the study of the Qur'an and hadith. This accounts for the widespread interest among the *ahl al-ḥadīth* of the late eighteenth century in the study and even in the memorization of the *Maqāmāt* of al-Hariri, a work that was linguistically challenging and that drew self-consciously on a pre-Islamic background.

It now seems useful to note the form these sources take, as this has been an issue among scholars up to the present day. Most of the works of the period in question, which touch on literary matters as on others, are glosses on seventeenth-century commentaries written on sixteenth-century texts. Most state that they contain nothing original and that they were composed only as very modest expansions or elaborations of what went on before to help students understand an overly condensed discourse. They are eclectic in the way they approach the subject matter, sometimes thereby suggesting at first glance a low level of mastery. This apearance is further reinforced by the frequent lament on the part of the authors of the difficulty of obtaining all the sources desired to settle a certain point. Another purely formal element of the period is that there is little or no mention of topical subjects or of foreigners, except as one finds them interspersed in the texts.

To interpret these works as modern scholars often do is to dismiss them. This I find ironic. Here is a body of thought that is serious, even innovative, and for that reason was put in a form that demands a committed reader. It is not a matter of esoteric and exoteric, it is a question of judgment, the sort of thing one would acknowledge in Montesquieu's titling his book *Les lettres persanes*, a work that has much more to do with France than Persia.

It thus seems useful to me to read these works with the expectation of finding things as a committed reader would—in other words at least partly as the author intended that his primary audience would—and thus to begin by reading the colophon, or *dibāja*. Invariably, the *dibāja* contains a thanksgiving prayer. This is important because, with the mention of God's name, certain expectations are created. One learns if the book comes more from the rationalist tradition, from the transmitted sciences, or from sufism. Further, the *dibāja* suggests how polemical a given work is likely to be. Will God, for example, smite those who hold false beliefs? The issue of originality does emerge, but it is clouded by the problem of the

author fearing he will be charged with false innovations. To protect himself from this possibility, he is likely to put his words in the mouth of pious and somewhat remote ancestors and hope his own ideas—some of which may very well be original—will go unnoticed. If he wishes to disagree with his teacher, and the teacher is still alive, he may deliberately choose a work by an author he wishes to attack that his teacher does not use. Thus, his claims as to his intentions regarding clarification and writing for students, while perhaps true, may be only part of the truth. The eclecticism in his approach is often an aspect of his polemic as well. If he agrees with the received interpretations on many points, he may skip over them in his own work.

To understand an eighteenth-century text, one must reflect not just on who the author is and what his chosen audience of peers is but also on what is taking place in his wider implied audience of hangers-on, the artisans and day-laborers found around any mosque center, hence the care shown by most authors in conveying information on the date of composition of a given work and the circumstances at that point of the writer. There was, for example, the finshing of a draft, the actual completion of the copy, and perhaps the giving of it to a copyist. There was also the question of whether the copyist had the copy approved or whether it was made by a later copyist.

To approach these fields as modern scholars have frequently done, simply from the position of expertise in one field or another, is thus not enough. Knowledge of a given field is likely to be too general to be of much assistance. It should also be noted that many shaykhs were polymaths, this being the norm of the period. Like their contemporaries elsewhere, they chose to write in a dozen different fields. It is therefore helpful to note that the authors often presuppose that their readers share their interdisciplinary orientation.

Finally, since shaykhs would not mention a sufi (who supported the artisans and working classes) by name in their writings, as this would dignify him, our knowledge of the sequence is crucial to decide why a book was completed at a certain time or why a certain polemic was being developed or who is actually being discussed.

How does a modern historian typically read an eighteenth-century gloss? In both the West and the Arab world in recent years, the accepted method is to read a sentence of the gloss, then jump to the commentary to see what the context is, then to the original text—all three of them being sandwiched on the same page. This method has its uses, but writing a history of the eighteenth century is not one of them. It presupposes that scholastic thought is static, that its reading simply requires a technician.

For the social historian today, the commentary and the original text are not very useful, because the social context of Egypt in the seventeenth and

sixteenth centuries respectively is scarcely known at all. In addition, the eighteenth-century author's relationship to this past is difficult to ascertain. What can be understood at this point are the words that the eighteenth-century author has written and the subjects on which he has dwelt.

It is also important for the social historian to avoid the pitfall of taking works in isolation, as is often done by scholars whose goal is to study a discipline. Here a historian of a discipline has different needs than a historian of a period. A single work—for example, al-Jabarti's work on medicine[7]—is not easily separable for the historian of a period from the same author's dozen-odd works in other fields. While this does not invalidate the traditional discipline-oriented analysis, what I am calling for is a different kind of endeavor—one that I think is appropriate to the task at hand. The vast majority of manuscripts listed in al-Jabarti's *ᶜAjā'ib al-athār* and elsewhere appear not to have been lost, as some scholars have assumed. Most of these manuscripts can be found in al-Azhar or Dar al-Kutub.

The question of style in literary sources is another area with which the social historian has to conjure. By and large, the subject of style is an area that has already been developed by students of classical literary history, but as is readily apparent it has been developed for their purposes and not for ours.

In the eighteenth century, the dominant style was rhymed prose, or *sajᶜ*, a form long considered by our literary scholars to be barren of meaning, given to exaggeration, imprecise, and inferior to either the classical poetic *qaṣīda* form or prose, *nathr*. Yet *sajᶜ* endured from the twelfth century to the early twentieth century—much longer than the style of the classical era. Why, we do not know. Whether it is, in fact, more or less precise than other forms is, of course, likewise unknown. Even more broadly, whether literary writing that appeals to the ethos of sincerity is actually more sincere than is *sajᶜ*, which does not, and if on that account is more worthy of our attention is a matter that needs to be thought out as well. What is it, after all, that would prevent sincerity from being jejune or *sajᶜ* from being cynically realistic? Whatever one may think, *sajᶜ* cannot be attributed—as it often still is—to 'Ottoman Turkish influence.'

Within the period we are covering, two small discoveries may be helpful in formulating a hypothesis about the role of *sajᶜ*. Firstly, as ᶜAbd al-Rahim ᶜAbd al-Rahman ᶜAbd al-Rahim has shown,[8] a particular *qaṣīda* written in *sajᶜ* in the early eighteenth century was, in fact, bitingly realistic and in every sense a powerful vehicle of social realism. Secondly, the only time that writers of *sajᶜ* were accused within Egypt of linguistic imprecision occurred when some Egyptian students returning from abroad claimed that the Syrian translators who made the first translations for Muhammad ᶜAli used imprecise and high-flown language. However, this accusation was made within the context of a social struggle: the Syrians were court followers whom the Egyptians

were seeking to displace. Language had become an area of intra-élite struggle.

The argument that *saj$^c$* is a 'corruption' of prose and of poetry is still by no means wrong. In the eighteenth century, classical rhyme schemes were poorly imitated; and in some cases, popular forms of culture were intermixed with them. A glance at the leading manuals of style, however, offers an explanation of why this might be the case, other than for reasons of decline or of ineptitude. The purpose of style, wrote the sufi shaykh Muhammad al-Hifnawi, was to express "matters of the heart."[9] What he meant was that style was a factor in the propagation of sufism, and that the balanced cadence of classical poetic forms was not as effective in holding the attention of the urban masses as was a rhythm with which they were more familiar. The need to propagate ideas across class lines created a new set of stylistic problems, and this needs to be studied. I suspect modern Egyptian music emerges from this type of context.

If the most important fields in eighteenth-century intellectual life were those that were directly related to the development of hadith studies, much took place as an indirect consequence or even independently of these imperatives. For example, the study of al-Hariri's *Maqāmāt* had the effect of encouraging prose writers to attempt to write their own *maqāmāt*. Several were composed in the eighteenth century. By the end of the eighteenth century it was becoming clear that when shorn of its didactic character and of its high-flown linguistics, the *maqāma* could serve as a progressive vehicle for the development of prose not dissimilar to that of the protonovel, as exemplified by the *Sketch Book* of Washington Irving, a work composed in roughly this period and supposedly influenced by the *maqāmāt* tradition, which the author studied. In the case of Egypt, Hasan al-$^c$Attar's *Maqāma*, an autobiographical sketch, showed both plot and character evolution.[10] In addition, it dealt with such complicated matters as sexual identity. In so doing, it linked a complex individual to the history of his times. Al-$^c$Attar's prose writings also included a series of letters—again one thinks of the epistolary tradition of the Enlightenment—written from Asyut in 1798 to his friend al-Jabarti in Cairo. In these letters, some of which al-Jabarti saved and published in his own writings, one also finds an awareness of self as well as an awareness of social problems.[11] Al-$^c$Attar the urbanite was not comfortable in the more rural, tribal Upper Egypt, the home ground of the Jabartis.

Al-$^c$Attar's *Maqāma* can also be seen as part of a broader literary revival. In the preceding generation, an important Azharite, $^c$Abdallah al-Shubrawi, wrote lyrical poetry quite unlike the prevailing *saj$^c$*. Lyricism was also noticeable in the poetry of al-$^c$Attar and others in the late eighteenth century, and in these works one seems to find the basis of the later romanticism that plays such a prominent role in Egypt in this century.

It is hard to separate the development of language and literature from the break with the static philology with which the period had begun, these fields being so interconnected. For example, in the field of lexicography, scholars concerned with the changing cultural situation turned to a historical approach to language. Al-Zabidi, whose fame as a lexicographer had spread from Morocco to India in the late eighteenth century, availed himself of the opportunity to meet pilgrims passing through Cairo and to visit the tribes to deepen his knowledge of usage. He sought in every way possible to confirm the existence of words that al-Firuzabadi and the later lexicographers gave as possibilities. An important result of al-Zabidi's work was a deeper self-consciousness about the language as it really was; for litterateurs this was a way out of using worn themes and rhyme patterns, the linguistic refuse that would exist in any period, $saj^c$ or no $saj^c$.

In grammar, al-$^c$Attar brought a utilitarian orientation to a similarly arcane and formalistic field. He in his own way was reacting to the 'Baroque' culture of the previous century. For example, in a manner anticipating the Nahw Wafiy school of the Egyptian Delta in the 1940s, al-$^c$Attar criticized earlier grammar commentators such as al-Siyuti and al-Azhari for failing to limit their discussion to what was essential. Increasing numbers of people, most of whom were not part of the philological élite, needed to be able to use grammar books. Indeed, this increasing number of people, who used al-Zabidi's dictionary and al-$^c$Attar's grammar books, ultimately became the audience for the modern novel, the novel emerging as the vehicle of emancipation of the culture.

What then of history-writing? As one could deduce from Lévi-Provençal's *Historiens des chorfa*, or Ahmed Abdesselem's *Les historiens tunisiens*,[12] or other works of standard scholarship, students of the modern and contemporary period identify Muslim history-writing with the somewhat secular chronicle-writing of royal courts. While this may not be entirely adequate, it certainly is true that chronicle-writing flourished in the old court cultures. Its function was to register the deeds of the ruler. Customarily, it took his life or that of his family as the principal locus of concern. In so doing, it was by definition oriented to the élite, emphasizing for that reason politics, diplomacy, and war. Where, however, the middle classes possessed a degree of power, they also had their forms of history, forms rooted in a different epistemology than that created by the chronicle, forms reflecting something of a merger of the real and the normative, a merger characteristic of hadith studies. The basic unit of this history-writing was the *tarjama*, as the *akhbār* was of the chronicle. Where the middle classes shared power with the court, as in eighteenth century, one finds this shared power reflected in—and for our purposes clarified by—such work as al-Jabarti's *$^c$Ajā'ib al-āthār fī-l-tarājim wa-l-akhbār*, in which the two epistemologies are combined.

Still, it is useful to note that for every court chronicle there were dozens of lives of inspired individuals. For this period one thus finds quite a vast outpouring of pietistic-cum-historical works. The same thing, of course, was occurring throughout Mediterranean Europe, and if one judges by contemporary scholarly work on such matters, it is as little attended there as it is in Egypt. If history to the historian of French or British history-writing is something largely secular, in the Mediterranean area, historians agree, for better or worse, it is not.

Among the sufi *tarājim* writers in Egypt there was a virtual fixation on one particular theme during the mid-eighteenth century, a theme that, while very traditional, was also then new. This was the Battle of Badr, the subject in this era of countless individual studies. Previously, during the classical period, the Battle of Badr had not been particularly singled out, but in this period it was. The reason for this appeared to be to show that those who fought with the Prophet Muhammad in this battle were extremely brave and to prove that previous accounts (usually unnamed) had exaggerated their number, thus in effect underestimating the prowess of the Muslims on that occasion. The surface appearance, then, is a correction of historical error. What is apparent is that the Egyptian merchants identified with the *Badrīyīn*. They too faced an uphill struggle, yet—as one might infer from text analysis—the Egyptian merchants were not able to band together and struggle as a single unit (for whatever reasons, probably simply the evolution of market conditions) as the *Badrīyīn* could. Thus, eighteenth-century writers treated the *Badrīyīn* in a somewhat new way—as individuals. No writer of this period dwelt on the collective bravery attributed to them in older books, but rather they stressed their individual attributes and purity. The struggle, as the eighteenth-century historians saw it, was to begin through an individual rededication to faith inspired by these great examples; a social outcome would result from this individual struggle.

The *Maqāmat al-ᶜAṭṭār*, like the *ᶜAjā'ib*, refers with great enthusiasm to the study of the rational sciences and to the practical results that they bring, referring even to the authors' contacts with the French. This is not simply an appreciation of Europe. Such works were written in Arabic for an audience that had suffered from the trauma of the French occupation. The reference was to the general lack of study of science in Egypt and to the problems associated with the mamluks' failure to support Egyptian studies of physcial science, leaving scholars to work in abstract fields such as *al-ḥikma* (which had no practical results) right up to the nineteenth century. Al-ᶜAttar's education with al-Dasuqi, who had to travel to study the physical sciences and logic, and his contact with the family of al-Jabarti, made him aware of what was lacking in Egypt. He himself was on the verge of traveling to carry on his education when he wrote the *Maqāma*.

Al-Jabarti too had a utilitarian side, revealed in his comments on technology. While al-Jabarti is often evaluated in terms of the fact that he was aware of Western science, this was clearly not his primary concern, which was with the Egyptian political system. He wanted to stem the deterioration of the mamluk *bayt* as a unit of loyalty and as a basis for rule. This is especially clear from a reading of volumes one to three. By the time he wrote the last volume of the <sup>c</sup>*Ajā'ib*, Muhammad <sup>c</sup>Ali was his patron, and he had to be more reticent.

In describing the traditional strengths of the Egyptian political system, al-Jabarti dwelt on what today one would term bureaucracy and civil society, emphasizing the strength of the ulama and of the major sufi shaykhs, a strength that brought continuity to Egypt,[13] demonstrating this point through a discussion of the lives of the shaykhs and ulama, both as a part of narrative history and outside it in his lengthy necrology notes.

Language is another key to al-Jabarti's history, and it too had a modernist utilitarian side. He used it particularly effectively in his study of the artisans and day-laborers, whom he feared and whom he believed only the ulama could control. Choosing his words carefully in particular descriptive passages, he listed their sufi orders, even noting some of their leaders, and their beliefs. In the narrative section of his work, however, where events are given their larger policy meaning, what is evoked through his choice of terms and his use of rhetoric is not so much the logic of a social dialectic but the image of the faceless mob.

A lacuna in social history prevents us from confidently extending this analysis of the utilitarian character of the period to the history-writing, for instance to the tribal studies of al-Zabidi, but one suspects much the same. From an aside by Hasan al-<sup>c</sup>Attar, one is made aware that the late eighteenth and early nineteenth century was a dire period for pastoralists and commercial tribes in Egypt, that many of them were being undermined by a breakdown of traditional trade routes and were being forced to settle. As this occurred, there took place a differentiation among them, the chief and a few elders becoming landowners while the majority became laborers. This differentiation—a part of the social transformation we have been discussing—was occurring, if al-<sup>c</sup>Attar was correct, at the same time that al-Zabidi was composing his praise of the glories of the tribal chiefs.[14]

## History-Writing on Modern Egypt

As the foregoing suggests, the history-writing on Egypt composed over the past thirty years has been marked by a certain rigidity in its views about the eighteenth century, the nineteenth century, and the ways in which these periods do and do not interrelate. This appears to be the case no matter what type of history one turns to. Could this be the result of cross-fertilization in a small field? One would doubt this. There are too

many epistemological and political problems to make this very likely. A writer in the political economy tradition would not be likely to consciously draw on an orientalist; Egyptian and Israeli writers would be unlikely to influence each other during a period of intense political conflict. The only way to explain this phenomenon is to postulate that the field of modern Egyptian studies does not exist in the scholarly mind today as an independent field; that, rather, it is a part of something else, this something else giving it its primary logic and identity. The argument of this section is that this is indeed the case, that this something else is that Egypt and other parts of the Middle East are parts of a 'Holy Land,' that the 'Holy Land' character of Egypt defines the parameters of even its modern history, explaining and justifying everything from the homogeneity of scholarly output to the commitment to maintain 1798 as a dividing point.

For historians in modern Middle Eastern history, the common view is quite different from what I am suggesting. The field as a whole postulates that it is entirely independent of anything larger than itself, having successfully fought off the claims of the older orientalism, and that in recent years it has progressively been developing according to its own logic. In this view, the birth of the field came with the turn to archival history and social analysis in the late 1960s and early 1970s, and no doubt there were important changes in this period. If one looks at the history-writing about Egypt from the period prior to that, what one finds is two rather pedestrian types of work: firstly, colonial history-writing, that is, works such as diplomatic histories emphasizing the role of the West; and secondly, communal ethnic history-writing, that is, works emphasizing the unchanging dialectic of Muslims and Copts. What was on the rise in the late 1960s, was nationally-centered, archivally-based history. Some of it took the form of political history concerned with nationalism, some of it was nationalist by implication but essentially social in its method. My contention is that by the 1990s, a survey of all this writing would reveal that despite changes and development that there had not been a clean break with the pre–1960s past, as many scholars suppose. The traditional parameters of Golden Age and decline followed by a Napoleonic invasion were all still in place, the differences between the older and the newer works thus not seeming to be all that great. History—or historicism—as a consequence (much to the distress of the generation that lived through this process) never quite became the important intellectual terrain that it was expected to be. Social and economic history, which was the great hope of the field, ultimately became quite mechanical. Let us consider some of the well-known examples of this work before developing the hypothesis of this section.

Going back to the early 1970s, the period of the rise of social and economic history, one must note André Raymond's *Artisans et commerçants*

*au Caire au XVIIIe siècle*, a work rich in possibilities for a comparative study of the rise of capitalism.[15] Regrettably, Raymond eschewed the theory one would have needed to carry such a project forward in favor of a narration of social facts leaving Egypt as a unique case, the work coming to a precipitous halt in 1798 to fit the Napoleonic watershed idea.

The same period—the 1970s—also saw the formation of an Egyptian social and economic history school. ᶜAbd al-Rahim ᶜAbd al-Rahman ᶜAbd al-Rahim emphasized at that time the theme of oppression of the Egyptian peasantry of the eighteenth century. (Later, his work shifted to the study of other social groups, as did that of his colleague Layla ᶜAbd al-Latif, who began with a study of Upper Egypt.) During this period as well, Ra'uf ᶜAbbas, ᶜAsim al-Dasuqi, and ᶜAli Barakat studied the class of large landowners. History, it appeared to those in Egypt, was at last being emancipated from the stagnation of the *'udabā'*, the *turāth* school, and the literary critics, who had long had the upper hand in the organization of culture.

A cotton economy was in place, and with it a large landlord class, and this class could be studied from the Egyptian archives. But it was, and is, hard to make such a study if one chooses to employ a Dependency School approach. In effect what happens is one loses the internal dynamic; slowly but surely, class turns into stratum, the large landlords becoming an élite, the bulk of the population a mass. As if this was the revenge of the *'udabā'*, most of modern Egypt thus never quite became a part of modern Egyptian history. Archivalism, as the most recent example, that of Kenneth Cuno,[16] shows, makes little difference. The dominant assumptions preclude the possibility that the indigenous can be historicizable or modern, no matter what the sources one chooses.

Let us turn to the political and cultural work that was published between the 1970s and the 1990s to see if what I call the traditional parameters manifest themselves in that part of the field as well. The state, as portrayed by Afaf Lutfi al-Sayyid Marsot in her canonical work on Muhammad ᶜAli,[17] was a vehicle of modernization, progressive perhaps, but nonetheless coercive—modernizing, but only because it was aligned with Europe. The ruler is thus shown as one connected to Europe and disconnected from the country's past. If one examines the assumptions here, one finds that Muhammad ᶜAli's state is coercive because the new policies it is pursuing are unpalatable at least to much of the population, and secondly, it is coercive because persuasion or compromise and consensus are not important. Is this realistic? What state—modern or otherwise—could survive simply through coercion? Is there really such a thing as enlightened despotism? Doesn't experience suggest, at least for the newer social history, that religion and culture and other aspects of persuasion must be deployed by any ruler who wants to survive? Can a ruler be a *deus ex machina*, or must he in fact be an accommodator of a social process? Yet,

following modernization theory, how could the first modernizer be anything but an autocrat and an outsider? The more logical one is about this in writing political history, the more 'Albanian'—meaning outsider—Muhammad ᶜAli becomes.

Politics inevitably enter into academic choices. I would be the first to grant the point that for a historian to assign an important role to religion and culture might seem at first glance to be problematic in Egypt. Who wants to go on spiritualizing the Orient? Such an approach might well also be tantamount to capitulating to the heritage school and thereby playing into the idea that the country has no modern history, that Egypt is "not like Europe."[18] But the extreme opposite—that modernization comes from the coercion of a dictator—is not acceptable either; there must be a specific culture of the eighteenth and nineteenth centuries that is not the same as the heritage, and this culture must be a part of the ruler–ruled relationship of that period.

In recent years, this began to happen in a small way. A colonial-centered approach to modernization reappeared in Egyptian studies. Timothy Mitchell's *Colonising Egypt*[19] may serve as an example. Mitchell's innovation was to postulate that upper-class Egyptians learned their modernity through visiting British museums in the nineteenth century in which things Egyptian were being exhibited. While one might doubt the utility of this line of argument, the main point is that Mitchell's work does try to use persuasion and culture. Unfortunately, it situates itself entirely within the familiar parameters, his use of Foucault and his critique of the Enlightenment notwithstanding.

Looking back over the past ten years, it would seem that just when a more comparative view of the eighteenth century was emerging in historical research, one that could serve the needs of pulling Egypt out of its 'Arabo-Islamic–Ottoman morass,' Foucault emerged to reinforce the claims of the French to monopolize the term Enlightenment. The effect of this for Egypt was to reinforce the hold of the existing framework of modern Europe–backward Orient that Mitchell simply uses.

In recent years as well, another old trend, communalism, made a recovery; it too accepts all the premises of the dominant paradigm. Ehud Toledano is a representative example of a historian who takes a communal school approach. Like several others, he would probably find the Ottoman archives the key to the study of the formation of modern Egypt. His view would be that historians have not given adequate weight to the Ottoman élite and its relation with the West. What stands out in Toledano's work as one reflects on his theory of modern Egypt is that whatever the novelty of his sources, his views are the same as those found in all the other schools. All of them essentialize the Ottomans in nineteenth-century Egypt, distinguishing them sharply from the "sons of the Nile," the two scarcely communicating.[20]

In short, what one would expect to generate intellectual conflicts simply does not. These trends, which are all seemingly so different, are really not—at least in crucial matters. They all serve to preserve the same somewhat élitist, Eurocentric view of Egypt, making the entrance of anything else difficult.

While, of course, this does not mean that these trends are of equal value (social history is by all odds the most important trend), or that other trends do not exist (they do), the problem is that countervailing trends are found, but found outside—and not integrated into—academia. The outcome of this state of affairs, I would argue, has not been for the best. Not finding a credible—that is, presumably, an Egyptian society–centered—view of the world in the university, the new generation of Egyptian students has seemingly decided to turn away from secular culture to an Egyptian-centered view of the world to be found—however imperfectly—in religion, history having failed.

As a consequence of what one might call this crisis of culture in Egypt, there has been a growing gap between academia and non-academia especially in Egypt around such questions as the origins of modernity, the problems of Eurocentrism, and the problem of how one can characterize the internal dynamic in Egypt.[21] In 1992, with the publication of my first book *The Islamic Roots* in an Arabic edition,[22] I noticed that the assumptions of the reviewers were quite different than they had been when the original came out in 1979 in English, the differences again being the most marked outside academia.[23] If in 1979 the work was hailed as that of an apostate, in 1992 its conclusions were taken for granted.

But is Egypt, with its somewhat stagnant history-writing, different from any other country? Is there any reason to single out what is going on here? While this is hard to judge, the following points stand out.

Prior to the age of the nation-state, Egypt regularly produced historians of gigantic stature, a phenomenon that came to an end only with ᶜAli Mubarak in the mid-nineteenth century. Historical creativity was not the problem it is today. Perhaps, of course, this was the general situation in the world; when history became more professionalized, it became more controlled and less free. Still, one might wonder why is it often said—and I believe justly so—that Middle East historical studies lag behind others.

It is not, as this essay has shown, a question of good trends and bad ones, but of why one finds basically all the trends functioning within the same parameters, parameters strongly contradicted by the existing evidence. In the concluding pages a brief attempt to come to grips with this fact is made. To begin with what is well known is that the study of the Middle East for established scholars in most places is still shaped by the presumption of the region's 'Holy Land' identity. According to this presumption, the mass populations of today are 'illegitimate,' their presence

or their study creating cognitive dissonance. As a consequence of this the historian of modern times identifies not with the modern Egyptians and their struggle but with the outside deliverer—for example, the West—Moses being the model.

Moses—to make this point clear—carried out his task of liberation by looking outward and by ultimately leaving Egypt. He left behind the unreformable, static pharaonic political order, the slave peasantry, and the mystery priest caste. It is this Biblical or Qur'anic body of lore—call it sociology—that one finds underlying what is written about Egypt even by specialists of the modern period. The coming of the West in this optic is like the coming of Moses' God, the bringer of hope. The existing political order—now as then—is static, corrupt, and incapable of change on its own. There is no dynamic. Muhammad ᶜAli is important because he turned to the West. The intellectuals are hard to understand, give or take the one or two—the reformers—who also sought a salvation in the West. The rest of the people do not really exist as people, and thus they are left outside of history.

Such ideas are not found in al-Jabarti, but they are found—or at least implied—in the absolutely secular writings of a Luwis ᶜAwad or of the moderately religious ᶜIzzat ᶜAbd al-Karim, as well as in those of nearly all modern Americans and Europeans who write about Egypt. Why should this be the case?

In the case of the United States—the instance with which I am most familiar—as one grows up and confronts the problems of the country's founding, one comes to think of one's ancestors either as mass murderers or as pioneers on an 'errand in the wilderness' à la Moses—that is, for Westerners it is not a real choice. Americans naturally feel themselves to be Westerners and thereby forgive their ancestors for what they did to the Native Americans. What happens in the service of God cannot be a crime.

Believing themselves to be Westerners, Americans imagine their birth to have been in the ancient Near East at the time of Revelation. It is this construction of self and other that makes Americans think the Middle East is more theirs than it is the Arabs'; that most Arabs, save a few who are educated (a synonym for Western-educated), really do not exist. They are nomads, who "shall fold up their tents like the Arabs and as silently steal away." This is the commonest resolution of the cognitive dissonance referred to above.

What can people in a democracy such as the United States make of the existence of the modern Arab world? The answer seems to be very little. The only way to make sense of the modernization of the Arab world is in apocalyptic terms, notions of the end of the world through war, the return of God. Such ideas are—sad to say—quite popular in America these days. The Gulf War was rationalized to many Americans in these terms. And,

even more unfortunately, this took place not only among the general population but even among the scholars.

Scholars—even in the Middle East Studies Association—were not willing to portray the real nature of Iraq or to counteract the media's attempt to compare Saddam Hussein to Hitler. Indeed, in the scholarly community one finds an intense and widespread interest in countries such as Iraq or Egypt in Biblical times and a considerably lesser interest in the societies that came thereafter—the Middle East, in both instances, segregated from other fields in special institutes and study centers as would befit a Holy Land.

Is there then a way out from this 'Holylanding' of the Middle East, an escape from this worldview that appears to account for the sterility of the scholarship? Here, the answer appears to be an affirmative one. As trends in scholarship now suggest, in another generation it will be possible for an American to seriously think of herself or himself as a North American and not as a Westerner. At that point, various details now known hazily about the contribution of Native Amercians to the formation of the country will be much clearer. At that point, what is known today fragmentarily about Franklin's and Jefferson's contacts with Native American political thinkers will be substantial enough to permit Americans to feel they are continuators of a North American polity and not simply outsiders and destroyers of it. At that point, the American cultural relationship to the Near East can become more abstract, the existence of a modern Arab-Egyptian population will matter less, and Americans should be able to study it more objectively.

To add to the dilemmas at the moment, one must note that something like this troublesome chosen-people ideology exists in Egypt as well, and it too has yet to be confronted. In the age of Isma'il, the modern state arrived along with the rise of archeology, quarrels over slavery and imperialism, and finally skin-color consciousness. Cultural hegemony in such a context, when it is well studied, will doubtless explain the paradox of how modern Egyptian intellectuals came from the land and yet trivialize their background. We have no explanation for this.

What, then, are scholars to do in our field with the idea of Egyptian modernity and its origins? This is the broader question. Clearly at present 1798 does not belong to Egyptian history any more than the Renaissance belongs to Italian history or the Enlightenment—properly understood—to France. Seventeen ninety-eight is a universal category, part of a wider belief system essentially unaffected by technical research such as ours. Should we let the matter alone until the academic climate of opinion changes? I think this is the weaker of our two main options. By drawing attention to the situation, I believe we, who are in a position to speak with some authority, are working to alleviate problems in Egypt—and in

Western countries as well—caused by the continuing hegemony of Holylandism.

This essay has tried to lay out the main contours of Egyptian history from 1760 to 1815 and to survey a range of relatively little-used sources that could contribute to its study as a period of Enlightenment. In doing this, it asks scholars to consider several matters: firstly, to question the contemporary practice of looking at the Enlightenment either as something inherently progressive (as scholars traditionally did) or as something inherently evil (as scholars following Nietzsche currently do), and to see it simply as a phase, one that led in a number of instances—and not just in France—to the capitalist nation-state. Secondly, it asks scholars specifically concerned with Egypt to evaluate their committment to upholding the 'Holy Land' perspective, one that excludes the eighteenth century from any role in modern history. Thirdly, it asks scholars to consider altering their methodology in order to recombine cultural history with social history. And finally, but relatedly, it asks scholars to clarify what they think modernity means in the case of Egypt. Is modernity an import? Is it, as the postmodernist trend asserts, irrelevant or is the production of a small capitalist sector in the eighteenth century still important?

This essay has argued this latter position, that while there may be obstacles to understanding 'Holy Land' countries, scholarship should sooner or later be able to discern that the social utilitarianism, the interest in history and language, the lyricism in poetry, and more broadly the religious and cultural justifications for trade in Egypt found in the scholastic tradition of the period live on and influence contemporary society. Sooner or later, scholars should be able to argue that in the struggles against Ash$^c$arism by the sufis and Maturidite theologians of that era (1760–1815) and of those that followed, people as reasonable beings began to emerge against the strictures of pure faith, and the modern Egyptian identity was formed.

In writing this, I would like to acknowledge my debt to the late Dr. Marsden Jones for his seminar on al-Jabarti. Those of us who took that class in 1969 came away feeling al-Jabarti's Egypt was as alive as our own.

## Notes

1   I would like to thank professors Dina Khoury, Rifaat Abou-El-Haj, and Talal Asad for reading versions of this essay. It was drawn in part from my book *Islamic Roots of Capitalism: Egypt, 1760–1840* (Austin, 1979). The concept of 'Italian road' invoked here as a way to interpret modern Egyptian history is explicated in my *Beyond Eurocentrism: A New View of Modern World History* (Syracuse, 1996). For the reader searching for a diversified idea of the Enlightenment, a useful work is *The Enlightenment in National Context,* edited by Roy Porter and Mikulas Teich (Cambridge, 1981), a work broadening

considerably the range of phenomena—and, of course, countries—considered. A work arguing for the version of the Enlightenment found useful here, the one in which modernity has scholastic roots, is O. Carlos Stoetzer, *The Scholastic Roots of the Spanish American Revolution* (New York), 1979. The author's discussion of taxation and of a nascent civil society emerging within the scholastic world (one making use of Arabic-derived words such as *alcabala*) adds to its interest. Vincenzo Ferrone's *The Intellectual Roots of the Italian Englightenment* (Highland Park, 1995), shows the level of scholastic rejection of the Newtonian world view in eighteenth-century Italy. John W. Van Cleve, *The Merchant in German Literature of the Enlightenment* (Chapel Hill, 1986), shows the gradually improving image of the German merchant in eighteenth-century culture as the middle class became increasingly involved in culture. These books represent a small sample of a much wider body of material linking the eighteenth and nineteenth centuries in various ways. Their existence serves as an indirect justification for reconsiderations in Egyptian history.

2   J. Heyworth-Dunne, *Introduction to the History of Education in Modern Egypt* (London, 1967).
3   Tawfiq al-Bakri, *Bayt al-ṣiddīq* (Cairo, 1906); *Bayt al-sadāt*, n.d.
4   Marshall Hodgson, *Venture of Islam* (Chicago, 1974), 2 vols.
5   An analysis of hadith can be begun with the catalogs of hadith books and manuscripts of al-Azhar and Dar al-Kutub. The writings of the leading figures are listed in al-Jabarti, *ᶜAjā'ib al-āthār fī-l-tarājim wa-l-akhbār* (Cairo, 1879), 4 vols; ᶜAli Mubarak, *al-Khiṭaṭ al-tawfiqiyya al-jadīda* (Cairo, 1886–88), 20 vols.
6   Mustafa al-Shadhili Salam, *Jawāhir al-iṭṭilaᶜ wa durr al-intifā'* (Cairo, 1931), on the Bayyumiyya.
7   A commentary on the *Tadhkarāt Da'ūd*, which focused on the simple remedies section.
8   ᶜAbd al-Rahim ᶜAbd al-Rahman ᶜAbd al-Rahim, "Dirāsa naṣṣiyya li-l-kitāb *Ḥazz al-quḥūf fī sharḥ Abī Shadūf*," *al-Majalla al-miṣriya li-l-dirasāt al-ta'rīkhiyya* 20(1973): 287–316.
9   Muhammad al-Hifnawi, "Ḥāshiyat al-Ḥifnāwi ᶜala sharḥ Abī Laythī al-Samarqandī," manuscript, Dar al-Kutub, *Majāmiᶜ* 155, folio 83B.
10  *Maqāmat al-ᶜAṭṭār*, manuscript, Dar al-Kutub, Adab 7574.
11  Al-Jabarti, *Maẓhar al-taqdīs fī dhahāb dawlat al-Faransīs* (Cairo, 1969), 14, 382.
12  Evariste Lévi-Provençal, *Les historiens des chorfa* (Paris, 1922); Ahmed Abdesselem, *Les historiens tunisiens* (Paris, 1973).
13  Al-Jabarti, *ᶜAjā'ib*, 1:5, on ulama rule.
14  Ahmad ibn ᶜAli al-Maqrizi, *al-Bayān wa-l-iᶜrāb ᶜan mā bi arḍ Miṣr min al-aᶜrāb* (Cairo, 1961), 9–10, 73, for al-ᶜAttar on the tribes.
15  André Raymond, *Artisans et commerçants au Caire au XVIIIe siècle* (Damascus, 1974), 2 vols.
16  Kenneth M. Cuno, *The Pasha's Peasants: Land, Society, and Economy in Lower Egypt, 1740–1858* (Cambridge, 1992).
17  Afaf Lutfi al-Sayyid Marsot, *Egypt in the Reign of Muhammad Ali* (Cambridge, 1984).

18 Recall Fritz de Jong's review of my book in *International Journal of Middle East Studies* 14 (1982). How could someone who knew Arabic read secular meanings into religious books?
19 Timothy Mitchell, *Colonising Egypt* (Cambridge, 1988).
20 See my review of Toledano's *State and Society in Mid–Nineteenth-Century Egypt* in *International Journal of Middle East Studies*, 24/2(1992): 365–69.
21 This appears to be changing with Marsot's recent *Women and Men in Late Eighteenth-Century Egypt* (Austin, 1995); see also Layla ᶜInan, *al-Ḥamla al-faransiya bayn al-ustūra wa-l-ḥaqīqa* (Cairo, 1992).
22 *Al-Judhūr al-islāmiyya li-l-ra'smāliyya* (Cairo, 1992).
23 An example of this newer, more generalist reception is ᶜAtif Ahmad's article about my book in *al-Qāhira* (April 1993), 152–63. In this article, Dr. Ahmad appeared to accept the revisionism often rejected in the history field but found it undeveloped; in his view, there was a bit of base and superstructure reductionism. While this warrants a reply, I am noting the review here simply to point out that the 'Holy Land' ideology at least at this point is not all pervasive; see also Farida Naqqash's review of my book in *al-Adab wa-l-naqd* (1993), 114–19 stressing the role of culture as a part of capitalism.

# Family Trees and Archival Documents
# A Case Study of Jerusalem's *Bayt* al-Dajani

## Arnold H. Green

Empiricism in historical research consists partly of cross-checking all relevant extant source materials against each other in order to reconstruct and explain a situation or episode as fully and as accurately as possible. Although some may consider it unnecessarily punctilious to verify recent generations of a family tree when neither inheritance nor title of nobility is at stake, doing so not only yields useful data but also demonstrates the empirical principle by exposing the risks of uncritically accepting a record without consulting others germane to it. This is particularly true if a) the family tree was elaborated more or less recently and essentially from memory and b) there exists ample pertinent but unconsulted documentation. Because the quantity and quality of documentation per se varies across space and through time, it is worth noting that the records of many Ottoman-era Arab societies are both numerically plentiful and richly informative, yet they have thus far been underutilized—at least for purposes of reconstituting families.[1]

This essay presents the results of cross-checking an early nineteenth-century section of the magnificent, memory-generated pedigree of Jerusalem's al-Dajani family with a corpus of contemporaneous documents from the local Islamic Court Archive. The results include the confirmation of most names and relationships and the clarification of a few others, the rediscovery of a number of perhaps forgotten male progenitors, the addition to the exclusively male family tree of as many female ancestors as can be identified in the documentary sources, and the expansion of our knowledge of the clan's socioeconomic circumstances. The latter por-

Figure 1. The Dajani family tree

tion of the essay discusses these four findings, in that order, while the first section briefly introduces *bayt* al-Dajani, its family tree, and the relevant archival documents.

## Introductory Background

Claiming descent from the Prophet Muhammad (d. 632) through al-Husayn ibn ᶜAli (d. 680),[2] Jerusalem's al-Dajani family began its more immediate history with Shaykh Ahmad Shihab al-Din (1480–1562), who in 1523 was appointed by Ottoman sultan Sulayman (r. 1521–66) steward over the traditional[3] tombs of kings David and Solomon along with two adjacent mosques. The appointment entailed control of *waqf*s (endowed lands, including four whole villages), which provided income for the buildings' maintenance and for the steward's salary, and which enabled Shaykh Ahmad al-Dajani[4] to use the complex as a sufi shrine and pilgrim hostel, *al-zāwiya al-dā'udiyya*. As the stewardships over the tombs, the *waqf*s, and the *zāwiya* became hereditary among Shaykh Ahmad's descendants, the Dajani family invested part of its income from *waqf* revenues and pilgrims' donations in agricultural land, shops, and residences (most of which they rented out). From its base in mystical institutions and endowed lands, the family thus broadened its interests to real estate and later to Islamic education; by the early eighteenth century the supervisory and financial posts over al-Madrasa al-Muzhiriyya (one of the colleges on al-Haram al-Sharif/Temple Mount)[5] had become Dajani legacies.[6] Prospering socioeconomically, *bayt* al-Dajani also grew numerically until, by the nineteenth century, it was recognized as being the largest clan in Jerusalem.[7]

However, unlike certain other notable families of Jerusalem (such as the Husayni clan),[8] *bayt* al-Dajani apparently did not possess a comprehensive, written family tree. This deficiency was rectified beginning in the late 1920s, when a project was launched to tap the memories of that generation's senior family members in order to update Shaykh Ahmad's genealogy by listing all of his male descendants. The result, in both scholarly and esthetic terms, was very impressive (Figure 1). On this larger, memory-generated record, by consulting archival documents I first identified thirty-one individuals who flourished between 1790 and 1836 and then, following the names and relationships of Figure 1, listed these on a downsized family tree that constitutes Figure 2. It bears mention here that cross-checking works both ways; establishing the relationships between the persons mentioned in the documents was greatly facilitated by referring to the family tree in Figure 1. Conversely, that record, generated recently from orally transmitted memory, can be verified, refined, and enlarged by corroborating its data with those found in contemporaneous archival documents.

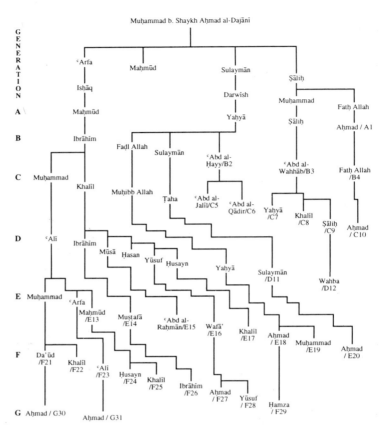

Figure 2. The Dajani family tree, 1790–1836

The most valuable written sources for this purpose are stored in large volumes in Jerusalem's Islamic Court Archive. The volumes contain *sijillāt* (records) of a variety of legal, economic, and social *taqārīr* (decisions/transactions).[9] For the period 1790–1836 I located a total of 225 *taqārīr* containing information about members of the Dajani family. To provide an idea of the documentation's nature, these *taqārīr* can be divided into two general categories, primary transactions and secondary proceedings, each of which can be subdivided per specific action.

The primary transactions include the following documentary genres: 1) *marriage contract*,[10] which typically identifies names of groom and bride (often also in terms of their fathers' names), the bride's legal status (minor or adult virgin, previously married woman), the brideprice (immediate and delayed portions), names of witnesses (often specifying relationships, if they are relatives), and date (see Figure 3 for a sample mar-

نزوج السيد ابو بكر ابن المرحوم السيد حسن السيد الدجاني بمختوبته السيدة خديجة بنت السيد خليل افندي الموقت البكر البالغ اصدقها مؤجلة سبعمائة غرشا اسدبا عملة قديمة مؤجلة لها عليه لاقرب احد الاجلين زوجها عمها السيد مصطفى افندي الموقت بشهادة وتعريف والدها والسيد نور الله الجماعي زواجا صحيحا شرعيا حرر اواخر محرم السنة ثلث واربعون ومايتين والف

Abu Bakr, son of the late Hasan al-Dajani, married his fiancée, Khadija, daughter of Khalil Afandi al-Muwaqqit. [She is] the adult virgin. He paid to her as bridal dower, [in the form of] an advanced portion, 700 lion piasters [in] traditional money. [This is] an advanced portion for her that is incumbent upon him [to pay] at the earliest of the two separations [death or divorce]. She was given in marriage by her paternal uncle, Mustafa Afandi al-Muwaqqit, with the witness and knowledge of her father and of Nur Allah al-Jama‘i. [This is] a valid, legal marriage. [This document] was recorded on the last day of [the month of] Muharram in the year 1243 [AD 1828].

Figure 3. Abu Bakr al-Dajani's marriage contract: original, Arabic transcription, English translation

riage contract); 2) *land sales contract*,[11] which identifies seller(s) and buyer(s) (relatives often functioned as agents; if so, relationships are specified), the number of shares (out of twenty-four) being sold (most property being jointly owned), whether the seller(s) acquired the property through purchase or inheritance (and, if the latter, from whom), the property's location and delimitation, the price, and the date; 3) *waqfiyya* or *waqf* deed,[12] via which a landowner constituted holdings as endowed land *(waqf)* and, if creating a "private *waqf*," specified the heirs among whom the endowment's revenues were to be distributed as inheritable yearly income; 4) *waqf audit*, whereby the Islamic Court sponsored the required annual examination of an endowment's accounts, under day-to-day control of its supervisor *(nāẓir)*, by all of its trustees *(mutawalliyyūn,* usually senior male family members); 5) *inheritance partition*,[13] whereby the Court applied the Qur'anic formula (4:11–12) to a deceased's estate, specifying each heir's relationship to the deceased; and 6) *letter of appointment*, whereby the Court formally named individuals to government and/or *waqf*-funded, often de facto hereditary posts (such as *waqf* supervisors or trustees, *imām*s of mosques, teachers at *madrasa*s, Court clerks or judges, and custodians of orphans).

The *taqārīr* representing secondary procedures usually involved legal

actions or disputes about property transactions, divisions of *waqf* revenues, partitions of inheritances, and distributions of salaried posts. Because many such disputes were intra-family, with one member or branch summoning others to court, family relationships are often clarified in these secondary *taqārīr*. The 225 specific documents, records of such primary and secondary transactions, contain considerable data about Dajani clan relationships, thereby constituting a large and valuable corpus with which to cross-check the memory-generated family tree. Excerpts from the various kinds of Islamic court records are given for selected individuals in Table 1.

## Confirming and Clarifying Relationships

On the one hand, the documents confirm most of the names and relationships as indicated on Figure 2, as translated from Figure 1. On the other hand, cross-checking revealed minor and major kinds of discrepancies. Firstly, variations in names were discovered. ᶜAbd al-Wahhab/B3 b. Salih[14] was often cited in the documents by his name's diminutive form, Wahba (for example, in 1239/1824 the Court appointed three brothers, including Yahya and Khalil, identifying them as "son of Wahba b. Shaykh Salih al-Dajani," to the trusteeship over the *waqf*s of al-Madrasa al-Muzhiriyya). By contrast, Da'ud/F21 b. Muhammad is more often called Da'udi ("Da'udi and his brother Khalil" occurs several times) or even "Muhammad Da'udi" (in 1232/1817 the marriage contract of "Nasab bt. Muhammad Da'udi" was witnessed by her father and her paternal uncle, Khalil).

Secondly and more seriously, in one case a relationship is represented differently in the documents than on the family tree. ᶜAbd al-Hayy/B2, having sons ᶜAbd al-Jalil/C5 and ᶜAbd al-Qadir/C6, is listed on the tree as the son of Yahya and the brother of Sulayman and Fadl Allah. While no document mentions ᶜAbd al-Hayy b. Yahya, several cite ᶜAbd al-Hayy b. Salih, identifying him at once as the father of ᶜAbd al-Jalil and ᶜAbd al-Qadir and as the brother of ᶜAbd al-Wahhab/B3 (for example, a *taqrīr* of 1224/1809 refers to "ᶜAbd al-Wahhab and his brother ᶜAbd al-Hayy [who are] sons of Salih," while another of 1240/1825 notes the appearance in court of "ᶜAbd al-Wahhab b. Salih al-Dajani and the sons of his brother—they are: ᶜAbd al-Qadir, ᶜAbd al-Jalil, and Hasan, the sons of the late ᶜAbd al-Hayy al-Da'udi."[15] It is conceivable that there were two men of the same name (each having a pair of sons with identical names), but it is more likely that the precise linkage of ᶜAbd al-Hayy/B2 to his immediate relations was ill-remembered and so incorrectly recorded on the family tree.

## Rediscovering Male Ancestors

While confirming most of the names and relationships on the memory-generated family tree, cross-checking it with the 225 archival documents

revealed it to be incomplete—even with respect to male ancestors—to the point that almost every numbered person listed on Figure 2 was found to have had additional sons. For example, besides Fath Allah/B4, Ahmad/A1 sired Muhammad, Abu'l-Sa ͨ ud, and Hasan;[16] besides ͨ Abd al-Jalil/C5 and ͨ Abd al-Qadir/C6, ͨ Abd al-Hayy/B2 sired Hasan;[17] besides Yahya/C7, Khalil/C8 and Salih/C9, ͨ Abd al-Wahhab/B3 sired ͨ Abd al-Wahhab/ Wahba;[18] and so on. Figures 4 and 5 show how many additional male progenitors may be added in specific instances; Sulayman/D11 engendered four sons, two grandsons, and four great-grandsons—and ͨ Ali had three sons—none of whom are mentioned on the family tree. Whereas some of these ancestors apparently died quite young, others married and produced families, including sons. For example, Hasan b. ͨ Abd al-Hayy/B2 married twice—his virgin cousin in 1225/1810, then a previously married woman in 1242/1827—and sired two sons and two daughters. However, at the time of his death in 1243/1828, Hasan's estate was partitioned among his siblings, indicating that all of his children predeceased him. This and other cases suggest that male ancestors omitted from the family tree were as a rule those whose male lines did not survive into the generation that constructed it from memory.

## Adding Female Ancestors

Perhaps the most dramatic and significant result of consulting the corpus of archival documents is that of adding to the exclusively male family tree scores of female ancestors. Marriage contracts, land sale contracts (wherein males often conducted their female relatives' economic transactions in court), and inheritance partitions in particular contain many female names while specifying family relationships. Thus a *taqrīr* of 1225/1810 recorded the marriage of Hasan b. ͨ Abd al-Hayy/B2 to his cousin, an adult virgin *(bikr bāligh)* named Dajaniyya bt. Ahmad/A1, for a brideprice of 1200 zlotis. A *taqrīr* of 1239/1824 indicates that ͨ Abd al-Wahhab/B3 b. Salih appeared in court as the legal agent for a) the children of his brother ( ͨ Abd al-Hayy), including Nafisa, and for b) Tarfanda bt. Muhammad [b. Sulayman/D11 b.] Taha; on their behalf he bought 3.2/24 shares in an estate near Damascus Gate for 500 piasters. According to a *taqrīr* of 1242/1827, when Abu'l-Sa ͨ ud b. Ahmad/A1 died, his estate was partitioned among his wife, Saliha bt. the late ͨ Abd al-Wahhab al-Dajani, his minor daughter Zaynab, and his siblings, including Dajaniyya.

The names and relationships specified in such documents permit the addition of females to nuclear families in various roles—mothers, sisters, wives, and daughters. Sometimes females can be added in each role. For example, Ahmad/E18 b. Yahya's mother was Mishayikh bt. Muhammad al-Dajani; besides his brother Muhammad he had sisters Khadija and Hasab; he married Amuna bt. Muhammad b. Sulayman/D11 al-Dajani;

Table 1. Selected documentary confirmation

| Name/no. on Fig. 2 | Exerpt of documentary language confirming identities and relationships on Figs. 1 and 2 | Kind of record | AD date |
|---|---|---|---|
| ᶜAbd al-Jalil /C5 | "ᶜAbd al-Jalil b. Shaykh ᶜAbd al-Hayy al-Da'udi married Marwa bt. Hasan Bayazid" | marriage contract | 1816 |
| Yahya /C7 | "The judge appointed Khalil, Yahya, and ᶜAbd al-Wahhab, sons of Wahba b. Shaykh Salih al-Dajani, . . . to the posts of shaykh and trustee over the *waqf*s of al-Madrasa al-Muzhiriyya" | appointment letter | 1824 |
| Sulayman /D11 | "Sulayman Taha al-Dajani, acting for his wife Ruqayya . . . , made a purchase with her money" | land sale contract | 1800 |
| Mustafa /E14 | "Shaykh Ibrahim Afandi al-Dajani, shaykh of the tomb, and his sons, Khalil and Mustafa" | *waqf* audit | 1797 |
| ᶜAbd al-Rahman /E15 | "ᶜAbd al-Rahman b. the late Musa Khalil Afandi al-Dajani married . . . Latifa bt. ᶜAbd al-Rahman al-Sulaymi al-Khalili" | marriage contract | 1811 |
| Wafa' /E16 | "There appeared in court . . . Wafa' b. Yusuf al-Dajani" | land sale contract | 1809 |
| Ahmad /E18 | "Ahmad b. the late Yahya al-Dajani, agent for his wife Amuna bt. the late Muhammad Taha, summoned [to court] Sulayman Taha al-Dajani" | inheritance litigation | 1810 |
| Muhammad /E19 | "Register of the estate of the late Ruqayya bt. Khalil ᶜAwda al-Da'udi . . . ; her estate is partitioned among: her husband, Muhammad Yahya al-Dajani" | inheritance partition | 1816 |
| Ahmad /E20 | "Register of the estate of the late Hajj Sulayman Taha al-Dajani . . . ; his inheritance is partitioned among: his wife, Ruqayya . . . ; his children: Darwish, Ahmad, Khalil, and ᶜUthman" | inheritance partition | 1819 |
| ᶜAli /F23 | "ᶜAli Afandi b. the late ᶜArfa al-Dajani . . . creates this *waqf*" | *waqf* deed | 1808 |
| Husayn /F24 | "The judge appointed . . . Khalil b. Ibrahim Turjuman [to recieve] 50 Egyptian silver pieces from *al-surra al-rumiya* [in which sinecure he] replaces the [former] beneficiaries, Hasan, Khalil and Husayn, the sons of the late Mahmud al-Dajani" | sales contract | 1821 |

Table 1 contd.

| Name/no. on Fig. 2 | Exerpt of documentary language confirming identities and relationships on Figs. 1 and 2 | Kind of record | AD date |
|---|---|---|---|
| Ahmad /F27 | "Yusuf and his full brother Ahmad, sons of the late regretted Wafa' Afandi al-Dajani . . . made a purchase with their own money from ᶜAli Afandi b. the late ᶜArfa al-Dajani" | land sale contract | 1823 |
| Yusuf /F28 | "The judge appointed . . . Ahmad and his brother, Yusuf, sons of the late Wafa' Afandi al-Dajani, [to receive] one of the 13 shares of the overseership and directorship over the *waqf*s of our Lord David and of Saint Ahmad al-Dajani" | appointment letter | 1828 |
| Ahmad /G30 | "Register of the estate of the late Da'udi Afandi b. Shaykh Muhammad ᶜAli al-Dajani . . . ; his estate is partitioned among: his wife, Sakina bt. ᶜAbd al-Salam al-ᶜAlami; and his children: the adults Ghasun and Nasab, and the minor Ahmad and his full siblings Da'udi and ᶜAlamiya" | inheritance partition | 1827 |

and his children included three sons and a daughter, Nasab. In many cases, however, mothers and/or wives could not be identified. Moreover, there no doubt existed additional sisters, wives, and daughters whose names either do not appear in the *taqārīr* or are referred to in such a way that their precise affiliation cannot yet be established. For example, a *taqrīr* of 1211/1797 recorded the marriage of Dujna bt. Muhammad al-Dajani to Ahmad al-Lutfi; but it is not clear which particular Muhammad was her father. Nevertheless, adding only those females clearly identified in the documents more than doubles the size of the family tree, as indicated in Figures 4 and 5, which append mothers, sisters, wives, and daughters to Sulayman/D11 (nine women) and ᶜAli/F23 (fourteen women).

## Socioeconomic and Cultural Circumstances

The documents give us a fuller, more accurate understanding of the Dajani family's socioeconomic circumstances, including a much clearer and more detailed picture of its revenue sources. They confirm the economic primacy of the *waqf*s supporting the tombs of kings David and Solomon and of Shaykh Ahmad al-Dajani. A *taqrīr* of 1821, while redividing the

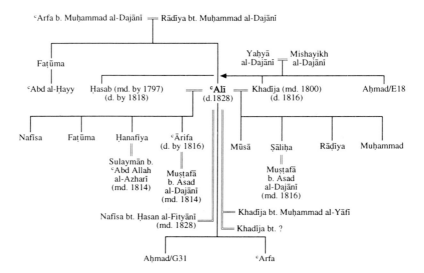

Figure 4. Relationships of Sulayman/D11 established by documents from 1790–1836

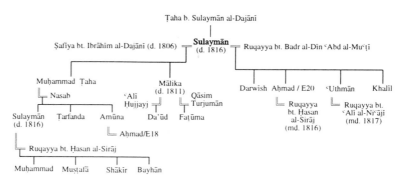

Figure 5. Relationships of ʿAli/F23 established by documents from 1790–1836

revenues into thirteen shares for the family's thirteen major branches, detailed these sources—for example, 4,000 piasters annually from the village of al-Mahdal, 3,000 piasters annually from the agricultural lands appended to that village, and similar amounts from the three other villages belonging to the endowment of David. These two endowments produced revenue in the forms of dividends and of salaries. While major salaried posts were shaykh, *nāẓir* (supervisor), and *mutawallī* (trustee), minor ones included carpet-spreader, light-kindler, and sweeper. The salaries for all the minor posts were long monopolized in one branch of the family until in 1809 ᶜAli/F23 b. ᶜArfa was summoned to court by the other twelve branches, which thereafter shared equally in the minor posts and salaries.

In addition to these primary *waqfs*, however, the Dajani family received income from several others. Among the *waqfs* mentioned in the documents are those of Taj al-Din al-Dajani, Muhammad al-Tamimi, Tamim al-Tamimi, Qasim Bey al-Turjuman (of which the revenues were shared with the Khalidi and Jaᶜuni families), Shaykh Ghunaym, Kujuk Ahmad Pasha (whose endowed lands were located mainly in Damascus),[19] Shaykh Muhammad al-ᶜAnbusi, and Shaykh Musa Jamal al-Din al-Sillat. Members of the Dajani clan also received income for serving as supervisors and trustees of several endowments that supported village mosques, for al-Madrasa al-Muzhiriyya and other facilities on al-Haram al-Sharif, and for the hostel for the aged *(al-takiyya)*.

While the majority of the family's income came directly or indirectly from *waqf* revenues, the documents reveal other sources, including agricultural lands. Land sales contracts between 1790 and 1836 demonstrate that Dajani family members continued to acquire—particularly in the hills around Jerusalem—revenue-producing gardens and vineyards: two vineyards in 1797, a set of terraced fields in 1815, the entire hill *(tall)* of Ibrahim Abu ᶜA'isha in 1816, the vineyard of Nur al-Din in 1830, the vineyards of al-Jarush and of the Bey as well as the garden of al-Bashir in 1835, and the vineyard of Rashid in 1836.

Among minor revenues were special sinecures. A pair of these—called *al-ṣurra al-rūmiyya* 'the Istanbul purse'[20] and *al-ṣurra al-miṣriyya* 'the Egyptian purse'—had been created by the Ottoman and Egyptian governments to support Islamic institutions and activities in Mecca and Jerusalem. By the nineteenth century the annual contributions from these funds had become divided among Jerusalem's notable families—the *afandiyyāt*—including *bayt* al-Dajani. Once acquired, these revenue sources could be inherited or sold; for example, in 1815 brothers Tahir and Shakir al-Dajani sold a share (worth four gold sultans and thirteen Egyptian silver pieces annually) to the *imām* of the Aqsa Mosque for 244 zlotis. Occasionally, the share in a sinecure specified a required act of devotion, a condition that applied even to women; in 1811 ᶜAlima bt. the

late Muhi al-Din al-Da'udi was appointed "reader of the word of God," replacing her brother, for the annual stipend of 600 zlotis.

An interesting variety of sinecure existed in the form of 'protection money' that Jerusalem's Christian and Jewish institutions paid for their continued safe existence. According to Amnon Cohen,[21] in the eighteenth century such payments went to the Ottoman governor. The documents of 1790–1836, however, reveal that the protection money was by then shared with the *afandiyyāt* families, which sold and inherited this income source as they did others. Referred to as "the accustomed practice" *(al-ᶜāda al-mutaᶜawwida)*, the payments took the form of cash, raw wool, cloth, raw wax, and candles. In 1817 Husayn/F24 and Khalil/F25 sold their inherited annual rights to six and one-third measures of cloth from the Roman Catholic monks and one-third measure of cloth from the Greek Orthodox monks. In 1822 the same brothers sold their annual rights to two measures of cloth from the Armenian monks. In 1825 Muhammad Da'udi/F21 sold his inherited annual rights to four measures of cloth from the Armenian cotton-sellers to Mustafa b. Khalil al-Khalidi for 400 piasters.

An important index to the Dajani clan's social circumstances can be found in its web of relationships with other families of Jerusalem, as revealed in marriage contracts and other documents. About one-third of the clan's marriages occurred on an intra-family basis—that is, Dajani men married Dajani women. In cases where Dajani men married women from outside their family, a common pattern—perhaps one-fourth of all marriages—was for them to take as wives previously married women. Because (as an additional factor) such women often did not come from prominent families, their brideprices were comparatively low; for example, in 1827 Husayn/F24 b. Mahmud married Amuna bt. ᶜAbd Allah, to whom he paid 200 zlotis (all of it as delayed portion). By contrast, contracts with previously unmarried women from *afandiyyāt* families (about one-third of the total) required rather higher brideprices; for example, in 1808 Ibrahim/F26 b. Mustafa al-Dajani married ᶜAfifa bt. Muhammad Hujjayj for a brideprice of 1500 zlotis (only 300 delayed), and in 1809 Mustafa b. Khalil al-Khalidi married Mahbuba bt. Khalil al-Dajani for a brideprice of 1200 piasters (300 delayed). Through such marriages *bayt* al-Dajani thus formed close social ties with other *afandiyyāt* families, including those of al-Jaᶜuni, al-Qutb, al-Khalidi, al-Fityani, al-Shihabi, Nusayba, al-ᶜAlami, Hujjayj, and al-Muwaqqit. If a marriage link became possible with a particularly prestigious clan, then financial considerations were subordinated to social ones; for example, when in 1834 Najib b. Mustafa al-Husayni married Khadija bt. Mustafa al-Dajani, the brideprice was only 500 piasters (all of it delayed).

## Summary and Conclusions

Cross-checking *bayt* al-Dajani's memory-generated family tree against over two hundred relevant archival documents enables us to confirm most of the names and relationships, to correct at least one major error, to recover numerous apparently forgotten male progenitors, to add scores of female ancestors, and to fill in the background of the clan's socioeconomic circumstances and activities. This exercise underscores the empirical dimension of historical research through exposing the risks of accepting a single source or set of sources without comparing it with every other piece of germane documentation available.

## Notes

1. During the early twentieth century the discipline of history moved away from its association with literature to find a place of sorts among the new social sciences. A parallel shift was that of genealogy away from a preoccupation with heraldry to become 'family history' in affiliation with demography. This shift entailed the birth of a methodology known as 'family reconstitution,' which consists of recreating family groups from records antedating the modern census. The pioneers were Michel Fleury and Louis Henry in France and then E. A. Wrigley in England; their methods have been adapted to societies with sets of records differing from those of Europe. See Louis Henry, *Anciennes familles genevoises: étude démographique, XIVe–XXe siècle* (Paris, 1956); Michel Fleury and Louis Henry, *Des régistres parroissiaux à l'histoire de la population: manuel de dépouillement et d'exploitation de l'état civil* (Paris, 1956); E. A. Wrigley, "Family Reconstitution," in *An Introduction to English Historical Demography*, ed. Peter Laslett et al. (Cambridge, 1966); James E. Smith and Phillip R. Kunz, "Family Reconstitution Used in Conjunction with Census Data," in *Selected Papers in Genealogical Research*, ed. P. R. Kunz (Provo, 1972).
2. *Ibn*, often transliterated as *b.*, means 'son of.' *Bint*, often transliterated as *bt.*, means 'daughter of.'
3. By 'traditional' is meant unconfirmed by archaeology and the earliest written sources. For example, while the 'traditional' site of the tombs of David and Solomon lies near the Dormition Abbey at the south end of what is now called Mount Zion, the Bible states that these kings were buried "in the city of David" (1 Kings 1:10, 11:43, 2 Chron. 9:31), which has been located by archaeologists on the Ophel Ridge south of Mount Moriah. See Benjamin Mazar, "Jerusalem: The Early Period and the First Temple Period," *The New Encyclopedia of Archaeological Excavations in the Holy Land* (New York, 1993), 2:698–701.
4. The *nisba*/surname is said to derive from *dajan* 'darkness,' because Shaykh Ahmad kept vigils in the dark, hitherto neglected tomb of David.
5. Michael H. Burgoyne, *Mamluk Jerusalem: An Architectural Survey* (Essex, 1987), 579–88.
6. Hasan al-Husayni, *Tarājim ahl al-quds fī-l-qarn al-thānī ʿashar* (Amman, 1985), 50–51; ʿArif al-ʿArif, *al-Mufaṣṣil fī ta'rīkh al-Quds*, 2nd ed. (Jerusalem, 1986), 255.

7   For a time, *bayt* al-Dajani published a family newsletter, called *al-Amal* 'the hope,' some of the issues of which contain historical articles—for example, "Jadd al-ᶜā'ila—man huwa," no. 4 (April 1985), 4; Shaykh Muhammad Jamal al-Din al-Dajani, "Zawiyat al-nabī Dā'ūd," no. 4 (April 1985), 5-7; Ibrahim Hasan Wafa' al-Dajani, "Nubdha ᶜan ta'rīkh al-ᶜā'ila al-dajāniyya," no. 5 (January 1986), 4–6; and "Ajdādunā," no. 5 (January 1986), 7–9.

8   Butrus Abu-Maneh, "The Husaynis: The Rise of a Notable Family in Eighteenth-Century Palestine," in *Palestine in the Late Ottoman Period*, ed. David Kushner (Leiden, 1986).

9   Jon E. Mandaville, "The Ottoman Court Records of Syria and Jordan [Palestine]," *Journal of the American Oriental Society* 86 (1966), 311–19, and "The Jerusalem Shari'a Court Records: A Supplement to the Central Ottoman Archives," in *Studies on Palestine during the Ottoman Period*, ed. M. Ma'oz (Jerusalem, 1975); Aharon Layish, "The *Sijill* of Jaffa and Nazareth *Shariᶜa* Courts as a Source for the Political and Social History of Ottoman Palestine," in *Studies on Palestine*, ed. Ma'oz; Beshara B. Doumani, "Palestinian Islamic Court Records: A Source for Socioeconomic History," *MESA Bulletin* 19:2 (December 1985), 155–72; ᶜAdel Mannaᶜ, "The *Sijill* as a Source for the Study of Palestine during the Ottoman Period, with Special Reference to the French Invasion," in *Palestine in the Late Ottoman Period*, ed.D. Kushner (Leiden, 1986). Besides Islamic court *sijillāt*, other kinds of records also exist in the Near East. See Daniel Crecelius, "Archival Sources for Demographic Studies of the Middle East," in *The Islamic Middle East, 900–1900*, ed. A. L. Udovitch (Princeton, 1981); A. H. Green, "Sources in the Arab World for Genealogy and Family History," in *World Conference on Records, August 12–15, 1980*, Series 909 (Salt Lake City, 1981), and "Family History in the Arab World: Archival History as a Complement to Ethnography," *International Journal of Sociology of the Family* 11 (July–December 1981), 327–46, and "Baptismal Registers of the Coptic Orthodox Church in Late Nineteenth-Century Jerusalem," *Genealogical Journal* 19:3–4 (1991), 123–37; and William A. Coulam, "The *Sijillāt* of Jerusalem's *Shariᶜa* Court as Sources for Islamic Family History," Senior Honors Thesis, Brigham Young University, 1994.

10  For the marriage contract as a historical documentary genre, see Louis M. Epstein, *The Jewish Marriage Contract* (New York, 1973); T. H. Weir, "Sadaka," *Shorter Encyclopedia of Islam* (Leiden, 1953), 483–84; Judith Tucker, "Marriage and Family in Nablus, 1720–1856: Toward a History of Arab Marriage," *Journal of Family History* 13 (1988), 165–79; Muhammad Bultaji, *Dirāsāt fī ᶜaqd al-zawāj* (Cairo, 1992); and A. H. Green, "A Late Nineteenth-Century Coptic Marriage Contract and the Coptic Documentary Tradition," *Le Muséon* 106:3–4 (1993), 361–71.

11  See Wilhelm Hoenerbach, "Some Notes on the Legal Language of Christian and Islamic Deeds," *Journal of the American Oriental Society* 81 (1961), 34–38; Y. Firestone, "Production and Trade in an Islamic Context: *Sharika* Contracts in the Traditional Economy of Northern Samaria, 1853–1943," *International Journal of Middle East Studies* 6 (April 1975), 185–209, and 6 (July 1975), 308–24.

12  See Mohammad Zain bin Haji Othman, "Origin of the Institution of Waqf," *Hamdard Islamicus* 6:2 (Summer 1983), 3–23; Muhammad Muhammad Amin, *al-Awqāf wa-l-ḥayāt al-ijtimāʿiyya fī Miṣr* (Cairo, 1980); Daniel Crecelius, "The *Waqfīyah* of Muhammad Bey Abu al-Dhahab," *Journal of the American Research Center in Egypt* 15 (1978), 83–105; Gabriel Baer, "Jerusalem's Families of Notables and the *Wakf* in the Early Nineteenth Century," in *Palestine in the Late Ottoman Period*, ed. D. Kushner (Leiden, 1986), 109–22.

13  See André Raymond, *Artisans et commerçants du Caire au XVIIIe siècle*, 2 vols. (Damascus, 1973–74), and "Les documents du *maḥkama* comme source pour l'histoire économique et sociale de l'Egypte au XVIIIe siècle," in *Les Arabes par leurs archives*, ed. J. Berque and D. Chevalier (Paris, 1976), 125–39; Abdul'aziz Muhammad Zaid, *The Islamic Law of Bequest* (London, 1986).

14  The '/B3' identifies this person on Figure 2.

15  In the documents, the *nisba*/surname al-Da'udi is used interchangably with al-Dajani.

16  This information was gleaned from many *taqārīr*, the most informative of which, recorded in 1243/1828, grouped several inheritance partitions into a single document after a number of deaths in a brief span—perhaps the consequence of an epidemic. With respect to males, this document [v. 312, p. 6] recorded, firstly, the death of Ahmad/A1 and the partition of his estate among his children, including sons Fath Allah, Abu'l-Saʿud, Muhammad, and Hasan; secondly, the death of Hasan; and, thirdly, the death of Abu'l-Saʿud.

17  Hasan is identified as the son of ʿAbd al-Hayy/B2 in several *taqārīr*, including his 1225/1810 marriage contract [v. 294, p. 20] and in a 1239/1824 appointment letter that awarded one of the posts held by the recently deceased ʿAbd al-Hayy/B2 to his three sons: ʿAbd al-Jalil, Hasan, and ʿAbd al-Qadir [v. 307, p. 125].

18  This son is identified, *inter alia*, in a 1239/1824 letter appointing Khalil, Yahya, and ʿAbd al-Wahhab, sons of Wahba b. Shaykh Salih al-Dajani, to succeed their father in a post [v. 307, p. 125].

19  Kujuk Ahmad Pasha was the Ottoman military commander who in 1635 defeated the Druze chieftain Fakhr al-Din Maʿn, whose lands in Damascus were seized and transformed into the *waqf* of Kujuk Ahmad Pasha. See H. A. R. Gibb and Harold Bowen, *Islamic Society and the West* (London, 1950), vol. 1, part 1, 173.

20  Gibb and Bowen mention the *ṣurra* being sent annually from Istanbul to Mecca, but not to Jerusalem. See Gibb and Bowen, *Islamic Society and the West*, vol. 1, part 1, 345.

21  Amnon Cohen, *Palestine in the Eighteenth Century: Patterns of Government and Administration* (Jerusalem, 1973), 257.

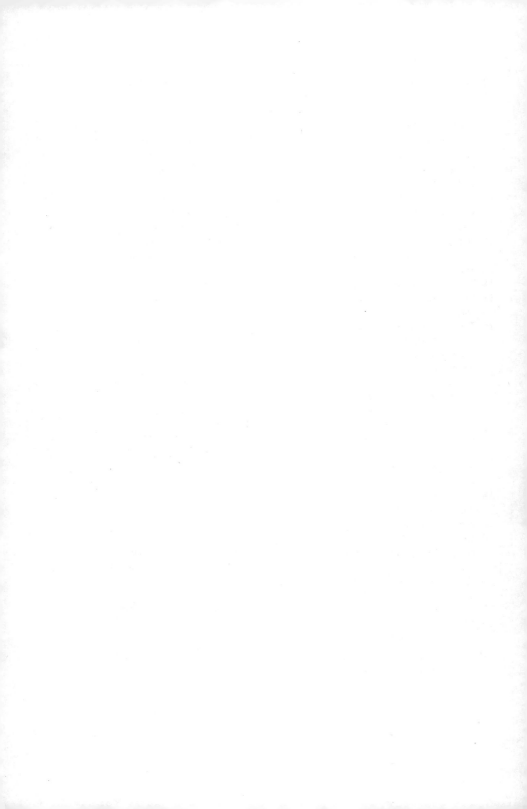

# AMIDI ON THE BASIS OF AUTHORITY OF JURISTIC OPINION

## Bernard Weiss

Throughout the jurisprudential writings of the renowned jurist–theologian Sayf al-Din al-Amidi (d. 631/1233), an important principle of legal methodology keeps emerging. The principle is usually stated as follows: *al-zann wājib al-ittibāᶜ fī-l-sharᶜ*, although wording changes slightly from occurrence to occurrence. Expressed in English, the principle states that considered opinion is authoritative in the realm of law. Considered opinion here means opinion that emerges out of *ijtihād*, and since only certain persons are qualified to engage in *ijtihād* we may understand the principle to be stating that the considered opinion of a *mujtahid* is authoritative in the realm of law. 'Authoritative' translates *wājib al-ittibāᶜ*, the more literal rendering of which would be 'must be followed, must be adhered to.' And although *sharᶜ* has a broader meaning than 'law,' I shall here let 'law' suffice as a translation.

The principle that considered opinion—opinion that emerges out of bona fide *ijtihād*—is authoritative in the realm of law is vital to the Muslim jurisprudential enterprise as envisioned by Amidi and most other Muslim jurists. It allows them frankly to acknowledge the uncertainty of much of the law without undermining its authority. One of the most fascinating aspects of Muslim jurisprudence lies in the fact that the more profoundly the legal theorists explored hermeneutical issues connected with the formulation of the law the more irresistable became the acknowledgment of the law's uncertainty. We must bear in mind that the Muslim jurists were all strict intentionalists, as well as strict voluntarists, in the case of the Sunni jurists.[1] Law was determined solely by the will of God

as expressed in texts, and therefore in seeking to interpret the texts nothing less than original intent—God's *murād*—would do. But the texts are hardly transparent conduits of the original intent. No texts are, even texts written in highly technical language. How much more is this true, therefore, of the sacred texts on which Islamic law is based, which do not employ a refined technical vocabulary of law.

The uncertainty of the law is the result of both the uncertainty of the texts themselves and the uncertainty of their meanings. Textual uncertainty is a feature of virtually all texts except the Qur'anic text. Amidi makes it clear that the authenticity of the Qur'an is indisputable and uses the principle of *tawātur* to justify this conviction,[2] as do all the jurists. But the texts of the Sunna and the texts in which expressions of the Ijma[c] are found do not for the most part enjoy the guarantee of *tawātur*. Semantic uncertainty, on the other hand, arises from problems having to do with interpretation, such as ambiguity, vagueness, generality, metaphorical versus literal meaning, express meaning versus implied meaning, and so on.

This is not the place to go into these various problems. What I am interested in is the fact that the acknowledgment of the law's uncertainty requires that, if the law is to have authority, a decisive role must be given to considered opinion. The authority of the law must, in other words, translate into the authority of considered juristic opinion. Considered opinion by definition does not transcend uncertainty, but it does reduce it by engendering the sense of the the probable *(rājiḥ)*. This sense of the probable is, however, entirely subjective: one jurist's sense of the probable may not coincide with that of another jurist. Hence the variability of the law expounded by the jurists and the existence of divergent schools of legal doctrine.

I have elsewhere distinguished two different kinds of authority in Islamic law.[3] There is, on the one hand, the authority of the foundational texts, which is absolute. This is an authority that is operative upon *mujtahid*s as they engage in the formulation of the law. And there is, on the other hand, the authority of juristic opinion, which is the subject of this essay. Since there may be a multiplicity of equally valid juristic opinions on any point of law, this authority cannot be absolute, and we must therefore describe it as a relative authority. It is operative, not in the realm of the formulation of the law, but in the realm of compliance with the law, in the realm of action, or [c]*amal*, or *ittiba*[c]. Since the *mujtahid* must obey the law as well as formulate it, this authority is operative upon him: his own considered opinion stands over his own [c]*amal* as a norm. But it is also operative upon all those who choose to be his followers in a relationship ordinarily called *taqlīd*. The authority is relative in that it bears only upon the *mujtahid* who formulates the opinion and his followers: it does not bear upon any others.

But how is the principle that considered opinion is authoritative in the realm of law to be itself justified? The justification cannot, according to Amidi's logic, be itself grounded in opinion, for this would result in circularity. And the principle cannot be regarded simply as self-constitutive, for this would result in the law's being entirely engulfed in uncertainty. Amidi wants the whole law to be grounded in some ultimate way in knowledge. He wants the law to be, in the final analysis, an object of ʿilm, and for this to be the case the principle of the authority of considered juristic opinion must be itself grounded in knowledge. If I may borrow a phrase from the title of one of Professor Rosenthal's books, Amidi wants knowledge to be triumphant—even in the murky realm of law.

Amidi makes a very revealing statement at the beginning of his great al-Iḥkam fī uṣūl al-aḥkām. This statement comes shortly after his definition of fiqh, which for him is the knowledge of al-aḥkām al-sharʿiyya, the rules of law. The important feature of this definition is the equation of fiqh with ʿilm. But how may fiqh be regarded as ʿilm, when so much of it rests upon the ẓann of mujtahids? Amidi has clearly wrestled with this question a good deal, as is evident from his important qualifying statement about fiqh, following his definition. The statement runs as follows in Arabic: al-fiqh al-ʿilm bi-aḥkām allāh aw al-ʿilm bi-l-ʿamal biha banāʾan ʿalā-l-idrāk al-qaṭʿī wa-in kanat ẓanniyyatan fī nafsiha.[4] The meaning is something like this: fiqh is the knowledge of God's aḥkām; or the knowledge, based on incontestable perception, of what constitutes (valid) conformity to these aḥkām, even though the aḥkām are in themselves a matter of opinion. What I think Amidi is saying is the following: fiqh is the knowledge of God's aḥkām, or rather—to be more precise (which is I think what aw conveys here)—it is the knowledge, based on sure grounds, of the obligation to accept as authoritative the articulations of the aḥkām by human scholars even when these articulations represent the mere opinion of these scholars. In other words, fiqh is is in the final analysis ʿilm, thanks to our certainty that the principle al-ẓann wājib al-ittibāʿ fī-l-sharʿ is true.

Thus if fiqh is to be ʿilm—if it is to be counted among the ʿulum, among those things that make a person a true ʿālim (and for Amidi and all Muslim jurists of the past this must be the case)—then the principle of the authority of considered juristic opinion must be shown through incontestable proofs to be sound. One would think that the arguments for this principle would be a matter of great urgency, but in fact Amidi does not present his arguments until he comes to the subject of qiyās, or analogy, which he discusses in a fairly late section of the Iḥkām.[5] I do not want to detain us here with a discussion of issues relating to qiyās. Suffice it to say that Amidi regards qiyās for the most part as productive of opinion, not certainty. If qiyās is to be regarded as a valid basis on which to construct the law, considered opinion must be shown to be authoritative. The prin-

ciple of the authority of juristic opinion is thus crucial to the defense of *qiyās* as a method of formulating rules.

It is, of course, not only *qiyās* that produces opinion as an optimal result. The whole enterprise of legal hermeneutics is largely opinion-engendering. We can only surmise that Amidi considered the discussion of *qiyās* to be the best context within which to present his arguments for the authority of juristic opinion because of the especially controversial nature of *qiyās* among the Muslim jurists. It is interesting that the question of the authority of juristic opinion is buried, so to speak, in discussions of *qiyās* and does not emerge on the agenda of Muslim jurisprudence as a topic in its own right. It comes up, as it were, incidentally and even casually. It is not placed 'up front' where one might expect to find it, considering the pervasiveness of the principle of juristic authority in the literature. This seems to me to be symptomatic of a salient feature of Muslim juristic writing: namely, that it was organized according to an agenda determined by dialectic, not by purely systematic considerations. The authority of juristic opinion was apparently never debated to any significant degree. It did not need to be placed 'up front.'

How, then, does one argue for the authority of juristic opinion? Amidi's answer is: through an appeal to the consensus, that is to say, the Ijma$^c$. He does not even consider other kinds of argument, such as argument from the Qur'an or the Sunna, or argument from purely rational considerations. On most great issues in Muslim jurisprudence one finds an array of different kinds of argument. Here one finds only argument from consensus. More particularly, it is to the consensus of the first generation of Muslims, the Companions, that Amidi makes his appeal. He is sure that there are countless cases where Companions of the Prophet would base their own action, or decide cases, or counsel others, on the basis of their considered opinion. He mentions some examples but insists that many others could be given. The point of his argument is that we have no record of any objection on the part of any of the Companions to this practice among their fellows. From this can be extrapolated a consensus of the Companions to the effect that *al-ẓann wājib al-ittibāc fī-l-sharc*.[6] This consensus belongs, of course, to the category of tacit consensus, *ijmāc sukūtī*, since it finds expression through absence of objection, that is to say, through silence.

The authority of considered juristic opinion thus derives from the authority of the Ijma$^c$. But has Amidi at this point successfully grounded the authority of juristic opinion in knowledge, thus making it possible to equate *fiqh* and $^c$*ilm*? When we turn to his discussion of the authority of the Ijma$^c$, we encounter a most fascinating intellectual struggle. Amidi, we have said, wants the *fiqh* to be $^c$*ilm*, but this requires, we now discover, that he ground the authority of the Ijma$^c$ in $^c$*ilm*. Only if the authority of

the Ijmaᶜ is grounded in ᶜilm can the Ijmaᶜ be itself a source of ᶜilm—a *hujja qaṭīᶜa*—such that the authority of juristic opinion will rest upon sure grounds and not dissolve in a sea of uncertainty.

But Amidi has difficulty finding a sure grounding in ᶜilm for the authority of the Ijmaᶜ. He acknowledges that this authority must be grounded either in the Qur'an or in the Sunna, since the Ijmaᶜ itself cannot be the basis of its own authority and since there are no convincing rationalist arguments. But the various Qur'anic texts that are commonly cited are inconclusive, and while the prophetic dictum "My community will not agree on an error" is somewhat more promising, along with various corroborative sayings of the Prophet, the general meaning that is to be extracted from them lends itself to diverse interpretation. The end result is that the authority of the Ijmaᶜ does not, according to Amidi, quite make it into the realm of ᶜilm. It turned out to be grounded in the end in opinion.[7]

Does this mean that Amidi's thinking about the authority of juristic opinion is marred by circularity? Is he not in the final analysis trying to base the authority of juristic opinion upon a foundation whose authority is itself based on juristic opinion? Does not the law get engulfed after all in uncertainty? To my knowledge, Amidi nowhere addresses this problem of circularity. He did not need to, since the dialectic community to which he belonged did not require him to, apparently. I would surmise that he was aware of the problem but still saw some value in grounding the authority of juristic opinion in a consensus of the most revered of all generations of Muslims, even if the existence of this consensus was a matter of opinion. Furthermore, it is significant that Amidi assesses the textual basis of the authority of consensus as giving rise to *al-ẓann al-qawī al-muqārib li-l-qaṭᶜ*,[8] opinion that is so strong as to border on absolute certainty. He also describes the texts as *aqrab al-ṭuruq fī ithbāt kawn al-ijmaᶜ ḥujjatan qaṭīᶜa*,[9] the proof that comes closest to establishing that the Ijmaᶜ is a sure authority.

Unable to ground the authority of the Ijmaᶜ in a firm foundation of knowledge, Amidi thus does the next best thing: he grounds it in opinion that is so strong as to border upon knowledge. But does this warrant considering the Ijmaᶜ to be a sure basis—*hujja qaṭīᶜa*—for the authority of juristic opinion such that *fiqh* may be equated with ᶜilm? Does the Ijmaᶜ— in this case the Ijmaᶜ of the Companions—afford us that incontestable perception *(idrāk qaṭᶜī)* on the basis of which we can know with full certainty that the *aḥkām ẓanniyya* that jurists construct are to govern our ᶜamal and be regarded as *wājib al-ittibāᶜ*? Amidi's answer seems to be a somewhat qualified yes. We can be as sure as we need to be, he seems to be saying, that the considered opinion of jurists is a sound basis for human action.

To summarize: I think that what Amidi has to say about the basis of

authority of juristic opinion fails to conceal an unresolved tension that lies at the heart of his jurisprudential thought considered as a system. It is a tension between a yearning for ʿilm—so characteristic of the intellectual community to which Amidi belonged—and a frank recognition of the indecisiveness of most hermeneutical endeavor, which also is so characteristic of the intellectual community to which Amidi belonged.

## Notes

1. On Sunni voluntarism see George F. Hourani, *Islamic Rationalism: The Ethics of ʿAbd al-Jabbar* (Oxford, 1971), 8–14. Hourani calls the voluntarist perspective "theistic subjectivism."
2. Sayf al-Din al-Amidi, *al-Iḥkām fī uṣūl al-aḥkām* (Cairo, 1917), 2:20–46; hereafter this work is cited as *Ihkam*.
3. Bernard G. Weiss, *The Search for God's Law: Islamic Jurisprudence in the Writings of Sayf al-Din al-Amidi* (Salt Lake City, 1992), 210, 252.
4. *Iḥkām*, 1:7.
5. *Iḥkām*, 3:413ff.
6. *Ibid.*
7. *Iḥkām*, 1:286–321. See my longer discussion of this passage in Weiss, *Search*, 195–210.
8. Sayf al-Din al-Amidi, *Muntaha-l-sul fī ʿilm al-uṣūl* (Cairo, n.d.), 1:51.
9. *Iḥkām*, 1:313.

# *HADĪTH ʿĪSĀ IBN HISHĀM* BY AL-MUWAYLIHI THIRTY YEARS LATER

## Roger Allen

My first acquaintances with Marsden Jones and with al-Muwaylihi's *Hadīth ʿĪsā ibn Hishām* almost exactly coincide. A frequent visitor to Oxford in the mid-1960s while I was undertaking my doctoral research, Marsden could hardly have been more helpful when I came to Cairo in 1966 in order to read my way through Dar al-Kutub's issues of the al-Muwaylihi newspaper, *Misbāh al-sharq*, then stored in the Citadel. As my researches into the pages of the newspaper revealed omitted passages and whole new chapters from al-Muwaylihi's work, he shared my enthusiasm and discussed the ramifications of what I was finding. My own concern at the time was to place al-Muwaylihi's acknowledged stylistic masterpiece into the context of early modern Arabic fiction, and, while I did insert a chapter on the *maqāma* tradition into my dissertation, its major focus was indeed on the work's status as precedent to future developments in Arabic fiction.[1] His interests were broader and more comprehensive; he was continually seeing the newly emerging features of al-Muwaylihi's original structure in a more retrospective context, the tradition of classical Arabic narrative. In the framework of this volume to honor the life and career of this great and generous scholar, I thus hope I may be allowed to look both backward and forward from *Hadīth ʿĪsā ibn Hishām*, in a revisit to the question of the work's status as a bridge between the classical tradition of Arabic belles-lettres and the emergence of a modern tradition of fiction.

The way in which the literary history of the Arabs has traditionally been organized brings with it a number of problems. In particular, the identification of a 'classical period' brought to a close by the fall of

Baghdad in 1258, and of a modern period seen as beginning (in the case of Egypt, at least) with the invasion of Napoleon in 1798, has required the creation of a thoroughly problematic 'hole-in-the-middle' period normally referred to as the 'Period of Decadence'—a term adopted into Arabic from the Western scholarly tradition. The adoption of such a schema, with its explicit assumption of a period of 'slump' before a 'renaissance,' does considerable violence to the notion of continuity within any literary tradition, as Norman Cantor has pointed out in his uniquely iconoclastic fashion in *Inventing the Middle Ages*.[2] With the classical literary tradition in Arabic, the *maqāma* appears to be a genre the very continuity of which presents itself as a clear challenge to the discontinuities that inevitably emerge from the adoption of such organizational criteria. Whatever may be the case with other literary genres (and we appear to know remarkably little about them),[3] the *maqāma* can be shown to thrive as a mode of literary expression throughout the period of six centuries (approximately the thirteenth to the nineteenth) regarding which the critical tradition has been almost universal in its unwillingness to address the esthetic issues involved, preferring instead to leap from 'classical' to 'modern' periods with a passing reference to what lies in between. From al-Hamadhani (d. 1008) to al-Hariri (d. 1122), al-Zamakhshari (d. 1143), Ibn Sayqal al-Jazari (d. 1273), al-Suyuti (d. 1505), Shihab al-Din al-Khafaji (d. 1653), and Nasif al-Yaziji (d. 1871)—and these are just a few of the more famous exponents of the genre—the *maqāma* flourished as an élite form of literature of enlightenment and entertainment in Arabic.

It is with an awareness of this generic continuity through several centuries that have been rendered problematic by our modes of analysis that the status of a work such as *Ḥadīth ᶜĪsā ibn Hishām* assumes a major significance. For when al-Muwaylihi chose in the 1890s to pen a whole series of newspaper articles on events and trends of current importance and to introduce them with the well-known phrase "ᶜIsa ibn Hisham narrated to us and said . . . ," he was not merely following the lead of a number of previous writers (including Ahmad Faris al-Shidyaq [d. 1887] in *al-Sāq ᶜalā al-sāq* with his al-Harith ibn Hammam) in beginning his pieces with the traditional opening of the *maqāma* genre, but going directly back to the apparent originator of the genre, Badīᶜ al-Zaman al-Hamadhani and making use by name of his narrator, ᶜIsa ibn Hisham, as a convenient persona through which to express his own views.

By the time that al-Muwaylihi edited his newspaper articles (originally called "Fatra min al-zaman" [A Period of Time]) and converted them into the book *Ḥadīth ᶜĪsā ibn Hishām* (1907), many Arab writers had tried their hand at novel writing. Among the first were Fransis Marrash (d. 1873), whose *Ghābat al-ḥaqq* appeared in 1865, and Salim al-Bustani (d. 1884; a son of the famous Biblical translator and encyclopedist, Butrus),

whose *Huyām fī jinān al-Shām* (Passion in Syrian gardens) was published in 1870. Salim's brother, Sa˓id (d. 1901), also published a novel in serial form on the pages of *al-Ahrām, Dhāt al-khidr* (Lady of the boudoir, 1884). The immense popularity of translated novels such as Dumas' *The Count of Monte Cristo* (an immediate favorite in every Middle Eastern language into which it was rendered) produced a demand for more examples of romantic, escapist fiction, which were often set in other historical periods and venues and which consisted of the elaborate adventures of swashbuckling heroes engaged in daring escapades and risky love affairs. The rapid expansion of the press in which such works were serialised was both a reflection of and a stimulus to a greater public awareness of the political issues that were having a major impact on the Middle Eastern region, and no more so than through European occupation. Thus, while the widespread popularity of the kind of novels that we have just described continued to play a large role in the development of a readership for fiction, and indeed while at the hands of an educationalist like Jurji Zaydan (d. 1914) the historical novel could become an instrument of incipient Arab nationalism by making its readers aware of the glorious heritage of the Arab–Islamic past, there was an immediate need for a kind of writing that would lead Arabic fiction in the more critically focused, social-reformist direction that was so much a part of the generic purpose of its Western models. It is surely one of the ironies in the development of modern Arabic fiction that two of the major steps in that direction were taken by writers who did not write novels but who preferred to couch their narratives in older frameworks. One is al-Muwaylihi himself, but before him there is the major figure of Ahmad Faris al-Shidyaq.

Al-Shidyaq's name is frequently linked with that of Nasif al-Yaziji in that both wrote works in the *maqāma* form. However, al-Yaziji's *Majma˓ al-bahrayn* (Meeting-Place of the Two Seas [a Qur'anic reference]), consists of a set of *maqāmāt* and is a genuine work of neo-classical revival, having been inspired by a reading of the *maqāmāt* of al-Hariri, one of the acknowledged masterpieces of Arabic prose literature. Al-Shidyaq's *al-Sāq ˓alā al-sāq fī-mā huwa al-Fār-Yāq* on the other hand is a prose narrative in four sections, each of which contains one *maqāma*. While these four *maqāmāt* reflect al-Shidyaq's clear delight in showing his vast knowledge of the Arabic lexicon (one is so complex that it needs its own glossary), the work is, as the title suggests, a crucial beginning to the process of fictionalizing narratives, in that the narrator—named Far-Yaq ('Far' from Faris, and 'Yaq' from Shidyaq)—is consciously autobiographical. Both Far-Yaq and his wife, Far-Yaqa, go on a journey to Europe and record their impressions of cities, universities, and people. The move of the narrator's world from the realms of fantasy and adventure to a commentary on the life of the present, not to mention the fictionalization of the

autobiographical later brought to classic heights in Taha Husayn's (d. 1973) al-Ayyām (1925; An Egyptian Childhood, 1932), represents one of the many beginnings in the lengthy process of developing an Arabic tradition of fictional writing.

Ḥadīth ᶜĪsā ibn Hishām is another major step in that same direction. While I would continue to adhere to the opinion originally stated in my 1968 dissertation that al-Muwaylihi was not trying to write a novel, and indeed did not do so, its topic and narrative strategy—not to mention its humor, not really replicated until Ibrahim al-Mazini's Ibrāhīm al-kātib (1931; Ibrahim the Writer, 1976)—nevertheless make it a major contributor to the beginning stages in the development of that genre. In A Period of Time I examine in detail the linkages between the news that was appearing on the pages of the al-Muwaylihi newspaper, Miṣbāḥ al-sharq, and the commentary on them that was to be found in the contents of the episodes of "Fatra min al-zaman"; I also note that a substantial segment of this material did not make its way into the book version of the work, Ḥadīth ᶜĪsā ibn Hishām.[4] In the sequence of episodes in which al-Muwaylihi shows a delight in highly ornate language—sajᶜ used at the beginning of each episode, followed by a polished prose style—he uses his (and al-Hamadhani's) narrator, ᶜIsa ibn Hisham, as a guide for a critical examination of Cairo in the 1890s. The disjointed nature of the 'plot,' so clear from a reading of the book version of al-Muwaylihi's work, is confirmed by the publication history of the episodes. The first 'sub-plot,' as it were, in which the pasha is taken through the labyrinthine processes of Egyptian law, whereby English colonial officials are supervising an Egyptian system of law based on French models (a topic that al-Hakim would later use to good effect in Yawmiyyāt nā'ib fī-l-aryāf [1937; The Maze of Justice, 1947]), has a splendid cohesion and sense of continuity to it, reflecting the talent for detailed description and dark humor of an author who was thoroughly acquainted with both the system and its denizens. The portraits of the westernised public attorneys, of the entryway to the sharīᶜa court, and of the administrative 'system' of the Public Records Office (daftarkhāna) show the bridge qualities of al-Muwaylihi's work to the full: couched in the verbal brilliance of sajᶜ, they are nevertheless superb portraits of contemporary Egyptians in real-life situations and at the same time a devastating criticism of the institutions that lie behind them. Once the pasha has been all the way through the system of courts and appeals and has obtained a pardon, the continuity of the narrative falls apart; hardly surprising in view of the fact that al-Muwaylihi published no further episodes for some time, while his father, Ibrahim (d. 1906), published a series of episodes of his own, entitled Ḥadīth Mūsā ibn ᶜIṣām. The narrative begins to replicate the features of a continuous narrative again when the most famous 'characters' in the book make their

appearance: the rustic ʿumda (a figure who is to be utilized by a large number of modern littérateurs, not least Najib al-Rihani with his famous ʿumda character, Kishkish Bey) and his two shifty companions, a khalīʿ (which I translate as 'playboy') and a merchant. Placing this trio into a whole series of Cairene scenarios, al-Muwaylihi not only indulges in an almost farcical humor of manners and fads, but manages to use the interplay between these three characters and the appalled reactions of those observing them to pass telling comment on the cultural confrontation that was taking place in Egypt at the turn of the century. The ʿumda, his purse full of the profits of his own greed and corruption, is no match whatsoever for the pseudo-sophisticated tastes and whims of his two companions, and he is tricked and bamboozled at every turn. This encounter between the Egyptian provinces and the rapidly changing capital city is a one-sided contest: money is lost, and cultural norms are flouted. Al-Muwaylihi's criticism of his country's current state and recent history is telling.

Looking forward from 1902 (when the episodes of "Fatra min al-zaman" were completed) we can see that al-Muwaylihi's work had some immediate effects. In the first place, his colleague Hafiz Ibrahim (d. 1932) published Layālī saṭīḥ (1906), a work very similar to that of al-Muwaylihi in its style, structure, and socio-critical purpose, and much influenced by the success of "Fatra min al-zaman," and incidentally one whose publication date of 1906 (that is, one year before that of Ḥadīth ʿĪsā ibn Hishām in 1907) is merely an accident of publication history, especially since Hafiz Ibrahim includes part of a chapter from al-Muwaylihi's work in his own. Layālī saṭīḥ lays particular stress on the events in Sudan, something that had also been part of al-Muwaylihi's original set of newspaper articles but which he omitted from the book version. The year 1907 also sees the publication of another piece of critical 'fiction,' Mahmud Tahir Haqqi's ʿAdhrāʾ Dinshawāy (The Maiden of Dinshaway, 1986), an account of the infamous episode in which some Egyptian villagers were sentenced to death after a confrontation with British army officers on a pigeon shoot. We are not dealing here with an enduring contribution to Arabic fiction, but the historical interest of the work lies in the way in which narrative is being adopted and further developed as a means of addressing societal issues of the present day.

And then there is Muhammad Husayn Haykal's renowned novel, Zaynab, composed in France in about 1911 and published in Egypt under the pseudonym 'Misri Fallah' in 1913. I must confess that this novel seems to me to have been given an unfair burden to carry, that of being 'the first real Arabic novel' or some other variant on the notion of 'first-ness.' While I would continue to insist that al-Muwaylihi's work is not in itself a novel (in spite of attempts by several critics to suggest that it is), the above listing of pioneers in the genre would appear to suggest that any

such designation of *Zaynab* needs a greater specificity to have any critical value. Those commentators who have attempted such a specification of *Zaynab*'s novelistic qualities have suggested that its pioneer status comes from the placement of Egyptian characters into an authentic setting. Here two questions arise: firstly, quite how far are either the characters or the setting of *Zaynab*, with its romanticized and nostalgic vision of the Egyptian countryside and its inhabitants, in any way 'authentic'?; and secondly, is not the picture of Egyptian society provided in *Ḥadīth ᶜĪsā ibn Hishām* of a much higher degree of accuracy and indeed of criticism? I am somewhat playing the role of 'devil's advocate' here, in that my goal is by no means to downplay the significance of Haykal's achievement. However, I do feel that the role of *Zaynab* in the development of modern Arabic fiction can be seen in a much clearer light if it is freed of the burden of being a 'first' in any particular category. Perhaps nothing illustrates this point quite so well as the significant temporal gap that separates *Zaynab* from the 1930s, when a number of Egypt's most illustrious littérateurs, many of them influenced by the ironic charm of Taha Husayn's *al-Ayyām*, commence the process whereby the novel can begin to fulfill its generic purpose as a critical commentator on society and the processes of change. Viewed within such an enlarged time-frame, *Zaynab* continues to occupy an important place. One might begin by noting that its principal theme, the status of women in society, is to become a major focus of Arabic fiction. Like the Pamelas, Clarissas, Amelias, and Fannies of English fiction, *Zaynab* lends a female name to a pioneer work of fiction, and by that very choice Haykal takes a considerable step forward from al-Muwaylihi whose only female character of any significance is a notorious dancer–prostitute with whom the ᶜ*umda* becomes heavily involved. Thus, while al-Muwaylihi's work may reflect the status quo regarding women's role at the turn of the century, his work does not mirror the views of his contemporary and colleague in Muhammad ᶜAbduh's entourage, Qasim Amin (d. 1907), whose views on the liberation of women are clearly reflected in Haykal's novel. A second realm within which Haykal moves the development of fiction forward is that of language and style. As we noted above, the important contributions of al-Shidyaq and al-Muwaylihi were both composed in a highly elaborate prose style. Numerous writers had meanwhile been making use of the medium of the press to find a new, simplified level of discourse in which the genres of fiction could be couched; among them we would mention ᶜAbdallah Nadim (d. 1896), Yaᶜqub Sannuᶜ (d. 1912), Mustafa Lutfi al-Manfaluti (d. 1924), and Jubran Khalil Jubran (d. 1931).[5] While Haykal's style and his predilection for description retains some of the image-laden properties of earlier discourse, the style of his narrative also reflects this search for a less elaborate vehicle for fictional expression. Furthermore, he takes a particularly

bold step in couching the albeit limited amount of dialogue that the novel contains in a written form of the colloquial dialect, a controversial topic that continues to preoccupy the community of Arabic fiction. The way in which Haykal used these features and others in *Zaynab* to address the problems of novel-writing and the issues of his day do indeed make it an important milestone in the development of the Arabic novel. The amount of critical attention that it has received and the number of works in other regions of the Arab world that emulate it serve as confirmations of its status. Even if it is not a 'first,' that does not diminish its pivotal role in pointing the way that 'the generation of the thirties' was to follow.

At the end of the 1930s, the young Naguib Mahfouz (b. 1911) published his first novel, <sup>c</sup>*Abath al-aqdār*, ironically (in this context) the first of three historical novels. Before long, however, and perhaps under the influence of the terrible hardships endured by Egyptian society during the Second World War, he turned his attention to the intrigues, corruption, and miseries of the present. With him, the Arabic novel in Egypt discovered a master craftsman who could bring its generic purpose to complete fruition.

In 1927, al-Muwaylihi's *Ḥadīth <sup>c</sup>Īsā ibn Hishām* suffered the ultimate fate of any great work of literature: it became a school textbook, thus prejudicing for many Egyptians any unjaundiced view of its value (as I can vouch regarding my opinion of several plays of Shakespeare!). Several of the more critical passages—on the shaykhs of al-Azhar, on the princes of the royal family, and on Muhammad <sup>c</sup>Ali's court conduct—were omitted, thus moving the text still further away from the focus and tone of the original episodes. In the same school edition (the fourth), one of al-Muwaylihi's other plans was finally implemented: the episodes of "Fatra min al-zaman" describing his visit to Paris to see the 1899 Paris exhibition were included under the title "al-Rihla al-thaniyya" (The second journey). The addition of this theme thus takes *Ḥadīth <sup>c</sup>Īsā ibn Hishām* both back to the pioneer travel works of al-Tahtawi (d. 1873) and al-Shidyaq and forward to the fiction of Yahya Haqqi (d. 1993), Suhayl Idris (b. 1923), Shakib al-Jabiri (b. 1912), al-Tayyib Ṣalih (b. 1929), and <sup>c</sup>Abd al-Rahman Munif (b. 1933). As I suggested in 1968, *Ḥadīth <sup>c</sup>Īsā ibn Hishām* is indeed a crucial bridge between classical Arabic narrative and the tradition of modern fiction. Developments in creative writing and criticism since then—not least, the use by contemporary fiction writers of classical narrative genres as a modernist gesture—only serve to emphasize the work's significance in the development of a tradition of modern Arabic fiction.

## Notes

1   Originally presented at Oxford in 1968, it was first published on microfiche by SUNY Press, Albany, in 1974. It is now available in a second edition as *A Period of Time*, St. Antony's Middle East Monographs 27 (Reading, 1992).

2  Norman Cantor, *Inventing the Middle Ages* (New York, 1991).
3  At this point it is as well that I confess that I am one of the two editors of the volume in the *Cambridge History of Arabic Literature* series that is to be devoted to the 'hole-in-the-middle' period (which we have now dubbed the 'post-classical period'), something that makes me particularly sensitive to these issues at the moment.
4  Full details of these omissions are provided in Roger Allen, "Ḥadīth ʿĪsā ibn Hishām: The Excluded Materials," *Die Welt des Islams* 12(1969):74–89, 163–81; and "The Unpublished Ḥadīth ʿĪsā ibn Hishām or Some New al-Muwaylihi Materials," *Humaniora Islamica* 2(1974):139–80.
5  For a discussion of the role of these writers, see Sabry Hafez, *The Genesis of Arabic Narrative Discourse* (London, 1993).

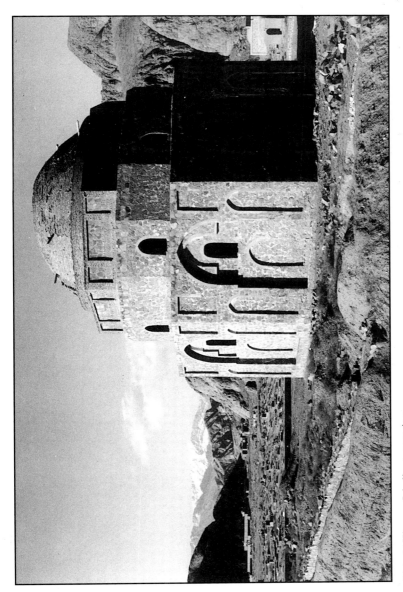

Plate 1. Kirman, Jabaliyya, exterior

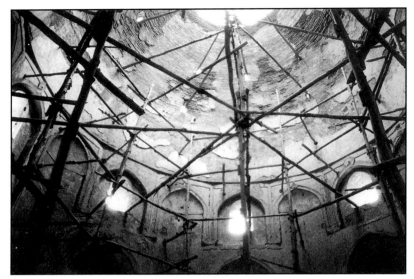

Plate 2. Kirman, Jabaliyya, interior

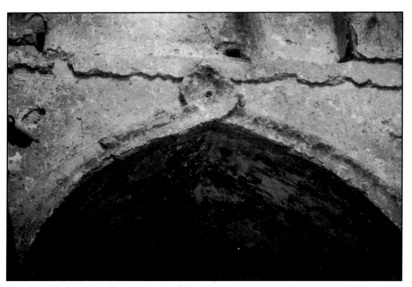

Plate 3. Kirman, Jabaliyya, detail of interior

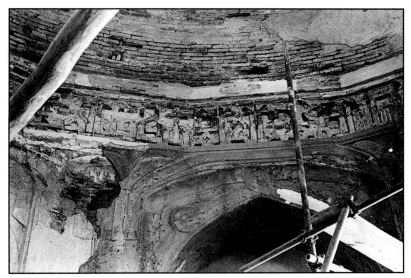

Plate 4. Natanz, Friday Mosque, *qibla* dome-chamber, detail of interior

Plate 5. Natanz, Friday Mosque, *qibla* dome-chamber, detail of interior

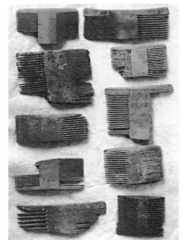

Plate 1

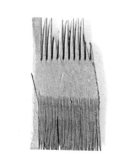

Plate 2

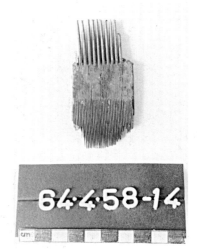

Plate 3

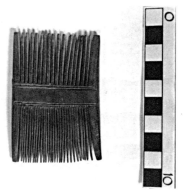

Plate 4

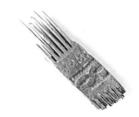

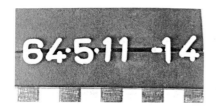

Plate 5

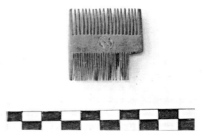

Plate 6

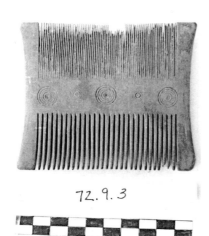

Plate 7

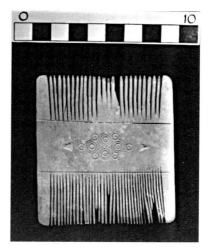

Plate 8

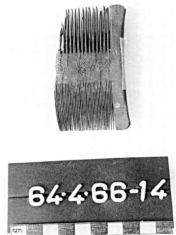

Plate 9

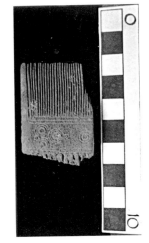

Plate 10

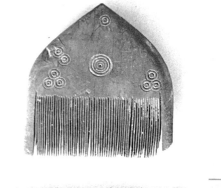

Plate 11

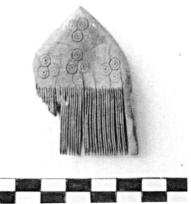

Plate 12

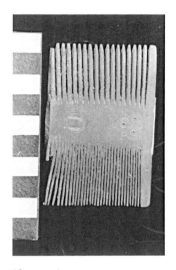

Plate 13

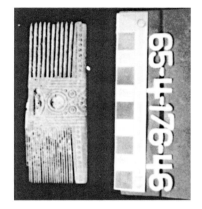

Plate 14

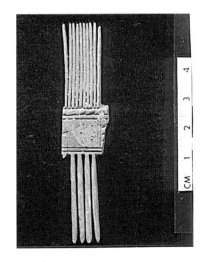

Plate 15

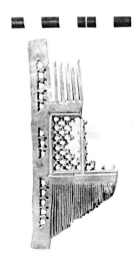

Plate 16

Plate 17

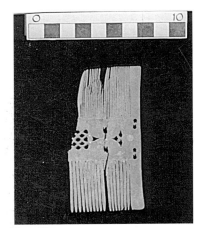

Plate 18

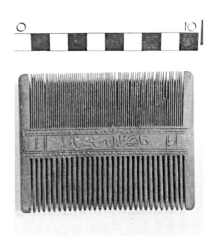

Plate 19

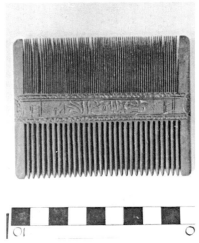

Plate 20

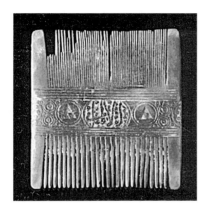
Plate 21

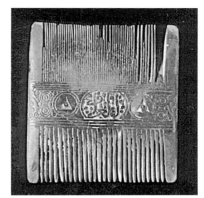
Plate 22

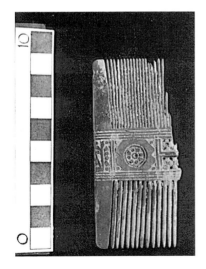
Plate 23

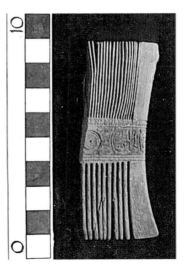
Plate 24

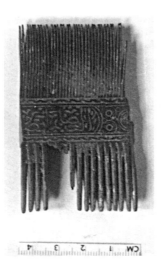

Plate 25

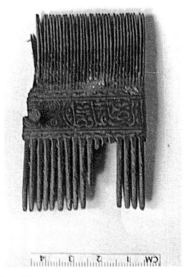

Plate 26

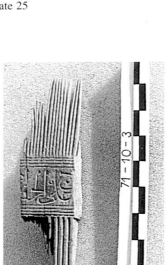

Plate 27

Plate 28

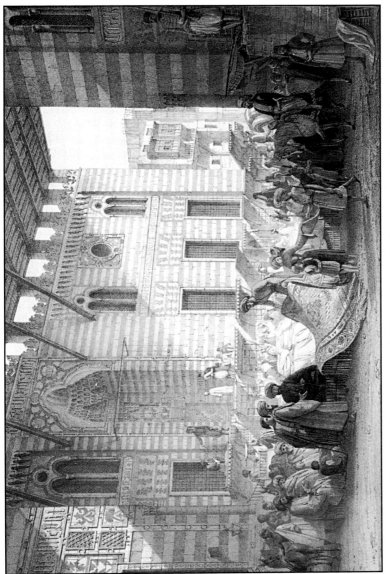

Figure 1. Robert Hay, *The Gooreeyeh*, pl. 4, *Illustrations of Cairo*, drawing by O. B. Carter.

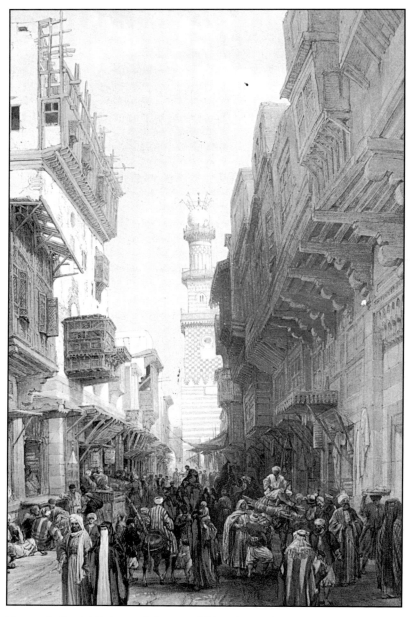

Figure 2. David Roberts, *Mosque el Mooristan*, pl. 110, *Egypt & Nubia*.

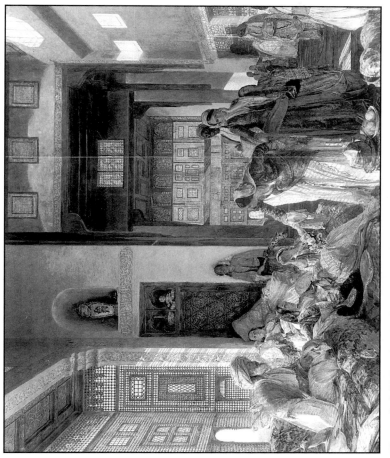

Figure 3. J. F. Lewis, *An Intercepted Correspondence.*

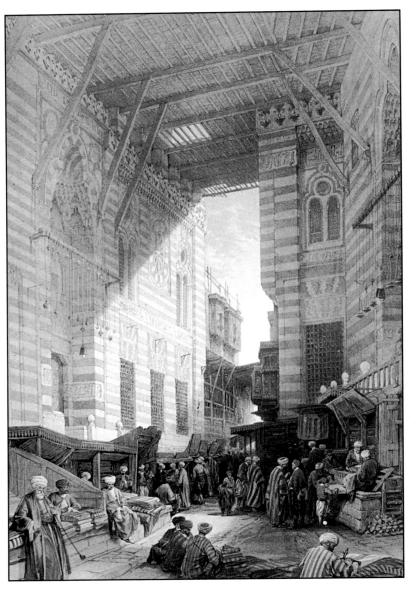

Figure 4. David Roberts, *Bazaar of the Silk Mercers*, pl. 96, *Egypt & Nubia*.

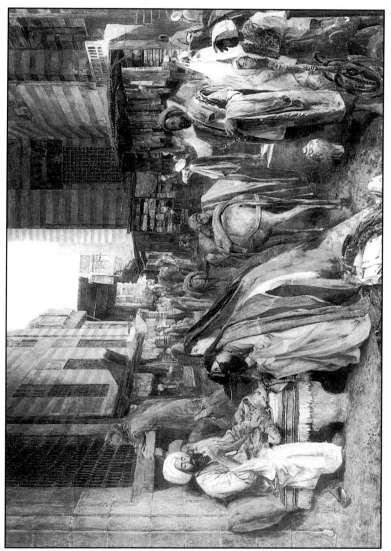

Figure 5. J. F. Lewis, *The Street and Mosque of the Ghooreyah*

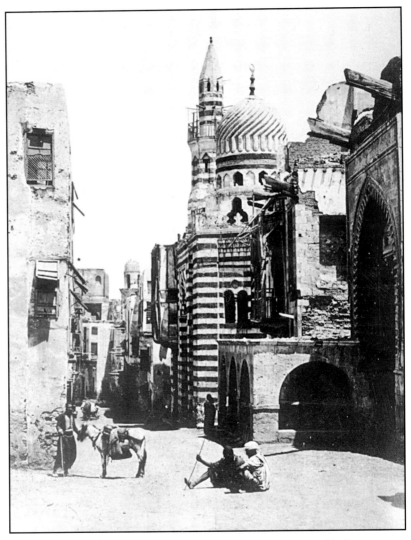

Figure 6. Francis Frith, *Street in Cairo* (Darb al-Ahmar with the mosque of Aytmish al-Bagazi), from *Egypt, Sinai & Palestine, Supplementary Volume* (London, 1862).

Motion of the Eighth Sphere'," *Proceedings of the American Philosophical Society*, 106 (1962) 264-299, esp. p. 274f.

28 – انظـر: G. Saliba, "Early Arabic Critique of Ptolemaic Cosmology: A Ninth-Century Text on the Motion of the Celestial Spheres", *Journal for the History of Astronomy*, 1994 (Forthcoming).

29 – انظر المقال الذى صدر مؤخرا: G. Saliba, "A Sixteenth-Century Arabic Critique of Ptolemaic Astronomy: The Work of Shams al-Din al-Khafri", *Journal for the History of Astronomy*, vol. 25 (1994), pp. 15-38.

30 – انظر هامش 25.

31 – لقد ورد ذكر كتاب بهذا العنوان لفلكي أندلسي عاش خلال القرن الحادي عشر الميلادي، ضمن كتاب آخر له مازال محفوظاً ضمن مجموعة مخطوطات الجامعة العثمانية في مدينة حيدر آباد (الدكن).

32- هذا الكتاب للرازي لم ينشر بعد، ولكنه أخضع لدراسة أولية ضمن كتاب مهدي محقق : فيلسوف ري، طهران، 1974، ص. 291 – 345.

14 – d'Abu'lwéfa Albuzdjani," *Journal Asiatique*, ser. viii, vol. 19, (1892) , pp. 408-471; Gazali, Félix Alcan, Paris, 1902.

14 – E.S. Kennedy, "Survey of Islamic Astronomical Tables," *Transactions of the American Philosophical Society*, new series, 46.2 (1956) pp. 123-177.

15 – مخطوط بودلي رقم .Seld A. inf. 30

16 – O.Neugebauer, *The Exact Sciences in Antiquity*, second edition, Brown University, 1957.

17 – Bernard Carra de Vaux, "Les spheres celestes selon Nasir-Eddin At-tusi," in P. Tannery, *Recherches sur l'Histoire de l'astronomie ancienne*, Paris, Gauthier-Villars et fils, 1893, pp.337-361.

18 – Neugebauer, *Exact Sciences ...*، المذكور سابقاً ، ص. 203 – 204.

19 – انظر V. Roberts, "The Solar and Lunar Theory of Ibn al-Shatir: A precopernican Copernican Model, " *Isis* 48 (1957), pp. 428-432.

20 – لقد جمعت هذه المقالات لا حقاً في كتيب صغير تحت عنوان : ابن الشاطر : فلكي عربي من القرن الثامن الهجري/الرابع عشر الميلادي ، معهد التراث العلمي العربي، جامعة حلب، 1976.

21 – انظر V. Roberts, "The Planetary Theory of Ibn al-Shatir: Latitudes of the Planets, *Isis*, 57 (1966) , pp. 208-219, esp. 210. وكرس استخدام هذا التعبير كنيدي عينه في مقاله الشهير "Late Medieval Planetary Theories," *Isis*, 57 (1966), pp. 365-378, esp. p. 365.

22 – حقق هذا الكتاب كل من نبيل الشهابي وعبد الحميد صبره ، وتم نشره في دار الكتب ، القاهرة ، سنة 1971.

23 – انظر N. Swerdlow, "The Derivation and First Draft of Copernicus' Planetary Theory: A Translation of the Commentariolus with Commentary". *Proceedings of the American Philosophical Society* 117 (1973) 423-512.

24 – تاريخ علم الفلك العربي : مؤيد الدين العرضي المتوفي سنة 664 هـ 1266 م «كتاب الهيئة» تحقيق وتقديم جورج صليبا ، مركز دراسات الوحدة العربية ، سنة 1990.

25 – لقد تعرضت لبحث هذه النقطة بالذات في مقدمة كتابي الأخير *A History of Arabic Astronomy : Planetary Theories During the Golden Age of Islam*, NYU Press, 1994, pp. 13f.

26 – المصدر السابق.

27 – O. Neugebauer, "Thabit ben Qurra, 'On the Solar Year' and 'On the

٢ – انــظـــر H. Suter, *Die Mathematiker und Astronomen der Araber und ihre* Werke, Abhandlungen zur Geschichte der mathematischen Wissenschaften mit Einschluss ihrer Anwendungen. X. Heft, Leipzig 1900.

٣ – انـظـــر C . Brockelmann, *Geschichte der Arabischen Literatur*, Verlag von Emil, Felber, Weimar, I. Bd, 1898 - Suplementband III, Leiden: E.J. Brill, 1939.

٤ – – H. Suter, "Die Astronomischen Tafeln des Muhammad Ibn Musa al-Khwarizmi in der bearbeitung des Maslama Ibn Ahmed al-Madjriti," *Mémoires de l'Académie Royale des sciences et des lettres de Danemark*, Copenhague, 1914.

٥ – – O. Neugebauer, "The Astronomical Tables of al-Khwarizmi", *Historisk-filosofiske Skrifter udgivet af Det Konglige Danske Videnskabernes Selskab*, Bind 4, nr. 2, Copenhagen, 1962.

٦ – C.A. Nallino, *Al-Battani sive Albatenii Opus Astonomicum*, Vol. I-III, Publ. Osservatorio di Brera, 40, Milano, 1899-1907.

٧ – كرلو نلينو ، علم الفلك : تاريخه عند العرب فى القرون الوسطى ، روما، ١٩١١.

٨ – الإشارة هنا إلــى كتابه الشــهيــر المتعــدد الأجزاء *Introduction to the History of Science*, Carnegie Institution of Washington, 3 volumes in five, 1927-1948.

٩ – F. Sezgin, *Geschichte des arabischen Schrifttums*, Leiden, E.J Brill, 9 volumes, 1967 - 1984.

١٠ – J. Golius, *Muhammedis fil. Ketiri Ferganensis qui vulgo Alfraganus dicitur Elementa Astronomica, arabice et latine*, Amsterdam, 1669.

١١ – وهما الأب والابـن ، وقد كان لهـما اليـد الطولى فى تاريخ علم الفلك العـربى فى فرنســا خلال القرن الفائت . انظر مــثلا L. - Am. Sédillot, *Matériaux pour servir á l'histoire comparée des sciences mathématiqués chez les Grecs et chez les Orientaux*,· Paris, 1845; L.P.E.A. Sédillot, *Prolégoménes des Tables Astronomiques d'Ouloug-Beg*, Paris, 1853; J.J. Sédillot et L.A. Sédillot, *Traité des intruments astronomiques des Arabes composé au treizième siècle par Aboul Hassan Ali du Maroc*, vol. 1-2, Paris 1834-1835.

١٢ – انظر اللائحة الكاملة لمؤلفـات هذا المستشرق الهام التي نشرها هـــ . جـــ . ســيـمان في مجلة إيزيس الأمريكية عدد ١٤، سنة ١٩٣٠، صفحة ١٦٦ – ١٨٦.

١٣ – انظر مــثـــلا Bernard Carra de Vaux, "Les spheres celestes selon Nasir-Eddin Attusi" in P. Tannery, *Recherches sur l'Histoire de l'astronomie ancienne*, Paris, Gauthier-Villars fils, 1893, pp. 337-361; "l'Almageste

كذلك تبين أن هذه الشكوك وهذه الانتقادات، التي كانت توجه إلى جوهر الفلك اليوناني، أدت بالتالي إلى إحداث ثورة فعلية نتج عنها محاولات عدة لإعادة صياغة علم الفلك على قواعد لا تشوبها الشوائب التي كانت تلم بعلم الفلك اليوناني. هذه الثورة هي التي اكتشفت معالمها في أواخر العقد السادس من هذا القرن ومازالت الأبحاث جارية في تبيين معالمها الكاملة. وهذه الثورة أيضاً هي التي مدت كوبرنيك على مايبدو بكافة النظريات الرياضية التى تم استخدامها في ثورته هو، والتي قام بها هو للغاية نفسها، ألا وهي محاولة تخليص علم الفلك اليوناني من الشوائب التي كانت تعتريه.

إن هذه الثورة التي تضمنها علم الفلك العربي كانت تحدث في إطار كتب الهيئة التي لم تتعرض إطلاقاً لا للتنجيم ولا إلى علم أحكام النجوم. فقد حصل إذن ضمن علم الفلك العربي انفصام جذري بين علم النجوم الرياضي الذي تضمنته كتب الهيئة وماشابهها وعلم النجوم الإحكامي الذي ذمه الشرع وتحاشاه العلماء.

وفي هذا الإطار تفيدنا المصادر المتعددة الآن أن الذين كانوا يهتمون بعلم الفلك الرياضي كانوا هم في نفس الوقت إما من رجال الدين أو من الذين لم يتعاطوا صناعة التنجيم، أو من الموقتين في الجوامع كما رأينا في حال ابن الشاطر الموقت وغيره ممن لم يتسن لنا ذكرهم.

أضف إلى ذلك أن هذه الثورة بلغت أوجها على مايبدو في الفترة اللاحقة لثورة الغزالي الأخرى على الفلسفة اليونانية. فالابحاث الجارية أرخت لها حتى القرن السادس عشر الميلادي ومازلنا في أول الطريق. فهل كانت هذه الثورة على علم الفلك اليوناني جزءاً مكملاً لثورة الغزالي أم كانت مستقلة عنها؟ وإذا كان علم الهيئة هذا مباحاً لرجال الدين إذ هم الذين يشجعونه أو الذين يقومون به، فلا يخفى ما لذلك من أهمية في تقرير قضية علاقة الدين بالعلم، وما إذا كانت العلاقة التي عرفتها الحضارة الغربية خلال عصر النهضة يصح تعميمها على الحضارات الأخرى أم لا.

كل ذلك يعيدنا إلى البدء، وإلى القول بأن تاريخ علم الفلك العربي لم يكتب بعد وأنه لن يكتب بشكل صحيح يعيد له القيمة الحضارية الذاتية، بعيداً عما إذا كان لهذا العلم تأثير على كوبرنيك أو غيره، ما لم يقم بكتابة هذا التاريخ أبناء هذه الحضارة أنفسهم، تماماً كما فعل الأوربيون في كتابة تاريخهم. أملي أن تكون الأبحاث الجارية الآن هي التي ستمهد الطريق لكتابة تاريخ هذا العلم العريق.

## الهوامش

١ - أبو حامد الغزالي، إحياء علوم الدين، المكتبة التجارية، الجزء الأول، ص . ٢٩.

بالدرجة الأولى.

من الناحية الثانية، لقد تابعت أيضاً عملية إحصاء المصادر التي تم فيها انتقاد الفلك اليوناني، لكي نتعرف على المدى التاريخي والفكري الذي بلغته هذه الانتقادات. وفي مقالات عدة ظهر معظمها خلال السنوات العشر الفائتة في مجلات متفرقة تمكنت من إثبات استمرارية هذا التراث الثوري في علم الفلك العربي حتى القرن السادس عشر الميلادي على الأقل.(٢٩) ولقد جمعت مؤخرا المقالات التي تشمل استعراض هذا المنحى الجديد لعلم الفلك فيما بين القرنين الحادي عشر والخامس عشر في الكتيب الذي ذكرته سابقاً والذي ظهر منذ ثلاثة أشهر تقريباً عن دار جامعة نيويورك للنشر.(٣٠)

## الخلاصة

دعوني أخلص الآن إلى رسم الصورة التي تحصلت لدينا حتى اليوم، وإلى الاتجاهات التي يمكن أن تتخذها الأبحاث المقبلة. لقد أصبح واضحاً أن علم الفلك اليوناني الذي عُرِّب خلال القرن التاسع الميلادي كان يتعرض منذ البداية إلى التمحيص، والانتقاد، وإعادة الصياغة، في نفس الوقت الذي كان يترجم فيه. السؤال الذي يطرح نفسه الآن، والذي يجب أن نجيب عنه في الأبحاث المقبلة، هو لماذا كان يحدث ذلك، ومن هم الفلكيون العرب الأكفاء الذين كانوا على مقدرة كافية لإثارة هذه التساؤلات حول الفلك اليوناني، وأين صار تدريبهم، ومن أين أتوا؟ الأجوبة القديمة التي ما زالت تتردد عن اشتراك الفرس والسريان في هذه الأعمال ليست كافية، لأننا نعرف كفاية عن مخلفات الفرس والسريان السابقة لهذه الفترة والمتزامنة معها، وكلها لا تفيد بأن مثل هذه الأعمال كان يمكن أن تتم بواسطتهم.

ولقد تبين أيضا أن الأعمال الفلكية العربية التي كان يجري فيها هذا النقاش وهذا الاعتراض على الفلك اليوناني كانت تكتب ضمن علم جديد تم تكوينه في هذه الفترة بالذات، ألا وهو علم الهيئة، الذي لا نعرف له مقابلا في علم الفلك اليوناني. وما نعرفه هو أن علم الهيئة هذا جاء على الأرجح نتيجة لدمج كتابين من كتب بطلميوس، ألا وهما كتاب المجسطي وكتاب اقتصاص أحوال الكواكب، في التيار الفكري العربي. ونتيجة لهذا الدمج بدأت الأسئلة تطرح وبدأ يبدو النقص النظري في علم الفلك اليوناني. كل ذلك أدى إلى نشأة تراث الشكوك الذي كان كتاب ابن الهيثم المذكور خير تعبير عنه. ولم يكن ابن الهيثم وحده قد اهتم بهذه الشكوك، إذ أصبحنا نعرف أيضاً أن أناساً آخرين أثاروا شكوكاً مشابهة لشكوك ابن الهيثم سمى بعضها استدراكاً على بطلميوس على سبيل المثال.(٣١) ولا كان علم الفلك ينفرد بشكوكه على التراث اليوناني. فهذا أبو بكر الرازي يثير شكوكه في علم الطب والفلسفة في كتابه «الشكوك على جالينوس».(٣٢)

وغيرها. كل ذلك من المقادير الأساسية في علم الفلك تضمنها الفلك اليوناني خطأً، وعاد علماء الفلك العرب ليصححوها.

ولكن نتيجة للاهتمام الجديد بالنواحي النظرية بدأت الأبحاث الجارية الآن تبين لنا أن هذه الأعمال الرصدية المبكرة كانت تتزامن مع التساؤلات النظرية التي كان علماء الفلك العرب قد بدأوا يثيرونها حول علم الفلك اليوناني. فقد تبين مثلاً أن علماء القرن التاسع الميلادي لم يكتفوا بإصلاح مقدار حركة أوج الشمس بل تعدوا ذلك إلى السؤال عن سبب الخطأ الذي وقع فيه بطلميوس في الدرجة الأولى. نشير هامشياً هنا إلى أن أوج الشمس ثابت غير متحرك عند بطلميوس، وأن العلماء العرب كانوا أول من أكتشف حركته. وبعد تساؤلهم عن سبب الخطأ الذي وقع فيه بطلميوس توصلوا إلى ابتداع طريقة رصدية جديدة أشاروا إليها باسم طريقة الفصول.(٢٧) وباستخدام هذه الطريقة الجديدة تم لهم تصحيح مقدار خروج مركز فلك الشمس، ومقدار تعديلها الأقصى بالإضافة إلى إثبات حركة أوجها. كل ذلك كان يحدث على ما يظهر خلال النصف الأول من القرن التاسع الميلادي الذي كنا نزعم أن العمل فيه كان محصوراً بترجمة التراث اليوناني إلى العربية. وزيادة على ذلك فقد بينت مؤخراً أن محمد بن موسى بن شاكر، الذي كان يعرف بالمنجم، وهو غير محمد بن موسى الخوارزمي الذي ذكرناه سابقاً، والذي توفي سنة ثماني مائة وثلاث وسبعين للميلاد، لم يكن يعترض فقط على النواحي الرصدية اليونانية وعلى طرق الرصد، بل كان يتعدى ذلك ليعترض على القواعد الفلسفية التي كان الفلك اليوناني يعتمد عليها. ففي رسالته التي سوف تنشر قريباً في مجلة «تاريخ علم الفلك»(٢٨) الصادرة في انكلترا يقول محمد بن موسى أن بطلميوس قد أخطأ عندما ظن أن الحركة اليومية التي نراها للفلك هي ناتجة عن حركة فلك تاسع محيط بفلك الكواكب الثابتة، إذ ليس يمكن أن يكون هناك فلك تاسع حسب القواعد الفلكية اليونانية ذاتها، وأن مثل هذا التناقض لا يجوز أن يشتمل عليه علم الفلك.

وعندما نتذكر أن محمد بن موسى كان يكتب ذلك الكلام قبل سنة ثمانمائة وثلاث وسبعين، أي قبل أن يترجم كتاب المجسطي لبطلميوس إلى العربية الترجمة الثانية التي قام بها اسحق بن حنين، تظهر لنا جليا قيمة هذه الأعمال المبكرة التي كان يشتمل عليها علم الفلك العربي. إذ لا شك أن عملية نقل التراث اليوناني إلى العربية كانت تجري في نفس الوقت الذي كان يقوم فيه الاعتراض على هذه الأعمال بالذات.

فالمقولة الشائعة التي كانت وما تزال توهمنا أن العرب أخذوا العلوم عن الحضارات القديمة، ونقلوها إلي الغرب اللاتيني دون إحداث تغييرات جذرية فيها، يتبين من هذه الأبحاث الجارية علي أنها مقولة عارية عن الصحة، ولا يمكن القبول بها بعد الآن. والنتيجة التي لا تقبل الجدال هي أن عملية النقل تلك كانت ترافقها عملية إبداع علي جميع المستويات، والمنحي الجديد يتطلب منا أن نؤرخ هذا الإبداع منذ أوائل نشأته، وأن نسأل عن الأسباب التي أدت إلى حدوثه

بدأت تتكاثر قليلاً قليلاً أوجه الشبه بين أعمال كوبرنيك وبين أعمال علماء الفلك العرب الذين أتوا قبله بحوالي ثلاثة قرون على الأقل. وبدأت الأسئلة تطرح عن مدى تأثر كوبرنيك بهؤلاء العلماء. وبالطبع بقي من هناك من يقول إن هذا الشبه هو من قبيل الصدفة لا غير، ولا يمكن أن نستنتج منه أن كوبرنيك كان مديناً لعلماء الفلك العرب بأي من نظرياته. أما بالنسبة للعاملين في تاريخ علم الفلك العربي فلم تعد علاقات كوبرنيك بهذا العلم مهمة إلى هذا الحد؛ إذ أصبح من واجبهم أن يتبينوا أهمية هذه الاكتشافات الجديدة بالنسبة لتاريخ علم الفلك العربي ذاته. وأصبح السؤال لماذا تمت هذه الأعمال بالدرجة الأولى، ومن هم الذين قاموا بها، وفي أي مناخ كانوا يعملون، ومتى بدأت هذه الأعمال ومتى انتهت، وعلاقة كل ذلك بالعلم العربي العام الذي كان المفروض به أن ينهزم أمام حملة الغزالي الشهيرة.

ولا يخفي ما لهذه التساؤلات من أهمية بالنسبة لتقييم عصور الحضارة وتقسيمها إلى عصور ذهبية، وفضية، وعصور انحطاط وما شابه ذلك.(٢٥) فهذه الاكتشافات التي تعددت خلال العقدين الفائتين أصبحت تشير بما لا يقبل النقاش إلى أن المقولة التي تنسب إلى الغزالي مسؤولية إجهاض العلم العربي والدخول في عصر الانحطاط هي مقولة لا يمكن أن تفسر وجود هذه الأعمال التي تم اكتشافها حتى الآن، والتي مازالت تكتشف يوماً بعد يوم. نتيجة لذلك لم يعد القرن الحادي عشر الميلادي، القرن الذي اعتمده سزكين نهاية لكتبه، قرناً يبدأ فيه عصر الانحطاط، بل أصبح قرناً يبشر بأعمال فلكية هائلة لم يعرفها العالم من قبل. وفي رأيي إن الفترة اللاحقة للقرن الحادي عشر تشكل عصراً ذهبياً بالنسبة لعلم الفلك العربي، وقد أشرت إلى ذلك في الكتاب الأخير الذي نشر في جامعة نيويورك.(٢٦) وبالطبع يجرنا ذلك إلى الحديث عن الأعمال التي كتبت بعد القرن الحادي عشر وعن السؤال عما إذا كانت تلك الأعمال أعمالا ثانوية ناتجة عن عصر انحطاط أم لا. ولا يخفي بأن هذه الاكتشافات أجبرتنا أن نبقي السؤال مفتوحاً على الأقل، وأن علينا أن نتبين بدء الفترة الإبداعية في علم الفلك العربي ونتبين نهايتها.

المنحي الثاني الجديد الذي بدأ العمل به خلال السنوات العشر الفائتة نتيجة لهذه التساؤلات هو محاولة جمع هذه الأعمال التي كانت تنتقد علم الفلك اليوناني، ومحاولة التعرف على مدى انتشارها، وعلى البيئة الفكرية التي نشأت فيها. القصد من هذا العمل هو أن نتبين أوائل هذا التراث الإبداعي وأن نسأل فيما إذا كان علم الفلك العربي بدأ أولاً بالتركيز على إصلاح الأخطاء الرصدية التي قام بها اليونان، والتي كانت تبدأ بالظهور في الأعمال التي اعتنى بها نالينو ومن تبعه، كان أيضاً يتعرض للنواحي النظرية في ذلك الفلك. الأخطاء الرصدية التي كانت معروفة لدي الجميع والتي صار تصحيحها خلال الفترة المبكرة شملت فيما شملت قضية انتقال نقطة الاعتدال، وانتقال أوج الشمس، وبعد مركز مدار الشمس عن مركز الأرض، ومقدار الميل الكلي لفلك البروج عن فلك معدل النهار،

نسبة الحلول المقترحة لهيئة الكواكب العليا من بعضها البعض. وبالرغم من اختلاف مراكز الحركات فجميعها تصف بدقة حركة الكوكب «و». كذلك نرى فيها جميعاً استخدام مقدمة العرضي بجعل خطي ع د ، ن ك دائماً متوازيين.

الشكوك ذاتها تاريخاً عربياً عريقاً.

الصورة التي بدأت تتضح حوالي أواخر العقد الثامن من هذا القرن تفيد بأن هؤلاء العلماء الذين أخذوا على عاتقهم إعادة صياغة علم الفلك اليوناني كانوا هم أنفسهم أصحاب نظريات وأنهم قاموا بإدخال تلك النظريات إلى صلب علم الفلك. نتيجة لذلك أضيفت أعمال ابن الشاطر إلى أعمال نصير الدين الطوسي الذي قلنا سابقاً نه كان قد اقترح نظرية جديدة تم استخدامها من قبل كوبرنيك. وفي نفس الفترة، تم لي الاهتداء إلى «كتاب الهيئة» لمؤيد الدين العرضي، وهو المهندس الدمشقي الذي قام ببناء آلات الرصد في مرصد مراغة، حيث وجدت فيه نظرية أخرى كان قد استخدمها كوبرنيك أيضا في هيئة الكواكب العليا. لذلك توليت تحقيق «كتاب الهيئة» للعرضي بكامله لكي يتسنى لنا أن نتبين الإطار الذي كانت تظهر فيه تلك النظريات ، ودفعته إلى مطبعة مركز دراسات الوحدة العربية في بيروت في أوائل الثمانينات، فتأخر ظهوره بسبب الحرب اللبنانية حتى سنة ألف وتسع مائة وتسعين.(٢٤)

مركزي عاش بعد الغزالي بحوالي ثلاثة قرون تقريباً يقوم بأعمال إبداعية تفوق إمكانية الفلك اليوناني وتطرح إمكانية إرساء قواعد علم الفلك الحديث على بساط البحث. هذه الأسئلة، وأسئلة عديدة مثلها، أثارت ضجة جديدة قلبت المقاييس والاعتبارات وحولت اتجاه دراسة علم الفلك العربي إلى المنحى الجديد الذي أود أن أوجز معالمه فيما يلى.

**الاتجاهات الحديثة في دراسة تاريخ علم الفلك العربي**

لا بد وأن تكونوا قد استنتجتم الآن أن أعمال ابن الشاطر، خصوصاً كتاب «نهاية السول» قد لاقت اهتماماً بالغاً خلال الثلاثين سنة اللاحقة. فبعد عودة كنيدي إلى بيروت قام هو ورعيل من تلامذته بدراسة جميع أوجه ذلك الكتاب، ونشروا مقالات عدة، معظمها صدر في مجلة إيزيس نفسها، حيث أبرزوا فيها معالم الإبداع في كتابات ابن الشاطر. (٢٠) ومن خلال دراسة كتاب ابن الشاطر تبين أنه لم يكن أول فلكي عربي يعترض على مقومات الفلك اليوناني، ويحاول أن يجد لها بديلاً. وكان ابن الشاطر نفسه قد دل على ذلك الطريق إذ ذكر صراحة في مقدمتي كتابي نهاية السول، والزيج الجديد، أسماء الفلكيين الآخرين الذين جاؤوا قبله والذين حاولوا تعديل الهيئة البطلمية. لقد ذكر هؤلاء الفلكيين ليقول إنهم لم يوفقوا بالقدر الذي توفق به هو. وبين هذه الأسماء التي ذكرها ابن الشاطر، نجد اسم ابن الهيثم المشهور في علم الضوء، واسم مؤيد الدين العرضي الدمشقي، ونصير الدين الطوسي، وقطب الدين الشيرازي، ويحي ابن أبي الشكر المغربي وغيرهم. ولما تبين حقاً أن معظم هؤلاء الفلكيين كانوا قد التحقوا في فترة من فترات حياتهم بمرصد مدينة مراغة في شمال غرب إيران الذي أقامه العاهل الإيلخاني بعد سنة واحدة من تدمير بغداد على يد المغول، أطلق أحد طلاب كنيدي اسم «مدرسة مراغة» على هذا الفريق من علماء الفلك.(٢١) وانطلق الباحثون خلال العقد السابع من هذا القرن يبحثون عن أعمال مدرسة مراغة بين طيات المخطوطات المبعثرة في جميع أنحاء العالم توخياً لإكمال الصرح الذي كان ابن الشاطر قد بدأ بناءه.

ونتيجة لتلك الأبحاث تبين أن هذه الأعمال العربية التي كانت تكتب خصيصاً لنقض الأعمال اليونانية كانت تشكل بحد ذاتها تراثاً متواصلاً تميز به علم الفلك العربي خلال عدة قرون. ففي أوائل العقد الثامن من هذا القرن قام عبد الحميد صبره ونبيل الشهابي بنشر رسالة لابن الهيثم نفسه كان ابن الهيثم قد كتبها خصيصاً ليبين فيها عورات علم الفلك اليوناني، وسماها «كتاب الشكوك على بطلميوس».(٢٢) ومن مضمون تلك الرسالة ظهر جلياً أن احتجاج علماء الفلك العرب على الفلك اليوناني لم يكن محصوراً على الناحية الرصدية فحسب، بل تعداها إلى نقاش القواعد النظرية لذلك الفلك. زد على ذلك أن الشكوك التي كان ابن الهيثم يعترض بها على بطلميوس كانت أيضاً شبيهة جداً بالشكوك التي أثارها كوبرنيك من بعد. (٢٣) وخلال السنوات القليلة اللاحقة تبين أن لهذه

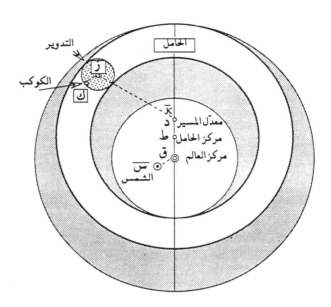

هيئة الكواكب العليا كما توهمها بطلميوس. ويظهر فيها جليا التناقض الذي اعترض عليه علماء الفلك العرب فيما بعد، ألا وهو وجوب حركة الفلك الحامل الذي مركزه نقطة «ط» حول نقطة وهمية غير ذلك المركز ألا وهي نقطة معدل المسير «د» فهذه الحركة التي تتعارض والأسس اليونانية ذاتها لطبيعة الفلك هي التي سميت فيما بعد بإشكال معدل المسير.

لست بحاجة أن ألفت انتباهكم إلى خطورة هذا الاكتشاف. خاصةً وأنه كان يمس روح النهضة الأوروبية وكان يمس أعمال واضع أسس علم الفلك الحديث. كذلك لسنا بحاجة إلى الإشارة إلى أن هذا الاكتشاف قلب الصورة المشهورة عن دور علم الفلك العربي، ودور العلوم العربية عامة، إذ نشأت عنه أسئلة عديدة هامة جدا. منها على سبيل المثال ما يتعلق بأعمال كوبرنيك نفسه. هل كانت تلك الأعمال تكملة لأعمال ابن الشاطر الدمشقي، أم أنها كانت أعمالاً إبداعية ثورية جديدةً كما هو معروف. وهل كان كوبرنيك متأثراً بأعمال ابن الشاطر، وهل نقلت أعمال ابن الشاطر إلى الغرب اللاتيني ليتسنى لكوبرنيك أن يتعرف إليها. وماذا عن دور العلوم العربية ذاتها. هل كانت تلك العلوم مكملةً للأعمال اليونانية كما كنا نظن أم أنها كانت هي الأخرى ثوريةً وجديدةً. وماذا عن علاقة الدين الإسلامي بالعلم. أحقاً أنه تعارض مع العلوم الدخيلة، وتمكن من القضاء عليها بعد ثورة الغزالي على الفلسفة اليونانية؟ كيف ذلك ونحن نرى مُوَقِّتاً في جامع

نص ابن الشاطر الدمشقي، يصف هيئة الأفلاك وحركات القمر والشمس تختلف تماماً عن تلك التي كان يتكلم عنها بطلميوس واضع أسس الفلك اليوناني. وزيادة على ذلك، لقد كانت هيئة ابن الشاطر تلك، خصوصا ما يتعلق منها بحركات القمر، هي الهيئة عينها التي تكلم عنها كوبرنيك عالم عصر النهضة الأوروبي، وصاحب الثورة التي تعرف باسمه في علم الفلك.

يجب أن لا يتسارع إلى الذهن أن ابن الشاطر الدمشقي كان سابقا لكوبرنيك بوضع علم الفلك الحديث الذي ينسب مركز العالم فيه إلى الشمس عوضاً عن الأرض. لأن ابن الشاطر لم يفعل ذلك وكان يعتمد الأرض مركزاً للعالم تماماً كما فعل بطلميوس من قبله ولا أريد أن أغوص هنا في النتائج التي ترتبت على نقل كوبرنيك لمركز العالم هذا من الأرض إلى الشمس، خصوصا في عصر النهضة الأوروبية، وعلاقة الكنيسة الكاثوليكية بذلك وما لحق ذلك من تنكيل واضطهاد. كل ذلك كان معروفاً عند جميع العاملين في تاريخ العلوم عامة، وفي تاريخ علم الفلك خاصة.

أما ما لم يكن يعرفه أحد، فهو أن كوبرنيك كان يصف هيئة جميع الأفلاك ماعدا القمر، على أنها أفلاك تدور حول الأرض أولاً ثم ينقل ذلك بخطوة نهائية إلى جعلها تدور حول الشمس. من الناحية الرياضية يمكن وصف تلك العملية النهائية بأنها عملية تغيير اتجاه المتجه الرياضي الذي يربط الأرض بالشمس، أي يمكن الإبقاء على جميع المعطيات في الهيئة التي تتمركز حول الأرض، أي بالإبقاء على هيئة ابن الشاطر، وبإتمام النقلة الأخيرة تصبح تلك الهيئة متمركزة حول الأرض، أي بالإبقاء على هيئة ابن الشاطر، وبإتمام النقلة الأخيرة تصبح تلك الهيئة متمركزة حول الشمس. أما بالنسبة للقمر فلا فرق بين الهيئتين إذ أن القمر يدور حول الأرض في هيئة الفلك القديم والحديث على السواء.

ما لم يكن يعرفه أحد أيضاً هو أن الهيئة التي حدسها كوبرنيك لحركات القمر، الذي يدور حول الأرض، كانت هي عينها الهيئة التي كان ابن الشاطر قد وصفها قبل ذلك بحوالي قرنين على التقريب. وكانت الهيئة التي أعدها للكواكب الأخرى، قبل نقلها إلى مركزية الشمس، هي أيضاً مشابهة تماماً للهيئة التي كان ابن الشاطر قد ابتكرها. فنتيجةً لهذا الاكتشاف التاريخي، أضاف نويغبور اسم ابن الشاطر إلى الملحق الذي كان يعمل عليه وأوعز إلى كنيدي أن ينشر وصفاً مستقلا لهيئة ابن الشاطر. أما كنيدي فأوعز بدوره إلى تلميذه ڤيكتور روبرتس أن يقوم بذلك. وكانت حصيلة هذه الإيعازات أن ظهر مقال شهير تحت عنوان «نظرية هيئة الشمس والقمر عند ابن الشاطر: هيئة كوبرنيكية سابقة لكوبرنيك.» نشر هذا المقال في مجلة إيزيس(19). الناطقة باسم جمعية تاريخ العلوم التي كان سارتون قد أسسها في أمريكا. وبولادة هذا المقال، والملحق الذي كتبه نويغبور، وقد صدر الاثنان سوية سنة ألف وتسع مائة وسبع وخمسين، كانت ولادة الاتجاه الجديد في تاريخ علم الفلك العربي، أي الاتجاه الذي يبحث عن علاقة علم الفلك الحديث بالأعمال العربية السابقة.

١١٣ الإتجاهات الحديثة في دراسة تاريخ علم الفلك العربي

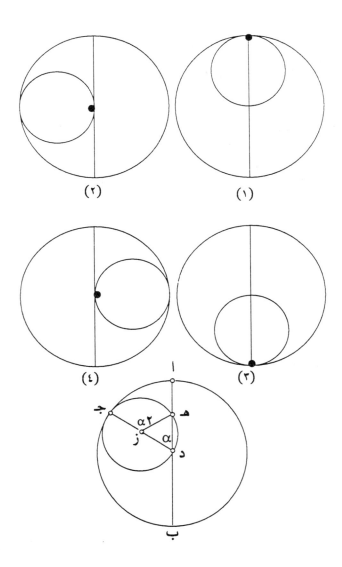

أصل الكبيرة والصغيرة . إذا فرضت كرتان متماستين من الداخل على نقطة ما مثل ، أ ، وفرض قطر الكبرى منهما مساوياً لضعف قطر الصغرى، فإذا تحركت الكبرى إلى جهة ما وتحركت الصغرى إلى الجهة المقابلة بحركة تساوى ضعف الحركة الأولى، عندها تتردد نقطة التماس ا على طول قطر الكرة الكبرى اب . فإذا تحركت في المثال الكرة الكبرى بقوس اج ، أى بقيمة $\alpha$ وتحركت الصغرى ضعف ذلك بقوس ج هـ ، أي بقيمة $2\alpha$ عندها تنتقل نقطة ا إلى هـ ، وثم إلى د وإلى ب ، وترجع على خط ا ا إلى حيث بدأت.

أكسفورد سنة ست وخمسين - سبع وخمسين وهو في طريقه إلى جامعة براون لقضاء السنة الدراسية هناك برفقة نويغبور. وتقول الأسطورة إن سبب زيارته لأكسفورد كان لإلقاء نظرة أخيرة على نسخة من كتاب الزيج الجديد الذي كتبه ابن الشاطر الدمشقي الذي كان يعمل مؤقتاً في الجامع الأموي في دمشق خلال النصف الثاني من القرن الثامن الهجري، أي الرابع عشر الميلادي.(١٥) وبالطبع فإن كلمة «جديد» في «الزيج الجديد» كانت تثير اهتمام كنيدي في الدرجة الأولى لأنه كان يتوقع أن يرى مقادير فلكية جديدة لم تكن معروفة من قبل، وبالتالي تشير إلى نشاط رصدي جديد في تلك الفترة المتأخرة من فترات تاريخ الحضارة الإسلامية.

وتتابع الأسطورة فتقول إن كنيدي الذي كان ينتظر كتاب «الزيج الجديد» في قاعة المكتبة البودلية إذا بعامل المكتبة يعطيه كتابا آخر لابن الشاطر لا علاقة له بالزيج الذي كان ينتظره. وهذا الكتاب الجديد الذي لم يكن كنيدي يعرفه من قبل، ولم يكن يبحث عنه بالدرجة الأولى، كان كتاب «نهاية السول لتصحيح الأصول»، لابن الشاطر عينه. وبانتظار الكتاب الصحيح الذي كان كنيدي قد طلبه من عامل المكتبة بدأ كنيدي بتصفح كتاب نهاية السول. وتوا تبين له أنه أمام عمل لم يعرف عنه شيء حتى تلك اللحظة، وأن محتويات ذلك الكتاب لا تشبه محتويات الكتب الفلكية السابقة، لا اليونانية منها ولا الهندية. عندها قرر أن يجلب معه إلى جامعة براون نسخة ميكروفيلم من ذلك الكتاب لتتسنى له دراسته عن كثب.

هناك في جامعة براون، كان نويغبور ينهي كتابه الشهير عن تاريخ العلوم الدقيقة القديمة.(١٦) وكان يحاول أن ينهي ذلك الكتاب بوصف موجز للأعمال الفلكية التي كان لها علاقة بأعمال بطلميوس اليوناني إذ كانت أعمال بطلميوس هذا محور الكتاب وكانت هي بدورها المصدر الأساسي الذي اعتمدته جميع الأعمال الفلكية السابقة للفلك الحديث. وكان نويغبور يحاول أن ينهي كتابه بوصف نظرية رياضية كان كوبرنيك، واضع الفلك الحديث، قد استخدمها أثناء نقضه للفلك اليوناني. كذلك كان نويغبور قد اكتشف أن تلك النظرية الرياضية التي استخدمها كوبرنيك كانت عينها النظرية التي كان قد وضعها نصير الدين الطوسي قبل كوبرنيك بنحو مائتي عام، وكان كارا دي فو قد ترجمها إلى الفرنسية في أواخر القرن الفائت.(١٧)

النظرية التي ابتدعها الطوسي سماها هو باسم «أصل الكبيرة والصغيرة» لأن قوامها حركة كرتين قطر الواحدة منهما ضعف قطر الأخرى وينتج عن حركتيهما الدوريتين حركة مستقيمة تتردد على قطر الكرة الكبرى: إن هذه النظرية تم استخدامها من قبل كوبرنيك أيضاً وهي التي يشار إليها الآن بمزدوجة الطوسي أو (Tusi Couple) بالانكليزية. كل ذلك مثبت الآن في الملحق الذي ضمه نويغبور إلى كتابه الشهير.(١٨)

وفي خضم تلك الأعمال يصل كنيدي وبيده نسخة من مخطوط نهاية السول لابن الشاطر. ينظر إليها نويغبور ويستنتج فوراً أن النص الذي أمامه، أي

كان قد التحق بالجامعة الأمريكية في بيروت سنة ألف وتسع مائة وست وأربعين، ألا وهو الأستاذ إدوارد كنيدي الذي تقاعد مؤخراً من تلك الجامعة، ويقيم الآن في مدينة برنستون في الولايات المتحدة. فخلال السنة الدراسية خمس وأربعين - ست وأربعين – لم يلتحق كنيدي بهيئة التدريس في الجامعة الأمريكية في بيروت فقط بل كان قد تعرف على أوتو نويغبور الذي كان يعمل آنذاك في جامعة براون. ومن سخريات القدر أن كنيدي أتى إلى جامعة براون بطريق جامعة هارفرد حيث كان يحاول أن يتتلمذ على سارتون. فإذا به ينتهي بالتتلمذ على نويغبور الذي كان يغوص إلى أعماق النصوص العلمية التاريخية بقدر ما كان سارتون يحاول أن يبقى على قشورها.

هكذا تولدت صداقة بين كنيدي ونويغبور وجعلت كنيدي يتوجه إلى لباب النصوص على طريقة نويغبور. ولما كان الاهتمام آنذاك بنصوص الأزياج الفلكية كما أسلفنا، وكان تحقيق الزيج البتاني الذي قام به نالينو المثل المحتذي، فقد حاول كنيدي أن يبقى ضمن هذا المنهج الذي كان نالينو قد أرسى قواعده. لذلك بدأ كنيدي حيث انتهى نالينو، وبدأ مباشرة بإحصاء جميع الأزياج الإسلامية المعروفة تحضيراً لدراستها المسهبة كمجموعة مستقلة. وفي سنة ألف وتسع مائة وست وخمسين نشر لائحة شبه كاملة بهذه الأزياج في مجلة الجمعية الفلسفية الأمريكية.(١٤) ونتيجة لتلك الدراسة الشبه إحصائية تبين أن المكتبة العربية الإسلامية كانت تحتوى على أكثر من مائتي زيج يمتد تاريخها من أوائل القرن التاسع الميلادي حتى القرن الخامس عشر وتبين أيضاً أن الزيجين اللذين كان قد تم نشرهما على يدي كل من سوتر ونالينو كانا فقط مثالين منفردين من مجموعة هائلة لا بد من دراستها.

عندما حدس كنيدي أن دراسة هذه الأزياج كمجموعة يمكن أن تفيد بحد ذاتها تاريخ علم الفلك العربي، بغض النظر عن الفائدة التي يمكن أن تحصل منها لتاريخ العلوم اللاتينية عامة. وباشر توّا بمحاولة التعرف على محتويات هذه الأزياج. وبالطبع بدأ أولا بجمع المقادير الفلكية التي تضمنتها، إذ يستطيع المرء أن يميز بواسطتها مدى استقلالية كل زيج عن الآخر. كل ذلك ظنا منه أن كل مقدار يجده في أي زيج من هذه الأزياج إما أن يكون هو المقدار عينه الذى نعرفه من المصادر اليونانية وغيرها وإما أن يكون مقداراً جديداً أتى و لا بد نتيجة للأرصاد التي قام بها أبناء الحضارة الإسلامية أنفسهم. هكذا حاول من دراسة هذه الأزياج أن يرسم خطاً بيانياً بمجموع الأعمال الرصدية التي تمت فيما بين القرن التاسع الميلادي والقرن الخامس عشر. وبواسطة هذا الخط يمكن أن نتعرف على علاقة بعض هذه الأرصاد بالبعض الآخر، وعلى علاقتها مجموعة بالمصادر الهندية واليونانية.

وتشاء الصدف، كما يحدث عادة في مثل هذه الحالات عندما يكون الحقل في طور الطفولة، ولا نعرف ما تخبئه لنا الآلاف من المخطوطات التي مازالت قابعة على رفوف مكتبات العالم، أن يصل كنيدي إلى مكتبة بودليان في

المكتبات التي مازالت قائمة في معظم البلدان الإسلامية والتي لم يصل إليها كل من بروكلمان وسوتر، إلا أنه بتوقفه عند سنة أربع مائة وثلاثين للهجرة لم يتوصل إلى الفترة التي شملها هذان المستشرقان. فلذلك بقيت كتب سزكين، مثل كتابات بروكلمان، محدودة الفائدة لعدم تعمقها في مضمون المخطوطات، وعديمة الفائدة بالنسبة للفترة اللاحقة لسنة أربع مائة وثلاثين الهجرية. وسوف نأتي بعد قليل على ذكر هذه السنة بالذات، وعلى النتائج السلبية التي ترتبت على التوقف عندها بالنسبة لتاريخ علم الفلك العربي، والتي ربما لم يقصدها سزكين.

لقد حاولت حتى الآن أن أحصر العرض في المصادر التي حاولت أن تعطي لمحة إجمالية عن تاريخ علم الفلك العربي، ولم أذكر العديد من المستشرقين الذين ساهموا في دراسة المصادر الأولية الفلكية من أمثال غوليوس(١٠)، وساديليو(١١)، وفيدمان(١٢)، وكارا دي فو(١٣)، وغيرهم، لأني ما زلت أرغب في أن أعطي فكرة عامة عن تطور هذه الدراسات، وعن النتائج المترتبة عليها بالنسبة للعاملين في تاريخ العلوم عامة، وفي حقل تاريخ الفلك العربي خاصة وكم كنت أتمنى لو اتسع الوقت لأشمل هذه الأعمال الأخرى.

دعوني أخلص الآن إلى وصف الصورة التي كونتها هذه الأعمال التي أشرنا إليها حتى الآن في ذهن القاريء الغربي والشرقي على السواء. فبانتهاء الحرب العالمية الثانية كانت الصورة الغالبة لتاريخ علم الفلك العربي أن ذلك العلم كان مكملاً للعلم الذي أخذته العرب عن الحضارة الهللينية اليونانية. شأنه في ذلك شأن تاريخ الفلسفة العربية التي كان لها نفس الصورة تقريباً. أما قيمة هذا العلم فكانت تكمن في مدى انتقاله إلى العالم اللاتيني، وفي مدى تأثيره على الأعمال الفلكية التي تمت في الغرب اللاتيني. بكلام آخر، إن قيمة علم الفلك العربي، رغم الجهود الجبارة التي قام بها نالّينو وسوتر، لم تكن تتعدى كونها تابعة لدراسة تاريخ العلوم اللاتينية.

كل ذلك ليس عجيبا، إذ أن كل حضارة يكون اهتمامها بالدرجة الأولى بتاريخ ذاتها، ويكون الدارسون من أبنائها قيمين على هذا التاريخ، يمحصونه ويدرسون كل ما يمت إليه بصلة. فحظ علم الفلك العربي أنه كان يمت إلى العلوم اللاتينية بصلة. لذلك لقى بعض الاهتمام الذي لم يحظ به علم الفلك الصيني مثلاً. زد على ذلك أن الاهتمام الذي أبداه كل من نالّينو وسوتر في علم الفلك العربي كان ينصب على الأزياج الفلكية العربية من زيج البتاني إلى زيج الخوارزمي وهذه الأزياج، رغم أهميتها، تشكل نوعاً محدوداً من الكتابات الفلكية، وليس مجال الإبداع فيها خصباً كما كانت الحال في المجالات الأخرى التي سنأتي على ذكرها

فبانتهاء الحرب العالمية الثانية كان الاهتمام بعلم الفلك العربي يتمحور حول هذه الأزياج الفلكية وعلى النتائج التي يمكن أن تستقي منها لأجل خدمة تاريخ العلوم الاوربية خاصة. في هذه الفترة بالذات يدخل الحقل أستاذ جديد

هذا. زد على ذلك أنا لا نعرف أحدا حتى الآن قام بعمل شامل مشابه للعمل الذي قام به ناللينو، مع العلم بأن الحاجة ملحة إلى كتابة تاريخ علم الفلك العربي.

أما الرعيل الثاني من أمثال جورج سارتون الذي كتب في النصف الأول من هذا القرن(٨)، وغيره من الذين حاولوا كتابة تاريخ العلوم بشكل عام، ومنها تاريخ علم الفلك العربي مدموجا مع العلوم الأخرى، فهؤلاء لم يكن باستطاعتهم أن يتعمقوا في فهم المعاني التي تضمنتها المصادر العربية، وبالتالي لم يتمكنوا من تقييمها بشكل علمي سليم. لذلك كانت كتابة سارتون، وجميع الذين حذوا حذوه من ابناء العربية، كتابة سطحية هامشية لا تثير اهتمام الطالب بالأصول العلمية ولا تحثه على تقصي المعاني التي توصل إليها العلماء العرب تقصيا وثيقا. ومن المؤسف حقاً أنا نرى جملة لا بأس بها من مؤرخي العلوم العربية المعاصرين يعتمدون سارتون الذي لم يأخذ من التراث العلمي العربي سوى القشور ويضربون صفحا عن أعمال العلماء الآخرين من أمثال ناللينو وسوتر ونويغبور وغيرهم الذين غاصوا إلى جذور هذا التراث ليبرزوا الجواهر الدفينة التي تضمنها.

ولكن من الناحية الإعلامية فقط، فقد كان لسارتون دور مهم في إبراز دور العلوم العربية عامة، ومنها علم الفلك. وذلك لأنه أثناء عمله يحتل مركزاً مهماً في جامعة هارفرد الأمريكية، وفي فترة من الزمن حين كان التركيز على تاريخ العلوم عامة ذا اعتبار لدي سلطات الجامعات الأمريكية. ولما كان سارتون من أوائل الواردين الأوربيين إلى الصرح الأكاديمي الأمريكي في فترة ما بين الحربين العالميتين، فقد حظي بنفس الاحترام الذي حظي به زملاؤه الوافدون من أوروبا وكان له الباع الطويل في تأسيس دراسة تاريخ العلوم في الجامعات الأمريكية. كل ذلك ساعد على خلق مناخ جديد في الأجواء الأكاديمية الأمريكية مفاده أن العلوم العربية مكملة للعلوم الإنسانية الأخرى، وخاصة علوم القرون الوسطى الأوروبية وعصر النهضة. ونتيجة للتأثير الإعلامي الذي خلفته كتابات سارتون أصبح الطالب الجامعي الذي ينوي التخصص في أي حقل من حقول تاريخ العلوم في هذه الفترة الأوربية يهتم، ولو بعض الشيء، بتاريخ العلوم العربية التي جعلها سارتون مكملة للعلوم اللاتينية. وهكذا كان عمل سارتون إعلاميا بالدرجة الأولى. فعدا جمعه لأسماء الكتب، وتركيزه على تسمية كل نصف قرن باسم عالم من العلماء، بمن فيهم العلماء العرب، فإن سارتون لم يدفع عجلة تاريخ العلم العربي إلى الأمام بأي شكل جذري، ولم يكن له تأثير يذكر على تاريخ علم الفلك العربي.

أخيرا يجب أن أنوه بالاعمال التي يقوم بها فؤاد سزكين في كتابه الذي ينشر تباعاً تحت عنوان «تاريخ التراث العربي»(٩)، والذي يعتبر إعادة منقحة لكتاب بروكلمان وما زال نشره يتوالى. فبالرغم من أن سزكين يتميز عن بروكلمان، ويقترب من سوتر في أنه يفرد لكل علم كتاباً، ويتميز عن كل من بروكلمان وسوتر بأنه يجمع إلى فهارس المكتبات الأوروبية الفهارس العديدة من

يعمل على تحقيق الترجمة اللاتينية.

لذلك نستطيع أن نفهم أهمية الدور الذي لعبه سوتر في تحقيق هذا الزيج، والدور التاريخي الذي قام به بالنسبة لتاريخ علم الفلك العربي. فإنه بعمله هذا لم يبرز فقط أحد أهم المصادر العربية الفلكية، بل تعدى ذلك إلى سد الثغرة التي كان قد أحدثها فقدان الأصل العربي لهذا الزيج. وإذا أخذنا بعين الاعتبار أن جميع المصادر العربية الفلكية الأخرى التي اعتمدت على علم الفلك الهندي هي أيضاً مفقودة، نستطيع أن نقدر أهمية هذا الكتاب الموضوعية إذ نستطيع بواسطته أن نتحقق من الدور الذي لعبه الفلكيون العرب في تعاملهم مع التراث الهندي الفلكي. ولما كانت المصادر التاريخية والعلمية من القرن التاسع الميلادي، القرن الذي كتب فيه الخوارزمي كتابه، نادرة جداً، فإن علينا أن نرحب بالخدمة التي أسداها لنا سوتر بإعادته هذا الكتاب إلى حيز الوجود.

على أن أنوه هنا بالخدمة المكملة لتلك التي أسداها سوتر، وهي التي قام بها في أواسط هذا القرن عميد مؤرخي علم الفلك بغير منازع أوتو نويغبور، الذي توفي منذ أربع سنوات تقريباً، والذي أرخ لعلم الفلك بجميع أطواره من العصور البابلية حتى عصر النهضة الأوربية. فقد لاحظ نويغبور أن سوتر لم يضف الحواشي اللازمة إلى التحقيق الذي قام به، لكي تكمل بواسطتها الفائدة المتوخاة من كتاب الخوارزمي. ولإتمام الفائدة قام نويغبور بإصدار كتاب مستقل، يعادل حجما كتاب الخوارزمي تقريبا، شمل فيه جميع التعليقات التي يمكن أن يبتغيها الطالب لفهم مقاصد الخوارزمي بحذافيرها.(٥)

أما العالم الذي أسدى إلى الناطقين بالضاد الخدمة الأجل في مضمار تاريخ علم الفلك العربي بالذات، فهو المستشرق الإيطالي كارلو ألفونسو نالينو الذي قام في أواخر القرن الفائت وأوائل هذا القرن بتحقيق الزيج الصابىء لمحمد بن جابر البتاني الذي عاش في أواخر القرن العاشر الميلادي.(٦) وقد شمل التحقيق أصل زيج البتاني العربي وترجمته اللاتينية مع تعاليق جمة زادها نالينو على حواشي التحقيق استقاها كلها من المصادر الفلكية السابقة واللاحقة للبتاني. ثم أعاد صياغة الملاحظات التي كان قد جمعها لتحقيق زيج البتاني بأسلوب خطابي وأعدها بشكل سلسلة من المحاضرات قام بإلقائها باللغة العربية على طلاب الجامعة المصرية في أوائل هذا القرن. بعدها أعاد تنقيح هذه المحاضرات وأبرزها في كتاب نشر في روما سنة ألف وتسعمائة وإحدى عشرة تحت عنوان «علم الفلك: تاريخه عند العرب في القرون الوسطى».(٧)

وقيمة العمل الذي قام به نالينو تكمن في أن نالينو لم يكن ضالعاً في علم الفلك العربي فحسب، بل كان يعرف حق المعرفة الإنجازات الفلكية التي كانت معروفة في أوربا آنذاك، كما كان فطحلاً في تاريخ الأدب العربي والحضارة الإسلامية. ونتيجة لهذه المعارف الموسوعية أصبحت محاضراته توا المرجع الرئيسي لتاريخ علم الفلك العربي في عصوره الأولى ومازالت كذلك حتى يومنا

البيبليوغرافية الخاصة بعلماء الفلك العرب ورياضييهم، وأخرجها في كتاب صدر في ليبزيك في مطلع هذا القرن بالضبط(٢) . ولا يخفى ما لمثل هذه الأعمال من القيمة العلمية إذ إن عملية الفهرسة هذه هي بمثابة الأساس الذي تقوم عليه جميع الدراسات الجدية. ولم يأت كتاب سوتر مشابهاً ومتزامناً مع كتاب بروكلمان الشهير حول تاريخ الأدب العربي(٣) صدفة، بل كان الاثنان يشكلان مظهراً من مظاهر اهتمام المستشرقين الأوروبيين بالتراث الشرقي. وكانت عملية المسح هذه بمثابة الخطوة الأولى لبدء الدراسات الاستشراقية الحديثة. أما ميزة كتاب سوتر فتكمن في أنه يفصلُ علم الفلك الرياضي وعلم الرياضيات عن باقي العلوم العربية التي تناولها بروكلمان فسهل بذلك عملية التركيز على العلوم الرياضية على أنها علوم مستقلة بذاتها.

أما المصادر التي استعان بها سوتر فقد كانت، مثل المصادر التي اعتمدها بروكلمان في كتابه ، تشمل زيادة على كتب الطبقات المشهورة، كفهرست النديم، وتاريخ القفطي، ووفيات ابن خلكان وغيرهم، العشرات بل المئات من فهارس المكتبات الأوروبية والعالمية التي كانت وما تزال مخزناً هاماً من مخازن المخطوطات العلمية العربية. فمجموعة الفلكيين والرياضيين العرب، أو قل الذين كتبوا باللغة العربية، التي تضمنها كتاب سوتر، أعطتنا للمرة الأولى لمحة عامة عن مدى هذا التراث العلمي وعن استمراريته عبر عصور الحضارة الإسلامية. كذلك استطعنا لأول مرة أن ننظر إلى حجم هذا التراث العلمي، وأن نتبين المحفوظ منه في مكتبات العالم والمفقود، أو الذي لم نصل بعد إلى تحقيق وجوده. كل ذلك مع العلم بأن المكتبات التي درس كل من سوتر وبروكلمان فهارسها كانت هي المكتبات الأوروبية بالدرجة الأولى ولم يتعداها إلا نادراً. فلذلك جاء كتاباهما بمثابة فهرس للأعمال العربية ومنها الرياضية والفلكية المحفوظة في مكتبات أوربا بالدرجة الأولى.

أما سبب اهتمام سوتر بعلم الفلك العربي، كعلم منفصل عن علم الرياضيات، فقد بدا واضحاً عندما قام في السنوات التي تلت نشر كتابه المعجمي بتحقيق الترجمة اللاتينية لكتاب محمد بن موسى الخوارزمي المعروف بكتاب الزيج، أو كتاب السند هند الصغير.(٤) وكلمة الزيج الفارسية الأصل، والمعربة هنا تشير إلى كون الكتاب من نوع الجداول الفلكية التي يعتمد عليها في حساب أماكن الكواكب السيارة لأي وقت شئنا. ولما كان الكتاب أيضاً معروفاً باسم السند هند فذلك يدل على كونه مستوحى من كتب الفلك الهندية التي تعرف بالسدهانتا، والتي كانت من أوائل الكتب الفلكية التي استقت منها الحضارة العربية. أما كتاب الخوارزمي هذا فقد كان أصله العربي مفقوداً، ولم يبق منه سوى المختصر الذي قام به مسلمة المجريطي في الأندلس في أوائل القرن الحادي عشر الميلادي مترجماً إلى اللاتينية على يد جيرارد الكريموني. فلا الأصل الخوارزمي، ولا المختصر المجريطي بقيا بأصلهما العربي، وكان سوتر

أبحاثهم الفلكية الجارية. فكلا الفريقين لا يستطيع أن يقوم بكتابة تاريخ علم الفلك العربي كما يجب.

أما العاملون في تحقيق التراث العربي ودراسته من العرب أنفسهم، فهم عادة ممن لا تستهويهم المصادر العلمية عامة، ناهيك عن علم الفلك بالذات، ويصرفون معظم جهودهم في دراسة المصادر التراثية الأدبية والدينية. وحتى لو أرادوا الإسهام في دراسة تاريخ هذا العلم، مدفوعين بعاطفة قومية أو دينية، فهم لا يستطيعون إلى ذلك سبيلاً؛ إذ ينقصهم التدريب العلمي الذي لا يستطيعون بدونه أن يفهموا مقاصد المصادر العلمية الفلكية.

فلا جرم إذا أن يكون تاريخ علم الفلك العربي قد بقي حتى فترة متأخرة جداً رهناً بأعمال المستشرقين الذين أولوا هذا العلم بعض الاهتمام، إما بسبب تعرضهم لتحقيق نص فلكي لاتيني مترجم عن أصل عربي بالذات، أو أثناء تعرضهم لكتابة تاريخ العلوم عامة، ومنها يلتفتون بشكل عابر إلى تاريخ علم الفلك العربي. وإذا استثنينا عميد المستشرقين في هذا المضمار، الأستاذ الإيطالي نالينو، الذي سنأتي على ذكره بعد قليل فإننا لا نرى بين هؤلاء المستشرقين من كان ليهتم بتاريخ علم الفلك العربي على اعتبار أن هذا التاريخ ذو قيمة حضارية بذاته.

فالفريق الأول الذي تعرّض لدراسة تاريخ علم الفلك العربي توخياً لتحقيق نص فلكي معين لم يكن يشتمل فقط على الذين كانوا ضالعين في تاريخ علم الفلك اليوناني واللاتيني، بل كان يشتمل أيضاً على أهم المستشرقين الذين اطلعوا على دقائق علم الفلك العربي ذاته. وكانت غايتهم من دراسة علم الفلك العربي دائماً تتمحور حول رغبتهم في آن يجيء تحقيقهم للنص الفلكي المنشود قريباً من التحقيق العلمي قدر المستطاع. ولأن تحقيق النص العلمي كان يتطلب معرفة دقائق العلم الذي يدور النص حوله، كان هذا الرعيل من المستشرقين يشمل بين أفراده أناساً يفقهون القواعد الأساسية لعلم الفلك، الحديث منه والقديم، كما كانوا متعمقين أيضاً في القواعد المتعارف عليها في تحقيق النصوص العلمية. ولكن لما كان اهتمام هذا الفريق محصوراً في إخراج النص العلمي التاريخي، فقد كانوا دوماً مقيدين بمتطلبات النص ذاته، ونادراً ما كانوا يتعدون ذلك إلى متطلبات مجموع علم الفلك العربي. ومن بين هؤلاء المستشرقين يجب الإشارة إلى مستشرقين اثنين، تعاصرا في أواخر القرن الفائت وأوائل القرن الحالي، ولعبا دوراً أساسياً في إرساء القواعد الحديثة لتاريخ علم الفلك العربي، ألا وهما هينريخ سوتر السويسري وكارلو ألفونسو نالينو الإيطالي.

أما سوتر، الذي كان يعمل في زوريخ في أوائل هذا القرن، فقد كان مهتماً بتاريخ الرياضيات العربية. ولما كان علم الفلك التعليمي الذي نقصده هنا علماً رياضياً بالدرجة الأولى، فقد أوصله اهتمامه بتاريخ الرياضيات العربية إلى الاهتمام بتاريخ علم الفلك العربي. فهو الذي جمع، ولأول مرة، المادة

# الإتجاهات الحديثة
## في دراسة تاريخ علم الفلك العربي

### جورج صليبا

إن تاريخ علم الفلك العربي الذي نتحدث عنه اليوم هو ذلك التاريخ الذي ما زال في طور طفولته، إن لم نقل إنه لم يولد بعد. السبب الرئيسي لذلك هو أن الدراسة الجدية لهذا التاريخ كانت ومازالت تتطلب أولاً معرفة واسعة بدقائق علم الفلك القديم، كما تتطلب ثانياً معرفة دقيقة بتاريخ الحضارة العربية. ولم يتسن بعد لهذا العلم أن يحظى برعيل من الباحثين يلمون بهاتين الناحيتين معاً. وعلم الفلك الذي نقصده هنا هو ذلك العلم الذي أشارت إليه المصادر العربية بعلم النجوم التعليمي أو علم الهيئة، وهو علم رياضي يتميز عن علم النجوم الإحكامي، أي التنجيم والنجامة. هذا الفرع الثاني من علم النجوم الذى ذمه الشرع الإسلامي، على حد قول أبي حامد الغزالي(١)، والذي تحاشاه معظم العاملين في علم الفلك النظري، لا يعنينا البتة في هذا المجال ولن نتعرض له لا من قريب ولا من بعيد. بل سوف ينصب اهتمامنا على دراسة الاتجاهات الحديثة في تاريخ علم الفلك التعليمي أو علم الهيئة. ولكن قبل الشروع في ذلك دعوني أبدي بعض الملاحظات العامة التي ستساعدنا على فهم تطور هذا العلم العربي القديم.

دعوني أبدأ بمسألة كتابة تاريخ علم الفلك العربي ذاته. فمما يؤسف له في هذا المجال هو أن الذين يهتمون الآن بتاريخ الحضارة العربية، أو إن شئت بتاريخ التراث العربي، سواء كانوا مستشرقين أو عرباً، هم عامةً غيرُ متبحرين في علم الفلك بالذات لا القديم منه ولا الجديد. وبالمقابل فالذين يهتمون بعلم الفلك، وهم في الأغلب من المستشرقين، لا يهتمون عادة بالتراث العربي بل يصبون اهتمامهم على متطلبات علم الفلك الحديث، وينظرون بين الفينة والأخرى إلى نص فلكي تاريخي ليستطلعوا منه فقط بعض المقادير التي قد تفيدهم في

## الهوامش

١ - انظر وصية الملك اختوي لابنه مريكا رع في : أحمد فخري، مصر الفرعونية، مكتبة الانجلو المصرية، القاهرة ١٩٦٠، ص ص ١٧١ - ١٧٦.

٢ - انظر الجبرتي، عبد الرحمن: عجائب الآثار في التراجم والأخبار، الجزء الرابع.

٣ - راجع : عبد الرحمن الرافعي، عصر محمد علي، القاهرة ١٩٥١.

٤ - انظر سعيد ابراهيم ذو الفقار: الإمبريالية البريطانية فى مصر ١٨٨٢-١٩١٤، جنيف د. ت.

٥ - راجع : زين العابدين شمس الدين : الإدارة الإقليمية في مصر في عهد محمد علي . رسالة دكتوراة، آداب عين شمس ١٩٨٥.

٦ - انظر: رؤوف عباس: النظام الاجتماعى في مصر الاجتماعية والسياسية، تعريب رءوف عباس، القاهرة ١٩٨٣.

٧ - الكسندر شولش: مصر للمصريين. أزمة مصر الاجتماعية والسياسية، تعريب رءوف عباس، القاهرة ١٩٨٣.

٨ - للمزيد من التفاصيل راجع: أحمد زكريا الشلق: حزب الأحرار الدستوريين. دار المعارف. القاهرة ١٩٨٢.

٩ - للمزيد من التفاصيل راجع: عبد العظيم رمضان: تطور الحركة الوطنية في مصر ١٩١٨ - ١٩٣٦. القاهرة ١٩٦٨.

١٠ - عبد العظيم رمضان: دراسات في تاريخ مصر المعاصر، القاهرة ١٩٨١، ص ص ٢٢٧ - ٢٢٩.

١١ - المرجع السابق ص ص ٢٢٩ - ٢٤٠.

١٢ - للمزيد من التفاصيل راجع: علي الدين هلال ، السياسة والحكم في مصر، العهد البرلماني ١٩٢٣ - ١٩٥٢،القاهرة ١٩٧٧ ص ص ١٠٩ - ١٣٤.

١٣ - فاطمة حسين المصري، الشخصية المصرية من خلال دراسة مظاهر الفولكلور المصري، دراسة نفسية تحليلية انثروبولوجية، الهيئة المصرية العامة للكتاب، القاهرة ١٩٨٤، ص ١٥٧ ومابعدها.

١٤ - أحمد فخرى: المرجع السابق، ص ص ١٦٥ - ١٧٠.

١٥ - راجع: أحمد الحتة: تاريخ الزراعة المصرية في عهد محمد علي، القاهرة، ١٩٥٠، علي الجريتلي، تاريخ الصناعة في مصر في النصف الأول من القرن التاسع عشر، القاهرة ١٩٥٢، محمود السروجي: الجيش المصري في القرن التاسع عشر، القاهرة د.ت.، علي شلبي، المصريون والجندية، القاهرة ١٩٨٨.

١٦ - حول انتفاضات الفلاحين في القرن التاسع عشر، راجع: علي بركات: تطور الملكيات الزراعية في مصر وأثرها على الحركة السياسية. القاهرة ١٩٧٩، وانظر أيضا:
Bear, G. *Studies in the Social History of Egypt*.

كانت تلك هي المرة الأولى التي يشق فيها العسكر عصا الطاعة على «ولي النعم» منذ عهد محمد علي، وبدأ الضباط المصريون يلعبون دورا سياسيا فعالا منذ ذلك الحين، حتى انتقلت اليهم قيادة العمل السياسي فكانت ثورة ١٨٨١ – ١٨٨٢ التي عرفت بالثورة العرابية.

ولا عجب – إذًا – أن نجد الجماهير الفلاحية المصرية تتحمس لهذه الثورة وتؤيدها، فقد رأت الجماهير في شخص أحمد عرابي – زعيم الثورة – «المخلص» الذي جاء ليرفع عن كواهلهم الظلم الاجتماعي الذي عانوا منه سنين طويلة، فانقضوا على رموز الظلم الاجتماعي (كبار الملاك) وهاجموا أراضيهم، وطالبوا بتوزيع الأرض على الفلاحين، ولم يبخلوا على الثورة بالدعم المادي، بل أقبلوا علي التطوع في صفوف الجيش دفاعا عن الوطن ضد التدخل الأجنبي.

وهكذا كان صبر المصريين على مظالـم السلطة له حدود كان تجاوزها يقود الى الثورة والتضحية بالنفس بـأسلوب انتحـاري فـريد. ورغم غياب الوعي السياسي – بالمفهوم الحـديث – عندهم، إلا أن وعيهم الغريزي بتفاقم الظلم والاستبداد جعل حـركـاتهم في مواجهة تتسم بالعنف والقـوة وإن افتقرت دائما إلى التنظيم الجيد. وبعد الاحتلال البريطاني ارتبطت مقاومة استبداد السلطة بالنضـال الوطني ضد الوجـود البريطاني في مـصر، كمـا ارتبطت – بعـد ثورة ١٩١٩ – بالنكسات الـتي عاني منها مـشروع الاسـتقلال الوطني والقصور في السياسات التي مارستها الحكومات التي تعاقبت على السلطة قبل ثورة ١٩٥٢.

وقد ظلت مقاومة الفلاحين لتحديات السلطة تتخذ شكل الهبات التلقائية غير المنظمة التي يتم القضاء عليها بالقوة الغاشمة، وإنزال أشد العقوبات بالمشاركين فـيهـا دون اهتمـام بحل المشكلات الـتي قـادت إلى تلك الهبـات. وظل الفلاحـون يفتقرون إلى القيادات السياسيـة الواعية وإلى الخبرة بالنضال الجماعي والتنظيم فضلا عن غياب الوعي الطبقي بينهم. وعلى النقيض من ذلك كانت مقاومة العمال لاستبداد السلطة وللظلم الاجتماعي أكثر تنظيما: تتخذ شكل الاضرابات وحركات الاحتجاج واحتلال المصانع. وأدي تلاحم الطلبة مع العمال في مناسبات سياسية كثيرة إلى اضفـاء طابع التنظيم على حركـات الاحتجـاج الموجهة ضد السلطة فنظمت الاضرابات، وشكلت الجمعيـات العلنية والسرية، وساهمت فى ذلك بعض الأحزاب السياسية والجماعات الأيديولوجيه.

ولم تقف السلطة مكتوفة الأيدي في مواجهة حركـات الاحتجاج الجماهيرية ففرضت الأحكام العرفية لفتـرات طويلة، ولجـأت إلى القوانين الاسـتثنائية والى سلاح القـمع والاغتـيال والسجن إلى غير ذلك مـن وسائل واجهت بها السلطة مقاومة الجماهير لاستبدادها.

الفلاحين المجندين، فانضم الجنود بأسلحتهم الى الثائرين، واضطرت الحكومة لتجريد قوات جديدة تركية (عام ١٨٢٤)، واستمرت المعارك بين الطرفين نحو ستة أسابيع انتهت بهزيمة الفلاحين والتنكيل بهم.

ولم تخمد نيران الثورة في الصعيد، فحدثت هبات محدودة في مناطق كثيرة تواجه دائما بالقمع وإحراق القرى الثائرة، كما حدث هبات مختلفة في بعض مناطق الوجه البحري كالشرقية ومنطقة البراري شمال الدلتا. وكان ضيق الحال، وثقل عبء الضرائب، والتجنيد العسكري، والعمل الجبري (السخرة)، وعسف السلطة واستبدادها، من بين العوامل التي حركت جماهير الفلاحين ضد الحكومة في النصف الأول من القرن التاسع عشر.

وأمام تكرار الانتفاضات الشعبية في مواجهة مظالم السلطة أصدر عباس الأول (عام ١٨٤٩)، قانونا يشبه قوانين الطوارىء، قضى بضرب الحصار حول القرى الثائرة، والحكم على من يتزعم التمرد بالسجن المؤبد، والحكم على المشاركين فيه بالسجن ثلاث سنوات، مع مضاعفة العقوبة في حالة استخدام «المتمردين» للأسلحة النارية.

ورغم قسوة ذلك القانون، وبشاعة أساليب القمع التي اتبعتها السلطة في مواجهة الفلاحين الثائرين، شهد عصر اسماعيل عددا من الانتفاضات، كانت أخطرها انتفاضة جرجا (عام ١٨٦٥) بزعامة رجل يدعى «أحمد الطيب» استطاع أن يحشد وراءه جماهير الفلاحين في مواجهة شرسة مع قوات الجيش التي ألحق الفلاحون بها الهزيمة، واضطرت الحكومة الى تجريد قوات عسكرية كبيرة بقيادة أحد كبار الضباط، استخدمت المدافع لمواجهة الفلاحين الثائرين واستطاعت تصفية انتفاضتهم وقتل الآلاف منهم، ومن بينهم زعيم الثائرين.

ومع اشتداد الأزمة المالية، وزيادة الضرائب، وتشدد الجباة في تحصيلها، مع وقوع القحط الذي تطور إلى مجاعة، تعددت انتفاضات الفلاحين طوال سبعينات القرن الماضي فى طول البلاد وعرضها فرغم بطش الحكومة بالمشاركين في تلك الانتفاضات، كان واقع الجماهير التعس يحركها للدفاع عن حقها في الحياة في مواجهة سلطة غاشمة تحرم جماهير المنتجين ثمرة كدهم، لتنعم به الطبقة الحاكمة من كبار الملاك التي لم تتحمل من أعباء الضرائب الا النزر اليسير، بينما وقع على عاتق الفلاحين تمويل الخزانة العامة ومواجهة مطالب الدول الأجنبية صاحبة الديون.

ولم يقتصر العنف الثوري على جماهير الفلاحين وحدهم، بل امتد ليشمل ضباط الجيش (من أبناء الفلاحين) الذين ضاقوا ذرعا بالتمييز في المعاملة داخل الجيش بينهم وبين الضباط الشراكسة، واعترض فريق منهم على قرار صدر بتسريحهم، فكانت المظاهرة الشهيرة التي نظموها احتجاجا على التدخل الأجنبى في شئون البلاد والظلم الاجتماعي معا (فبراير ١٨٧٩)، والتي أجبرت الحكومة على الرجوع عن قرارها.

الجماهيري، والتي كان لها فضل تنصيبه واليا على مصر.

واتخذت المقاومة السلبية أشكالا مختلفة. كالإهمال المتعمد في تنفيذ التعليمات الخاصة بزراعة الأرض، وترك الأرض تعاني البوار، طالما كان عائد الإنتاج يذهب – في معظمه – إلى الدولة، أو حتى الفرار من القرى تخلصا من التزاماتهم الإنتاجية والمالية، وكذلك الهرب من المصانع التي جندوا للعمل بها قسرا، حتى اضطرت الحكومة إلى إلزام شيوخ القرى بكفالة عمال المصانع، وألزمتهم بإحضارهم في حالة الهرب من المصنع، وتعمدت تأخير دفع أجورهم شهورا حتى تربطهم بالمصانع، فلا يفرون منها على أمل استخلاص مستحقاتهم المالية.

ورغم أن الجيش الحديث والخدمة فيه، كان أول انصهار للمصريين في بوتقة المواطنة، وأول مصدر لنمو الشعور بالانتماء الوطني، ومبعث احساس الجندي المصري بقدراته وكفاءته، ورغم بسالة الجيش المصري الحديث في المعارك التي خاضها في المشرق العربي كله، إلا أن بقاء الجنود في الخدمة العسكرية دون تحديد لمدة زمنية معينة، حتى كان البعض يقضون سنوات عمرهم كلها شاكين السلاح، جعل الفلاح المصري يحاول التهرب من الجندية بإتلاف بعض أعضائه وإلحاق العاهات بنفسه حتى يصبح غير لائق للخدمة العسكرية، وإزاء انتشار هذه الظاهرة، اضطر محمد علي الى تشكيل فرقة عسكرية للقيام بالأعمال المعاونة للمجهود الحربي من أصحاب العاهات، حتى يؤكد للناس ألا سبيل للتخلص من الخدمة العسكرية، فيكفون عن إلحاق العاهات بأنفسهم تهربا من الخدمة العسكرية.

غير أن المقاومة السلبية لم تستمر طويلا، وخاصة أن الدولة لا حقت الفلاحين بمطالبها المالية إلى حد أعجزهم عن سدادها، ولم تترك لهم من عائد عملهم إلا ما يقل عن الوفاء بحاجاتهم الأساسية، فهبت انتفاضات فلاحية تلقائية، شهدت مصر عددا منها في عصر محمد علي، اتخذت طابع العنف، مثل انتفاضة الصعيد عام ١٨١٢ التي واجهتها السلطة بإحراق القرى الثائرة وذبح سكانها وانتفاضة فلاحي المنوفية عام ١٨٢٣ التي أخمدت بنفس الطريقة.

وشهد الصعيد عدة انتفاضات في عشرينات القرن التاسع عشر، بلغت إحداها حد التمرد على السلطة، وطرد موظفي الحكومة من الاقاليم، وإقامة نوع من السلطة الشعبية في قنا والمنطقة من حولها، واضطرت الدولة إلى استخدام الجيش لقمعها، فدار قتال حقيقي بينه وبين ما يقرب من أربعين ألف فلاح بقيادة شخص عرف باسم «أحمد المهدي»، ولم تهدأ الأقاليم إلا بعد تصفية الانتفاضة الشعبية وسقوط مئات القتلى من الفلاحين، وفرار الناجين منهم إلى الصحراء ليعودوا إلى التمرد على السلطة من جديد عندما نشبت انتفاضة أخرى من إسنا إلى أسوان وامتدت الى جرجا، واستفحل أمرها حتى كلفت الحكومة الجيش بقمعها. ولكن القوات التي توجهت إلى المنطقة الثائرة كانت – هذه المرة – من

وبعـثروا أشلاءهم، وصب الـشعب انتقـامـه على الأغنيـاء، فنهبوا الـقـصـور وأحرقوهـا ... وصب الناس نقـتمتهم على أطفال الأغنياء، فـصاروا يقذفون بهم الجدران ... حتى رجال الأمن أصبحوا في مقدمة النـاهبين ..». وهكذا ثار الفلاح الصابر المطيع عندما بلغ الظلم مداه، وبلغ التناقض الاجتماعى حد الأزمة، فلم يفرق بين معبد لإله، أو ديوان الحكومة، أو مـخزن للدولة، أو حتى مدفن لفرعون مقدس.(١٤)

وتاريخ مصر الإسلامية حافل بالانتفاضات الشعبية التي لم تخل من العنف والدمار، والتي وجهت ضد مظالم السلطة ، وبلغ عددها ثلاث انتفاضات كبيرة فى الدلتا والصعيد على مـدى نحو ربع القرن في مطلع القرن الثاني الهجـري (الثامن الميلادي)، وبلغت ذروتها زمن الأزمات الاقتصادية والمجاعات على طول العـهـد الإسلامي، ولم تقل عنفا ودمـارا عـمـا شـهـدنـاه في العـصـر الفرعوني.

كل تلك القـرائن التاريخـية تقـوم دليلا على عـدم قبول المصريين لضيم ورفضه للذل والمـهانة، واستهـجانهم للظلم وتحفزهم لمواجهته عندما ينفد صبرهم. وتلك القرائن تـدحض الربط بين نمط الانتاج الاقتصـادى والسلوك الجمعي للشعب، مثل الربط بين البيـئـة الزراعية والمسالمة والخنوع. غير ان ذلك لا يعني أن المصريين مـيالون بطبعـهـم للعنف وسفك الدماء ، فـالعنف في سلوكهم استثناء تدفعهم اليه ظروف معينة أفرزها الواقع التاريخي.

وفي عهد محمد علي الذي شهد بناء الدولة الحديثة - على نحو مارأينا - ضربت الدولة بإجـراءات التحديث الكثير من المؤسسات الاجتماعية التقليدية، فأضعفت طوائف الحرف دون أن تقوم بتصفيتها، ودخلت طرفا في مجتمع القرية الذي كان مغلقا على نفسه من قبل فـفـكت روابطه، وحركت شبابه من الأرض إلى الخدمة في الجيش الحديث، أو العمل في المصانع الجديدة. وأصبح المصريون مـسئـولين أمـام السلطة عن أعمالهم وسلوكهم كأفراد، بعد أن كانوا يتعاملون مع السلطة في العصر العثمانى كجماعات من خلال الطائفة أو القرية. غير أن السلطة لم تعن بتوعيتـهم لمـا تريد، أو تعبئـتهم مـعنويا لتحقيقـه، فهم ينتزعون من الأرض للخدمة العسكرية بدعوى الجهاد، ومن ثم عرف الجيش بـ «الجهادية»، دون أن يفهموا طبيعـة هذا الجهاد ومدى ضرورته وجدوى تلك الحروب التي يخوضونها. تعاملت معهم الدولة كأدوات تخدم أغراضها المختلفة، ولم تتعامل معهم كبشر، ومن هنا كانت مواقف الجماهير السلبية من نظام محمد علي - رغم خطورة مشروعه الحضاري والسياسي - ومن هنا كانت مقاومتهم السلبية للسلطة.(١٥)

وترجع تلك المقاومة السلبية الى غياب الوعي السياسي، وافتقاد القدرة على التنظيم، بقدر ماترجع إلى غياب القيادة الشعبية القادرة على تحريك الجماهير، بعد أن صفى مـحـمـد علي القيادات الشعبية التقليدية التي أتقنت أساليب الحشد

الأكابر، ومثل: «مهما الفلاح ارتقى تبان فيه الدقة». ولا يقف الأمر عند الاستسلام للواقع الاجتماعي بل يمتد الأمر الى تأييد السلطة المطلقة والثراء الواسع مثل «الاعتبار للمال مش للرجال» أو «أصلك فلوسك وجنسك لبوسك» أو «إذا شفت الفقير جري يبقى بيقضي حاجة للغني» و «طلب الغنى شققه كسر الفقير زيره». فالفقير يعمل مخلصا لخدمة السلطة ويتفاني في ذلك ثم ينال جزء سنمار «آخر خدمة الغز علقة»، وإن كان يستخف بذوي السلطان ويرى فيهم الفساد وخراب الذمم: «حاميها حراميها» و «إرشوا تشفوا» و«يفتي على الإبرة ويبلع المدراة».

وهكذا يفيض الأدب الشعبي بالتعبير عن معاناة الجماهير من بطش السلطة وماتركه في ضمير المصري من آثار نفسية سلبية لا زالت آثارها ماثلة في مجتمعنا إلى اليوم كاللامبالاة : «أردب ماهولك ماتحضر كيله، تتغير دقنك وماينوبك غير شيله». وفقدان روح المغامرة وإيثار السلامة: «امشي سنة ولا تخطي قناة». وفقدان الأمل فى إقامة العدل بغض النظر عن المكانة الاجتماعية : «المية ماتجريش في العالي». إلى غير ذلك من أمثال شعبية عبرت عن معاناة المصري الطويلة من استبداد السلطة والظلم الاجتماعي حتى شاع عند بعض الدارسين عزوف المصري عن الصراع وإيثاره السلامة وصبره على الظلم حتى أنه يتحمل من المظالم ماتنوء به كواهل البشر، وقلما يثور على واقعه التعس، التماسا لعون من السماء يدفع عنه الضيم، «اصبر على جار السوء لا يرحل لا تيجى له غارة» و«يابخت من بات مظلوم ما بتش ظالم» إلى غير ذلك من أمثال تدل على الخنوع والاستسلام والرضا بالواقع على غلاته، وعدم الطموح إلى تغييره.(١٣)

ورغم أن تحمل المصريين للظلم وصبرهم عليه حقيقة تاريخية لامراء فيها، إلا أن ذلك الصبر لم يكن أبدا بغير حدود ، فهناك حدود للطاقة على التحمل تنفذ عندما يتحول الأمل في الخلاص من الواقع التعس إلى سراب، عندئذ لا يبقى في قوس صبر المصري منزع للسهام ، فيهب الشعب عن بكرة أبيه هبات تلقائية تتخذ طابع العنف، وتلحق الدمار برموز الظلم والاستبداد.

وقراءة تاريخ مصر منذ أقدم العصور تزودنا بالأدلة الناصعة على انتفاض الشعب المصري عندما يتبدد أمله في الخلاص من واقعه الأليم، وعندما يفتقد أسباب العيش، وعدم قبوله الضيم ، وتنكيله بالمستبدين والظالمين على الصعيدين السياسى والاجتماعي.

ولعل أحداث الثورة الاجتماعية التى شهدتها مصر أواخر أيام الأسرة السادسة في عهد الدولة القديمة (عام ٢٢٨٠ قبل الميلاد) خير دليل على عدم استكانة المصريين للظلم، وانفجار غضبهم ، «فانقلبت البلاد الى عصابات، ولم يعد الناس يحرثون حقولهم، وأضرب الناس عن دفع الضرائب، وهجموا على مخازن الحكومة ونهبوها، واعتدوا على مقابر الملوك الآلهة فنهبوا مافيها،

خلال الهيئتين التشريعية والتنفيذية على رعاية مصالحهم الطبقية الضيقة وحدها، ووقفوا سدًا منيعًا فى وجه دعوات الإصلاح التي روج لها بعض من تميزوا ببعد النظر من مثقفي نفس الشريحة الاجتماعية، فرفضوا المقترحات التي قدمت لحل بعض جوانب المسألة الاجتماعية التي تفاقمت خلال تلك الفترة، ورأوا أن إبقاء الطبقات الفقيرة تعاني الفقر والجهل والمرض (ثالوث المسألة الاجتماعية عندئذ) أضمن لمصالحهم، فتقاعسوا عن محاولة إيجاد حلول للمسألة الاجتماعية التي زادت تفاقما، وأدت إلى استفحال مظاهر الرفض الاجتماعي التي قوبلت دائما بالقمع من جانب السلطة. وهكذا أدى غياب الوعي الاجتماعي عند الطبقة التي لعبت الدور الرئيسي في الهيئتين التشريعية والتنفيذية في تلك الحقبة إلى سحب البساط – تدريجيا – من تحت أقدامها، لصالح الجماعات الأيديولوجية التي استمدت جماهيرها من أبناء البوجوازية الصغيرة على وجه الخصوص، حتى قامت ثورة يوليو ١٩٥٢ لتقيم سلطة جديدة على أنقاض تلك التي أقامها دستور ١٩٢٣، وتوجه الضربات القوية للطبقة الاجتماعية التي لعبت الدور الرئيسي في ظلها.

لم تكن السلطة في مصر – إذا – سلطة شعبية، وإنما كانت أوتقراطية أساسا تتركز في يد الحاكم الفرد فرعونا كان أم خليفة أم سلطانا أم ملكا، تعاونه نخبة متميزة اجتماعيا اختصت بالثراء (الجاه) والنفوذ، عانت الجماهير من بطشها وعسفها واستبدادها، وترك ذلك كله أثره في الأدب الشعبي وفي كثير من العادات الاجتماعية النابعة من التمايز الاجتماعى والمعبرة عن الترتيب الهرمي (الهيراركي) للمجتمع المصري، مثل ترجل الفلاح عن دابته اذا مر بمجلس أحد الأعيان أو حتى انتزاعه والسير حافيا اذا مر أمام أحد هؤلاء، أو ماكان شائعا قبل ثورة يوليو ١٩٥٢ من تقبيل الفلاح ليد صاحب الأرض (السيد) حتى لو كان صبيا غض الأهاب.

واستخدم الوعاظ آيات قرآنية بعينها لتأكيد هذا التمايز والحض على طاعة أولي الأمر، والتسليم بالتفاوت في الثروات على أساس ان الله وحده مقسم الأرزاق، وازدراء الثروة والتنفير منها على أساس أن الفقير أقرب الناس إلى الله مما يدفع الفقير إلى الرضا بوضعه الاجتماعي وعدم التطلع إلى مابيد الغني، والقبول بالتمايز الاجتماعي «لكل صغير كبير ولكل رئيس مرؤوس» و«اللي مالوش كبير يشتري له كبير» و«لما انت أمير وأنا أمير مين يسوق الحمير» إلى غير ذلك من أمثال شعبية تعبر عن القبول والرضا بالتمايز الاجتماعي بل وعده أمرا طبيعيا.

كما تعبر الأمثال الشعبية عن الخضوع التام للسلطة والاستكانة لها كقولهم «اللي يتجوز أمي أقوله ياعمى» أو «ارقص للقرد في زمانه» أو «بلد بتـعبد تور، حش وارمي له» أو «طاطي رأسك مابين الروس أحسن الماشي عليك يدوس». وتعبر عن الرضا بالواقع واليأس من إمكانية تغييره مثل «إن طلع من الخشب ماشة يطلع من الفلاح باشا» فهناك استحالة أن يكون لأبناء الفلاحين شأن كأبناء

تولت فيها الحكم وزارات تتمتع بالشعبية السياسية تركزت معظم الإنجازات التي تحققت خلال الفترة، والتي كانت تقدر – عندئذ – باعتبارها مكاسب ذات بال مثل إبرام معاهدة ١٩٣٦ وإلغاء الامتيازات الأجنبية، وإلغاء صندوق الدين العام، وتأسيس جامعة الدول العربية، وصدور أهم التشريعات السياسية والاجتماعية، وانشاء ديوان المحاسبة، وديوان الموظفين، وغير ذلك من إنجازات تشريعية نتجت عن استقرار تلك الوزارات استقرارا نسبيا وتمتعها بشعبية لا يستهان بها.

كان الملك – اذًا – هو مصدر السلطات (وليست الأمة)، يشاركه فيها الإنجليز من خلال حقيقة وجود جيش الاحتلال على أرض مصر، ومن خلال ما كان لهم من حق التدخل في شئون مصر الدفاعية والتشريعية في إطار التحفظات الأربعة التي كفلها تصريح ٢٨ فبراير ١٩٢٢، ثم من خلال ماتمتعت به «الحليفة بريطانيا» من مزايا وفرتها معاهدة ١٩٣٦ بعد إبرامها.

وكيفت الأحزاب السياسية الليبرالية نفسها مع هذا الوضع (بما فيها الوفد)، فجعلت من الوصول إلى السلطة هدفا لها لتحقيق الاستقلال الوطني (الذي تراه) بوسيلة واحدة هى المفاوضات، غير أن هدف الوصول إلى السلطة احتل مركز الصدارة على حساب الغاية المنشودة من ورائه (الاستقلال الوطني)، وتجلى ذلك في المهاترات التي حفلت بها الصحف الحزبية على مر تلك الحقبة، وفي ارتماء أحزاب الأقلية في أحضان قصر عابدين (الملك) تارة وتمسحهم بأعتاب قصر الدوبارة (دار المندوب السامي ثم السفارة البريطانية بعد ١٩٣٦) تارة أخرى، للحصول على جواز المرور إلى السلطة، ولم يسلم الوفد من ذلك – أيضا – فكان دخوله انتخابات ١٩٢٤ بعد وفاق مع القصر، وكانت الانتخابات الحرة التي حملته إلى السلطة في ١٩٣٦ و ١٩٥٠ نتيجة رضاء الانجليز والملك عن اتاحة الفرصة له للعب دور محدود ينتهي باقالة وزارته عندما يرى الطرفان أنه قد أدى دوره أو عندما يحسون أنه قد هم يتجاوز ذلك الدور. وفرض الإنجليز حكومة الوفد على الملك فرضا (حادث ٤ فبراير ١٩٤٢) عندما اقتضت مصلحتهم وجوده في السلطة.

وفي ظل ماسمي بالتجربة الليبرالية، كانت السلطة مغنما عند كل الأحزاب السياسية التي وصلت إليها (بما في ذلك الوفد)، تسعى للإستفادة من وجودها المحدود المدى بتحقيق أكبر قدر من المكاسب الشخصية لقيادتها وأنصارها، وإن تميز الوفد بمحاولة تحقيق بعض المطالب التشريعية للجماهير المصرية في أضيق الحدود، بما لا يضر بالمصالح الخاصة بالشريحة العليا من البورجوازية المصرية ضررا بالغًا، ويحقق استرضاء قطاعات من الجماهير التي يستند إليها في شعبيته (على نحو ماحدث في عهد وزارة ٤ فبراير ١٩٤٢).

وفي ظل ذلك النظام، أخليت ساحة البرلمان والسلطة للشريحة العليا من البورجوازية المصرية من كبار الملاك الزراعيين وأصحاب الأعمال، فعملوا من

الفترة. فقد حل برلمان ١٩٢٤ (الذي انعقد في مارس) في ديسمبر من نفس العام. وعندما أجرت وزارة أحمد زيور باشا الانتخابات اجتمع مجلس النواب الجديد يوم ٢٣ مارس ١٩٢٥ ليحل في اليوم نفسه. وانعقد البرلمان الثالث في يوليو ١٩٢٦ لدورات ثلاث، ثم أوقف محمد محمود باشا الحياة النيابية لمدة ثلاث سنوات قابلة للتجديد (عام ١٩٢٨)، ولكن وزارته سقطت قبل انتهاء تلك المدة. وانتخب برلمان رابع في يناير ١٩٣٠ ليحل فى السنة نفسها (وهى الفترة التى شهدت الإطاحة بدستور ١٩٢٣، واصدار دستور أكتوبر ١٩٣٠) ووضع قانون انتخاب جديد ضيق من حق الانتخابات وقصره على شرائح اجتماعية معينة وفي ظل هذا الانقلاب الدستورى انتخب برلمان خامس استمر أربع دورات تشريعية قطعها عودة دستور ١٩٢٣ من جديد تحت ضغط الحركة الوطنية (ديسمبر ١٩٣٥)، وانتخب البرلمان السادس في ظله (مايو ١٩٣٦)، ولم يستمر أكثر من عامين، وقام البرلمان السابع في ابريل ١٩٣٨، والثامن في مارس ١٩٤٢، والتاسع في يناير ١٩٤٥، والعاشر في يناير ١٩٥٠.(١٢)

ومع عدم استقرار الحياة النيابية خلال تلك الحقبة، عانت مصر من عدم استقرار السلطة التنفيذية، فتعاقبت الوزارات على الحكم الواحدة تلو الأخرى، ولم تعمر أي منها الا أربعة عشر شهرا في المتوسط، مما كان له آثاره السلبية على الأدارة الحكومية، وحال دون متابعة السياسات التى كانت تتبناها تلك الحكومات المتعاقبة.

ومن الغريب أن تشكيل البرلمانات العشرة التي شهدتها مصر خلال تلك الحقبة كان يتناقض تناقضاً كبيرا من مجلس تشريعى لآخر، فنجد الحزب الذي أحرز الأغلبية في مجلس نيابي، يحتل مقاعد الأقلية في المجلس الذي يليه، وقد تتحول هذه الأقلية إلى أغلبية ساحقة في برلمان تال ينتخب بعد شهور قليلة، وهلم جرا، دون أن يكون هذا التحول انعكاسا حقيقيا لتغير موازين القوى على الساحة السياسية. أو يكون تعبيرا عن انحسار الشعبية عن حزب سياسي لصالح حزب آخر أو عن تغير اتجاهات الرأي العام، بقدر ماكان تعبيرا عن مكونات «طبخة الانتخابات» ولم يستطع حزب الأغلبية (الوفد) الذي كان يقود الحركة الوطنية أن يصل إلى الحكم إلا من خلال انتخابات تجريها وزارات محايدة في ظروف معينة تفرضها مقتضيات الحالة السياسية.

وهكذا كانت الديمقراطية الليبرالية التي عرفتها مصر قبل ثورة يوليو ١٩٥٢ ديمقراطية وهمية، وكان الحكم - في حقيقة الأمر - أو تقراطيا بيد الملك، تعاونه نخبة محدودة من الشرائح العليا للبورجوازية المصرية ربطتها بالقصر روابط التحالف والمصالح المشتركة. ويتضح ذلك عندما نقارن عدد السنوات التي انفرد فيها القصر بالحكم من خلال أحزاب الأقلية بعدد السنوات التي حكم فيها الوفد باعتباره حزب الأغلبية البرلمانية. ففى الفترة الواقعة بين ١٩٢٤ - ١٩٥٢ حكم القصر مدة تقرب من ٢٩ عاما بينما حكم الوفد أقل من ثماني سنوات، وحكم مؤتلفا مع الأحرار الدستوريين لمدة عامين. وخلال تلك السنوات العشر التي

وقد ترك الدستور أهم نقطة في الحكم النيابي دون أن يحددها التحديد الكافي مثل سلطة الوزراء وصلتهم بالشعب ممثلا فى نوابه من جهة، وإشرافهم على ما يؤدي اليه من خدمات عن طريق المصالح والإدارات من جهة أخرى. كما أجمل إجمالا مخلا فى بيان موقفهم من رئيس الدولة (الملك)، واكتفى بأن يصوغ ذلك فى عبارات غامضة تحتمل كل تأويل.

وقد أدت السلطات الكبيرة التي خص بها الملك نفسه في الدستور الذي صدر كمنحة من الملك للشعب، أدت إلى إضعاف التجربة الليبرالية والاضرار بالدستور، فاتخذ القصر من أحزاب الأقلية أدوات يستند إليها في حكمه، وزيفت الانتخابات ليتم بذلك القضاء على المبدأ القائل بأن الأمة مصدر السلطات، والذي يمثل محور الليبرالية. وامتدت عمليات التزوير لتشمل جداول الانتخابات، فتم استغلال النص الذي يقضي بتحرير جداول الانتخابات بواسطة مأموري الأقسام والمراكز والعمد، فقامت الإدارة بوضع جداول ملفقة تتضمن تكرارا للأسماء، وأسماء أشخاص لا وجود لهم وأسماء الموتى، وكانت الانتخابات تجري وفق هذه الجداول التى لا تعبر عن المواطنين تعبيرا دقيقا، وتفتح الباب على مصراعيه لتزوير ارادة الشعب.

ومما زاد الطين بلة، قيام الإدارة بحجب التذاكر الانتخابية عن أنصار الخصوم، إذ جرت العادة على أن يعاد طبع التذاكر الانتخابية قبل إجراء انتخابات مجلس النواب، وكان يتولى توزيعها العمد في القرى وأقسام الشرطة في المدن، فكان من السهل عدم تسليم التذاكر لأنصار خصوم الحكومة، ومن ثم يتم التحكم فى نتيجة الانتخابات. وأصبح وزير الداخلية في الحكومة التي تتولى إجراء الانتخابات يملك تحديد شكل مجلس النواب. هذا فضلا عن ارهاب الأميين من الناخبين (وهم الغالبية) الذين كانوا يصوتون شفاهة، فكان الاعتداء نصيب من يعطي صوته لغير أنصار الحكومة.

أضف إلى ذلك ماشاع من رشوة الناخبين وشراء أصواتهم من جانب بعض المرشحين وخاصة فى المدن، وماجرت عليه العادة من تخلص الحكومات من العمد والمشايخ المعارضين لها بفصلهم قبل الانتخابات لضمان نجاح مرشحي السلطة.(١١)

وهكذا كانت المارسات الانتخابية في الحقبة المسماة بالليبرالية تمسخ جوهر النظام الليبرالي الذي يقوم أصلا على الإرادة الحرة للناخب فى اختيار من ينوب عنه ويمثله في المجلس النيابي، فنادرا ماكانت نتيجة الانتخابات تعبر تعبيرا صادقا عن الإرادة الحرة للناخب، وبذلك لم يكفل دستور ١٩٢٣ لمصر حياة ديمقراطية صحيحة. ولعل ذلك يفسر عدم استقرار الحياة النيابية في مصر في الحقبة الليبرالية، فمنذ برلمان ١٩٢٤، توالت على مصر عشر هيئات نيابية حتى قيام ثورة يوليو ١٩٥٢، ولم يكمل برلمان واحد سنواته الخمس على مدى تلك

التى تحمل جنود الاحتلال، واقتلعت قضبان السكك الحديدية، وهـوجمت مراكز الشرطة، وفى نفس الوقت هوجمت قصور كبار الملاك ونهبت، ونظمت المظاهرات العارمة والإضرابات.

ولعل ضراوة العنف الوطني الذي صاحب ثورة ١٩١٩ كانت وراء اتجـاه أغلبية «الوفد المصـري» إلى محاولة التوصل إلى اتفاق مع بريطانيا حـول صيغة استقلال ذاتي، فقد خشى الباشاوات من اندلاع أتون الغضب الشعبي الذي طال مصالحـهم بقدر ماطال مصالـح الاحتلال البريطاني، ومن ثم كان ميل أغلبـيتهم إلى مقابلة الإنجليز في منتصف الطريق والركون إلى الاعتدال.

وهكذا صـدر تصريح ٢٨ فبراير ١٩٢٢ – الذي وصفه سعـد زغلول بـ «النكبة الوطنية» – ليعطي مصر استـقلالها منقوصاً، وشكلت لجنة إدارية لإعداد الدستور وصفها سعد زغلول بـ «لجنة الأشقياء» وفرض على مصر إطاراً جديداً للسلطة حدده دستور ١٩٢٣.(٩)

وانطلق الدستور من مـقومات الليبرالية، فقـام على فكرة الحريات الفردية، واشتمل على بـاب للحقوق والحريات العامـة يدور حول مقومين رئيسيين هما: المساواة والحـرية، فنص على المساواة بين المصريين جميعاً أمـام القانون، وفى التمتع بالحقـوق المدنية والسياسية، وفى تولي الوظائف العامة، وفيما عليهم من الواجبـات العامة، فلا تميـيز بين المواطنين بسبب الأصل أو اللغـة أو الدين. كذلك اقر الدستور للمواطنين الحـرية الشخصـية، وحرية الاعتـقاد، وحـرية الرأي والاجتماع، وحق تكوين الجمعيات، وحق مخاطبة السلطات العامة، وضمن حرمة المنازل والملكية الخـاصة، فحظر انتزاعها إلا للـمنفعة العامـة، وفق القانون، كـما حظر مصادرة الثروات ونفي المصريين خارج البلاد.

ورغم النص على أن الأمة مـصدر السلطـات، وأن يكون الحكم نيابيـا، ويتمتع مجلس الوزراء بالهيمنة الكاملة على مـصالح الدولة، ومسئوليـة الوزراء تضـامنيـة أمام مـجلس النواب، تمتع الملك بوضـع خـاص في الدستور، فـذاته مصـونة لا تمس، ولا يتحمل مسئولية، ويمارس سلطاته من خلال وزرائه، ولا تنفذ توقيـعاته في شـأن من شـئون الدولة إلا إذا وقع عليهـا رئيس الوزراء والوزراء المختصون، وأوامره لا تخلي الوزراء من المسئوليـة (سواء كانت شفهية أو مكتوبة). ومع ذلك كان للملك حق إصدار مراسيم لها قوة القانون، كما كان له حق تعيين الوزارات وإقـالتها، وحق حل مـجلس النواب حلا مطلقا دون شروط. واحتفظ الملك لنفـسه بحق إنشاء ومنح الرتب والنياشين، وتولية وعـزل الضباط، وتصريف شئون الأزهر ومعاهده الدينية والأوقاف. وجعله الدستور متحكما في التصديق على القوانين عن طريق الأعضاء المعينين في مجلس الشـيوخ (٢/٥ الأعضاء) وكذلك كل مـايـتصل بتـعديل الدستور (الذي اختـص به مـجلس الشيوخ).(١٠)

منتجي القطن الذين ارتبطت مصالحهم المادية مع السوق البريطانية ، الذين رأوا في (إصلاحات) الاحتلال مبرراً لوجوده، فقبلوا به وبالتعامل معه مادام يعمل – من وجهة نظرهم – على تطوير مصر، ورأوا أنه عندما يرى مصر قد تقدمت (بفضله)، وأن أهلها أصبحوا مؤهلين لحكم أنفسهم بأنفسهم. فسوف يبادر بالجلاء بعدما يجد أن مهمته قد انتهت ، وأن رسالته (الحضارية) قد انجزت، ولا بأس من تنظيم علاقة مصر ببريطانيا على أساس تعاقدي في صورة معاهدة تضمن لبريطانيا مصالحها الاستراتيجية في إطار علاقة (صداقة) بين البلدين. (٨)

وهكذا خلت الساحة أمام الأعيان وحزبهم «حزب الأمة» فقبلوا بالتعاون مع بريطانيا – ومعهم النخبة التركية الشركسية – خلال الحرب العالمية الأولى، على أمل أن تقدر بريطانيا لمصر وقوفها إلى جانبها وقت الشدة، فتمنحها درجة من درجات الاستقلال، لابد أن ترتقي معها مصر مدارج الاستقلال خطوة خطوة حتى تحقق الاستقلال التام.

ومن رجال حزب الأمة المعتدلين «العقلاء» كان تشكيل «الوفد المصرى» عام ١٩١٨ ، بعد مقابلة ١٣ نوفمبر الشهيرة التى شارك فيها ثلاثة من أقطاب حزب الأمة على رأسهم سعد زغلول باشا للسعي لتحقيق الاستقلال بالطرق «السلمية»، وحرص سعد أن يمثل في الوفد عناصر من الأقباط والحزب الوطني وان ظلت أغلبية «الوفد» لرجال حزب الأمة.

كان المصريون قد بلغوا الحد الأقصى من تحمل مظالم السلطة خلال الحرب العالمية الأولى حيث نهب الريف المصري، وسخرت قواه العاملة في خدمة المجهود الحربي لبريطانيا وحلفائها، وبلغت تكاليف المعيشة ضعف ما كانت عليه قبل الحرب، وأدت عودة المصنوعات الأجنبية إلى التدفق على السوق المصرية عند نهاية الحرب إلى إغلاق المصانع التي قامت خلال الحرب أبوابها وتخفيض بعضها لإنتاجها، وتفاقم مشكلة البطالة ، وضاق الناس ذرعاً بالاحتلال وتطلعوا إلى إزاحة كابوسه من بلادهم.

لذلك أعطى المصريون تأييدهم للوفد على أمل أن ينجح المعتدلون فيما أخفق فيه المتطرفون. فإذا كان النضال الشعبي قبل الحرب الأولى قد عجز عن أن يزحزح بريطانيا عن موقفها ،فلعل الباشاوات دعاة التعاون مع الإنجليز يكونون وجوهاً مقبولة عند بريطانيا، تثق في نواياهم وتقدر لهم موقفهم، فتقبل التفاوض معهم حول الاستقلال، وخاصة أنهم كانوا على استعداد لإبرام معاهدة صداقة وتحالف معها تحفظ لبريطانيا مصالحها الاستراتيجية. وإذا ببريطانيا تتنكر لأصدقاء الأمس، وتنفى قادة الوفد وعلى رأسهم سعد زغلول باشا، وهنا انفجر بركان الغضب الشعبي في ثورة عارمة (مارس ١٩١٩)، وخرج الفلاحون والعمال والطلبة والموظفون والنساء ربات الخدور، ليصبوا غضبهم على رموز السلطة، سلطة الاحتلال، ورموز الاستغلال الاجتماعي معاً، فهوجمت القطارات

وكان «الأفندية» أكثر الفئات المصرية انفتاحا على المؤثرات المختلفة الداخلية والخارجية ، وأكثر الفئات الاجتماعية تقبلاً للجديد . واستطاع أفرادها أن يطوروا حياتهم على نحو جديد في نمط معيشتهم وأزيائهم وعلاقاتهم الأسرية تشبها بالأرستقراطية التركية أحيانا وبالأجانب أحيانا أخرى ، ولم يقطع بعضهم الصلة بأصولهم الريفية وإن ظلوا يتعالون عليها.

ورغم هذه المشاركة النسبية للمصريين في الإدارة ظل طابع السلطة أوتقراطيا استبداديا طوال الفترة السابقة على صدور دستور ١٩٢٣ . فلا يعني وجود مجالس نيابية في مصر منذ عام ١٨٦٦ عندما أنشأ اسماعيل «مجلس شورى النواب» أن ثمة مشاركة شعبية في السلطة عرفتها مصر في ذلك الحين، لأن نشوء الحياة النيابية – على هذا النحو – لم يأت نتيجة الصراع بين الجماهير والسلطة المطلقة بغرض الحصول على حق المشاركة في السلطة ؛ وتقييد الحكم بقيود دستورية تحفظ للأمة حقوقها وتجعلها مصدر السلطات ، وإنما كان قيام الحياة النيابية استكمالاً لمظاهر الدولة الحديثة وفي صورة منحة من الحاكم جعلت اختصاصاته محدودة، للحاكم أن يقبل مشورته أو يرفضها دون إبداء أسباب ، كما جعلت عضويته قاصرة على مشايخ القرى والعمد والأعيان الذين شكلوا الزعامات التقليدية للريف، وجاء إشراكهم في هذا الاطار النيابي بهدف الحصول على تأييدهم للحكومة وتسهيل مطالب الحكومة عند الأهالي . ولم يتحول الأعضاء إلى معارضة وطنية حقيقية إلا عندما شجعهم إسماعيل على ذلك عام ١٩٧٩ لتخفيف ضغوط الدول الأجنبية عليه ، وهو تطور لم يستفد منه إسماعيل (الذي عزل من منصبه) بقدر ما أفاد به الأعيان الذين طوروا حركتهم والتحموا بالعسكريين من المصريين خلال أحداث ثورة ١٨٨١ المصرية المعروفة بالعرابية.(٧)

وإذا كان الاحتلال البريطاني قد حرص على إقامة نظام نيابي من ثلاث درجات هي : مجالس المديريات ، ومجالس شورى القوانين والجمعية العمومية ، فإن ذلك لم يهدف إلى إتاحة الفرصة أمام المصريين للمشاركة في السلطة ، وإنما كان يهدف إلى استقطاب الأعيان لتأييد سياسة الاحتلال ، والتعرف على رغباتهم وتوجيه القرارات بالقدر الذي لا يضر بمصالح أولئك الأعيان مع إسقاط بقية المصريين تماما من الحساب. ورحب الأعيان بهذه الرعاية (السامية) من جانب الاحتلال فقبلوا بالتعاون معه باعتبارهم «أصحاب المصالح الحقيقية» بين المصريين بحكم كونهم كبار الملاك الزراعيين ، وبادلهم الاحتلال الود فعدهم «العقلاء» في مواجهة أبناء الطبقة الوسطى الصغيرة من الأفندية الذين شكلوا جماهير الحزب الوطني فيما بعد بزعامة مصطفى كامل ومحمد فريد الذين عدَّهم الاحتلال «المتطرفين»

وهؤلاء المتعاونون أو «المعتدلون» كما سماهم رجال الاحتلال ، هم الذين خلت أمامهم الساحة السياسية بعد ضرب الحزب الوطني قبل الحرب العالمية الأولى ، «أصحاب المصالح الحقيقية» كما كانوا يطلقون على أنفسهم ، كبار

فيها ويبدل وفق هواه : فهو تارة يعدلها أو يوقفها أو يلغيها ، وتارة أخرى يعيد نشاطها ويهتم بمشورتها . فالأمر مرده إليه وحده وبدأت تظهر تدريجيا فروع لكل إدارة حكومية في صورة مجلس أو ديوان كديوان الجهادية (الحربية) وديوان البحرية ، وديوان التجارة والشئون الخارجية ، وديوان المدارس (التعليم) وديوان الأبنية والأشغال ، ثم ديوان الفاوريقات (الصناعة) ، ووضعت – لأول مرة – اللوائح التي تحدد اختصاصات هذه الدواوين وواجبات موظفيها ، ودرجاتهم ، وطرق تأديبهم ، وعلاقة الدواوين بالديوان الخديوي الذي اختص بالنظر في الشئون الداخلية إلى غير ذلك من أمور أوجبها التنوع في وظائف السلطة مع نشأة الدولة الحديثة مثل إنشاء محكمة خاصة للنظر في جرائم كبار الموظفين عرفت باسم «جمعية الحقانية» وأخرى للنظر في المنازعات التجارية عرفت باسم «مجلس التجارة» . واستمر هذا النظام بصورة أو بأخرى حتى أدخل نظام الوزارة عام ١٨٧٨.(٥)

وكانت الوظائف الكبرى – حتى أواخر القرن التاسع عشر – تكاد تكون وقفا عل الأستقراطية التركية التي كانت تضم أخلاطا من أتراك آسيا الصغرى والمغرب وتونس ، والشراكسة ، بالاضافة إلى الأكراد والشوام والأرمن ، وكان العنصران الأخيران هما الغالبين على مناصب الإدارة المالية والأمور الخارجية لإتقانهم لها وللغات الأجنبية . ولم يكن يجمع بين تلك العناصر سوى التمسك بأساليب الحياة التركية ، واتخاذ التركية لغة للحديث والمعاملة ، واشتملت تلك الفئة على بعض المصريين الذين هيأت لهم ثقافتهم وإجادتهم للغة التركية فرصة ولوج الوظائف الكبرى والمشاركة في الإدارة. غير أن عددهم كان محدوداً، وحرص الحكام على صبغهم بالصبغة التركية ، فكانوا يزوجونهم من جواريهم المعتقات التركيات ، والشركسيات حتى يألفوا العادات وأساليب الحياة التركية، وكان من يحظى بهذا (الشرف) من المصريين يصبح مؤهلاً لتولي المناصب الكبرى . وترتب على ذلك كسر حدة انعزال الأتراك على أنفسهم (إلى حد ما)، وحمل اليهم دماء جديدة ازداد تدعيمها نتيجة حرص كبار الموظفين من المصريين والأعيان من كبار الملاك على الإصهار الى العائلات التركية ، مما أدى إلى إيجاد روابط وصلات اجتماعية بين الأتراك وبعض عائلات أعيان المصريين .

وبعد الاحتلال أصبحت الوظائف الحكومية الكبرى من نصيب الأوربيين عامة والإنجليز خاصة ، واتجهت سلطات الاحتلال إلى إسناد الوظائف الهامة إلى الجيل الجديد من أبناء الأعيان المصريين والأتراك الذين تلقوا ثقافة غربية بالجامعات الأوربية فكان منهم المديرون وبعض رجال الإدارة والقضاء والنيابة.(٦)

أما وظائف الإدارة الدنيا في قطاعات المالية والنقل والخدمات (السكك الحديدية، البرق ، البريد ، المديريات الإقليمية) فكانت من نصيب المصريين من فئة «الأفندية» الذين أفرزهم نظام التعليم الحديث سواء في ذلك المدارس الحكومية أو الأهلية التي أنشأتها الجمعيات الاسلامية والقبطية وكان من بينهم بعض الشوام.

المختلط المظلة القانونية التي وفرت الحماية لرأس المال الأجنبي في حركته في السوق المصرية .

وهكذا شهد النصف الثاني من القرن التاسع عشر نصب شباك التبعية حول مصر ، التي أدت – في نهاية الأمر – إلى تحويل مصر إلى وحدة متخصصة في إنتاج المواد الأولية (وخاصة القطن) لخدمة السوق الرأسمالية العالمية ، وكان من الطبيعي أن يتوج هذا التحول بالتدخل السياسي والعسكري الأجنبي بحجة حماية المصالح الأجنبية في مصر ، والذي تمثل في الاحتلال البريطاني عام ١٨٨٢ .

وفي ظل الاحتلال البريطاني ، تم إحكام روابط التبعية الاقتصادية بجعل مصر وحدة متخصصة في إنتاج القطن لخدمة الصناعة البريطانية ، وأجهضت كل المحاولات التي قام بها بعض المصريين لإقامة صناعة وطنية . وبلغت التبعية ذروتها بربط الجنيه المصري بالجنيه الاسترليني عام ١٩١٤ ، وبذلك كان الاقتصاد المصري أشبه مايكون بالبقرة الحلوب التي ترعى على أرض مصر . وتمتد ضروعها عبر البحر المتوسط لتحلب في أوربا ، فقد كان هناك ضخ منتظم لفائض الإنتاج الاقتصادي المصري إلى بنوك أوربا في صورة فوائد وأقساط القروض ، وعائدات رؤوس الأموال الأجنبية الموظفة في مصر.(٤)

وكان أبرز نتيجة لهذه التبعية انعكاس أزمات العالم الرأسمالي على الاقتصاد المصري ، فعانت مصر من أزمة ١٩٠٧ . كما عانت من الكساد العالمي الكبير (١٩٢٩ – ١٩٣٢) . هذا فضلا عن تعبئة الاقتصاد المصري لخدمة بريطانيا وحلفائها في الحربين العالميتين الأولى والثانية . مما عرض البلاد لأزمات اقتصادية واجتماعية كان لها صداها فيما بين الحربين العالميتين .

هذا التطور الذي شهدته مصر منذ مطلع القرن التاسع عشر كان له انعكاسه على بنية السلطة في مصر الحديثة منذ محمد علي الذي كان يستند إلى نظام إداري محكم اتسم بالمركزية المطلقة ، حرص على إعلاء كلمة السلطة وبسط هيبتها في جميع أنحاء البلاد وعلى جميع ساكنيها ، بعد إزالة كل الحواجز التي تحول بينه وبين الاتصال المباشر بالشعب دون وسطاء ، وأخضعت الوحدات الإدارية في الأقاليم لسلطان الحكومة المركزية المطلق مع اهمال تطوير الهيئات الإدارية المحلية .

وارتبطت بتلك المركزية في الحكم أوتوقراطية شديدة ، فالحكم في مصر كان مرده إلى إرادة الحاكم ، ومن ثم كان محمد على حريصاً على البت في شتى المسائل المتعلقة بمختلف نواحي الحكم الجليلة والبسيطة على حد سواء . وكان لا بد من إيجاد مؤسسات إدارية يتدرب من خلالها الموظفون على أداء مايسند إليهم من أعمال . ومن ثم كانت المجالس المختلفة التي أنشأها محمد علي لتقديم المشورة في المسائل الإدارية والعسكرية ، وان لم يعمل على إعطاء تلك المجالس فرصة النمو الذاتي من خلال تدعيم سلطاتها وتحسين أوضاعها ، فكان يغير

ذلك التطور الذي شهدته مصر في عهد محمد علي (١٨٠٥ – ١٩٤٨) كان يمثل تجربة تنمية تعتمد على الامكانات الذاتية لمصر ، فرغم الضخامة النسبية للمشروعات الإنمائية التي تمت في إطار تلك التجربة ، لم تقم إلا على أكتاف مصر وحدها ، باستثمارات مصرية خالصة ، قدم فيها المصريون – مرغمين – ثمرة كدهم وجهدهم وعرقهم ، ولم يكن هناك مجال لأي استثمارات أجنبية ، فلم تعقد مصر قروضا لتمويل مشروعاتها الإنمائية أو السياسية ، وبذلك لم تتح لرأس المال الأجنبي الفرصة للتسلل الى مصر ، بما يتبعه من نفوذ سياسي . وطوال مايزيد على الأربعين عاما كان القرار السياسي قراراً مصرياً يعبر عن مصالح مصر وحدها ، ولم يكن نتاجاً لضغوط خارجية.(٣)

ولعل ذلك يفسر الشراسة التي ضربت بها القوى الإمبريالية التجربة المصرية في تسوية ١٨٤٠ – ١٨٤١ الشهيرة ، بما تضمنته من إلزام محمد على وخلفائه بتطبيق المعاهدات المبرمة بين السلطان والدول الأجنبية وكان من شأن تطبيقها فتح السوق المصرية على مصراعيها أمام البضائع الأجنبية ، واتاحة الفرصة للتجار الأجانب للتعامل مباشرة مع المنتجين في السوق المصرية . وكان معنى ذلك ضرب تجربة التنمية المصرية بالاعتماد على الذات ، عن طريق كف يد الدولة عن إدارة الاقتصاد الوطني ، وتقليص موارد الدولة المالية لتقتصر على الضرائب وحدها ، بدلا من استئثارها بفائض الانتاج الاقتصادي كله ، لا ليذهب إلى المصريين – أصحابه الشرعيين – ولكن ليضخ الى الخارج في خزائن البنوك والشركات الأوربية . ومعنى ذلك تصفية الدور الذى تلعبه الدولة في عملية التنمية ، واجهاض تجربة التحديث المستقلة التي بدأت تتشكل في عهد محمد علي.

ولما كانت مصر قد خطت – في ذلك العهد – خطوات واسعة في طريق ربط السوق المصرية بالسوق العالمية من خلال التوسع في إنتاج المحاصيل النقدية وخاصة القطن ، فإن ضرب تجربة الصناعة الحديثة في مصر التي كانت تستهلك جانبا لا بأس به من هذه المحاصيل باعتبارها مواد أولية ، جعل الاقتصاد مهيأ للعب دور أساسي كمورد للمحاصيل النقدية للسوق العالمية ، بقدر مالعبت السوق المصرية دوراً ملحوظا في جذب رؤوس الأموال الأجنبية للاستثمار في مصر .

وأدى اختفاء دور الدولة كممول أساسي للإنتاج الزراعي إلى وجود فراغ ملأته رؤوس الأموال الأجنبية مع غياب بديل مصري يتمثل في طبقة من الممولين المصريين ، وجاء ذلك إما في صورة استثمارات مباشرة في قطاع العقارات والخدمات ، أوفي شكل قروض للدولة استخدمتها في استكمال مشروعات البنية الأساسية التي تيسر سبل ربط السوق المصرية بالسوق الرأسمالية العالمية (كالري والسكك الحديدية ، والبرق ، وتطوير المدن ، وغيرها من الخدمات) ، أو في صورة مشروعات استراتيجية تخدم المصالح الإمبريالية بالدرجة الأولى (مثل قناة السويس) . وقدمت الامتيازات الأجنبية والنظام القضائي القنصلي ثم

العيش ، وعز القوت وغاب الأمن ، أما اختلال ميزان العدل ، فكانوا دائما أكثر صبرًا عليه.

ومع مطلع العصر الحديث ، شهدت مصر تغيراً في مفهوم المصريين للسلطة أخذ ينمو تدريجيا مع بداية القرن الماضي (التاسع عشر) ، كأثر هام من آثار الحملة الفرنسية على مصر (١٧٩٨ – ١٨٠١) ، فقد تحمل المصريون عنت العثمانيين والمماليك وطغيانهم وظلمهم طالما كانوا يوفرون لهم الحماية والأمن ، فإذا بهم يعجزون عن ذلك في مواجهة (الفرنجة) ، فقد قضت الحملة على سطوة المماليك على البلاد ، وكسرت شوكتهم وأظهرت ضعفهم وعجزهم أمام المصريين، الذين رأوا – لأول مرة – أن بإمكانهم الاعتماد على أنفسهم دون المماليك للدفاع عن ديارهم وأعراضهم ، وأدت مشاركة نخبة المصريين فى المجالس التى أقامها بونابرت فى مصر إلى تغير نظرتهم إلى السلطة ، ولحقوق المحكومين قبل الحكام ، وواجبات الحكام نحو المحكومين ، فكان لذلك أثره البارز في توجيه «الزعامة الشعبية» من الأعيان والعلماء ، وفي طبع حركتها بطابع معين في السنوات التى أعقبت خروج الحملة من مصر ، جعل من نخبة المصريين الشعبية عنصرًا فعالاً على الساحة السياسية.

وبقدر ماهزت الحملة الفرنسية مفهوم السلطة عند المصريين ، هزت كذلك مفاهيم العدل والأمن والحماية والمشاركة في السلطة ، وأيقظت عند النخبة الجديدة وعيا سياسيا جعلها تختار بنفسها شخص الحاكم (محمد علي) ، وتفرضه فرضا على ولي الأمر (السلطان) ، ولا تسلم أمر البلاد دون قيد أو شرط ، وإنما تملي عليه شروطها – لأول مرة في تاريخ مصر – في وثيقة مكتوبة (حجة) سجلت في المحكمة الشرعية ، ألزمته بإقامة العدل والاعتماد على مشورة العلماء والأعيان فلا ينفرد وحده بالقرار.(٢)

غير أن محمد علي تحلل من قيود تلك الوثيقة ، بعدما عصف بالقيادة الشعبية التي نصبته واليا ، وملكته أمر مصر ، وانفرد بالسلطة ليستخدمها في إقامة صرح مشروعه السياسي الذى أرسى دعائم مصر الحديثة ، بفضل ماأدخله من تغييرات على البنية الأساسية للمجتمع المصري ، وعلى مؤسساته الاجتماعية على مدى ما يزيد قليلا على الأربعين عاما ، قام خلالها بتحديث الاقتصاد المصري بما ترتب عليه من تغيرات اجتماعية ، وأعاد تنظيم مؤسسات الحكم بما يتفق مع المهام الجديدة التي اضطلعت بها السلطة ، التي لم تعد مجرد جهاز جباية وأمن – كما كانت من قبل – بل أصبحت أيضا جهاز إنتاج وخدمات (أحيانا) ، كما أقام نظاماً تعليمياً حديثاً جنبًا إلى جنب مع نظام التعليم التقليدي الديني ، الى غير ذلك من تطورات تفاوتت من حيث ألاتساع والعمق ، ولكنها أسفرت في نهاية الأمر عن إرساء دعائم المجتمع المصري الحديث ، بغض النظر عما أحاط بالتجربة من سلبيات أثرت على مردودها الاجتماعي ، وعلى صلابة الدعائم التي قامت عليها .

أهناسيا (الأسرتان التاسعة والعاشرة من الدولة القديمة) يحذر ابنه من أي تابع له يكثر من الكلام ويحشد خلفه أتباعا كثيرين وينصحه بقوله : «اطرده ، اقتله ، امح ذكراه هو وأتباعه الذين يحبونه» ، ويوصيه بأن يعلي من شأن رجاله ويقويهم» فما أعظم الشخص العظيم عندما يكون رجاله المقربون عظماء .... وما أعظم وأقوى الذين يكون لهم نبلاء كثيرون» ومن الطريف أن ينصح الملك ولده بأن يعاقب الناس بالضرب والاعتقال عندما يخطئون ، وألا يقتل أحداً إلا إذا ثار عليه.(١)

كان الناس إذاً من وجهة نظر السلطة أدوات إنتاج يفلحون الأرض لتتدفق خيراتها على الخزانة العامة ، ويُقَوَّمون بالعصا وفقدان الحرية إذا تقاعسوا أو قصروا في أداء واجباتهم ، أو ارتكبوا يوما ما تعده النخبة الحاكمة جرما يستحق العقاب . وبذلك لم يكن أمام الناس من سبيل لدفع الظلم عن أنفسهم سوى الشكوى (تماما كما فعل الفلاح الفصيح في مصر القديمة) ، وأن يستعينوا بعدالة السماء على جور أهل الأرض شأن سائر المستضعفين. وعندما دخل العرب مصر لم يتغير الإطار العام للسلطة من حيث تمركزها في يد نخبة تستند إلى القوة، وكانت هذه المرة قوة الفتح ، ولم يتغير مفهوم استناد السلطة إلى مصدر إلهي ، فالأرض أرض الله والملك ملك الله يورثه من يشاء من عباده المتقين، بل تحولت الفكرة إلى تفويض إلهي صريح على يد العثمانيين فيما بعد تأثرا بالتفويض الإلهي عند البيزنطيين ، وكان الحكم لا يخلو من طابع الاستغلال، وإذا كان عمر بن الخطاب قد لام عمرو بن العاص على عدم تركه ما يكفي من لبن أبناء البقرة والإسراف في استنزاف حليبها إشارة الى الاشتطاط في جباية الخراج ، فإن أحداً من الخلفاء المتعاقبين لم يلق بالاً إلى ما يلحق بالمحكومين من أذى من جراء تعسف الولاة ، فتعاقبت ثورات المصريين نحو القرنين من الزمان ضد الحكم الإسلامي حتى أخمدت بالعنف المبالغ فيه في عهد الخليفة المأمون .

وهكذا ظلت السلطة المركزية النخبوية في مصر تسيطر على مواردها الاقتصادية . فالأرض أداة الانتاج في المجتمع الزراعي ملكٌ للدولة ، يسيطر عليها الجالس على إريكة الحكم سواء كان عاملا لخليفة أو خليفة أو سلطاناً مملوكياً أو عثمانياً . ولا مجال لمشاركة الناس في السلطة إلا في أدنى درجات سلم البيروقراطية ، أما الدرجات الأعلى فاحتفظت بها النخبة الحاكمة وموقع الجماهير هو موقع الشغالة في مملكة النحل ، يكدون ويكدحون لإنتاج الفائض الذي يتدفق على جيوب حكامهم وخزانة الدولة يوم لم يكن هناك حدود تفصل بين تلك الجيوب والخزانة العامة . ويتوقع الناس في المقابل أن توفر لهم السلطة الأمن وتقيم العدل وتحقق الرخاء ولا يطمعون فيما هو أبعد من ذلك. وهم ينصرفون الى أداء واجباتهم طالما كان ثمة حد أدنى من ذلك الثالوث متوفراً ، وقلما يشقون عصا الطاعة على السلطة إذا ضاقت بهم سبل

## المصريون والسلطة:
## رؤية تاريخية

### رؤوف عباس

عرفت مصر السلطة المركزية المستندة الى القوة الغاشمة المستمدة من حق إلهي أسطوري منذ ٣٢ قرنا قبل الميلاد – على أرجح الأقوال – وبذلك تكون مصر أقدم بلاد الدنيا قاطبة في التوصل إلى هذا الشكل التنظيمي المتميز للجماعة البشرية. وجاء قيام هذه السلطة المركزية نتاجا للظروف البيئية في بلد عماد حياته الزراعة التي تقوم على الري النهري من مصدر واحد هو النيل، ومن ثم كان قيام السلطة المركزية ضرورة أملتها ظروف البيئة لتنظيم الاستفادة من مياه الري. استمراراً للعمران، وكان لا بد أن تعقد لواءها لأقوى الحكام وأكثرهم بطشا حيث لعبت طبيعة مصر السهلة المنبسطة دورا فعالا في تمكين مثل ذلك الحاكم القوى من بسط سلطانه على الآخرين. واستكان الناس لهذه السلطة المركزية ولرموزها طالما كانت توفر لهم الحماية وتيسر لهم العيش. وراحت النخبة الحاكمة تدعم مكانتها من خلال ما نسجته حول نفسها من أساطير استقرت في وجدان الناس. أضفت عليها من صفة القداسة، وجعلت حقها في السلطة مستمدا من الآلهة مستنداً إلى رعاية السماء، وبذلك اقترنت طاعة الحاكم بطاعة الإلهة والعكس بالعكس وان كان ذلك لا يعني أن الناس تحملوا عنت السلطة دون حدود، فقد كان هناك دائما حد أقصى لاحتمالهم. اذا تجاوزته السلطة انفجروا ثائرين انفجار البركان الذي يكتسح في طريقه كل شيء حتى الحرمات المقدسة طالما كانت تتعلق بالحكام الغاشمين على نحو ماسنرى.

ومع تعاقب العصور طوال تاريخ مصر القديم ظل للسلطة المركزية نفس الطابع القدسي الذي صاغه الضمير الجمعي للمصريين عبر مئات القرون. والذى يجعل السلطة مركزة في يد «الفرعون» صاحب الحق الإلهي لا ينازعه فيها أحد، ولا يعلو صوت على صوته، فها هو ذا الفرعون «اختوى» من ملوك

٨٥

## الهوامش

1- Uriel Heyd. *Studies in Old Ottoman Criminal Law*. Oxford University Press, 1973, pp. 313, 314, 333.

2- رشيد رضا. تاريخ الأستاذ الإمام، القاهرة، بدون تاريخ، ١/ ٣٦٠.

3- السابق ١/ ٦١٧.

4- راجع تواريخ صدور قوانين الأحوال الشخصية الشاملة في . Anderson, J. N. D. *Law Reform in the Muslim World*. London, 1959, pp. 40-42.

5- كولسون، تاريخ التشريع الاسلامي (الترجمة العربية لمحمد سراج)، ص ٢٠٢ وما بعدها.

6- الكمال بن الهمام (محمد بن عبد الواحد) فتح القدير. المطبعة الأميرية، ١٣١٨، ج ٤/ ١٢٨ ومابعدها، وابن نجيم، البحر الرائق، طبعة بولاق، ج ٣ / ١٣٥.

7- ابن رشيد ، بداية المجتهد. دار الخلافة العلية، بدون تاريخ، ٢/ ٥٠، وابن قدامة، المغني، ج ٦ / ٥٢٤ ومابعدها.

8- السنهوري ، عبد الرازق . الوسيط القاهرة : دار النهضة العربية ، ١٩٧٠ ، ج ١/ ٨٢٧.

9- علي الخفيف ، أحكام الوصية : بحوث مقارنة، ص ١١٦.

10- فتح القدير، ٤/ ١٢٨، البحر الرائق، ٣/ ١٣٥.

11- المادة ١ من برسوم ١٩٢٩ .

12- المادة ٢ من المرسوم السابق .

13- المادة ٣ من المرسوم نفسه .

14- القرار رقم ٤٤ لسنة ١٩٧٩ .

15- القانون رقم ١٠٠ لسنة ١٩٨٥ .

16- الزيلعي ، تبين الحقائق، شرح كنز الدقائق، ج ٢/ ١٤٨، وبداية المجتهد، ٢/ ٥٨.

17- المادة ٣٧ من قانون الوصية الصادر عام ١٩٤٦.

18- المادة ٧٦ ومابعدها من قانون الوصية.

19- راجع قانون رقم ١٨٠ لسنة ١٩٥٢ بالغاء نظام الوقف على غير الخيرات.

20- قانون رقم ٢٤٧ لسنة ١٩٥٣ بشأن النظر على الأوقاف الخيرية.

واحترام الملكية الخاصة محل الاعتبار الرسمي والشعبي فإن من الواجب النظر إلى القوانين العديدة المتعلقة بالأوقاف لتنشيط دورها الاجتماعي والتعليمي الذي كان لها في الماضي .

ويدلنا هذا على النتائج البعيدة لمنهج التقنين في التفكير الفقهي الحديث ، حيث أصبح سلاحا فعالا لتغليب الاتجاهات الاجتماعية السائدة في الصياغات التشريعية عن طريق التخير من الآراء الفقهية التي أنتجتها القرون الأربعة عشرة السابقة أو باستئناف الاجتهاد الرامي إلى الإصلاح في مجال الأسرة .

## مستقبل التجديد

تعين آلية التقنين للأحكام الفقهية المتعلقة بالأسرة على تحقيق الإصلاح الاجتماعي وتعميق جذوره والإسراع به . وقد يسرت هذه الآلية أسلوبا لمواجهة تعسف بعض الأزواج في الإضرار بزوجاتهم في أحوال الامتناع عن النفقة والهجر والشقاق ، كما يسرت أسلوبا لتقيد زواج الصغار وتقييد الطلاق وتعويض الزوجة عن بعض الأضرار التي تلحق بها . ويدل هذا على أن هذه الآلية يمكن الاعتماد عليها لتحقيق الأهداف المشروعة الأخرى التي تستلزمها الضرورات الاجتماعية في مجال الأسرة .

وفي اعتقادي أن صياغة قانون شامل للأسرة في مصر أحد أهم الأهداف التي تفرض نفسها على الراغبين في الإصلاح ، لتيسير رجوع القضاة إلى النصوص القانونية الواجبة التطبيق بدلا من تكليفهم بالرجوع إلى المؤلفات الفقهية التي لم يدرب الكثير من هؤلاء القضاة على الرجوع إليها والقراءة فيها وفهمها . وتيسر صياغة تقنين شامل لأحكام الأسرة الإفادة من الجهد القضائي وأحكام المحاكم في هذا القرن . ولا يوجد سبب واحد معقول يسوغ التقاعس عن تحقيق هذا الهدف . وقد صدرت في سوريا ولبنان والأردن تقنينات شاملة للأحوال الشخصية مما عساه أن يؤدي إلى تشجيع الاتجاهات الداعية إلى التقنين الشامل في مصر .

ومن جهة أخرى فإن اختصار إجراءات التقاضي المطولة في قضايا الأحوال الشخصية والتي تتسبب في إلحاق الظلم بالمرأة في أحوال كثيرة من الأمور التي سيضطر الراغبون في الإصلاح إلى التفكير فيها بعد أن ارتفعت أصوات عاقلة عديدة بالتنديد بهذه الإجراءات والكشف عن أوجه الأذى التي تؤدي إليها . وتبذل وزارة العدل جهودا مكثفة منذ فترة في مراجعة لائحة ترتيب المحاكم الشرعية الصادرة عام ١٩٣١ ، والوزارة الآن بسبيلها إلى إصدار اللائحة الجديدة فيما تطالعنا به الأنباء مما عساه أن يزيل الظلم الناشيء .

المقترنة بعقد الزواج إذا لم تخالف عرفا ولم تناقض مقتضى عقد الزواج والمصالح المرتبطة به. وإنما يلزم صوغ قسيمة عقد الزواج على نحو يلفت نظر المتعاقدين إلى حقهم في اشتراط مايريانه محققا لمصالحهما مع التنبيه بوسائل الإعلام المختلفة إلى هذا الحق (١٦).

ومن جهة أخرى فإن هذه التقنينات الحديثة قد اتجهت إلى المنع من زواج الصغار بالأسلوب المشار اليه فيما سبق، واشترطت لتوثيق عقد الزواج ألا يقل سن الزوجة عن ست عشرة سنة وسن الزوج عن ثماني عشرة سنة. غير أن القانون قد ترك الباب مفتوحا للتحايل عليه بما أجازه للمأذونين من حق التثبت من سن الراغبين في الزواج بشهادات التسنين المعروفة، وهو ما يفتح الباب للتساؤل حول جدية الرغبة في الإصلاح وحقيقة دوافع أصحاب الاتجاهات إليه وسلامة المنهج الذي ارتضوه. وهناك تغييرات عديدة تضمنها قانونا الميراث والوصية الصادران عام ١٩٤٣ و١٩٤٦ على التوالي، لعل من أهمها جواز الوصية للوارث (١٧). والحكم بالوصية الواجبة للأحفاد الذين يموت والدهم أو أمهم في حياة جدهم (١٨). وبموجب جواز الوصية للوارث أصبح من حق المورث أن يعطي بعض ورثته أو أحدهم مقداراً من التركة على سبيل الوصية خلافا لما أخذت به المذاهب الفقهية الأربعة من بطلان ذلك. أما الوصية الواجبة فقد قصد من شرعها إلى حماية الأحفاد الذين مات عائلهم أو أمهم من قبل وفاة المورث، ولا يرث هؤلاء الأحفاد شيئا لوجود من يحجبهم ممن يتقدم عليهم من الأولاد المباشرين. وقد تمثل الحل في فرض نصيب للأحفاد يماثل نصيب الأصل الذي ينحدرون منه بما لا يزيد عن الثلث وعلى الرغم مما يثيره هذا الحل من مشكلات فنية فقد أخذت به قوانين الأسرة في البلاد العربية بعد تطبيقه في مصر.

وفي اعتقادي أن قوانين الأوقاف المتعاقبة في الصدور ابتداء من عام ١٩٤٦ إلى عام ١٩٦١ كانت لها أهداف أخرى غير إصلاحية. ذلك أنها قد آلت في النهاية إلى إلغاء الأوقاف (١٩) الأهلية وإلى أيلولة أراضي الأوقاف إلى هيئة الإصلاح الزراعي مع ايجاب تعويض الهيئة لوزارة الأوقاف بدفع ثمن هذه الأراضى على أقساط طويلة المدى. وقد بدأ التغيير في أحكام الأوقاف بالإشارة إلى عيوب إدارتها واستيلاء النظار عليها وحرمان المستحقين فيها من حقوقهم، ورأى البعض وجوب إنهاء الأوقاف حتى لا تتجمد الأموال الموقوفة وتبتعد عن التداول. غير الذي بان بعد أن وصلت التعديلات إلى نهاياتها في عام ١٩٦١ أن القصد هو وضع أموال الأوقاف تحت يد الحكومة وفي وزارة من وزاراتها حتى تضمن التصرف في هذه الأموال على النحو الذي تشاء (٢٠). ومن جهة أخرى فقد كانت هذه الأموال في يد المسئولين عن مؤسسات شعبية وخيرية ودينية على نحو لم يكن مناسبا لاتجاهات المركزية فى التخطيط والإدارة والسيطرة والتأميم والمسئولية الشاملة للدولة. وإذ تغير هذا الاتجاه الآن وأصبحت اللامركزية

منحصرا في العجز الجنسي الدائم منذ تاريخ حدوث الزواج طبقا لما هو مقرر في المذهب الحنفي (١٠) كما تقدم.

ويتعلق تقييد إيقاع الطلاق وتقليل حالات وقوعه فيما أخذت به هذه التقنينات باتجاهها إلى رفع المعاناة عن المرأة . وهو مايتضح فى استبعاد مرسوم ١٩٢٩ طلاق السكران والمكره من الوقوع (١١) كما يدل عليه الحكم الوارد في هذا المرسوم نفسه بعدم وقوع الطلاق المعلق على فعل شيء أو تركه مالم يقصد الزوج إيقاع الطلاق به (١٢) . ومن جهة أخرى فقد تضمن هذا المرسوم الحكم بأن الطلاق المتعدد لفظا أو إشارة لا يقع إلا طلقة واحدة (١٣). وقد عملت هذه التقنينات كذلك على إثبات حقوق جديدة للزوجة فيما يتعلق بواجب زوجها في الإنفاق عليها . ويتضح هذا المقصد في إدخال مصاريف علاجها ضمن بنود النفقة الواجبة لها بعد أن كانت هذه البنود منحصرة في الغذاء والكسوة والمسكن . وقد خرج التقنين في إلزام الزوج بنفقة تطبيب الزوجة وعلاجها على مقررات المذاهب الأربعة ، وأخذ فى هذا بمذهب الزيدية (١٤) وفي الاتجاه نفسه قرر مرسوم ١٩٢٩ عدم إسقاط نفقة الزوجة بخروجها للعمل المشروع مالم يظهر ان استعمالها لهذا الحق المشروع مشوب بإساءة استعمال الحق أو مناف لمصلحة الأسرة وطلب منها الزوج الامتناع عن هذا العمل.

ويتفق مع اتجاه هذه التقنينات إلى رفع المعاناة عن المرأة ما أخذت به في تنظيم أحكام الحضانة ، حيث رفعت سن حضانة النساء للصغيرة إلى سن العاشرة وللصغير إلى اثنتى عشرة سنة مع إعطاء القاضي سلطة تقديرية للحكم بإبقاء الصغيرة في يد الحاضنة فوق ذلك إلى أن تتزوج والصغير إلى سن الخامسة عشرة (١٥) .

وقد سعت هذه التقنينات كذلك إلى حفظ حقوق الزوجين والأولاد بما رسمته من إيجاب توثيق كل من الزواج والطلاق وبفرض الجزاءات المناسبة بمخالفة هذا الواجب ، حيث رتبت المنع من سماع الدعوى على عدم توثيق الزواج، كما رتبت على عدم التوثيق العقوبة بالحبس إلى ستة أشهر أو الغرامة إلى مائتي جنيه أو بالحبس والغرامة معا ، وإنما أوجبت ذلك لظروف الحياة الحديثة واتساع المجتمعات وخطورة الحقوق المتعلقة بالزواج والفرقة .

وإذا كانت المرأة قد نعمت بهذه الحقوق على نحو أكسب الأسرة شيئا من الاستقرار ويسر لها القيام بوظائفها الاجتماعية إلى حد كبير فان التطلع إلى تحقيق المزيد من التقدم في هذا المجال باتباع المناهج الفقهية مايزال حيا في النفوس . وقد بدأت بعض النداءات ترتفع للمطالبة بحق الزوجين فى تنظيم حياتهما الزوجية بالاتفاق عند التعاقد في الزواج على مايرايانه محققا لمصلحتهما أو لمصلحة أي منهما، من الشروط، مما لا يخالف الأصول المعتبرة ولا المباديء العامة لنظام الزواج . ولا تتطلب الاستجابة لهذه الرغبة استصدار أحكام قانونية جديدة ، بل يكفي العمل بقواعد المذهب الحنفي القاضية بتصحيح الشروط

استعمال الحق .

ويشبهه أن اكتشاف التفكير القانوني لمفهوم الشخصية الاعتبارية أو القانونية legal person كان أساسا لعدد من الاجتهادات الفقهية الحديثة . من ذلك اشتراط قبول ممثل الجهة أو الشخصية المعنوية ليصح الوقف طبقا لما جاء في المادة التاسعة من قانون الوقف الصادر عام ١٩٤٦ . ويشبهه ماجاء في المادة العشرين من قانون الوصية ١٩٤٦ ، حيث قضت هذه المادة بأن الممثل القانوني للمؤسسه التي تتمتع بشخصية قانونية هو الذي يملك التعبير عن قبول الوصية ، ولا تلزم إلا بعد قبوله .

وتغري هذه الأمثلة على الاعتقاد بأن ممارسة الاجتهاد ستفتح الطريق للإفادة من تطور التفكير القانوني في النظم القانونية المختلفة ، وسيجد الفقيه المسلم نفسه مطالبا بدراسة هذه النظم ومعرفة أساليبها المختلفة في التصدى للمشكلات التي تواجهه لتوسيع دائرة اختياره ولتحقيق نوع من التعاون المثمر مع دارسي القانون في الوصول إلى حلول مقبولة للمشكلات الاجتماعية المعاصرة .

وينبغي تشجيع مثل هذه الاجتهادات العملية التي تيسر إجراءات التقاضي ووصول العناصر الضعيفة في المجتمع إلى حقوقها . من ذلك قانون رقم ٦٢ لسنة ١٩٧٦ بشأن إلزام بنك ناصر الاجتماعي بإيفاء ديون النفقة المستحقة للزوجة ، وإن قيد ذلك بحدود المبالغ التي تخصص لهذا الغرض من قبل إدارة هذا البنك ، مما يعني ترك العديد من الزوجات المستحقات للنفقة للمعاناة في سبيل تنفيذ الحكم بالنفقة على أزواجهن . وفي اعتقادي أن تيسير إجراءات التقاضي في مجال الأسرة وتشكيل محاكم متخصصة ومدربة في هذا المجال من أوجب الواجبات التي تحتمها المصلحة الاجتماعية والعدالة . ولا ريب في أن الحاجة ماسة لذلك .

## موضوعات التجديد في قوانين الأسرة

تناولت التقنينات المصرية المتعلقة بالزواج والفرقة استنادا لهذه المناهج السابقة عددا كبيرا من الموضوعات التي يكشف الإلمام بها عن هموم هؤلاء المجددين ومقاصدهم والمشكلات التي نصبوا أنفسهم لحلولها ومدى نجاحهم في علاج هذه المشكلات .

ومن الواضح أن أحد أهم الأهداف المقصودة من هذه التقنينات هو العمل على رفع الظلم الذي كانت تعانيه المرأة وتحسين مركزها داخل الأسرة . يبدو هذا جليا في إعطاء الزوجة الحق في طلب التفريق وإنهاء الزواج لأسباب امتناع الزوج عن الإنفاق عليها أو لعجزه الجنسى أو لإضراره بها أو لغيابه وهجره لها أو لسجنه طبقا لما جاء في مرسومي ١٩٢٠ و ١٩٢٩ . وقد أثبت هذان المرسومان الحق للزوجة في التفريق بأي من هذه الأسباب بعد أن كان حقها فيه

الضعف توالي هذه التعديلات التي ألحقت بهذا لقانون بعد عام ١٩٥٢ حتى تعطل العمل بأكثر أحكامه .

**الاجتهاد**

على الرغم من اختلاف ظروف الحياة الحديثة وأنواع التعامل فيها وكثرة المؤسسات الاجتماعية والمالية والاقتصادية التي جدت في هذا العصر مما يتطلب النظر الفقهي المستقل فان كثيرا من المشتغلين بالعمل الفقهي لا يسلمون بالحق في الاجتهاد . ويتذرع هؤلاء لرأيهم في إنكارالحق في الاجتهاد بعدم وجود القادرين على ممارسته ممن تجتمع فيهم شروطه . ومع ذلك فقد دعا إلى الاجتهاد في هذا العصر محمد عبده وطالب بفتح الباب لممارسته باعتباره السبيل لتحقيق الإصلاح التشريعي في مجال أحكام الأسرة .

ولايجد المرء دورا كبيرا لممارسة الاجتهاد في قوانين الأحوال الشخصية المصرية وإن اتضح الاستناد إليه في بعض الأمور ذات الأهمية المحدودة . ومن ذلك ماجاء في المادة الثالثة عشرة من قانون الوصية الصادر عام ١٩٤٦ ، فقد قضت هذه المادة بجواز الوصية بقسمة أعيان التركة بين الورثة بحيث يعين لكل وارث أو لبعض الورثة قدر نصيبه ، وتكون هذه الوصية لازمة بوفاة الموصي ، حتى لو زادت قيمة ماعين لأحدهم عن استحقاقه في التركة ، وتعد هذه الزيادة وصية هي الأخرى . ومن الواضح أن الوصية بقسمة التركة بين الورثة دون رجوع إلى أذنهم قد جازت في القانون ترتيبا على جواز الوصية للوارث طبقا لما تضمنته المادة السابعة والثلاثون من القانون المذكور .

ولعل من الواضح الذي لا يحتاج إلى تأكيد القول بأن بعض المفاهيم القانونية كانت ذات أثر بالغ في عدد من الاجتهادات الفقهية الحديثة . من ذلك أن النجاح الذي لقيته صياغة نظرية التعسف في استعمال الحق abuse of right قد شجع عددا من الباحثين المحدثين على إعادة اكتشاف هذه النظرية في نصوص الفقه الإسلامي ومؤلفاته القديمة مما أدى إلى التأثر بها في عدد من الاجتهادات المتعلقة بالأسرة . من ذلك استقرار المحاكم المصرية على الحكم بالتعويض عند التعسف في استعمال الحق في فسخ الخطبة بعد تأرجح واضطراب (٨) وبهذا أصبح العدول عن الخطبة إذا اقترن بأي من الأفعال أو الأقوال التي تؤدي إلى الإضرار بالطرف الآخر سببا من أسباب وجوب التعويض عن هذا الإضرار. وهذا هو الأساس في حكم بعض الباحثين المحدثين بمنع الوصية إذا كان القصد منها هو مضارة الورثة . ولهذا يرى أحمد إبراهيم أن من المضارة في الوصية أن يوصي ببعض ماله ، ولو دون الثلث ، إذا أراد بذلك حرمان الورثة من ميراثهم كله أو بعضه . وهذا هو ما انتهى إليه الشيخ الخفيف أيضا (٩) وليس المنع من الوصية إذا انطوت على قصد الإضرار بالورثة إلا تطبيقا من تطبيقات مفهوم التعسف في

إطار لإضفاء مظهر التقليد والمتابعة لآراء أئمة الفقه السابقين وإخفاء الباعث الحقيقي، وهو الاستجابة للاتجاهات التجديدية الحديثة ، ولا يعدو التخير بهذا أن يكون أسلوبا للتحيل وستر الدوافع والغايات الحقيقية .

وعلى سبيل المثال فقد أخذ قانون الوصية المصري الصادر عام ١٩٤٦ بجواز الوصية للوارث فى حدود ثلث التركة دونما حاجة إلى موافقة سائر الورثة طبقا لما جاء فى مادته السابعة والثلاثين مخالفا في هذا مااتفقت عليه المذاهب الأربعة والزيدية والإباضية والظاهرية . وإنما استند هذا القانون في تصحيح الوصية للورثة إلى مذهب الشيعة الإمامية وأبي مسلم الأصفهاني . ومن الواضح أن الباعث الحقيقي لمخالفة ما استقرت عليه المذاهب هو الاستجابة لبعض الآراء الداعية إلى إعطاء المورث الحق فى الإيصاء لمن يراه أحوج من غيره من الورثة لمرض أو عجز أو صغر أو تبطل أو لمن يريد مكافأته من الورثة لقربه منه أو معونته له . ولا تعني الإشارة للمذهب الشيعي أو رأي أبي مسلم الأصفهاني اطمئنان واضعي القانون إلى صحة أدلة الشيعة وبطلان رأي الجمهور بقدر ماتعني الاستئناس بالمذهب الشيعي ورأي أبي مسلم في تقوية مقترحهم بتصحيح الوصية للوارث .

ومن جهة أخرى فإن التخير يحتمل النظر إليه على أنه منهج للاجتهاد ، يقوم على وضع المجتهد آراء غيره من الفقهاء السابقين والمعاصرين أمامه لوزنها في ضوء قوة الدليل وتحقيق المصلحة الاجتماعية وترجيح مايراه أولى . ويحقق اعتبار التخير منهجا اجتهاديا على هذا النحو إلحاق المسئولية عن الرأي المأخوذ به إلى المتخير نفسه ، بدلا من إلحاق هذه المسئولية بالسابقين عليه . وإذ يرتفع المتخير بهذا النظر إلى مرتبة المجتهد فإن عليه أن يستكمل أدوات المجتهد وأن يستجمع شروطه وأن يتبع مناهجه فى البحث والاستدلال . ولقد مارس المجتهدون الكبار في عصور النضج الفقهي التخير بمنهج الاجتهاد فحقق لهم التواصل بين الأجيال ويسر لكل جيل الانتفاع بما تركته الأجيال السابقة . أما السبب الثاني في اضطراب تصور منهج التخير لدي الباحثين المحدثين فيرجع إلى خلطه بمنهج التلفيق الذي يقوم على المزج بين الآراء المختلفة في الموضوع الواحد ، والمراوحة بينها دون منطق قانوني وعلى نحو يتسم بالسذاجة في الصناعة الفنية . وعلى سبيل التوضيح فإن قانون الوقف المصري الصادر عام ١٩٤٦ يزاوج بين الأخذ بمذهب أبي حنيفة الذي انتهى إلى عدم مشروعية الوقف وأبطاله وبين الأخذ بمذهب أصحابه وسائر الفقهاء الذين حكموا بجوازه . وتبدو هذه المزاوجة فيما تضمنته المادة الحادية عشرة من هذا القانون من الحكم بجواز رجوع الواقف عن وقفه وتغيير مصارفه وشروطه . أما قبل العمل بهذا القانون فلم يكن يجوز للواقف الرجوع فيه ولا تغييره . ويهذا تضمن صدر هذه المادة الاستناد إلى مذهب أبي حنيفة القاضي بإبطال الوقف على حين جاء آخرها مستندا إلى مذهب الجمهور القاضي بصحة الوقف وتأبيده وينبىء هذا المزج بين الرأي ونقيضه في مادة واحدة عن ضعف في الصناعة الفنية . وقد يسر هذا

ذلك أن مرسوم ١٩٢٩ تضمن إعطاء الحق في التفريق للزوجة لمجرد الشقاق والضرر ، طبقا لما جاء في مواده من ٦ الى ١١ . ويستند القانون فى إعطاء هذا الحق إلى المذهب المالكي دون غيره من المذاهب الأخرى : الحنفية والشافعية والحنابلة (٧) ومستند المالكية من السنة حديث : لا ضرر ولا ضرار . وعلى الرغم من قوة مستندهم هذا فإنهم انفردوا بما ذهبوا إليه عن سائر المذاهب الأخرى . وقد انتقلت هذه القاعدة المالكية بعد تبني مرسوم ١٩٢٩ لها إلى قوانين الأحوال الشخصية العربية والإسلامية تباعا .

وإنما حدث تبني هذه القاعدة المالكية في هذه القوانين في ظروف الدعوة إلى النهوض بالمرأة في المجتمعات الإسلامية وتحرك المنظمات النسائية لتخفيف المعاناة عنها . ومن هذا تتضح العلاقة بين التطور الاجتماعى وبين التفكير الفقهي والتشريعى ، كما تتضح إمكانات توظيف أسلوب التخير لتحقيق أهداف اجتماعية مشروعة . ومن الواضح أن الهدف ، وهو تحسين وضع المرأة ورفع المعاناة عنها، قد تحدد أولا في حركة اجتماعية عامة ، ثم تبني التفكير الفقهي هذا الهدف في مجاله الخاص فوجد ضالته في هذه القاعدة المالكية «التطليق للضرر» التي لم يكن بالوسع تحقيق الهدف الاجتماعي العام بدون استدعاء هذه القاعدة وإعمالها في هذا المجال .

وينتشر الاعتماد على منهج التخير من المذاهب الفقهية على هذا النحو في جميع التقنينات الحديثة المعمول بها في البلاد العربية والإسلامية لا في مجال الأحوال الشخصية فحسب بل وفي القوانين المدنية أيضا ، فيما يجسده القانون المدني الأردني الصادر عام ١٩٧٦ وقانون المعاملات المدنية الإماراتي الصادر ١٩٨٥ .

ولا يخطيء الناظر إلى الفتاوي الفقهية التي تصدرها هيئات الرقابة الشرعية للمصارف الإسلامية أن هذه الفتاوى مستندة كذلك إلى منهج التخير نفسه والأخذ بهذا الرأي الفقهي أو ذاك على النحو الذي قد يؤدي إلى استدعاء الفقهاء الأقدمين للإجابة عن معاملات حديثة لم يكن بوسعهم أن يتخيلوها لعدم وقوعها لهم . وعلى سبيل التوضيح فقد جرى استدعاء عقد المضاربة القديم ليحكم العلاقة بين المصرف الاسلامي وأصحاب الأموال التي يستثمرها لهم وأصبح مايستحقه أصحاب الأموال من عوائد نسبة من الربح الفعلي على حين يستحق المصرف الذي يأخذ دور المضارب النسبة الباقية من الربح ، أما الخسارة التي قد تحدث للأموال فإن أصحابها هم الذين يتحملونها طبقا لأحكام المضاربة الفقهية .

ويجدر الالتفات إلى أن منهج التخير لم يظفر بالقبول العام في البناء الأصولى الحديث على الرغم من انتشار الاعتماد عليه في هذه المجالات الفقهية العملية المتنوعة . ومرجع الاضطراب في النظر إلى المنهج بين الباحثين المحدثين أمران : أولهما عدم الاتفاق على طبيعته ، حيث ينظر إليه البعض على أنه مجرد

على الإشارة فيما بعد إلى أوجه المظالم المترتبة على الاقتصار في القضاء على أحكام المذهب الحنفي . من ذلك ما رواه الأستاذ أحمد محمد شاكر عن والده الذي كان من تلاميذ الإمام عن امرأة شابة حكم على زوجها بالسجن مدة طويلة ، وارادت عرض أمرها على المفتي ليرى لها رأيا في الطلاق من هذا الزوج كي تستطيع الزواج من غيره . ولم يلبث العلماء أن صاروا إلى الاتفاق على صحة الاعتماد على أسلوب التخيير . ويدين ظهور قوانين ١٩٢٠ و ١٩٢٩ وما تلاها بالفضل إلى القبول الذي حظى به الاعتماد على أسلوب التخيير . ذلك أن أحكام هذين القانونين المشار اليهما (١٩٢٠ – ١٩٢٩) مستمدة من الآراء المتضمنة في المذاهب الأخرى غير المذهب الحنفي الذي عليه العمل في مصر . وبهذا يمثل المذهب الحنفي الأحكام الواجبة التطبيق عموما إلا فيما استثنى بهذين القانونين والقوانين الأخرى التي تبعتها .

ويتضح الاعتماد على التخيير من المذاهب الفقهية لحل مشكلة اجتماعية شغلت بال المصلحين في معالجة موضوع التفريق بين الزوجين بطلب المرأة . ذلك أن المذهب الحنفي لا يعطي الزوجة الحق في طلب التفريق من زوجها الا إذا كان بالزوج عيب يمنع وصوله لها ولو مرة واحدة (٦) ، وذلك لعدم تحقق المقصود الأصلي من الزوج ، وهو التوالد والتناسل مع وجود مثل هذا العيب . أما المذاهب الأخرى فقد أجازت الحق للمرأة في التفريق إذا وجد بالزوج عيب يمنع قيام الحياة الزوجية أصلا كالعجز الجنسي الكامل ، سواء حدث هذا العيب قبل الزواج او طرأ بعده ، وللزوجة الحق كذلك في طلب التفريق إذا كان العيب منفرا ويمنع من تمام الحياة الزوجية كالامراض المعدية التي لا أمل يرجى في الشفاء منها ، كالجنون والعتة وما إلى ذلك مما لا يستطاع استمرار الحياة الزوجية معه إلا بصعوبة بالغة .

ويقضي العدل وفهم المصالح المترتبة على الزواج إعطاء المرأة الحق في التفريق بأي من هذه العيوب التي لا تقوم الحياة الزوجية على وجهها الصحيح بوجودها . غير أن الاستقرار على العمل بالمذهب الحنفي أدى إلى إعجاز القضاة عن الاستجابة لطلب الزوجة التفريق في هذه الظروف . وينطوي إجبار الزوجة على الاستمرار في علاقة لا تريدها إلى إرهاق شديد لها وإضرار بها ، ولذا مست الحاجة إلى الإصلاح ، ونجح المجددون في كسب قوى المعارضة واستمالتهم للخروج على المذهب الحنفي والأخذ برأي جمهور الفقهاء في التوسع في أنواع العيوب التي تجيز للزوجة الحق في طلب التفريق بحكم القاضي . وقد تحقق هذا الإصلاح بمرسوم ١٩٢٠ حيث جاء في مادته التاسعة ومابعدها النص على حق الزوجة في التفريق إذا وجد بالزوج عيب مستحكم لا يمكن البرء منه مطلقا أو يمكن البرء منه بعد زمن ، وكان بقاؤها مع الزوج بهذا العيب يضر بها ضررا شديدا ، شريطة ألا تكون قد رضيت باستمرار الزواج بعد علمها بهذا العيب .

وقد أمكن التوسع فيما بعد في الاعتراف للزوجة بالحق في طلب التفريق .

ويعني هذا الأسلوب رفع الحماية القضائية عن الزوجين إذا قل سن أحدهما عن هذا التحديد ، وهو مايؤدي إلى التشجيع على البعد عن هذا الزواج الذي تمتنع المحكمة عن سماع أي نزاع بشأنه .

وقد أخذ بهذا الأسلوب الشكلي أو الإجرائي لحث الناس كذلك على توثيق زواجهم توثيقا رسميا على يد موظف مأذون بهذا التوثيق . وإنما القصد من هذا الأخذ هو تيسير عمل المحاكم في قضايا الميراث والنفقة والنسب ومنع التزوير وضياع حقوق الناس في هذه الأمور الخطيرة . ذلك أن المادة ٩٩ من اللائحة المذكورة قد تضمنت النص على أنه لا تسمع عند الإنكار دعوى الزوجية مالم تكن مؤيدة بوثيقة زواج رسمية ، بتفصيلات حددتها هذه المادة . ومعنى ذلك أن دعوى الزوجية ومايترتب عليها من نفقة وميراث لن تنظرها المحكمة مالم توجد وثيقة رسمية تؤيد هذه الدعوى مما يترتب عليه تشجيع الراغبين في الزواج على توثيقه لضمان حقوقهم الناشئة عن هذا الزواج .

ولم يسلم هذا الأسلوب الإجرائي من الانتقاد على الرغم من مساعدته في تحقيق الأهداف الاجتماعية المنشودة ، دون مساس بالجانب الموضوعي ، حيث بقي زواج الصغار والزواج بدون توثيق على الصحة من الوجهة القانونية . وأبرز ماوجه لهذا الأسلوب من نقد أنه يتنافى مع حق الإنسان في اللجوء إلى قاضيه الطبيعي عندما يستشعر أي ظلم . ولا يحق لولي الأمر أن يمنع قضاته جميعا من النظر في نزاع معين وإن كان له الحق في تنظيم هذا الأمر وتحديد قضايا بعينها لتنظرها هذه المحكمة أو تلك (٥) ومن جهة أخرى فإن الاعتماد على هذا الأسلوب في البلاد التي أخذت به لم يؤد إلى حل هاتين المشكلتين ، فمازال زواج الصغار متفشيا بمساوئه العديدة في المجتمع المصري ، ومازال الزواج العرفي غير الموثق توثيقا رسميا بتعقيداته التي يثيرها منتشرا كذلك . وهو مايعني أن الاعتماد على هذا الأسلوب وحده في معالجة هذه المشكلات الضخمة غير كاف .

ومن الجائز لهذا الاعتماد على قواعد موضوعية متباينة لتأكيد النتائج الإصلاحية المشروعة التي أرادها المجددون في الماضي . من ذلك الاعتماد على فرض عقوبات معينة لمن تسول له نفسه الإقدام على زواج مخالف للسن القانونية أو زواج غير موثق .

### التخير من المذاهب الفقهية

نادى محمد عبده في تقريره الذي أعده لإصلاح المحاكم الشرعية عقب توليه منصب الإفتاء عام ١٨٩٩ بوجوب إعداد تقنين سهل العبارة من جميع المذاهب الإسلامية المعتبرة بناء على أن خلافهم رحمة للأمة . وقد هاجم المعارضون للإصلاح هذا المنهج ورأوا أنه يؤدي إلى التلفيق بين المذاهب وتتبع رخصها ، وهو مامنع منه جمهور علماء المسلمين . غير أن تلاميذ الإمام محمد عبده دأبوا

المعارضة للتجديد والإصلاح على أشدها ، حتى نجحت في وأد مشروع تقنين الأحوال الشخصية الذي أعدته اللجنة المشكلة من كبار علماء المذاهب الأربعة في عام ١٩١٥ .

ومن المحتمل أن هذا الفشل الذي منيت به اللجنة في تقديم مشروع شامل لأحكام الأحوال الشخصية قد أدى إلى إقناع المجددين بالاكتفاء بأسلوب الإصلاح الجزئي ، وتقديم مشروعات تتعلق بأحكام محددة تمس فيها الحاجة إلى التقنين والخروج عن الأحكام المعمول بها والمستمدة من المذهب الحنفي . ويختلف هذا الأسلوب الجزئي في تقنين بعض مسائل الأحوال الشخصية عن أسلوب التقنين الشامل لهذه المسائل على النحو الذى أخذت به بعض البلاد العربية كسوريا التى صدر قانونها لأحوال الشخصية عام ١٩٥٣ متضمنا الأحكام التى يرجع إليها القاضى في موضوعات الزواج والطلاق والميراث والوصية والأهلية والوصاية على الصغير (٤) . وقد يوحى أسلوب التقنين الجزئي لبعض مسائل أو موضوعات الأحوال الشخصية بقوة المعارضين للتجديد والإصلاح وقدرتهم على التأثير في المجالس التشريعية على الرغم مما تتسم به بعض هذه التجديدات الجزئية من عمق وموضوعية .

ومهما يكن الأمر فقد استقر الوضع في اواخر الربع الأول من هذا القرن على حق المجالس النيابية والتشريعية في إصدار تقنينات لا تلتزم بأحكام مذهب فقهي واحد ، هو المذهب الحنفي أو غيره . وقد كان التسليم للمجالس النيابية بهذا الحق هو الذي فتح الباب لصدور هذه التشريعات والتقنينات التي توالى وضعها موضع التطبيق أعوام ١٩٢٠ و ١٩٢٩ و ١٩٣١ و ١٩٤٣ و ١٩٤٦ وماتلاها مما يصعب حصره في هذا الحيز .

## الأسلوب الشكلي في الإصلاح

لعل قوة المعارضة مسئولة كذلك عن اعتماد المصلحين على الأسلوب الشكلي آو الإجرائي لتحقيق الهدف الاجتماعى المقصود تحقيقه . وإنما يتعلق هذا الأسلوب بمنع المحكمة من نظر الدعوى في أحوال خاصة بما يؤدي إلى التأثير على السلوك الاجتماعي في الاتجاه المقصود للإصلاح . يوضحه – على سبيل المثال – أن موضوع زواج الصغار من الموضوعات التي شغلت أذهان المصلحين ، وظهرت لهم خطورة هذا الزواج على صحة المرأة وعلى من تنجبهم فضلا عن المساوىء الأخرى المتمثلة في ارتفاع معدلات الطلاق في مثل هذا النوع من الزواج . ولم يكن بالوسع مع قوة المعارضة اللجوء إلى حل هذه المشكلة بقاعدة موضوعية تحدد سنا معينا للحكم بصحة الزواج .

وقد تمثل الحل لهذا فيما نصت عليه الفقرة الخامسة من المادة ٩٩ من لائحة المحاكم الشرعية ١٩٣١ حيث جاء فيها أنه لا تسمع دعوى الزوجية إذا كانت سن الزوجة تقل عن ست عشرة أو سن الزوج عن ثماني عشرة سنة .

مجال يستعصى على التغيير أكثر من غيره ، وهو مجال الأحوال الشخصية .

## التقنين

يعني التقنين صياغة الأحكام الشرعية وترتيبها ترتيبا منطقيا على النسق الذي استقرت عليه القوانين الحديثة . وقد عرفت الدولة العثمانية التقنين في عهد سليمان القانوني ، وتولى شيخ الإسلام أبو السعود صياغة عدد من القوانين الشرعية لتطبيقها في البلاد الأوربية المفتوحة . وقد تولى هذا المنصب (شيخ الإسلام) قريبا من تسعة وعشرين عاما (١٥٤٥ - ١٥٧٤) اعترافا بأهمية الجهود التي بذلها في هذا الصدد(١) ولعل مجلة الأحكام العدلية اكمل هذه التقنينات التي صدرت في الفترة العثمانية . وهذه المجلة التي وضعت موضع التطبيق في الشام والعراق وتركيا منذ عام ١٨٨٧ م حتى منتصف هذا القرن كانت تقنينا مدنيا كاملا ولكن عابها الاقتصار على المذهب الحنفي وحده .

وعلى الرغم من هذه التجارب العديدة في تقنين أحكام الفقه الإسلامي فإننا نلاحظ تردد بعض العلماء في الإقدام عليه ، بل ومحاربتهم له . وهذا هو الذي يبدو بوضوح فيما يرويه رشيد رضا من أن الخديوى إسماعيل طلب من علماء الأزهر تأليف كتاب في الحقوق «والعقوبات موافق لحال العصر ، سهل العبارة ، مرتب المسائل على» نحو ترتيب كتب القوانين الأوربية ، فرفض هؤلاء العلماء ذلك ، وعللوا رفضهم فيما يذكره رشيد رضا بالمحافظة على «طريقة سلفهم الأزهري فى كيفية التأليف ، وهو أن يكون الكتاب مؤلفا من متن وشرح وحاشية» . أما تأليف كتاب يقتصر على القول الراجح بعبارة سهلة مقسم إلى مسائل وأحكام يتوالى سردها ومرقمة بأرقام على كيفية كتب القوانين الأوربية فقد رأوا أنه «من البدع الهادمة» لسنة سلفهم الأزهري . وقد أراد الخديوى إسماعيل الاستعانة برفاعة رافع الطهطاوى فى إقناع الشيوخ بهذا ، وفاتحه في هذا الامر ، وقال له «إنك منهم ونشأت معهم فأنت أقدر على إقناعهم» فاعتذر له رفاعة بقوله : «إننى يامولاي قد شخت ولم يطعن أحد في ديني فلاتعرضني لتكفير شيوخ الأزهر إياى في آخر حياتي وآقلني من هذا الأمر ، فأقاله» (٢) .

لكن الحاجة إلى تقنين الأحكام الشرعية قد عادت إلى الظهور مرة أخرى في التقرير الذى أعده محمد عبده لإصلاح المحاكم الشرعية عقب توليه منصب الإفتاء في مصر عام ١٨٩٩ ، حيث اشتمل التقرير على المطالبة بوجوب تأليف لجنة من العلماء لاستخراج كتاب في أحكام المعاملات الشرعية ينطبق على مصالح الناس المعاصرة ، ويكون سهل العبارة على هيئة مجلة الأحكام العدلية دون تقيد بأحكام المذهب الحنفي (٣). وعلى الرغم من الجاذبية المنطقية لهذا المطلب الاصلاحى الوارد في التقرير فإن تقنين الأحكام الشرعية في مجال الأحوال الشخصية في مصر بالإفادة من الاجتهادات المتضمنة في المذاهب الفقهية الأخرى غير المذهب الحنفي لم ير النور في حياة محمد عبده ، واستمرت

# منهج التجديد التشريعي في الأحوال الشخصية في مصر في القرن الأخير

## محمد سراج

### تقديـم

يهدف هذا البحث إلى استكشاف القواعد المنهجية والأسس التي سيطرت على وعي المجددين في تلك التشريعات المتعاقبة التي صدرت بمصر في هذا القرن إبتداء من مرسوم رقم ٢٥ لسنة ١٩٢٠ حتى مرسوم رقم ١٠٠ لسنة ١٩٨٥. ومن الواضح أن استخلاص هذه القواعد والأسس أمر محفوف بالمخاطر، لاحتمال إغفال بعض القواعد المنهجية والتركيز على بعضها الآخر، مما عساه أن يؤدى في النهاية إلى إعطاء صورة منقوصة لملامح هذا المنهج. ومن جهة أخرى فإن هذا البحث محاولة لطرح مشكلة المنهج في الدراسة الفقهية. لقد خطت الدراسات القانونية خطوات واسعة في تحديد المناهج المختلفة التي تقوم عليها، ومايزال الدرس الفقهي بعيدا في مجمله عن التمييز بين المناهج المستقرة في الدراسات القانونية. وعلى سبيل التوضيح فإن اللافت للنظر أن مناهج الفقه المقارن ماتزال علما على الدراسات الفقهية الخلافية التي تتناول الخلاف بين المذاهب الفقهية المختلفة بدلا من التركيز بمنهج القانون المقارن comparative law على إجراء الموازنة بين النظر الفقهي والتفكير القانوني لاكتشاف أوجه الاتفاق والاختلاف ومعرفة أسباب ذلك. وكذا فإن المنهج التاريخي المستخدم لرصد تطور التفكير الفقهي وربط هذا التطور بأسبابه الاجتماعية ماتزال ملامحه بعيدة عن الوضوح الواجب. لقد صاغ الفقهاء منذ أمد بعيد قاعدة «اختلاف الفتوى باختلاف الزمان والمكان والظروف»، وقد كان من الواجب أن تؤدى هذه القاعدة إلى تحديد ملامح المنهج التاريخى في الدراسة الفقهية وإلى الربط بين التفكير الفقهي وأساليبه وبين التطور الاجتماعي. وسنرى كيف أسهمت التطورات الاجتماعية في مصر في هذا القرن في صياغة عدد من التجديدات التشريعية في

16- David Gallagher. *Modern Latin American Literature* Oxford, 1973, pp. 90, 187.

17- يجد القارىء دراسة على قدر من التفصيل لهذه المسرحية في كتابي
M.M. Badawi *Early Arabic Drama.* Cambridge 1988, pp. 38-40.

18- يجد القاريء عرضا مفصلا لهذه المسرحية فى المرجع السابق ص 120 - 133.

19- Ali B. Jad. *Form and Technique in The Egyptian Novel 1912-1971* London, 1983, p.51.

20- يجد القاريء دراسة مفصلة لهذه المسرحية فى كتابى : : ,M.M. Badawi
*Modern Arabic Drama in Egypt.* Cambridge, 1987, pp. 95 ff.

21- جورج طرابيشي : شرق وغرب : رجولة وأنوثة (بيروت 1977) ص 15.

آخر يكاد يكون وصفيا أو ميتافيزيقيا. ومن هنا جاءت إنسانيته العميقة أو عالميته.

## الهوامش

1- Jaroslav Stetkevych. *The Zephyrs of Najd: The Poetics of Nostalgia in the Classical Arabic Nasib*, Chicago, 1993.

2- انظر مثلا : - H.A.R. Gibb. "Arab Poet and Arabic Philologist," *Bulletin of the School of Oriental & African Studies*, XII (1947-48) 576 ff.

3- انظر. *The London Review of Books*, 21 November 1991, p.98.

4- في ندوة عقدت بالرياض بمناسبة فوزنا بالاشتراك بجائزة الملك فيصل العالمية في الأدب العربي لعام ١٩٩٢.

5- « النقد والحداثة » تأليف عبد السلام المسدي في مجلة « فصول » مجلد ٥ عدد أول أكتوبر - ديسمبر ١٩٨٤، ص ٢٣٢ - ٢٣٣.

6- «الفكر الأدبي المعاصر» تأليف جورج واطسن ترجمة محمد مصطفى بدوي. الهيئة المصرية العامة للكتاب ١٩٨٠، ص٩، ١٠.

7- صحيفة «الحياة» عدد ١١٤٥٣ - يوليو ١٩٩٤.

8- د. محمد مفتاح : الشعرية في شعر الشابي، بحث مقدم للدورة الرابعة لمؤسسة جائزة عبد العزيز سعود البابطين للإبداع الشعري ١٠ - ١٢/١٠/١٩٩٤ - فاس - المملكة المغربية.

9- «أخبار الأدب» عدد ٧١ - ٢٠ نوفمبر ١٩٩٤.

10- انظر مثلا د. عبد القادر الرباعي: «الصورة الفنية في النقد الشعري : دراسة النظرية والتطبيق» دار العلوم للطباعة والنشر - الرياض ١٩٨٤، ولا سيما حديثه عن «أم أوفي» في معلقة زهير ص ٢٣٦ ومايليها.

11- Robin Ostle (ed.). *Modern Literature in the Near and Middle East 1850-1970*, London, 1991.

12- Wole Soyinka. *Art, Dialogue and Outrage : Essays in Literature and Culture* Ibadan, 1988, xiii, 189.

13- Ngugi wa Thiong'o. *Decolonizing the Mind* London

14- انظر هنريت عبودي في عرضها لكتاب طاهر بكري - صحيفة الحياة ١٧ يناير ١٩٩٥ Taher Bakri. *Littérature de Tunisie du Maghreb*, Paris, 1994 .

15- ضحى محمد شيحة : «الأدب المغربي الناطق بالفرنسية بين الأمس واليوم» مجلة «عالم الفكر» مجلد ١٩ عدد أول ابريل - مايو ١٩٨٨ - ص ٢٢٨.

تعرض من وجهة نظر مكدونالد يجد القارىء نفسه يتعاطف معه كأنسان. إذ يقع مكدونالد في غرام امرأة شرقية (شيرين) ولا يستطيع أن يقاوم عاطفته، كما تتجاهله السلطات البريطانية في لندن وتتنكر له ويؤلمه إحساس حاد بإن الإمبراطورية – التي لها ولاؤه المطلق – في تدهور وأن الأمريكان عديمو الذوق والثقافة سيحلون محلها بمالهم وسطوتهم – كل هذه الأحاسيس يصفها الروائي وصفا دقيقا شفافا، بحيث تكاد تصبح شخصية هذا الدبلوماسى البريطاني شخصية مأساوية. فى سباق المسافات الطويلة نجد موقفا هو نقيض ما وجدناه في الأعمال السابقة ؛ فالعلاقة الغرامية هنا بين امرأة شرقية ورجل أوربي، امرأة هي أقرب إلى شخصية Justine في «رباعية الإسكندرية» للورانس دوريل Durrell. فهل يعني هذا أن حاجة الرجل الشرقي أو العربي لتأكيد ذاته ومساواته للرجل الأوربي لم تعد ملحة كما كانت من قبل ؟ أو أن هذا التطور يعود إلى زيادة تحرر المرأة الشرقية ؟ إذ نلاحظ أنه من أجل عنصر الجنس الذي فيما يبدو تزداد حتميته فى الرواية لم يعد الروائيون العرب مثل إدوار الخراط أو المرحوم جبرا إبراهيم بحاجة إلى إدخال شخصيات نسائية أوربية في رواياتهم بل يستطيعون الآن أن يصوروا نسوة من العرب والمسلمين فى علاقات عاطفية مع الرجال. كذلك فإن الروائيات العربيات أنفسهن مثل الروائية اللبنانية حنان الشيخ (ولدت ١٩٥٤) في «حكاية زهرة» (١٩٨٠) أو غادة السمان السورية (ولدت ١٩٤٢) في «كوابيس بيروت» (١٩٧٦) لا يجدن حرجا في وصف نواح من الحياة الجنسية للمرأة. وهنا بون شاسع بين الوضع الحالى وبين ما أثارته ليلي البعلبكي (١٩٣٦) من ضجة حين نشرت «أنا أحيا» و «سفينة حنان إلى القمر» (١٩٦٤).

لضيق الوقت أمكنني فقط الحديث عن أحد الموضوعات المتكررة أو الثوابت وهو الصراع بين الشرق والغرب. إلا أن ما قلته عن هذه الموضوع ينطبق أيضا إلى حد بعيد على غيره من الموضوعات، مثل الصراع بين المدينة والقرية أو بين الفرد والسلطة. ولا يدعو هذا إلى العجب لأن هذه الموضوعات كما سبق أن قلت مرتبط بعضها ببعض، لأنها التعبير الأدبي عن المعركة الأليمة التي يخوضها العرب في سبيل الحداثة. لقد عاش المويلحي في عصر انتقال فعبر عن ذلك التغير الفكري والاجتماعي والحضاري الخطير الذي أصاب المجتمع التقليدي في مصر. وعلى نفس المنوال نجد أن معظم كبار الكتاب اللاحقين أمثال طه حسين وتوفيق الحكيم ويحيي حقي وطاهر لاشين – ونجيب محفوظ ويوسف إدريس وعبد الحكيم قاسم وعبد الرحمن منيف قد سجلوا جميعاً، كل فى جيله، انطباعاتهم عن مراحل أخري من هذا التغير الحضاري كما عبروا عن مواقفهم إزاءه. فالكاتب العربي الحديث يقوم بدور الشاهد على عصره، يلحظ عن كثب مجتمعه، ويسجل ما يجري فيه على كافة الساحات من سياسة وغيرها. وأثناء قيامه بدوره هذا كضمير أمته اليقظ تراه أحيانا يبدي إحساسا مرهفا بمرور الزمن وتعاقب الأحداث. وفي حالة كاتب عظيم مثل نجيب محفوظ يكتسب هذا الإحساس بعدا

وبينما نرى أن موضوع الصراع بين الشرق والغرب وسوء فهم أحدهما للآخر له حضوره البارز في الرواية إلا أنه من التعسف أن نعتبر هذه الرواية مجرد عرض لهذا الصراع لا أكثر. فموسم الهجرة إلى الشمال تعالج ضمن ما تعالج من موضوعات الغربة أو الاغتراب وعدم التوازن بين العقل والعاطفة، ومشكلة الهوية، والعلاقة بين الوعي واللاوعي وطبيعة الشر. فليس مصطفى سعيد مجرد نموذج للمثقف العربي أو الإفريقي في أوربا ؛ فهو له شخصيته المتميزة وله تاريخه الخاص. وهو رجل ممزق مأساوي توقف نموه عاطفيا وإن كان ذهنه الحاد قد بلغ درجة نادرة من النضج، ومشاعره إزاء النساء حددها إلى حد ما غياب الأب في حياته، وحرمانه من عاطفة الأمومة الحقة. والشر الذي يمثله لا ينتهي بموته بل يستمر في صورة جريمة قتل حسني ودّ ريس.

وفي هذه الرواية نجد أن إشكالية الهوية الثقافية التي تقبع تحت الصراع بين الشرق والغرب قد تعمقت واكتسبت بعدا آخر، واندرجت تحت الإطار الأوسع لإشكالية الهوية الفردية أو الذات وهي مادة الروايات الكبرى.

طبعا لسنا بحاجة إلى دراية بالنقد النسائي لكي ندرك أن الذي يمثل الغرب في الكثير من الأعمال وغيرها امرأة شابة جميلة على علاقة غرامية أو جنسية بشاب فحل يمثل الشرق، حتى يمكن تفسير ذلك ببساطة بأن نقول إن الذكور العرب في أوربا ولأسباب واضحة عادة يتمتعون بمقار من الحرية الجنسية أكبر ما يتمتع به الإناث العرب.

كما أن الحركة الرومانطيقية في الغرب نظرت إلى الشرق باعتباره موطن الأسرار والملذات والجمال الغريب، كذلك فإن الحركة الرومانطيقية التي تماثلها في الشرق وكما يتضح بالذات في شعر على محمود طه جعلت أوربا موطن الجمال الحسي والحرية الجنسية، فالمرأة التي يتغنى بها الشاعر هي شقراء جميلة ذات شعر ذهبي. غير أن هذه الظاهرة في الرواية العربية قد وجد لها البعض (مثل جورج طرابيشي) (٢١) تفسيراً أعمق. ففي ثقافة مركزها الذكورة والفحولة كالثقافة العربية تصير وسيلة لاستعادة الإحساس بالتكافؤ أو المساواة مع الرجل الأوربي الذي باستعماره الوطن العربي كان كأنه سلبه ذكورته أو خصاه. وعلى ضوء هذا التفسير يكتسب آخر عمل سأذكره دلالة خاصة.

تدور أحداث رواية «سباق المسافات الطويلة» لعبد الرحمن منيف (١٩٧٩) في إيران في أواخر أيام وزارة مصدق قبيل سقوطه وعودة حكم الشاه الاستبدادي بمعونة الأمريكان والإنجليز. والراوي بيتر مكدونالد موظف بوزارة الخارجية البريطانية متفان في خدمة الإمبراطورية ورأسه مفعم بالآراء المسبقة والتصورات التقليدية التي يعتنقها الغربيون عن الشرق وسحر الشرق وكسل الشرق. وهذه الرواية على عكس معظم الروايات العربية تجعل شخصيتها الرئيسية رجلا أوربيا، وعلى الرغم من أنها تدين السبل الدنيئة التي يسلكها الاستعمار الغربي لتحقيق مآربه على حساب أهل البلد، إلا أنه نظرا لأن الأحداث

جنسية بهن انتحرن من أجله. أما الرابعة وكانت امرأة لعوبا ذات نزعة نحو العنف فقد تيم بها لدرجة أن تيم أن تزوجها. وكان زواجا عاصفا خانته فيه و انتهى بأن قتلها حين غرس السكين بين ثدييها بناء على طلبها بينما هي راقدة عارية على السرير. و كان يود لو حكم عليه بالإعدام فيكون ذلك تكفيراً عن حياته التي أحس بأنها مجرد أكذوبة. إلا أنه نتيجة الدفاع عنه وشهادة أساتذته في صفه حكم عليه بالسجن لمدة سبع سنوات. وبعد أن أطلق سراحه طاف في العالم، ثم عاد إلى بلده ليقيم في ود حامد وييني حياته من جديد كمزارع فيها وتزوج من امرأة سودانية هي حسني وأنجب منها ولدين. ويذهب الراوي إلى الخرطوم ليتسلم عمله كمدرس ولا يزور قرية ود حامد إلا في العطلات. ويمر عامان على حكاية مصطفى له بعدهما يعلم أن مصطفى قد مات غريقا في النيل، وإن لم يعثروا على جثته، وأنه قد ترك له مظروفا بداخله رسالة يرجوه فيها أن يتعهد برعاية أرملته وولديه وكافة أموره. كما ترك له مفتاح غرفة في بيته لم يكن يسمح لأحد بدخولها. ويباشر الراوي هذه الرعاية، ولكنه سرعان مايفاجىء بأحد رجال القرية ودّ ريس وهو مزواج يطلب منه أن يقنع أرملة مصطفى بقبول عرضه الزواج منها على الرغم من أنه يكبرها بحوالي أربعين عاما. وحين يفاتحها الراوي في الموضوع على مضض تخبره بأنه إن أجبرها على هذا الزواج قتلته وقتلت نفسها. ويعلم الراوي خبر موت حسني فيعود إلى ود حامد حيث يخبره بعض الأهالي بعد لأي بتفاصيل الجريمة، وأنه إلى حد ما مسئول عما حدث لأنه كان عليه أن يتزوج حسني نفسه. وفي هذه اللحظة يشعر بأنه على الرغم من كونه الآن رجلاً متزوجا وله طفل إلا أنه ربما كان يحبها فيذهب إلى دار مصطفى سعيد، ويدير مفتاح الغرفة الممنوعة، فيجدها مفروشة على الطراز الإنجليزى الكامل، كما لو كانت غرفة مكتب أستاذ إنجليزى، وبها مكتبة غنية فى شتى فروع المعرفة، ولكن لا يوجد فيها كتاب واحد باللغة العربية. هي قطعة من إنجلترا حافظ عليها سرا في بيته ؛ فهي دليل قاطع على غربة مصطفى سعيد. ويجد الراوي أيضا بعض أوراقه ومذكرات ويومياته ويحاول على أساسها أن يسد بعض الفجوات في قصة حياته. ولكن الصدمة التي تصيبه تجعله يتوقف عن القراءة ويسرع إلى النيل في الهزيع الأخير من الليل، ويخلع ملابسه قاصدا الانتحار، فيما يبدو، ولكنه وهو وسط النيل يعدل عن ذلك ويقرر أن يعيش على الأقل نتيجة إحساسه بالواجب غير آبه بما إذا كان للحياة معنى فيصرخ طالبا النجدة.

من هذا الملخص المقتضب يتضح مقدار ما في حياة الراوي وحياة مصطفى سعيد من تداخل وامتزاج. إنه في مواضع عدة من الرواية يصعب الجزم، حتى على الرواي نفسه - بأن مصطفى سعيد قد وجد فعلا، أو بأنه كانت له حياة خارج ذهن الراوي، وبأنه ليس إلا تجسيدا للاوعي الراوي أي ذاته الأخرى.

معقدة تضم كعنصر من عناصرها دراما الإيمان والشك. ولكن تجربة الغرب يبدو أنها مرحلة ضرورية لابد للشرقي أن يجتازها لكي يكتشف هويته.

وفي «الحي اللاتيني» (١٩٥٣) يستخدم الأديب اللبناني سهيل إدريس العلاقة بين عدد من الطلبة العرب وبين نساء فرنسيات في باريس، ليس فقط لينتقد الجوع الجنسي الذي يعاني منه الشاب العربي، ونفاق المجتمع العربي، ولكن أيضا كوسيلة من خلالها يتبع تطور شخصياتهم فيجعل هذه العلاقة مرحلة من مراحل النضج العاطفي والسيكولوجي – ذلك النضج الذي يلزمهم لكي يتمكنوا من القيام بأعباء قضية القومية العربية. فالبطل اللبناني عليه أن يتحرر من سيطرة أمه ويحاول أن يكفر عن خطيئته إزاء الفتاة الفرنسية جانين التي أخلصت له الحب، وحملت طفلة، ولكنه هجرها بإيعاز من أمه. أما جانين فكانت ترى من واجبها يقضي عليها أن تتخلي عنه بعد إجهاضها لأنها لم ترد أن تقف عقبة في سبيل قضيته القومية. رسالة المؤلف هنا سياسية في جوهرها وإن كان يشوبها أحيانا رومانطيقية مغرقة وشيء من الوجودية المفتعلة.

العمل التالي الذي أود أن أشير إليه هو أهم وأنضج بكثير من «الحي اللاتيني» وهو «موسم الهجرة إلى الشمال» الذي نشره الروائي السوداني الطيب صالح في ١٩٦٧. هو أيضا رواية تدور حول تربية البطل، وهي غنية بالأفكار وذات بنية دقيقة متداخلة، وتعتمد على وسائل فنية متطورة، مثل التوازي والتعارض، واستخدام تيار الوعي، ومعالجة بارعة للزمن بحيث يمتزج الماضي والحاضر وتتطور الشخصيات عن طريق لمحات استرجاع الماضي flashback. دعني أذكركم بأحداث الرواية الرئيسية. تبدأ الرواية بالراوي يعود إلى قريته ود حامد بعد غياب سبع سنوات للدراسة في انجلترا ويشعر بالسعادة إلى حد يقرب من التصوف لاجتماع شمله بأهله الفلاحين على الرغم من فقرهم بالنسبة للمجتمع الصناعي الأوربي. ويثير اهتمامه شخص غريب على القرية بمظهره وحديثه المتميز، هو مصطفى سعيد. وتنشأ الصداقة بينهما ويعترف له مصطفى سعيد بقصته بعد أن يكسب ثقته، ويعده بألا يبوح بسره إلى أحد. نشأ مصطفى يتيماً؛ إذ مات أبوه قبل ولادته فأنشأته أمه، ولم تكن تضفي عليه الكثير من عطف الأم، ولذلك فلم يكن تربطه بها عاطفة قوية. وقرر وهو طفل الذهاب إلى المدرسة، وتفوق في دراسته، بحيث أرسله ناظر المدرسة الإنجليزي إلى القاهرة ليتم تعليمه. وفي القاهرة نزل عند أسرة إنجليزية (مستر ومسز روبنسون) وأغدقت عليه الأسرة المحبة والرعاية، ولا سيما السيدة روبنسون، التي عاملته معاملة الأم لابنها، والتي شعر نحوها بشيء من المشاعر الجنسية التي تصاحب فترة المراهقة. وبعد إتمام تعليمه الثانوي دبرت له الأسرة مامكنه من الدراسة في انجلترا، حيث أتاح له نبوغه أن يعين أستاذا للاقتصاد في جامعة لندن. وفي انجلترا عقد مصطفى عزمه على أن يؤثث غرفته ويزينها بالطراز الشرقي البحت.

ويستغل جاذبيته الجنسية وظروفه كإفريقي لينتقم من الذين استعمروا بلده بأن يغزو أكبر عدد من نسائهم. وثلاثة من النسوة اللائي كان على علاقة

نادي شباب مجاور مجموعة من تلاميذ المدارس يغسل وجوههم، ويعدل من مظهرهم ليصبح لائقا. ويرن جرس التليفون ثانية ليخبرهم القنصل بأنه تسلم برقية تفيد بحدوث زلزال في بلده، ولذلك فلن يستطيع حضور الحفلة. عندئذ يقرر الزوجان أن يبدآ الحفلة فيلقي صابر بك خطبة رسمية يعلن فيها للضيوف نبأ حصوله على الميدالية ويريهم صورة فوتوغرافية لها. وينقض الضيوف ولاسيما التلاميذ على الطعام ويلتهمون معظمه. وبعد قليل تأتي رسالة أخرى من القنصل مؤداها أنه وقع خطأ في البرقية، وأنه بإمكانه أن يحضر الحفلة كما وعد. فيأمر الزوجان الضيوف بالكف عن الأكل ويحاولان أن يعيدوا شيئا من النظام والترتيب في البهو. وتنتهي المسرحية بوصول القنصل وهو يخطو خطوات بطيئة ووقورة يتبعه خادم بزي رسمي يحمل الميدالية في صندوق فاخر وينحني له الزوجان والضيوف احتراما ويهتفون جميعا يا Excellence.

في هذه المسرحية ينتقد محمود تيمور نقدا لاذعا حماقات الطبقات العليا من المجتمع وتفاهاتهم التي يشغلون بها أنفسهم لملء الفراغ في حياتهم ويسخر من قيمهم الزائفة ومشاجراتهم وسخافاتهم البلهاء ومظاهرهم الكاذبة وتقليدهم الأعمى للمظاهر السطحية للحياة الغربية، بما في ذلك شراء الزوجين صورة زيتية سيريالية لا يعرفان أعلاها من أسفلها.

ولكن يجدر بالذكر أنه لكي يتذوق المتلقي الفكاهة في بعض الأحيان يلزمه أن يكون على دراية واعية بالثقافة الغربية ذاتها ولهذا دلالته طبعا(٢٠).

وفي العام التالي (١٩٤٤) نشر يحيى حقي قصته الشهيرة «قنديل أم هاشم» وهي ما يسمونه Bildungsroman أي نوع القصص الذي يصف تربية البطل. والبطل إسماعيل يقف عند مفترق الطرق أو ملتقي حضارتين. لقد نشأ في حضارة إسلامية تقليدية، ولكنه وهو شاب في سني التأثر تعرض لتأثير الحضارة الأوربية الحديثة، حين قضى سبع سنوات في انجلترا يدرس الطب. وأثناء دراسته نشأت له علاقة غرامية بإحدى زميلاته في الدراسة، وقد أخذت على عاتقها مسئولية تثقيفه ففقد إيمانه بالدين وحل محله إيمان لا يقل قوة بالعلم والعقلانية. وحين يعود إلى مصر وهو مفعم حماسا لإصلاح وطنه تصدمه معتقدات أسرته وخرافاتها فيثور ضدها وتكون لذلك نتائج وخيمة. ولكن غربته تنتهي حين يمر بتجربة شبه صوفية يدرك بعدها كيف يقبل أهله التوفيق بين إيمانه التقليدي وبين علمه الذي تعلمه في انجلترا. وفي «قنديل أم هاشم» يكتسب الصراع بين الشرق والغرب بعدا روحيا ثقافيا. ففي هذه القصة يحاول مثقف مصري أن يوفق بين قيم الشرق والغرب، لأن كليهما له قيمه، وحاجة المرء إلى تأكيده هويته الثقافية يمكن إشباعها، ولكن ليس على حساب الرفض التام للآخر. لقد بعدنا كثيراً عن موقف إيفانوفيتش المبسط الساذج في رواية الحكيم. هذا بالإضافة إلى أنه على الرغم من أن البطل وإن كان يرمز لمصر في نهاية القرن الماضي، وهي تجربة تقوم فيما يبدو على ضرورة الخيار بين مجموعتين من القيم، إلا أنه ليس مجرد رمز، بل هو شخص ينبض بالحياة يمر بتجربة مركبة

قصة الحب هذه تهدف إلى تبيان الفارق بين إخلاص الشباب الشرقي المطلق وعاطفته وتفانيه وبين التفكير العملي المنفعي لامرأة لا من الغرب. إلا أن هذه القصة تشغل حيزا صغيرا من الكتاب الذي يدور معظمه حول تأملات صديق البطل المريض إيفانوفيتش الروسي المغترب حول مزايا الشرق والغرب، فيعتبر الحضارة الغربية مجرد لعنة لأنها تقدس القيم المادية ؛ فإسهامها هو ميدان العلم والتكنولوجيا اللذين يفقران الحياة، لأن الحياة الحقة هي حياة الروح. ويدعو ايفانوفيتش إلى العودة إلى الشرق منبع الحياة ؛ ففيه وحده خلاص البشرية. إن رواية «عصفور الشرق» تتسم في بدايتها بالفكاهة والرشاقة ولا سيما في وصف الحكيم لغرام البطل بالفتاة الفرنسية، عاملة شباك التذاكر، التي يضفي عليها محسن غلالة من المثالية المضحكة – إلا أن هذا الطابع الفكاهي الجذاب يختفي تدريجيا ليحل محله الكآبة الناتجة من إحساس البطل بالخيانة من ناحية ومن أفكار إيفانوفتش السوداء من ناحية أخرى. ويختلف تناول الحكيم لموضوع الصراع بين الشرق والغرب عن تناول سابقيه في أنه ذو طابع فكري فلسفي ؛ إذ يصوغه في حدود روحانية الشرق ومادية الغرب. لقد اعتبر معظم النقاد رواية «عصفور من الشرق» تعبيرا عن رفض الحكيم للغرب. ولكن هذا الحكم في الواقع أبعد ما يكون عن الصواب – لأن هذه الرواية دليل ناصع على مقدار تشرب الحكيم للفكر الأوربي. فإدانة إيفانوفتش للغرب وماديته هي ذاتها لون من التفكير الغربي الذي كان شائعا في ذلك الوقت، ومصدرها الكاتب المشهور جورج دوهاميل ((Georges Duhamel : Scènes de la vie future (1930)) الذي هاجم الحضارة الصناعية الأوربية بحجة أنها تنزع إلى سلب الناس إنسانيتهم وإلى القيم الثقافية التقليدية (١٩). كذلك لا يمكن أن يصف نشوة الاستماع بموسيقى بيتهوفن كما وصفها الحكيم في هذا الكتاب إلا شخص أثرت فيه الثقافة الأوربية ومست فيه أعمق الأعماق.

في «حفلة شاي» لمحمود تيمور (١٩٤٣) نعود إلى عالم الكوميديا وموضوع التقليد الأعمى لقشور الحضارة الغربية ومظاهرها السطحية. صابر بك وزوجته فكرية هانم، وهي امرأة عصبية المزاج، ينتميان إلى الطبقة العليا من المجتمع، ويقرران أن يعقدا حفلة شاي تكريما لقنصل دولة غربية سيحصل منها صابر بك على ميدالية تقديرا لجهوده في تشجيع رياضة ركوب الدراجات، ويستغل الزوجان هذه المناسبة ليظهرا للغير أهميتهما وعلو مركزهما في المجتمع، فيدعوان عددا كبيرا من الشخصيات البارزة بمن فيهم رجال السياسة والسلك الدبلوماسي وينصان في الدعوة على ضرورة ارتداء زي السهرة الرسمي. ولكن لسوء حظهما لا تسير الأمور حسبما يريدان. إذ تبين أن تاريخ الحفلة يتعارض مع تاريخ حدثين مهمين فلا يحضر سوى حفنة من الضيوف يؤكد ضآلة عددهم البهو الشاسع المقام فيه خوان هائل. ويرن جرس التليفون ليخبرهم القنصل بأنه سيتأخر قليلا نتيجة لضغط العمل، فيأمران أحد الخدم بأن يجمع من الشارع أكبر عدد من الناس المناسبين ليزيدوا من عدد الضيوف، فيحضر الخادم من

إبعاد ابنه عمته، حالما يكتشف أنه تربطه بها رابطة عاطفية. فينتحر الابن وتجن ابنة أخية، وحين تعلم نوريسكا بموت ابنها تهرع وهي في حالة هيجان لمجابهة همام وتطلق عليه النار فترديه قتيلا عقابا له على ما جناه على الكثيرين.

من هذا التلخيص قد يبدو أن «الذبائح» إن هي إلا ميلودراما رخيصة. ولكن الواقع عكس ذلك تماما ؛ فهي مسرحية محكمة البناء لدرجة مدهشة. يسودها إحساس بالسخرية التراجيدية، وشخصياتها يتحقق فيها من التعقيد والغنى والحيوية ما يجعلنا نقبلها كشخصيات مقنعة نتعاطف معها بكل جوارحنا. فهمام يصوره لنا المؤلف رجلا عسكريا في رتبة عالية ذا مهابة عظيمة شديد العناية بابنه وابنة أخته، ولكنه طاغية محافظ شديد المحافظة ويمثل خير تمثيل العقلية العسكرية ذات النظرة الواضحة كل الوضوح، ولكنها نظرة محددة فيما تراه، ومايراه من المشاكل يشعر بأنه لابد أن يكون له حل سهل. ليس بمقدوره على الإطلاق أن يدرك مدى ما في العواطف من تناقض وتعقيد يجعل كل شخص فردا فريدا من نوعه ؛ فلا ينظر إلى نوريسكا إلا على أنها مجرد نموذج لامرأة أوربية، لم تستطع آن تقبل أساليب الحياة الشرقية، لا على أنها شخصية لها ذاتها الفريدة وأنها متحررة في تفكيرها، وغير مستعدة لأن تقبل دور الزوجة التقليدية السلبية الخنوع الذي يود أن يفرضه عليها.

أما نوريسكا فهي شخصية مثالية من الغرب أخذت على عاتقها مسئولية تحرير مصر - رجالها ونسائها - لكي يمكنهم أن يلقوا عن كاهلهم عبء الاستعمار ؛ ولكن الناس حولها مازالوا مقيدين بالماضي، وهي يعوزها الصبر اللازم لتغييرهم. غير أن القول بأن همام ونوريسكا هما في جوهرهما شخصيتان فريدتان لا يعني على الإطلاق أنهما في نفس الوقت لا يمثلان موقفين متعارضين من الحياة ومن الماضي بكل تقاليده، من حرية المرأة ومن مفهوم الزوجة المثالية. وبسبب هذه الخلافات العميقة من ناحية، ونتيجة لمزاجها ولطبيعة شخصيتها المتطرفة من ناحية أخرى كان لا بد أن ينشأ الصراع التراجيدي في إطار الصراع بين الشرق والغرب، وتدور المسرحية، كما يدل عنوانها، حول العلاقات بين الأفراد، إذ يتصور أيضاً جناية الآباء على الأبناء بأنانيتهم وانشغالهم بهمومهم الشخصية، فيقع الجيل الجديد الحساس ضحية للنزاع بين أفراد الجيل القديم.

بعد اثنى عشر عاما (أي في ١٩٣٧) نشر توفيق الحكيم رواية «عصفور من الشرق» وهي في ظاهرها تمثل رفضا للثقافة الغربية. وتدور أحداث الرواية كما نعلم في باريس، حيث نجد البطل محسن وهو طالب مصري يقيم في باريس بقصد دراسة الثقافة الأوربية.

ويقع محسن في غرام امرأة فرنسية ويعيش في حالة نشوة لمدة أسبوعين بعدها يستيقظ من حلمه اللذيذ حين تهجره المرأة، لتعود إلى حبيبها الفرنسي، الذي كانت قد تشاجرت معه في الأيام التي قضتها مع محسن. ومن المفترض أن

في الكثير من النقاط. ومع ذلك فإن موقفه بصفة عامة هو موقف المعتدل غير الرافض لها كل الرفض. والنتيجة التي يصل إليها في آخر فصل في كتابه هي أن سبب الخلل في المجتمع المصري هو «دخول المدنية الغربية بغتة في البلاد الشرقية وتقليد الشرقيين للغربيين في جميع أحوال معاشهم كالعميان لا يستنيرون ببحث ولا يأخذون بقياس ولا يتبصرون بحسن نظر ولا يلتفتون إلى ما هناك من تنافر الطباع وتباين الأذواق واختلاف الأقاليم والعادات ولم ينتقوا الصحيح من الزائف والحسن من القبيح بل أخذوها قضية مسلمة وظنوا فيها السعادة والهناء وتوهموا أن يكون لهم بها القوة والغلبة وتركوا لذلك جميع ما كان لديهم من الأصول القويمة والعادات السليمة والآداب الطاهرة».

والصفة الانتقالية التي يتميز بها شكل «حديث عيسى بن هشام» وأسلوبه ولغته إنما هي انعكاس للوضع الحضاري الانتقالي الذي يدور حوله هذا العمل الأدبي المهم. فهو عبارة عن قنطرة للعبور من القديم إلى الحديث، أو حلقة الوصل بين القديم والحديث، أسلوبا ومضمونا. إنه من ناحية الأسلوب يبدأ بالسجع ثم لا يلبث أن ينتقل منه إلى النثر المرسل، يبدأ على هيئة مقامات ولكن يتحول ويتطور وينمو بحيث لا تسعه حدود المقامة الضيقة فيصبح في عناصره الوصفية والسردية شيئا أقرب إلى الرواية منه إلى المقامة، أو على الأصح شيئا بين بين. كذلك فإنه من ناحية الرؤية والتفكير ينتقل من الأنماط التقليدية الجامدة إلى الأنماط الحديثة المتطورة في الحياة والفكر. ولذلك فإنه يحتل مكانا مركزيا في تطور الأدب العربي الحديث ولا سيما في مجال الرواية والقصة القصيرة والمسرح في مصر وخارج مصر. ذلك أن موضوع «حديث عيسى بن هشام» هو أثر الحضارة الأوربية الحديثة على المجتمع الإسلامي العربي التقليدي أو الصراع بين القيم الإسلامية التقليدية والقيم الأوربية الحديثة وهو عين الموضوع الذي أصبح من الموضوعات الأثيرة لدى الأجيال اللاحقة من الكتاب والأدباء.

والمثل التالي للتوتر بين قيم الشرق الغرب يدور في نطاق الزواج في مأساة «الذبائح» لأنطون يزبك التي عرضت على المسرح بالقاهرة في ١٩٢٥. ولأن هذه المسرحية لاتزال غير معروفة على النطاق الذي هي جديرة به سألخصها بسرعة(١٨). همام باشا ـ أميرلاي على المعاش ـ بعد زواج قصير الأمد من أمينة يقع في غرام امرأة أوربية هي نوريسكا، ويتزوجها بعد أن يطلق أمينة. لكن زواجه من نوريسكا يتبين له بعد مدة أنه غير موفق على الرغم من أنه دام عشرين عاما ويحافظ عليه الرجل من أجل ابنه الذي أنجبه منها وابنة أخته اليتيمة الأبوين التي تنشأ في رعايته. وكان لمشكلاته الزوجية أثر وخيم على صحته وأعصابه، بحيث نراه في بداية المسرحية شخصا مريضا محطم الأعصاب ترعاه ممرضة جديدة. وحين يكتشف أن الممرضة هي زوجته الأولى جاءت متنكرة للعمل من أجل لقمة العيش بعد أن ساءت ظروفها المالية ـ عندئذ يشعر بتأنيب الضمير لأنه ظلمها وأساء معاملتها حين طلقها. ولكى يكفر عن ذنبه يتزوجها ثانية. عندئذ تستشيط نوريسكا غضبا، ويدور شجار عنيف كان له أثر

تاريخها على قدر كبير من النضج والجاذبية. وفيها نجد أول نقد لاذع للتقليد الأعمى للمظاهر الخارجية السطحية للحياة الغربية في المجتمع المصري. فمريم زوجة تاجر موسر من أصل متواضع من الأسكندرية. لها طموحات وادعاءات اجتماعية، تريد أن تنتمي إلى الطبقات الأرستقراطية المتفرنجة، وتحاول أن تظهر بمظهر هذه الطبقات، فتجبر زوجها على اتباع أسلوب الحياة الفرنسية في بيتها وتجعله يصحبها إلى فرنسا لقضاء عطلة الصيف كل عام بل وتدفعه إلى التقدم بطلب للتجنس بالجنسية الفرنسية. وهي ترفض بتاتا فكرة زواج ابنتها من يوسف الشاب المهذب الذي تود أن تتزوجه الابنة، لأنه مجرد مصري من عامة الشعب، وذلك لأنها قد عقدت عزمها على أن تزوجها من ابن أرستقراطي فرنسي كانت تعرفت عليه أثناء إقامتها هي وزوجها في باريس في الصيف الماضي. والمسرحية، هي كوميديا تقوم على الخداع والتنكر ويظهر فيها أثر موليير (في Georges Dandin & Le Bourgeois Gentilhomme) تصور سلوك ابنتها ويوسف وما يلجآن إليه من تصرفات تمكنهما من خداع الأم بحيث يتم زواجهما. وتنشأ الفكاهة في معظمها من محاولة مريم المضحكة لتقليد العادات الأوربية دون أن تفهمها وبإقحامها العبارات الفرنسية في الحوار. وهكذا فهذه المسرحية تتهكم على سلوك فئة من المجتمع تتسم بالادعاء والتصنع والتكلف، ولكنها فئة محدودة، لأن الشخصيات الرئيسة فيها من الشوام غير المسلمين، وهدفها السلطة والجاه اللذان يصاحبان التجنس بالجنسية الأوربية في عهد الامتيازات الأجنبية. ولذلك فالمسرحية تتناول طبقة على هامش المجتمع المصري التقليدي وليس في مركزه(١٧).

وعلى عكس الأميرة الاسكندرانية نجد حديث عيسى بن هشام لمحمد المويلحي وكان من أتباع الأفغاني ومحمد عبده. وقد نشر الحديث أصلا في شكل مقالات في جريدة أبيه مصباح الشرق بين ١٨٩٨ و ١٩٠٣ ولم يظهر في صورة كتاب إلا في ١٩٠٧ ونال الكتاب رواجاً نادراً، ويرجع ذلك إلى حد ما إلى أن مؤلفه في معظم الأحيان لا يقدم آراءه عن طريق مباشر إنما يجسدها في مواقف محسوسة، ومن خلال سرده يعرض لنا صوراً كاريكاتورية تهكمية في منتهى الحيوية والجاذبية. وقصة عيسى بن هشام كما هو معروف قصة قيام أحمد باشا المنيكلي ناظر الجهادية في عصر محمد على من قبره في أواخر القرن التاسع عشر ليرى في مصر عالما غير عالمه ومجتمعا جديدا بأوضاع مختلفة وقيم أخلاقية ونظم قانونية متباينة. وهو يمر - عن طريق اصطدامه بالقانون في بداية القصة - بتجارب عدة من شأنها أن تتيح للمؤلف أن يقابل بين ما كان عليه المجتمع المصري في النصف الأول من القرن التاسع وما آل إليه في أواخر ذلك القرن. والتغيرات الكبرى التي رأى المويلحي أنها طرأت على المجتمع هي تغيرات طوبوغرافية تتعلق بمظهر المدينة وتغيرات قانونية واجتماعية وتغيرات ثقافية وتغيرات أخلاقية. ويعتبر المويلحي أن مصدر هذه التغيرات ولاسيما الأخلاقية هو تغلغل المدنية الأوربية في المجتمع المصري - تلك المدنية التي يدينها المويلحي

والأحلام المزعجة أحيانـاً له مايقابله مثلاً في كتاب Soyinka «مـات الرجل» The Man Died وفيـه يصف تجربته كسجين سياسي لمدة عامين. هذا وإن كان مايصفه Soyinka لا يبلغ من البشاعة مانجده في بعض الروايات العربية.

هذا وموضوع إحباط الفرد الضعيف الذي تقهره قوى هائلة غير متكافئة في مجتمع ينصب له العداء من الموضوعات المألوفة في نتاج الشعراء والروائيين والمؤلفين المسرحيين العرب أمثال صلاح عبد الصبور ومحمد الماغوط وميخائيل رومان وسعد الله ونوس، وعلي سالم ولاسيما الروائيين وكتاب القصة القصيرة ابتداء من نجيب محفوظ وصنع الله إبراهيم وعبد الرحمن منيف إلى يوسف إدريس وزكريا تامر. وهو أيضا من الموضوعات المألوفة في نتاج كتاب أمريكا اللاتينية ؛ فيقول أحد مؤرخي هذا الأدب دافيد جلاجر (١٦) David Gallagher. Modern Latin American Literature 1973. pp. 95, 187 «إن معظم كتـابات أمريكا اللاتينية إنما تدور حول موضوع الفشل على نحو أو آخر» ولعل هذا يفسر إلى حد ما انجذاب بعض المثقفين العـرب إليها. هذا بالإضافة إلى لجوئها إلى ما يسمى الواقعية السحرية magic realism. وفيهـا تلعب الفانتـزى أو الإغراق في الخيال دورا مزدوجا ؛ إذ يمثل الهـرب من واقع أليم أو إلغاءه لحين، وفي الوقت نفسه يخلق عالما سيرياليا يدعو لمقارنته بعالم الواقع بقصد إدانة الواقع. وهو ضرب من التخيل لا شك يسهل تذوقه على قراء «ألف ليلة وليلة».

في نتاج عدد كبير من شعراء الـغرب المحدثين غالبا ما نجد إشارات إلى بابلو نيرودا Neruda . وحين يقول" Gallagher " في كتابه عام ١٩٧٣ «إن معظم كتـاب أمريكا اللاتينية من الشبـاب ملتزمون سيـاسيا، وجميعهم تقريبا يساريون» إنما كأنه يصف أدباء العرب في ذلك الوقت.

وينبغـي أن ندرك أنه على الرغم من أن هذه الموضوعـات التى أشرت إليـها تتردد فى الأدب العربي الحديث بشكل لافت للنظر حقـاً، إلا أن ترددها لا يعني مجرد تكرارها. فالتاريخ لا يعيد نفسه تماما، كما أن الأدب الحي النابض لا يعيد نفسه ولذلك فعندمـا يعالج الموضوع من جديد إنما يكتسب بذلك مـعنىً جديدا، دلالة جديدة أو بعدًا آخر. فحينما تتغير الشفرة شيئًا ماتتعدل الرسالة بالمثل. ولنأخذ مثلا ثنائي الشرق والغرب وهو موضوع هذا البحث. وسوف أقتصر على عدة أمثلة فقط من بين عدد لا حصر له من المؤلفات التي لا تزال تظهر كما نرى في نتاج سليمـان فياض (أصوات : ٧٣ - ٩٠ ) أو الروائي الليبي أحمد إبراهيم الفقيه (في ثلاثيته : سأهبك مدينة أخرى - هذه تخوم مملكتي - نفق تضيئه امراة واحدة ١٩٩١ - ٩٣) والأمثلة التي اخترتها وهي أعمال أدبية ذات قيمة تفوق قيمتها التاريخية، هى خمسة لكتاب مصريين وثلاثة لغير المصريين. وأكثر من مائة عام تفصل أقدم هذه المؤلفات عن أحدثها.

أول هذه المؤلفات مسرحية «الأميرة الاسكندرانية» من تأليف مـؤسس المسرح المصرى يعقوب صنوع كتـبها بين ١٨٧١ - ١٨٧٢، وهى على الرغم من

الكتاب العرب المعاصرين مثل جمال الغيطاني أو إميل حبيبي حيث يلجأ الكاتب إلى تقليد أسلوب أعمال أدبية من العصور الوسطى أو خلق أصداء لها لكي يعمق من أثر السخرية عن طريق توسيع مجال المستويات اللغوية والأسلوبية – هذا الاستخدام ليس في متناول كتاب يشعرون في أعماقهم بأنهم غرباء على اللغة ولا يملكون تراثها الأدبي بأكمله.

وربما كان أدب أمريكا اللاتينية الحديث هو الأقرب من وضع الأدب العربي الحديث الذي كان عليه أن يحدد موقفه حداثة ليس فقط بالنسبة إلى الغرب العدواني وإنما أيضا بالنسبة إلى ماض أدبي غني يزداد الإحساس ببعده عن العالم المعاصر. إذ كان على أدب أمريكا اللاتينية أن يحدد موقفه إزاء التراث الثري للأدب الأسباني. ومع ذلك فالتشابه بين الأدبين ليس كاملا، لأن أسبانيا كانت الدولة المستعمِرة، وكذلك كان ينظر إليها في أمريكا اللاتينية بشيء من العداء، وبالتالي كانت كراهيتها والميل إلى رفضها أشد بكثير مما شعر به حتى شعراء الرفض العرب، سواء الرومانطيقيون منهم أمثال الشابي، أو المحدثون مثل أنس الحاج، إزاء التراث العربي.

كذلك فالالتزام السياسي لدى الكتاب العرب المحدثين من شعراء وروائيين ومؤلفين مسرحيين، وما ولده ذلك في معظم الأحيان من مناوأة الفرد للسلطة – لا شك له ما يوازيه في نتاج الكتاب الذين عاشوا أو لا يزالون يعيشون تحت نظم سياسة جائرة في شتى أنحاء العالم. فمناهضة الحكومات الغاشمة والكفاح ضد الاستعمار وإدانة الفساد والتهرؤ والتسيب من الموضوعات الشائعة في الروايات الإفريقية في عهد الاستعمار ومابعده ابتداء من نتاج الجزائريين مثل «ثلاثية الجزائر» لمحمد ديب (التي تتألف من «البيت الكبير و «الحريق» و «النول» و «نجمة» لكاتب ياسين، والنيجيريين مثل Chinua Achebe, Things Fall Apart و Wole Soyinka في Train of Wheat (١٩٦٧) والكاتب الصومالي نور الدين فرح Nuroddin Farah (b. 1944) الذي ألقى على ثلاثة من رواياته عنوان تنويعات على لحن دكتاتورية أفريقية Variations on the Theme of African Dictatorship. كذلك ساد الأدب الأفريقي المكتوب بالفرنسية أثناء فترة الإستعمار فكرة الأدب الملتزم التي دعا إليها جان بول سارتر في مقالاته التى جمعت فيما بعد في كتابه «ماهو الأدب» ?Qu'est-ce que la littérature وكان سارتر ذاته من أكبر المؤيدين لحركة الزنجية Negritude. أما بعد الاستعمار فقد كان أكبر الأثر لفرانتز فانون الفيلسوف الاجتماعي من المارتنيك Frantz Fanon (1925-1961) الذي تنبأ في كتابه «المعذبون في الأرض» The Wretched of the Earth بالفشل والخيانة والإحباطات التي ستصيب دول أفريقيا بعد الاستقلال. إن كلمة «الالتزام» التي صارت من الشعارات الهامة في الأدب العربي ونقده في الخمسينات والستينات من هذا القرن إنما هي ترجمة مباشرة لا صطلاح سارتر engagement. كذلك إن مانجده في العديد من الروايات العربية من وصف للسجون والمعتقلات السياسية يبلغ حد الرعب

سواء رضوا بذلك أو لم يرضوا – يؤكدون تبعيتهم الثقافية وفي أفضل نتاجهم إنما كانوا في الواقع يضيفون إلى أدب أسيادهم عن طريق توسيع نطاق هذا الأدب وتطويع اللغة الأوربية بحيث تتمكن من التعبير عن الحساسية غير الأوربية، ولذلك يعتبر نتاجهم ضربا من الأدب الإقليمي regional literature التابع لهذه اللغة. وهذا الكلام ينطبق أيضا على سائر الأدب الإفريقي المكتوب باللغة الإنجليزية أو الفرنسية. ولقد عبر عن التناقض أو هذه الأزمة الكاتب الكيني نجوجي وثيونجو Ngugi wa Thiong'o بحماسه المعهود في كتابه «تحرير العقل من الاستعمار»[١٣] Decolonizing the Mind، وفيه يهاجم فرض المستعمر لغته على الشعوب المستعمرة، فيقول : «لقد كانت الرصاصة وسيلة الإخضاع الجسدي بينما كانت اللغة وسيلة الإخضاع الروحي» ويقول : «نحن معشر الكتاب الإفريقيين عن طريق مواصلتنا الكتابة بلغة أجنبية (أوربية) إنما نعلن تبعيتنا. ألسنا بذلك نظل نؤكد روح العبودية والخنوع والاستعمار الجديد على الصعيد الثقافي ؟» وبالمثل كان الأديب والشاعر الجزائرى مالك حداد يقول : «اللغة الفرنسية إنما هي منفاي» مقابلا بقوله هذا عبارة الشاعر الفرنسى أراجون «اللغة الفرنسية إنما هي موطني»[١٤]، فالكتابة بلغة غير الأم هي ضرب من الغربة والاستلاب، ولذلك عز عليه أن يستمر في الكتابة بلغة المستعمر بعد أن أصبح مواطنا حرا في دولة ذات سيادة. كذلك قال أحد الكتاب التونسيين (١٩٧٤)[١٥] «عندما أعبر بالفرنسية فإني لا أكون نفس الشخص الذي يعبر بالعربية، ومن هنا يتولد لدي إحساس بالقطيعة والتمزق قد يصل إلى درجة الجمود».

هذا... وإن كان لا بد من التنويه بأن بعض الكتاب المغاربة لا يزالون يكتبون بالفرنسية ولا يجدون غضاضة في ذلك، مثل مصطفى التليلي في تونس، ورشيد بوجدره بالجزائر والطاهر بن جلون في المغرب.

إن مشكلة الاختيار بين النماذج الأدبية التقليدية الأصيلة وبين النماذج المستوردة من الغرب لم تنشأ بطبيعة الحال في الأدب الإفريقي كما نشأت وبدرجة حادة في الأدب العربي الحديث، وأقصد طبعا الأدب المكتوب باللغة العربية. إذ لا يمكننا أن نتصور أن يظهر في أفريقيا عمل مثل «حديث عيسى بن هشام» لمحمد المويلحي الذي يمثل من الناحية الشكلية والأسلوبية رحلة انتقال من التقليدى إلى الجديد المعاصر. فرواية «الأشياء تنحل» Things Fall Apart (١٩٥٨) لمؤلفها النيجيري Chinua Achebe، وهي تتناول موضوع التغير الثقافي في شكل التصادم بين الحياة التقليدية والغزو الأوربي، هي أبسط بكثر من «حديث عيسى بن هشام»؛ إذ إنها لم تواجه مؤلفها بمشكلات الشكل واللغة – هذا من ناحية. ومن ناحية أخرى فإن غياب التراث الأدبي المحلي المكتوب إنما يحرم المؤلف من إمكانية استخدام تراثه بقصد السخرية أو المقابلة أو التأكيد أو التوضيح أو التعتيم وما إلى ذلك من وسائل أسلوبية وبلاغية توسع من مجال الأداء الفني. إن الاستخدام الخلاق البارع لما يسمى التناقض في إنتاج بعض

إذ إن المدينة عادة مدينة حديثة شاهدت قدرا من التحديث أو التغريب على الصعيد الطوبوغرافي والاجتماعي. كما أن محاولة تحديد ماهية الذات بالنسبة إلى الآخر تشمل رقعة شاسعة تتدرج من الموقف الانتقادي إزاء التقليد الأعمى المضحك للمظاهر الخارجية للسلوك الأوربي إلى الاهتمام الجاد القلق بمشاكل التأثر بالقضايا الفكرية والروحية والجمالية الأجنبية. كذلك هناك الصراع الأليم والذي يبلغ أحيانا حد المأساة بين الفرد وبين السلطة الحاكمة الغاشمة، تلك السلطة التي كانت يوما سلطة الأوربي المحتل والتي تحولت بعد الاستقلال إلى حكم وطني ظالم، في صورة عسكرية غالبا. هذا الصراع هو أحد الموضوعات المتكررة الرهيبة، ويمثل صرخة الكاتب من الأعماق، طلبا للحرية، في ظل حكم استبدادي، وتأكيدا لحقوق الفرد الديمقراطية في دولة حديثة - تلك الحقوق التي للأسف الشديد تعسف بها الحكومات والنظم في ذات محاولتها لتحقيق الحداثة.

ومن الواضح أن هذه الموضوعات ليست مقصورة كلية على الأدب العربي الحديث ؛ إذ نجد بعضها في الأدب التركي الحديث أو الأدب الفارسي الحديث كما تبين من دراسة مقارنة ظهرت مؤخرا بالإنجليزية بعنوان «الأدب الحديث في الشرق الأدنى والأوسط» (Modern Literature in the Near & Middle East) (١١) (1850 - 1970) قام بتحريرها د. روبن أوستل Robin Ostle. كما أن البحث عن الهوية نراه في الكثير من الأدب الإفريقي المكتوب باللغتين الفرنسية والإنجليزية، كما نراه في أدب أمريكا اللاتينية، وأيضا قبل ذلك في الأدب الروسي في القرن التاسع عشر. ومع ذلك فهناك بعض الاختلافات في حالة الأدب العربي الحديث. فالعرب كما هو معروف لهم ماض ثقافي زاخر، تراث هائل من الأدب كان من شأنه أنه في عدة نواح جثم على صدر الحاضر وكبله بالأغلال فكاد يشله عن الحركة. أما الأدب الإفريقي جنوب الصحراء الكبرى المكتوب بالفرنسية أو الإنجليزية فليس له تراث غني مكتوب باللغات المحلية. وهذا بسط الموقف وعقده في نفس الوقت : إذ كان على الأدباء أن يخلقوا لأنفسهم ماضيا مثاليا هو مزيج من الأساطير والتاريخ الذي هو أقرب إلى الخيال. وهكذا نجد الكاتب النيجيري وولي سوينكا Wole Soyinka الحائز على جائزة نوبل للأدب ينعي على الأدب الإفريقي حرمانه من التراث المكتوب الذي لو وجد لصار أساسا صالحا للتربية الثقافية وتنمية الحس الجمالي(١٢).

وفي شمال أفريقيا وفي الجزائر بالذات حيث كان الفرنسيون يمحون التراث الأدبي العربي من الذاكرة العامة نجد أن الكتاب قبل أن تنشط حركة التعريب إثر الاستقلال كانوا مضطرين إلى أن يؤكدوا هويتهم داخل نطاق أدب أسيادهم المستعمرين الدخلاء وفي حدود معايير هذا الأدب. لقد كانوا سجناء موقفهم ؛ إذ إن اللغة الوحيدة التي كان بمقدورهم أن يؤكدوا فيها ذاتيتهم وشخصيتهم المستقلة هي لغة أسيادهم الأجانب التي كانت بالضرورة تنطوي على التراث الثقافي والقيم الحضارية لهؤلاء الأسياد، وبالتالي نشأ هذا الوضع المتناقض، وهو أنهم من خلال محاولتهم تأكيد حريتهم واستقلالهم إنما كانوا -

أو التفعيلة بصفة عامة.

وإننا لنتساءل أيضا ما جدوى هذا الجهد الذي بذله الناقد في تصنيف هذه الظواهر والفروقات الأسلوبية الشكلية وفي إيجاد المصطلحات الفنية ؟ هل يقربنا من شعر الشابي شبرا واحداً وهل يزيد من متعتنا به وفهمنا له مقدار ذرة ؟ وحين يتحدث ناقد آخر (٩) عن « انهيار مرحلة الشاعر الأكبر أو الزعيم الأكبر أو المفكر الأكبر أو الشيخ الأكبر وبروز قامات كثيرة وأصوات كثيرة لها حضورها المتفاوت» وعن «ميل جديد في السياسة إلى قبول الآخر والتعددية والخروج من ذلك بالرؤية الواحدة الطاغية المسيطرة » وهكذا كما لو كان الشعر مثل السياسة ينبغي أن تسوده الديمقراطية بحيث نلغي القيمة ولا نفاضل بين شاعر وآخر – حينئذ يحتم واجبنا علينا أن ندين هذا الخلط في الأمر ونطالب بالمزيد من الوضوح في الفكر الأدبي.

إني لآمل أن هذه المرحلة من الفكر الأدبي ما هي إلا مرحلة عابرة، وأننا لابد أن نعود عن قريب إلى وضع وسط، يتحقق فيه شيء من التوازن، ولا نخشى فيه من أن نؤكد العلاقة الحميمة بين الأدب وواقع التجربة البشرية، كذلك لا نخشى من أن نقول إن النقد الأدبي من حيث هو ضرب من النشاط الفكري يتعامل مع النتاج الإبداعي الأدبي بقصد توضيحه وإلقاء المزيد من الضوء على مختلف جوانبه، ومن ثم زيادة تجربة قراءته متعة وغنى – إنما هو جهد بشري نبيل جدير بالاحترام ولا يجوز تحويله إلى إبداع شعري مقنع أو إلى صورة باهتة تافهة من الفلسفة أو الاجتماع أو علم النفس أو اللغويات فيصبح بذلك شبه فلسفة أو شبه اجتماع أو شبه علم نفس وما إلى ذلك. هو جهد مشروع لذاته وفي ذاته وعلى الناقد أن يستعيد ثقته بنفسه حقا ولا يعيش عالة على غيره إن كان يريد أن يأخذه مأخذ الجد الفيلسوف وعالم الاجتماع والنفس واللغويات. وفي الوقت ذاته على الناقد أن يتواضع أمام النص الذي هو بصدد تفسيره فيجعله نصب عينه دائما ولايضل سبيله في خضم من التأويلات غير المسئولة والتأملات الشخصية الذاتية التي هي ليست من النقد في شيء والتي تتجلى في أخطر صورها في بعض مانشر حديثاً عن الشعر الجاهلي (١٠).

وبعد – فلنعد إلى الثوابت فنقول إن الموضوعات المتكررة في الأدب العربي الحديث هي في الواقع مرتبط بعضها ببعض إذ يبدو أنها تنشأ من طبيعة المجتمع العربي الحديث أو على الأصح من ذات عملية تطوره التاريخي منذ القرن التاسع عشر حتى الآن. هي التعبير الأدبي عن صدمة الصراع بين المجتمع التقليدي والعالم الغربي الحديث وعن بحثه المحض عن هويته وصراعه الذي لا يني لتحقيق الحداثة أو المعاصرة بما يصحب هذا الصراع من متناقضات ومظاهر مترامية الأطراف على مستوى المأساة والملهاة معا. فالتأزم في العلاقة بين المدينة والقرية يوازي وغالبا ما يتعلق بالتأزم في علاقة الشرق بالغرب أو العربي بالأوربي.

النقد الحديث تحدثت عن خطر العودة بنا إلى الموقف الشكلي التصنيفي المجرد، موقف المصطلحات البلاغية التي وصلت إلينا منذ ابن المعتز وعبر العسكري والسكاكي والسيوطي وإن ظهرت في ثياب جديدة ونوهت بضرورة تأكيد التجربة والعنصر الحياتي في الأدب لأننا نختلف عن الغرب في أننا ما تخطينا الشكلية الجامدة إلا حديثاً نسبياً وفي أواخر القرن الماضي وأوائل هذا القرن بالذات، كذلك تحدثت عن خطر الانجراف في تيار موضة الحديث والجري وراء تلك الموضة في النقد الجديد الفرنسيّ التي تنزع نحو الانغلاقية والغموض حتى إننا نجد رائدها رولان بارت يرى بأن الوضوح قيمة برجوازية طبقية ينبغي أن يتخلص منها التفكير الثوري المتحرر. وعلى الرغم من المكاسب الهائلة التي نالها الفكر الأدبي والنقدي العربي في السنوات الماضية سواء في اتساع أفقه أو في رهافة ودقة أدواته – تلك المكاسب التي أسهمت مجلة «فصول» بالذات في تحقيقها – إلا أن هذين الخطرين : خطر غلبة الشكلية والمصطلحات الفنية وخطر الانغلاقية والولع بالغموض لا يزالان ماثلين للأسف. ففي مراجعة لديوان أدونيس «أبجدية ثانية» في صحيفة «الحياة»، وهي صحيفة تستكتب كبار المثقفين نقرأ هذه الكلمات في بداية المقال (٧) : أدركت الأشياء حالتها الأخيرة. دفعتها تجربة أدونيس إلى الاختبار حتى كشف عن طبيعتها النهائية. وهي وصلت إلى التفسخ بعدما تفككت عناصرها، وتحررت علاقاتها. وتم الانتقال مما هو عضوي إلى ماليس كذلك، بتغيير كيمياء المادة. فجأة خضعت الأشياء لصياغة شعرية – كيمياء اللغة – تقول الأسباب والعلاقات وتستجيب لحرية الذات في أن تكون الممارسة الشعرية (كتابة – تجربة – قراءة) «متاها» يصل الجسد الفردي بها تاريخه الرمزي والجماعي».

ونحن نتساءل ما الذي يقصده بالضبط هذا الناقد بهذه الألفاظ وهذه الأحكام التي يطلقها بدون ضابط ؟ ألم يكن بمقدوره أن يعرض فكرته بمقدار أكبر من الوضوح، هذا إن كان في ذهنه شيء يستحق أن يسمى فكرة ؟ وها هو مثل آخر يرد في دراسة حديثة عن الشعرية في شعر الشابي (٨).

يقول الناقد بعد أن يصف شعر الشابي بأنه «شعر التوازي بامتياز» :

هذه بعض المفاهيم التي اقترحناها لوصف «طبيعة التوازي»، وقد كانت : التوازي المقطعي والتوازي العمودي والتوازي المزدوج والتوازي الأحادي وشبه التوازي من ظاهر وخفي، وتوازي التناظر ؛ على أن هذه المفاهيم تعلقت بسطح التعبير اللغوي للخطاب الشعري فقط. ولذلك ها نحن أولاء نتقدم خطوة أخرى فنقترح مفاهيم تقارب البنية العميقة لأي خطاب مهما كان جنسه ونوعه ونمطه. والمفاهيم هي : توازي المطابقة وتوازي المماثلة وتوازي المشابهة وتوازي المكافأة وتوازي المواصلة. إن هذه المفاهيم تجعل من التوازي مكوناً لكل خطاب بعكس ما تذهب إليه كثير من النظريات باعتبار التوازي خاصة شعرية خالصة من دون أنواع الخطاب الأخرى، على أننا لا ننكر أن تجليات التوازي في الخطاب الشعري أعلى درجة وأشد هيمنة، بل وأخص به دون سواه مثل الوزن في الشعر القديم

واهتمام الكتاب بهذه الموضوعات هو ما أنوي دراسته في هذا البحث. وفي هذا الصدد أريد أن أوضح موقفي في هذه الدراسة. إنني لست من المتحمسين للبنيوية ولا ما بعد البنيوية أو التفكيكية وإن كنت لا أنكر إنجازات هذه المذاهب.

لقد كنت حتى قبل سقوط بول دي مان Paul de Mann عن عرشه، ومازلت إلى اليوم من أتباع اليوم مايعرف بالمذهب الإنساني في النقد، أي المذهب الذي يؤمن بأن الأدب هو أساسا يعني بما يعانيه الإنسان من تجارب دافئة نابضة بالحياة، وليس مجرد بنية أو نظام أو بهلوانية لغوية أو مايعبر عنه بما يشبه المعادلة الرياضية أو برسم بياني أو تخطيطي، وبأن الأديب أو المؤلف لم يمت بعد ولن يموت أو لم يختف كلية وراء ما يسمى بالنص. إنني لا أستطيع أن أطرح جانبا قضية القيمة بحيث أعتبر إعلانا في صحيفة مهما كان حظه من البلاغة ومهما كانت طرافته في مناقشة أسلوبية أو سيكولوجية أو كوثيقة اجتماعية ثقافية على نفس المستوى أو بقدر الأهمية التي أنسبها إلى قصيدة للمتنبي أو المعري أو سونيتة لشكسبير. كذلك لا أستطيع أن أهبط إلى مستوي اللعب بالألفاظ مهما كانت درجة التعقيد أو الذكاء في قواعد اللعب بنتاج أدبي يتصارع مؤلفه مع سر الوجود البشري بغية اكتشاف المناطق المظلمة والأبعاد المجهولة من النفس، جاهداً في محاولة تفهم العواطف الإنسانية الجامحة، أو سبر أغوار معضلة الألم، أو حتى يحاول أن يخفف من عناء المعذبين في الأرض بالدعوة إلى اتخاذ إجراء سياسي أو اجتماعي معين. إن الأدب أعظم وأسمى بكثير من مجرد التسلية. هذا قول كان يوما ما يعتبر قضية مسلمة، ولكنه للأسف يلزم أن نكرره اليوم حتى وإن كنا بذلك نعرض أنفسنا لتهمة الإفراط في الجدية. إن الكثير من النقد الأدبي الأكاديمي الذي ينشر اليوم ولا سيما في أمريكا والذي يستمد إلهامه من فرنسا – ذلك النقد الذي وصفه الناقد الكبير فرانك كيرمود Frank Kermode (٣) بأنه يتسم بالتكنولوجيا ويثقل ظهره المصطلحات الفنية مما ينفر القاريء منه – أدي في نظري بإفراطه في استخدام المصطلحات الفنية المدرسية إلى الضرر بالأدب بأن أفقده لكثير من جديته وعلاقته المباشرة بالحياة – هذا على الرغم من أنه ذاته يعاني من جدية مزعومة وصرامة زائفة. ولست بحاجة إلى تبيان مدى تأثر الكثير مما يكتب الآن باللغة العربية بهذا النوع من النقد ولا سيما في ميدان النقد النظري أو نظرية الأدب، بحيث إنني منذ وقت غير طويل سمعت بأذني الدكتور محمد يوسف نجم يشكو من أنه يقرأ الكثير من هذه الكتابات ولا يفهم مايقرأ (٤). ولا أظن أن الدكتور نجم هو وحده الذي لا يفهم. فها هو الدكتور محمود الربيعي يقول في عرضه لأحد الكتب في النقد (٥) : «لا شبهة عندي في أن وضوح لغة النقد الأدبي هو جوهره وذلك لأنه سر نجاحه ؛ إذ سر نجاحه نفاذه إلى عقول الآخرين ونفوسهم. وحين تصبح هذه اللغة غامضة على أمثالي (ممن يدعون التخصص في النقد الأدبي) يكون ثمة خلل ما، في مكان ما، يحتاج إلى إصلاح». منذ سنوات عديدة (في مقدمة ترجمة جورج واطسن : الفكر الأدبي المعاصر (٦) في بداية انتشار حركة

أصاب الأدب العربي في العصر الحديث فيما يخص مفهوم الأدب ووظيفة الأديب. فالنظرة القديمة للأدب العربي التي كانت سائدة في القرون الوسطى حتى أواخر القرن التاسع عشر اعتبرت إجمالاً أن وظيفة الأدب هي إما التعليم والتهذيب الأخلاقي والروحي أو التسلية والإمتاع عن طريق التمكن من اللغة والبراعة اللفظية. هذه النظرة آخذت تختفي تدريجياً ويحل محلها الإيمان بأن الأدب ينبغي له أن يعالج الواقع الاجتماعي ويعكسه بقصد تغييره وإصلاحه. كذلك أخذت تختفي ظاهرة الأمير أو الوالي الذي كان يشجع الشعراء بجوده وسخائه على أن يهرعوا إليه ليتغنوا بمحامده في قصائد رنانة تخلد اسمه. وحلت محلها ظاهرة جمهور القراء وأغلبهم من الطبقة الوسطى أو مايشبهها ممن تلقوا تعليمهم في المدارس الحكومية الحديثة، وليس في المعاهد التقليدية الدينية التي كانت علوم الدين بطبيعة الحال أهم برامجها. ونتيجة لإدخال الطباعة لم يعد القراء يعتمدون على عدد قليل من المخطوطات المنسوخة غالية الثمن بل أصبح في مقدورهم الحصول على كتب مطبوعة وصحف ومجلات. إلى هذا الجمهور الجديد من القراء توجه الشاعر الحديث، فنشر نتاجه الشعري على صفحات الصحف والمجلات ولم يعد يعول فقط على إنشاده قصائده لجمهور محدود. وهكذا أخذ يختفي الشاعر الصانع الذي كان يعرض سلعته على من يدفع له أغلى ثمن فيها، ويحل الشاعر الملهم، الشاعر المرهف الحس الذي يعتبر الإخلاص من أهم قيمه، والذي يؤمن إيمانا عميقا بالقضايا الكبرى ولاسيما ضرورة إصلاح العيوب في مجتمعه. أما كاتب النثر التقليدي الذي كان يستهدف تسلية جمهوره المحدود من ذوي الثقافة بأن يأخذ من كل فن بطرف ويدبج رسائله إلى زملائه الكتاب أو مقاماته المرصعة بألوان البديع فقد أخذ يحل محله الأديب المسئول صاحب المقالة أو الصحفي الذي يلهبه الحماس وتهمه القضايا الفكرية والدينية والاجتماعية والسياسية بقدر ماتهمه قضايا اللغة والأدب. ومهما كان موقف بعض النقاد المنظرين الآن من مسألة المحاكاة في الأدب mimesis في عصرها ما بعد البنيوية والتفكيكية فإنه في غاية الأهمية أن نتذكر أن بروز مفهوم الأدب ضمناً كمحاكاة للواقع هو الذي مكن الأدب العربي الحديث من الظهور على مسرح الحياة على الإطلاق. هذه حقيقة تاريخية جوهرية لا يجوز إغفالها أو تناسيها - هذا طبعا على شرط أن لا نفهم المحاكاة الفهم المفرط في السذاجة الذي يهبط بها إلى مستوى التصوير الفوتوغرافي الآلي أو الواقعية الفجة - ذلك الفهم الشائع هذه الأيام لسوء الحظ. بل نأخذ المحاكاة بالمعنى الإبداعي الخلاق الذي قصده اليونان حين اعتبروا الموسيقى ضربا من المحاكاة لأنها تسعى إلى تصوير حركات الروح أو خلجات النفس. فبدلا من النماذج المثالية التي يحفل بها الأدب التقليدي والشعر بالذات ونماذج معروضة في معظم الأحيان بلغة هي غاية في التصنع والتكلف - بدأ الكتاب العرب المحدثون يعالجون موضوعات من واقع المجتمع تخضع للمشاهدة والاختيار، وذلك في الأشكال المستوردة حديثا وهي الرواية والقصة القصيرة والمسرحية.

وغـال الحـداثـةَ شــرخُ الشــبــاب      ولو شــــبـت المـردُ في الشــيّــب
وغـاب الرفـاق كــأن لم يكــن         بهم لك عــهــد ولم تصــحــب
إلى أن فـنــوْا ثـلّــة ثـلّــة           فناء الســراب على الســبــســب

هذا صحيح. غير أن هنالك مجموعة من المواضيع يتكرر ظهورها في الأدب العربي الحديث منذ نشأته تقريبا – مواضيع لا يمكن أن يغفلها من يدرس هذا الأدب ويتابع تطوره منذ أواخر القرن الماضي حتى الآن. وهذه ظاهرة تستوجب التفسير أو على الأقل هي جديرة بالملاحظة. وتجعلنا ننظر إلى الأدب الحديث نظرة شمولية ونحاول إلى حد ماتحديد علاقته بسائر الآداب الأخرى في العصر الحديث.

ولا أقصد بالثوابت تلك التقاليد التي غلبت على الشعر العربي القديم إلى درجة يندر أن يوجد لها مثيل في الآداب الأخرى – تقاليد اصطلحت عليها الجماعة وتواضعت عليها الثقاة في زمن مضى وظلمت تستلهمها الأجيال وتحتذيها. ولعل أبرز مثل لهذه التقاليد هو ظاهرة النسيب في القصيدة العربي التي كانت ولاتزال تجتذب أنظار الدارسين الذين ربما كان أحدثهم هو ياروسلاف استيتيكيفتش Jaroslav Stetkevych في كـتـابه الشـيـق The Zephyrs of Najd. ولقد حاول بعض الباحثين أن يبين أن صمود هذه التقاليد طوال هذه القرون مرده أنها كانت تؤدي وظيفة اجتماعية وسيكولوجية في المجتمع العربي، وأنها – شأنها في ذلك شأن أي تراث مشترك – لها أثر عاطفي عميق في حياة الجماعة يربط أفرادها بماضيهم كما يربطهم بعضهم بالبعض الآخر (٢). لا لست أقصد الأغراض أو القوالب أو الصور أو صيغ الالفاظ، وإنما أقصد مجالات الاهتمام أو حقول الرؤية التي من خلالها ينظر الكاتب إلى الوجود، وعبرها يحاول تفسيره أو يعرض نقده للحياة إن جاز لنا اليوم أن نقتبس عبارة الناقد الإنجليزي ماثيو أرنولد التي كانت شائعة يوما ما. هذه المجالات يستخدمها أو يستعيرها الكتاب الروائيون وكتاب القصة القصيرة والمسرحية وإلى حد ما الشعراء كي يعبروا عن مواقفهم أو آرائهم بالمعنى العام جدًا لكلمة آراء إزاء العلاقات البشرية ولا سيما في سياق اجتماعي وسياسي.

هذه الموضوعات المتكررة غالبا ما تأخذ شكل صراع بين طرفي نقيض أو ثنائيات من الأضداد أو المحاور مثل القرية والمدينة، والتقاليد والحداثة والشرق والغرب أو العرب والأوربيين والسلطة والحرية والمجتمع والفرد المنبت غير المنتمي أو المهمش. إنها موضوعات في باطنها ثقافية أو حضارية، اجتماعية وسياسية يجسدها الكتاب في مواقف إنسانية ويكسبونها عمقا ودفئا بدرجات متفاوتة حسب مايتميز به الكاتب من رحابة الروح والقدرة على التعاطف وبالطبع مهارة الأداء، وهو من الملامح المميزة للأدب العربي الحديث. أما أن نجدها أولا نجدها بهذه الصورة في الأدب القديم، وذلك لأسباب تاريخية وثقافية عديدة، فليس في نيتي الخوض فيها الآن. إلا أنه ينبغي أن أذكر واحدًا من الأسباب لما له من علاقة مباشرة بموضوع بحثي، ألا وهو التغيير الجذري الذى

# الثوابت في الأدب العربي الحديث*

## محمد مصطفى بدوي

عنوان هذه الدراسة وهو «الثوابت في الأدب العربي الحديث» قد يدعو إلى التساؤل، لأنه فيما يبدو ينطوي على شيء من التفكير الميتافيزيقي. هل يعني أنني أقصد أن للأدب العربي الحديث صفة لازمة من شأنها أن تضفي عليه هذه الثوابت ؟ صفة لا توجد في غيره من الآداب سواء كانت غربية أو شرقية وسواء كان مصدرها أفريقيا أو أمريكا اللاتينية - صفة طبعت هذا الأدب في الماضي وسوف تطبعه في المستقبل بهذا الطابع الذي يميزه وحددت شخصيه إلى الأبد؟ الجواب عن هذا السؤال هو بالنفي طبعاً، لأن مثل هذه الدعوى مرفوضة مبدئياً. فالأدب العربي الحديث كغيره من الآداب مادته مجمل التجربة البشرية. فالبشر يولدون ويعانون في حياتهم ثم يموتون، أو كما قال الشاعر الإنجليزي ت. س. إليوت بقدر غير يسير من التبسيط وبصراحة قاسية :

ميـــلاد ثم جــمــاع ثم مــوت -

هذا هو كل ما في الأمر إن أردت الجد.

أقول «بقدر غير يسير من التبسيط» لأن الأدب في الواقع مهما كانت لغته يدور حول مايقع بين هذه الحدود الثلاثة أو مايسميه بعض علماء الأنثروبولوجيا بطقوس المرور أو مراسيم الانتقال من مرحلة إلى أخرى من مراحل عمر الإنسان - ذلك العمر الذي لخّصه شوقي في قصيدته «مصائر الأيام» بأسلوب أكثر عاطفية وبموسيقية نادرة :

وخدّش ظُفر الزمان الوجوهَ      وغيّض من بشرها المعجِب

(*) نص محاضرة عامة ألقيت في الجامعة الأمريكية بالقاهرة في ٢١ مارس ١٩٩٥.

٢١ - نفسه، ص ٢١٧.

٢٢ - نفسه، ص ٢٢١.

٢٣ - يقول السيد ابراهيم في تحليله لاحدى قصائد زهير بن أبي سلمي معلقا على استخدامه لكلمة العماء :

«واختيار كلمة العماء لمناسبة، فان الكلمة مقصودة لذاتها لما فيها من الاشارة إلى حجب الرؤية.» انظر : الرمز والفن واللغة، ص ٢٦.

والقارىء لتحليل السيد ابراهيم لقصيدة زهير وعنوانه «الرمز الشعري وفكرة البحث عن الحقيقة» يلحظ التشابه بين ماكان زهير بسبيله ومايحاوله الحارث بن حلزة ولا شك ان قراءتي لتحليل السيد ابراهيم كانت وراء فهمي لمعلقة الحارث، رغم ان قصيدتي الحارث وزهير متباينتان من حيث الظاهر.

٢٤ - شرح المعلقات، ص ١٢٥.

٢٥ - نفسه ص ٧.

٢٦ - نفسه ص ٩.

٢٧ - نفسه ص ٦١.

٢٨ - نفسه ص ٩٩.

٢٩ - الشعر واللغة ص ٤٧.

٣٠ - شرح المعلقات ص ٧٥.

٣١ - ديوان المتنبي، بيروت، المكتبة الثقافية، ب. ت، ص ٢٥٦.

٣٢ - ديوان شوقي، توثيق وشرح أحمد محمد الحوفي، القاهرة، دار النهضة مصر ١٩٧٧، ص ١٩٢.

٣٣ - نفسه ص ١٩٩.

٣٤ - ديوان المتنبي، ص ٥٠٢.

٣٥ - نفسه ص ٥٠٧.

٣٦ - نفسه ص ٥١١.

٣٧ - الشعر واللغة ص ١٥٨.

بالتساؤل في ملحق دراسته عن التقاليد الفنية للقصيدة الجاهلية. انظر :

عز الدين، حسن البنا، الكلمات والأشياء – القاهرة – دار الفكر العربي ١٩٨٨م ص– ٢٨١.

١٠ – الوجود الشعري، مصطلح استفدته من لطفي البديع الذي علمنا التفرقة بين وجود الشيء في الواقع ووجوده في الشعر .

١١ – ناصف، مصطفى، قراءة ثانية لشعرنا القديم، مطبوعات الجامعة الليبية ب. ت، ص ١٣٢.

١٢ – شرح المعلقات، ص ١٩٨.

١٣ – قراءة ثانية لشعرنا القديم، ص ٥٣.

١٤ – شرح المعلقات، ص ٢٠١.

١٥ – القرشي، أبو زيد محمد، جمهرة أشعار العرب، تحقيق علي محمد البجاوي، القاهرة، دار نهضة مصر، ١٩٦٧، ج ٢ ص ٤٤٦.

١٦ – شرح المعلقات، ص ٢٠١.

١٧ – «الإرادة الشعرية» مصطلح آخر مستفاد من لطفي البديع. انظر مثلا : عبد البديع، لطفي، الشعر واللغة، الرياض، دار المريخ للنشر، ١٩٩٠، ص ٤٧.

١٨ – «كائنات شعرية»، هذا ايضا من مصطلحات لطفي عبد البديع في تحليله للشعر. ويلاحظ أن هذا المصطلح مع مصطلح «الوجود الشعري» يدلان على اعتداد لطفي عبد البديع البالغ بالتفرقة بين وجود الشيء في الطبيعة ووجوده في الشعر، فالأول وجود محايد موضوعي فيزيقي لا ينطوي على معنى، أما الثاني فوجود لغوي ثقافي ينبغي الكشف عن دلالته عن طريق القراءة الفاحصة لتفاصيل التعبير اللغوي المرتبطة به، والاهتمام بما بين هذه التفاصيل من علاقات. الناقة، مثلا، حيوان خلقه الله أو أوجدته الطبيعة، أما ناقة طرفة في معلقته فهي كائن شعري صنعته "الإرادة الشعرية" للشاعر المسمى طرفه بن العبد. والإرادة الشعرية لطرفه لا تتعلق بطرفه الذي يحدثنا عنه التاريخ، بل تتعلق بالذات الشعرية، وهي ذات قوامها من تقاليد الشعر وملكته، بالمعنى الذي تحدث عنه لطفي عبد البديع. انظر :

عبد البديع، لطفي، التركيب اللغوي للأدب، القاهرة، مكتبة النهضة المصرية، ١٩٧٠، ص ١١٦ – ١٦٠.

١٩ – «التفكير الشعري» مصطلح استخدمه السيد إبراهيم للدلالة على أن التفكير في الخطاب الشعري له قوانينه الخاصة التي تستنبط أيضا بطريقة خاصة. انظر :

محمد، السيد إبراهيم، الرمز والفن واللغة، القاهرة، مكتبة النهضة المصرية، ١٩٨١.

٢٠ – شرح المعلقات، ص ٢١٦.

«منوالاً» ينسج عليه الشعراء المختلفون فينتجون منسوجات طللية تختلف باختلاف الشكل الذي يسعي إلى نسجه. المنوال واحد لكن طرق الغزل تختلف من شاعر لآخر ومن حالة لأخرى.

## الهوامش

1 – استخدم ابن خلدون تعبير «الصور الذهنية المجردة» أثناء شرحه لمصطلح الملكة الذي استخدمه في مجالات المعرفة المختلفة، وإن لم يعن بشرحه إلا في مناسبة تناوله للملكة اللسانية والملكة الشعرية أنظر:

مقدمة ابن خلدون، القاهره، كتاب التحرير، 1966 ص 483 – 513.

وقد حاولت القاء الضوء على المضمون النقدي لمصطلح ابن خلدون في اطروحتي للدكتوراة. انظر :

بريري، محمد احمد، الاسلوبية والتقاليد الشعرية : دراسة فى شعر الهذليين، عين الداسات والبحوث، القاهرة، 1995، ص 26 – 30.

وقد طورت شرح هذا المصطلح وبيان تضميناته في مقال نشر بمجلة فصول. أنظر : «الملكة الشعرية والتفاعل النصي : دراسة تطبيقية على شعر الهذليين»، فصول، القاهرة، ديسمبر 1989، ص 20 – 39.

وقد حاول ميشال زكريا ان يربط بين كلام ابن خلدون عن اللغة والنظريات الغربية المعاصرة في علم الالسنية. انظر :

زكريا، ميشال، الملكة اللسانية في مقدمة ابن خلدون، بيروت، المؤسسة الجامعية للدراسات والنشر والتوزيع، 1986.

2 – الزوزني، ابو عبدالله الحسين، شرح المعلقات السبع، بيروت، دار الجيل، د. ت  ص ص 191 – 214.

3 – نفسه، ص 99.

4 – المفضليات، تحقيق أحمد شاكر وعبد السلام هاورن، القاهرة، دار المعارف، ط 4، 1976، ص 135.

5 – نفسه، ص 181.

6 – ابن منقذ، اسامة، المنازل والديار، تحقيق مصطفى حجازي، القاهرة، دار سعاد الصباح، ط 2، 1992، ص 86.

7 – نفسه، ص 65.

8 – ديوان امريء القيس، تحقيق محمد ابو الفضل ابراهيم، القاهرة، دار المعارف، ط 4، 1977، ص 27.

9 – وقد ضم حسن البنا عز الدين عددا كبيرا من مطالع القصائد الطللية التي تبدأ

بهـــا نبطـــى مـن اهـــل الســـواد     يــدرس أنســـاب أهـل الـفــلا

وأسودُ مـشْـفَـرُهُ نصْـفُـــــــهُ     يُــقــالُ لـه أنت بدرُ الدُّجـى(٣٦)

إن سخرية شوقيَ من أبيس وعبادته هي التي استدعت كافورا الاخشيدي والمتنبي، وكأن خضوع المصريين لهذا العجل يشبه خضوعهم لكافور. «وعجلية» كافور تنسحب عليه وعلى غيـره من «السادات» الذين قال عنهم المتنبي إنهم عبيد أقزام.

ولم يكن أحمد شوقـي يقصد إلى تذكر المتنبي وكافور سـخريةً من مصر والمصريين وحكامهم الخصيـان، وإنما استجاب رغمـاً عنه للمبدأ الجمـالى المستقر فى عقله الباطن فكان استدعاؤه لابى العلاء ثم المتنبى تعزيزاً لإثارة الإحساس بالشك في أبي الهول ومايمثله.

كان شوقي في لحظات تألقه الشعري قادراً على استبطان المبادىء الجمالية للشعر العربي والـنسج على منوالها نسجـاً جديداً، غيـر أن توهج شاعرية شوقي في قصيدة أبي الهول آل في الأبيات الأخيرة إلى نوع من الخطابة المباشرة. وهذا ماأشار إليه لطفى عبد البديع حين قـال عن هذه القصيدة إنهـا «تضم في آخرها أبيـاتا لا تكافىء مافي أولـها من لغة نحتها مـن خلود الصخـر والحجـر الذي يحتضن الجثث ليدفع عنها الفناء».

## خاتمة

لم تكن نزعة الشك عند الشاعر العربي مجرد مضمون شعوري، بل كانت تحقيقاً لصورة ذهنية مجردة تنتظم موضوعات القصيدة كلها. ولم تكن القصيدة تراكما لموضوعات مـن مـثل النسيب والناقة والفـرس وغيرها من الموضوعات التـقليدية الشائعة. إن الشاعر يشكل كل موضوع منها بحيث يتجلى فيه الصورة الذهنية المجردة التي تحقـقها القصـيدة بكل ما تنطوى عليـه من مـوضوعـات، وبكل ماينطوى عليه كل موضوع منها من تفصيلات. كل موضوع في القصيدة يأخذ من الموضوعات الأخرى ويعطيها.

وإذا صح أن موضوعات الشعـر القديم يرتبط كل منهـا بعدد من التقـاليد الأسلوبية، فـإن الشاعر في القصيدة الواحدة يختـار بعض هذه التقـاليد وينفي بعضها الآخر بتوجيه من الصورة الذهنية المسيطرة عليه. ولولا ذلك لكان اختيار الشاعر لتفاصيل موضوعاته عشوائياً.

إن كل موضوع من موضوعـات الشعر القديم ينطوي على ما يشبه لغة langue أو شفرة يستخدمـها الشاعر لكي ينتج كلامـاً parole يناسب الصـورة الذهنية المجردة التي يعد كلامه تحقيقا لها.

وإذا رجعنا إلى التعبير المجازي الذي استخدمه ابن خلدون في شرحه لمعنى الملكة الشـعرية قلنا إن الموضوع الذي يعـالجـة الشاعر، كالأطلال مـثلاً، يشبه

أسـال البيـاض وسـل السـواد وأوغـل منقـاره فى الحفـر
فـعـدت كـأنـك ذو المحبـسـين قطيع القيـام سليب البصـر

ولا أظن أن التشـابـه بين صنيـع شـوقى مع أبي الهول وصنيـع طرفـه مع الناقة مما يخفى فكلاهما شـيد وبنى، ثم عاد فتشكك فيما شـيده، كلاهما بنى ثم فكّك بناءه.

ولم يكن عقد المشابهة بين أبي الهول وأبي العلاء المعري من قـبيل المقارنة الحسيـة بينهمـا، بل الأحرى أن تكون فكرة الشك نفسها هي التي حفزت ذاكرة أحمد شـوقي إلى استدعاء أبي العـلاء الذي يعد بحق إمام المتشككـين في الشـعر العربي القديم. وينبغي ألا ننسى في هذا السـياق أن قسـوة الشاعر المتمثلة في تنقير عيني أبي الهول وإسـالة بياضهما وسوادهما تذكرنا بقسوة طرفة حين راح يهدم الناقة تهديماً لافتا للنظر.

وأغلب الظن أن إثارة الإحساس بالشك كانت وراء استدعاء المتنبي في قول الشاعر :

| وبعض العـقـائـد نيـر عـسـر | وآبيس في نيـره العـالمـون |
| ويرجي النعيـم وتخشى سـقر | تسـاس بـه معـضـلات الأمـور |
| ولو أخـذتـه المـدى مـاشـعـر | ولا يشـعـر القوم إلا بـه |
| وإن صـاغ أحمـد فـيـه الدّرر | يـقل أبو المـسـك عـبـدًا له |

لأن من يتذكر المتنبي وكافور الإخشيدي لا بد أن يتذكر شعراً من مثل قول المتنبي يهجو الإخشيدي والمصريين :

| وسـادة المسلمين الأعـبـد القـزم | سـادات كل أناس من نفـوسـهـم |
| يـأمة ضحكت مـن جهلها الأمم (٣٤) | أغـاية الدين أن تحفـوا شـواربكم |

أو قوله :

| أنا الغـني وأمـوالـي المواعيـدُ | أمسيتُ أروحَ مثرٍ خازناً ويـداً |
| عن القرى وعن الترحـال محـدود | إني نزلتُ بكذّابينَ، ضيفُهُـمُ |
| من اللسان، فـلا كـانوا ولا الجـود | جود الرَّجـال من الأيدي، وجودهم |
| إلا وفي يـده من نـتّهـم عـودُ | مايقبض الموتُ نفسًا من نفوسهم |
| أو خانَـه فله في مصـرَ تمهيـد | أكلما اغتال عبدُ السوء سـيـده |
| فالحرُّ مستعبـدُ والعبدُ معـبود | صار الخصي إمـام الآبقين بها |
| فـقد بشـمن وماتـفنى العناقيـد (٣٥) | نامت نواطير مصر عــن ثعالبها |

أو قوله :

| ولكنـه ضـحـك كـالبكا | وكم ذا بمصـر من المضـحكات |

البحث عن تلك الحقيقة هو الذي حدا بالمتنبى أن يفهم وقوف الشعراء على الأطلال بأنه وقوف يتوجه عن رغبة في البحث عن شيء ثمين وذلك حين قال :

بليت بلى الاطلال إن لم أقف بها      وقوف شحيح ضاع في الترب خاتمة(٣١)

أما في العصر الحديث فقد أخضع أحمد شوقي أبا الهول لنوع من التفكير الشعرى يقربه من تفكير الشاعر القديم في الطلل والناقة .

بدأ شوقي قصيدته بأن جعل من أبي الهول معادلاً لمعاني البقاء والخلود ومقاومة الفناء. فأبو الهول عنده «لدة الدهر» يسافر في الزمان ولا يزول إلا في الموعد المنتظر، شأنه في ذلك شأن الجبال الراسيات :

أبا الهول طال عليك العصر      وبلغت فى الأرض أقصى العمر
فيالدة الدهر لا الدهر شب      ولا أنت جاوزت حد الصغر
إلام ركوبك متن الرمال لطى      الأصيل وجوب السحر ؟
تسافر منتقلاً في القرون،      فأيان تلقى غبار السفر ؟
أبينك عهد وبين الجبال،      تزولان في الموعد المنتظر ؟ (٣٢)

كما أن أبا الهول هو عند أحمد شوقي «نديم الزمان» و «نجى الأوان» و «سمير العصر» :

أبا الهول انت نديم الزمان نجى الأوان، سمير العصر
بسطت ذراعيك من آدم ووليت وجهك شطر الزمر

إن حرص أحمد شوقي على بقاء أبي الهول صورة أخرى من حرص الشاعر القديم على بقاء الرسوم والاطلال والآثار، وأبو الهول على كل حال أثر. ولعل شارح ديوان شوقي استشعر هذا التشابه بين الآثار الفرعونية واثار الديار في الشعر القديم حين علق على قول شوقي :

فلا تستبين سوى قرية      أجدّ محاسنها ما اندثر

فقال "أجد محاسنها مااندثر، يقول ان طلولها الدوارس ورسومها المندثرة البوالي أجدت محاسنها" (٣٣). وقد وقف أبو الهول نفسه على الأهرام وقوفا يشبه وقوف الشاعر القديم على الطلل :

أطلت على الهرمين الوقوف كثاكلة لا تريم الحفر

غير أن الشاعر بعد أن جعل من أبي الهول معادلاً لفكرة الخلود، لم يلبث أن خضع للمبدأ الشعرى القديم فبدأ في إثارة الشك في هذا البناء الضخم الذي شيده فقال :

أبا الهول ويحك لا يستقل مع الدهر شيء ولا يحتقر
تهزأت دهراً بديك الصباح فنقر عينيك فيما نقر

لم يخرج طرفه عن مبدأ الشك، أو التردد بين البناء والهدم طوال معلقته إلا مرة واحدة، وذلك عندما تناول موضوع الغزل حين قال عقب مقدمته الطللية:

| | |
|---|---|
| وفي الحيِّ أحوى ينفُضُ المردَ شادنٌ | مظاهرُ سِمْطَيْ لؤلؤٍ وزبرجدِ |
| خذولٌ تراعى ربربا بخميلة | تناول أطرافَ البريرِ وترتدى |
| وتبسم عن ألمى كأن مُنَوَّرا | تخلل حُرَّ الرمل دعصٌ له ندِ |
| سقته إياةُ الشمس إلا لثاتهِ | أُسِفَّ، ولم تكدم عليه، بإثمدِ |
| ووجهٌ كأن الشمسَ ألقت رداءَها | عليه نقيُّ اللون لم يَتَخَدَّدِ |

تبدو المرأة في هذه الأبيات كالحقيقة الناصعة فقد صاغتها اللغة الشعرية من اللؤلؤ والزبرجد. ومن هنا كان الالحاح على المزج بين هذه المرأة والشمس، فتارة يستقي ثغرها أشعة الشمس وتارة أخرى تصبح تلك الشمس رداءً لوجهها. ومن هذا الباب أيضاً انجذاب الشاعر إلى الإشارة الى الألوان الناصعة الواضحة فقد شبه المرأة في أول كلامه بظبي أحوى في كحل العينين وسمرة الشفتين ثم عاد إلى نفس المعنى في البيت التالي فقال ان ثغرها ألمى، أي أن ثغرها يضرب لون شفتيه إلى السواد. ولعل الشاعر كان يلتمس معنى الضوء والنور حين قال «أن منورا» من قولهم نور النبت، أي أخرج نوره. أما الإثمد فالوجه في ذكره أن «نساء العرب تذر الاثمد على الشفاه واللثات فيكون ذلك اشد للمعان الاسنان». تجسد هذه الأبيات إذن معنى اللمعان والوضوح والصفاء بأكثر من طريقة. ولا يخفى في هذا السبيل حرص الشاعر على تقرير حقيقة أن الرمل حر أي خالص لم تشبه شائبة. ولعلها لم تكن مصادفة أن ينهي الشاعر هذا القسم بقوله عن وجه المحبوبة إنه «نقي اللون»، لأن هذا اللون النقي يكاد يكون المعنى المجرد الذي تتظاهر التفصيلات المختلفة لإثباته. ولئن جسدت اللغة الشعرية معنى الصفاء واللمعان عن طريق الاثبات فقد اقتنصته عن طريق النفي في قول الشاعر «لم تكدم عليه» وفي قوله «لم يتخدد».

كان طرفة إذن يبحث في المرأة عن معنى الحقيقة الواضحة اللامعة بعد أن عذبه التردد بين الشك واليقين طوال القصيدة. ولا يستبعد أن الشاعر كان يجسد معنى عبر عنه بلغة تقريرية إلى حد ما حين قال فيما بعد :

لعمرك ما أمرى على بُغمَّةٍ     نهاري ولا ليلي على بسرمدِ

يقول الشارح إن «صل الغم» التغطية، والفعل غمَّ يغُمّ، ومنه الغمام لأنه يغم السماء، أى يغطيها، ومنه الأغم والغماء، لأن كثرة الشعر تغطي الجبين والقفا». إن المرأة فى غزل طرفة هي نقيض الغم، أى التغطية والالتباس. انها الوضوح والالتماع واليقين في مقابل الشك. لذلك نقول إن مايسمى الغزل في معلقة طرفة يبدو كالشعاع الذي يلتمع في فضاء القصيدة الضبابي الداكن.

إن البحث عن حقيقة صافية يمكن أن يكون معنى يفسر كثيراً من أمور الشعر العربي القديم الذي ينأى، بسبب كونه شعرا، عن التعبير المباشر. ولعل

| | |
|---|---|
| وأن أدع للجلى أكن من حماتها | وإن يأتك الأعداء بالجهد أجهد |
| وإن يقذفوا بالقذع عرضك أسقهم | بكأس حياض الموت قبل التهدد |
| بلا حدث أحدثته وكمحدث | هجائي وقذفي بالشكاة ومطردي |
| فلو كان مولاى امرءاً هو غيره | لفرج كربى او لأنظرنى غدى |
| ولكنَّ مولاي امروء هو خانقي على | الشكر والتسآل أو أنا مفتدى |
| وظلمُ ذوي القربى أشدُّ مضاضة | على المرء من وقع الحسام المهند |
| فذرنى وخلقي إننى لك شاكر | ولو حلَّ بيتي نائياً عند ضرغد |

يُظهر الشاعر في هذه الأبيات ولاءه الشديد لذوي قرابته على الرغم مما وقع عليه من ظلم. وقد صاغ هذا المعنى في نغمة ضارعة شاكية. بل لا يخفي ما في لهجة هذه الأبيات من نغمة خاضعة إلى حد بعيد. ويكاد الشاعر أن يسلم مقاليده لمجتمعه، بل ويكاد أن يأسف على ما فاته

| | |
|---|---|
| فلو شاء ربي كنتُ قيس بن خالد | ولو شاء ربى كنتُ عمرو بن مرثد |
| فأصبحت ذا مال كثير وزارني | بنون كرامٌ سادةٌ لمسوَّد |

يوشك الشاعر أن يعلن عن خضوعه المطلق لقيم مجتمعه واتساقه معها اتساقا لا تشوبه شائبة. الا أن الشاعر انقلب على هذا كله فجأة حين قال عقب تلك الأبيات مباشرة :

| | |
|---|---|
| أنا الرجل الضربُ الذي تعرفونه | خشاشٌ كرأس الحيَّة المتوقِّد |

فجعل من نفسه «رأس الحية» بما يثيره هذا التعبير من دلالة كثيفة على شدة العداء. لقد عاد الشاعر إلى صيغة البناء ثم الهدم، فبعد أن أظهر إيمانه بمجتمعه وخضوعه له بدأ في هدم هذا الإيمان بإظهار العداء الشديد لهذا المجتمع. وينبغي ألا نفصل كلامه فيما يلى البيت الأخير عما قبله. إن الحدة والعنف الشديدين في هذه الأبيات موجهان بطريقة غير مباشرة إلى ابن عمه مالك وإلى قرط بن معبد وقيس بن خالد وعمرو بن مرثد بوصفهم جميعاً تمثيلاً لمبادىء الولاء الاجتماعي :

| | |
|---|---|
| فآليتُ لا ينفك كشحي بطانة | لعضب رقيق الشفرتين مهند |
| حسام اذا ما قمتُ منتصرا به | كفى العودُ منه البدءَ ليس بمعضد |
| أخى ثقة لا ينثنى عن ضريبة | إذا قيل مهلاً قال حاجزه قد |
| إذا ابتدر القومُ السلاحَ وجدتَني | منيعاً إذا بلَّت بقائمه يدي |

وقد اتبع طرفه هذه الأبيات بالأبيات التي هدم فيها الناقة تهديماً، وتقويض الناقة يعد تقويضا للقيم الاجتماعية السائدة.

الداخلي في القصيدة وبذلك كان التطرق إلى السفينة مقدمةً او إرهاصاً بما سيأتي بعده.

بعد أن أثار الشاعر معاني التوجس تغير موقفه من الناقة تغيراً ملحوظاً :

أحلت عليها بالقطيع فأجذمت      وقد خب آل الأمعز المتوقد
فذالت كما ذالت وليدةُ مجلس     تُري ربَّها أذيالَ سحل ممدَّد

بدأ الشاعر في ضرب الناقة بسوطه، وأظهرت بدورها نوعاً من الخضوع، بعد أن كانت ربيبية الإحساس بالقوة والصلابة. بل أصبحت الناقة مقترنة بالوهن والضعف. قال طرفة في وصفه لصوت جارية تغني:

إذا رجَّعت في صوتها خلْتَ صوتَها    تجاوبَ أظآرٍ على رُبَعٍ رَدي

كان الشاعر قد شبه الناقة «بجارية ترى ربها اذيال سحل ممدد» أما في هذا البيت الأخير فإنه يشبه صوت الجارية بصوت نوق حزينة. ويشبه ذلك قوله:

إلى أن تحامتني العشيرةُ كلها     وأفردتُ إفرادَ البعيرِ المعبَّد

وقد انتهى الموقف السلبي تجاه الناقة إلى نوع من الكفر المطلق بها :

وبرك هُجُودٍ قد أثارتْ مخافتى       بواديها، أمشى بعَضْبٍ مُجَرَّد
فمرَّت كهاةٌ ذاتُ خَيْفٍ جُلالَةٌ       عقيلةُ شيْخٍ، كالوَبيلِ يَلنْدَد
يقولُ وقد تَرَّ الوظيفُ وساقُها      ألسْتَ ترى أنْ قد أتيْتَ بمُوءْيدِ

لم ينحر الشاعر الناقة بل هدمها هدما «تر الوظيف وساقها». لقد أنفق الشاعر جهداً ملحوظاً في بناء الناقة ولكنه في لحظة كفره بها حطمها. ومن المهم أن نتذكر هنا ماقاله عن «الوظيف» فيما سبق :

تُبارى عتاقاً ناجياتٍ وأتْبَعَت      وظيفاً وظيفاً فوق مَوْرٍ مُعَبَّد

إن ذكر الوظيف في سياق بناء الناقة ثم ذكره بلفظه في سياق هدمها يعد بمثابة تنبيه على أن الشاعر يعمد إلى هدم الناقة التى كان قد بناها. لقد بنى «الوظيف»، وهاهو الآن يهدمه

فإذا ما انتقلنا من حديث الشاعر عن ناقته إلى حديثه عن ابن عمه مالك نلحظ في بادىء الأمر حديثاً تشيع فيه نغمة مشفقة

فما لى أراني وابنَ عَمِّىَ مالكاً     متى أدنُ منه يناَءَعنى ويَبْعُد
يلومُ وما أدرى علامَ يلومنى       كما لامنى فى الحىِّ قرطُ بنُ معبد
وأيأسنى من كل خيْرٍ طلبتُه       كأنا وضعناه إلى رَمْسٍ مُلْحَد
على غيرِ شىءٍ قلتُه غيرَ أننى     نشدت فلم أغفل حمولةَ معبد
وقربت بُالقُربىَ وجدُّك أننى       متى يك أمرٌ للنكيثةِ أشهد

ولكن هل اطمأنت نفس الشاعر إلى هذا البناء المحكم القوي أم سيفعل به مافعل بالأطلال والوشم والهوادج والسفن ؟

أعتقد أن الشاعر في نهاية حديثه عن الناقه عاد إلى التشكك وبث معاني الريبة والخطر وذلك حين قال في نهاية مايسمى وصف الناقة ذاكراً عينيها ثم أذنيها :

طحوران عُوّارَ القذى فتراهما          كَمَكْحـولَتى مَذعـورةٍ أُمِّ فَرْقَـدِ
وصادقتا سمع التوجّس للسُرى          لهـجْـسٍ خَـفيٍّ أو لصَـوْتٍ مُنَدَّدِ
مـؤلَّـلَتان تعـرفُ الصِّدْقَ فـيهمـا          كَـسـامِـعَـتَىْ شـاةٍ بحَـوْمَلَ مُـفْـرَدِ

ثم قال

وإن شئت سامى واسطَ الكور رأسُها    وعامت بضبعيها نجاءَ الخَفَيْـدَدِ

يقارن الشاعر في هذه الأبيات بين الناقة وبقرة وحشية مذعورة كما قارنها بثور وحشي مفرد «وخص المفرد لانه اشد فزعا وتيقظاً واحترازاً».(٣٠) ومن هذا الباب أيضا تشبيه الناقة بظليم يسعى للنجاء من خطر يتهدده. إن هذه الكائنات التي شبه بها الشاعر ناقته توحي بمعنى الخطر لاقترانها في الشعر العربي بمحاولات القنص والصيد. لذلك لم يكن غريباً أن يتذكر الشاعر معنى التوجس «صادقنا سمع التوجس»، كما لم يكن غريباً أن يذكر السراب :

أحلت عليها بالقطيع فأجْـذَمَتْ          وقـد خَبّ آلُ الأمْـعَـزِ المتَـوَقِّـدِ

إن السراب هو مظنة الماء على غير الحقيقة، مما يسهم مرة أخرى في تغذية الشعور بالشك. كان من الطبيعي إذن أن يصرح الشاعر بمعنى الخوف :

على مثلها أمضى اذا قال صاحبى          ألا ليتنى أفديك منها وأفتدى
وجاشت إليه النفسُ خوفاً وخاله          مصاباً ولو أمسى على غير مرصد

ماتزال فكرة السراب كامنةٌ في عقل الشاعر لأن من يتوهم الهلاك وهو في مأمن كمن يرى الماء في السراب.

ومن اللافت للنظر أن الشاعر قبل أن يبدأ في إثارة مشاعر الشك والريبة تذكر السفينة فقال مشبهاً عنق الناقة بسكان السفينة :

وأتلع نهـاض اذا صـعَّـدت به          كـسُكّان بوصيٍّ بدجلةَ مصْـعَـدِ

أوحى الشاعر من خلال ذكره للسفن في مقدمة الطللية بمعنى المخاطرة والترقب ولكنه ذكرها هنا بشكل وصفي محايد إلى حد بعيد. بيْد أنّ ذكر السفينة في حد ذاته يُعد تذكيراً بما أوحت به السفينه فيما سبق. بعبارة أخرى، لم يكن ذكر السفينة أمراً عارضاً، بل كان التفكير الشعرى الآخذ فى إثارة الإحساس بالشك هو الدافع وراء استدعاء السفينة مرة أخرى. هناك إذن نوع من التناص

| | |
|---|---|
| أمـون كـالـواح الإران نصأتُـها | على لاحب كـأنـه ظهـر بُرجُـد |
| جمـاليـة وجنـاءَ تـرْدى كـأنها | سـفنّـجـةٌ تبـرى لأزْعـرَ أرْبَـد |

وتتجلى فكرة البناء الضخم من حيث المعجم الشعري في إشارات متعاقبة فالناقة «أمون كألواح الإران». أما فخداها فكأنهما بابا قصر مرتفع :

| | |
|---|---|
| لـها فخدان أكْمـلَ النَّحضُ فيهمـا | كـأنـهـمـا بـابـا منيف ممرّد |

ومن هذا القبيل أيضاً قوله:

| | |
|---|---|
| أمَـرت يداها فـتْـلَ شَـزْر وأجْنَحَتْ | لـها عُـضُـداها فى سـقيف مُـسَـنَّـد |

وقوله:

| | |
|---|---|
| كقنطرة الرومىّ أقسـم ربُّـها | لتُكْتَـنَفَـنْ حـتى تُشـادَ بقَـرْمَـد |

وقوله:

| | |
|---|---|
| وجمجمـةٌ مثـل العـلاة كأنمـا | وعي الملتقى منها إلى حرف مبـرد |

وينحت طرفه الناقة من مادة شديدة الصلابة كما في قوله " :

| | |
|---|---|
| وطىٰ مَحَـال كـالحنىّ خلوفُـه | وأجـرنـةٌ لُـزَّت بـدأى مـنضَّـد |
| كـأن كنـاسَىْ ضـالـةٍ يُكنفانـها | وأطْـرَ قـسـىَ تحت صلب مـؤيَّـد |

وقوله :

| | |
|---|---|
| وعـينان كـألْماوِيَّـتَيْـن اسـْتكنَّـتـا | بكهفى حجاجىْ صخرة قلتِ مورد |

وقد أشار لطفى عبد البديع إلى هذه الأبيات وغيرها وسمّى صنيع طرفة «بالأسلوب النحتى المعمارى»(29). جعل الشاعر صفات هذا الكائن الذي نسميه الناقة بحيث تتلاحق ويتبع بعضها بعضاً فتكون كل صفة بمثابة لبنه تضم إلى غيرها لتقيم هذا البناء الهائل. إن الناقة من فرط ما بناها الشاعر من معجم يشير الى الكهف والصخر والقصر المرتفع صارت بمثابة قلعة حصينة. وقد عمق الشاعر الإحساس بمعنى البيت الآمن أسلوبيـاً عن طريق واو العطف التي كررها الشاعر تكرارًا لافتـًا أثناء خلقه لهذا الكائن الشعري :

| | |
|---|---|
| وأتْـلعُ نَهَّـاضٌ اذا صَـعِّـدَتْ بـه | كَسُكَّان بوصىّ بدجلـة مُصْـعِد |
| وجُمْجُـمـةٌ مـثـل العَـلاة كأنمـا | وَعَى الملتَـقَى منها إلى حَـرف مبرد |
| وخـدٌّ كقرْطَاس الشَّـامى ومشفـر | كسـبْت اليمانى قـدُّه لـم يُجَـرَّد |
| وعـينان كـالماوِيَّـتَيْـن اسـتكنـتـا | بكهْفَىْ حَجاجَىْ صخرة قلتِ مورد |

ويلاحظ أيضا في هذه الأبيات وفي غيرها كاف التشبيه التي تجىء بعد الاسم التـالي لـواو العطف. إن هذا التكرار يرسخ الإحساس ببناء ضخم يتكون من اجزاء متشابهة يرصها النص الشعري جزءًا فوق جزء.

الذي أقدمه من معنى اللعب.

رحلة المالكية إذن محفوفة بالخطر إذا نظرنا في لغة الشاعر نظرة لا يلهيها ظاهر الكلام عن باطنه. يتسق تشكك طرفة في رحلة المالكية مع تشككه في بقاء الأطلال. ومما يلاحظ في هذا السبيل أن تشبيه الطلل بالوشم وتشبيه الحدوج بالسفن شائعان في الشعر القديم، غير أن استخدام طرفة لهما قلب المعنى المباشر للتشبيهين. فالوشم دليل الثبات والظهور، لكن طرفه جعله بحيث لا ينفك عن معنى الذهاب والفناء «باقي الوشم». وعلى نفس المنوال فإن السفن الضخمة يفترض فيها الايماء إلى معنى الرحلة الآمنة، بيد أن طرفه جعلها بحيث توحي بمعنى المخاطرة.

ظلت روح الشك مسيطرة على خطاب طرفة في معلقته، ولعلها لم تكن مصادفة أن ينهي قصيدته بتلك الابيات :

وأصـفـر مـضـبـوح نظـرت حـواره       على النار واسْتَوْدَعْتُـهُ كَفَّ مُـجْمِد
سـتُبـدى لك الايامُ ماكنتَ جاهـلا       ويأتيك بـالأخبـار مـن لم تـزَوِّدِ
ويأتيك بالأخبـار من لم تبـعْ لـهُ       بتـاتـاً ولم تضَـرِبْ لـه وقت مـوعـدِ

عاد الشاعر الى المقامرة مرة أخرى بما توحي به من معنى المخاطرة وبما تثيره من إحساس بالشك، ثم دعم هذا الإحساس حين أشار في البيتين الأخيرين إلى أن المستقبل يحمل «أخبارا» غير متوقعة، مما يهز من ثقتنا فيما هو قائم، إن البيتين الأخيرين يكثفان من الإحساس بالترقب نظراً لتأكيده على معنى المفاجأة التامة التي تنطوي عليها الأيام، ستخبرنا الايام بشيء ما. ولانعرف من نص طرفة شيئاً عن طبيعة هذا الشيء. لانعرف ا ن كانت الايام «ستبدي» لنا "أخبارا" سارة" أم العكس. لا نعرف إن كانت تلك الايام تنطوي على مكسب أم خسارة. نحن إذن بازاء مايشبه مقامرة. العلاقة إذن واضحة بين البيتين الأخيرين والبيت السابق عليهما. كما أن العلاقة واضحة بين الأبيات الثلاثة الأخيرة ومفتتح القصيدة فيما يسمى بالنسيب.

إن صيغة الشك عند طرفة تتخذ أشكالاً مختلفة، لكن الغالب عليه أن يؤسس الشيء ويبنيه بناءً قوياً ثم يعود فيتشكك فيما بنى. فعل ذلك حين بنى حدوج المالكية على فكرة السفن الضخمة الآمنة ثم مالبث أن تشكك في تلك الحدوج حين ذكر الجور والهداية وحين ذكر المفايلة. وكان قبل ذلك قد شبه الطلل بالوشم بما يوحي بمعنى البقاء ولكنه أضاف الوشم إلى «باقي» فهز من ثقتنا في بقاء الطلل.

سارطرفة على هدي من هذا المبدأ الشكلى نفسه في حديثه عن الناقة إذ راح يعيد خلقها بحيث أحالها إلى كائن شعري يجسد معنى القوة والصلابة موحياً من خلال صوره ومعجمه اللغوي بمعنى البناء الضخم الذي يلجأ الشاعر إليه دفعاً لهمومه :

وإني لأمضى الهم عند احتضاره       عَوْجـاء مـرْ قـالٍ تروحُ وتغتـدى

سيتجه طرفة بنسبيه وجهة أخرى غير وجهة صاحبيه، إن وجه الشبه المباشر بين الرسوم او الأطلال من جهة والوشم من جهة أخرى هو معنى البقاء والثبات. أما صياغة طرفة لهذا التشبيه فتؤدي معنى معاكساً، إذ أحال الوشم، رمز البقاء والثبات، إلى بقايا ذاهبة في قوله «باقي الوشم». لقد هز طرفة من ثقتنا في الوشم وأعلن عن تشككه في بقاء الأطلال. غير أن هذا كله تم على الأرجح، دون قصد، وإنما دُفع طرفة إلى صياغة تشبيه الطلل بالوشم على هذا النحو لأن تفكيره الشعري، كما سيتكشف فيما بعد، يتجه إلى بث معنى الشك.

يقول طرفة بعد هذا البيت :

كـأن حُـدُوجَ المالكيَّـة غُـدْوةً      خلايا سـفين بالنّـواصف من دَد
عَـدَوْلـيَّـةٌ أو من سـفين ابن يامـنٍ      يجورُ بها الملاحُ طوراً ويهتدي

عظَّم الشاعر من شأن حدوج محبوبته حين قارن بينها وبين سفن ضخمة «خلايا سفين» فـأضفى على رحلة المالكية الاحساس بالسير الواثق المطمئن ولم يكن ذكر اسماء الأعلام؛ «ابن يامن» و«عدولي»، إلا محاولة لتحقيق عظم شأن السفن عن طريق إضفاء مسحة واقعية عليها، فبدت المالكية في رحلتها محصنة لأن الهوادج حين قرنت بتلك السفن الضخمة اكتسبت صفة الحصن المنيع. لكن المرء، مع ذلك، لا يستطيع أن يذود عن عقلة معاني ثانوية ترتبط بالرحلة في البحر، مثل معاني المخاطرة أو الغرق أو الضلال، فكلها معان يمكن أن توحي بها الرحلة في البحر. فهل يحتمل النص أياً من هذه المعاني؟ للاجابة عن هذا السؤال ينبغي أن ننظر في التفاصيل. يشير النص إلى معنى المخاطرة والضلال في «يجور بها الملاح طورا ويهتدي»، يخامر الشك عقل الشاعر في مدى سلامة الرحلة البحرية لأننا بازاء احتمالين، احتمال الجور واحتمال الاهتداء. ان هذا التردد بين الجور والاهتداء هو الذي دفع الشاعر إلى تطويل التشبيه. أراد الشاعر أن يشبه الحدوج بالسفن الضخمة التي توحي بمعنى الحماية، لكنه في اللحظة التالية بدأ يبث شكوكه عن طريق الاستطراد في الحديث عن المشبه به فساق تفصيلات لا تخدم المعنى الأصلي الذي ساق التشبيه من أجله، بل تخدم معنى ثانويا توحى به الرحلة في البحر، وهو معنى المخاطرة. ولقد زاد الشاعر من تكثيف هذا المعنى الثانوي حين مـد التشبيه مرة أخرى، لما قارن بين شق مقدمة السفينة للماء وشق الرمل إلى نصفين في لعبة المفايلة. إن كلمة «مفايلة» مشتقة من قولهم فال رأي فلان فال جانب الصواب. إن مجانبة الصواب تتجاوب في هذا النص مع معنى «الجور» وهو الخروج عن جادة الطريق (ولايقال هاهنا إن «المفايلة» اكتسبت معنى اصطلاحياً يشير إلى لعبة معينة، ومن ثم لا يجوز أن نعود إلى المعنى الأصلي الذي اشتقت منه الكلمة، لأننا لو سلمنا بمثل هذا نكون قد ساوينا بين الشعر ومطلق الكلام). يضاف إلى ذلك أن المفايلة كانت وسيلة للمقامرة. وفي المقامرة تتساوى احتمالات الفوز والخسارة كما تساوت احتمالات الجور والاهتداء لـدى الملاح. إن فكرة المقامرة أولى بالعناية في سياق هذا الفهم

أما الغلبة في البيتين اللذين ينهي بهما الشاعر نسيبة فهي بلا شك للمعاني السلبية التي بدأ بها

وقد فعل امرؤ القيس شيئاً قريباً مما فعل لبيد، إذ عبر عن معنى ثبات الرسوم وبقائها قائلا :

قفا نبك من ذكرى حبيب ومنزل     بسقط اللوى بين الدخول فحومل
فتوضح فالمقراة لم يعف رسمها     لما نسجتها من جنوب وشمأل(٢٥)

ثم قال مضيفاً على هذه الرسوم الباقية معنى الحياة :

ترى بعر الآرام في عرصاتها     وقيعانها كأنه حب فلفل

لقد بث امروء القيس معنى الحياة من خلال الآرام والعرصات وحب الفلفل ولم يكن الجمع بين «عرصات» و«حب فلفل» مصادفة. ينقل الشارح عن التهذيب «سميت ساحة الدار عرصة لأن الصبيان يعرصون فيها أى يلعبون ويمرحون»(٢٦) ترتبط العرصات إذن بمعنى الطفولة. ولا تختلف الطفولة عن " حب الفلفل من حيث دلالة كل منهما على إمكانية النمو أو على معنى الحياة المتفتحة.

أضفى امروء القيس إذن على الرسوم صفة الدوام، واستنبت لها الحياة غير أنه ينهي نسيبة قائلا :

وان شفائى عبرة مهراقة     فهل عند رسم دارس من معول

يعلن امروء القيس في هذا البيت الأخير عن تشكك في إمكانية التعويل على رسوم ذاهبة فانية بعد أن كان قد اكسبها معنى الثبات والدوام وبعد ان بث فيها معنى الحياة.

والكلام عن شكوك الشعراء كما يتمثل في ميلهم الى بناء الموضوع ثم هدمه أو التشكيك في أمره يعد مدخلا مناسبا لقراءة معلقة طرفة.

تظهر روح الشك عند طرفة في أول بيت من معلقته حين يقول :

لخولة أطلال ببرقة ثهمد     تلوح كباقي الوشم في ظاهرالید(٢٧)

ان تشبيه الاطلال والرسوم بالوشم شائع في الشعر العربى، وقد رأينا مثالا له عند لبيد. نضيف إليه قول زهير :

ودار لها بالرقمتين كأنها     مراجيع وشم في نواشر معصم(٢٨)

يرتبط الوشم عند زهير ولبيد بمعنى التجديد أو البعث. أما عند طرفة فلا نجد شيئا من ذلك ولعل ذلك راجع الى انه لن يحدثنا عن معاني الخصب والنمو كما فعل لبيد او كما فعل زهير حين قال مثلا :

بها العين والآرام يمشين خلفة     وأطلاءها ينهضن من كل مجثم

البعث والتجدد: «أنها زبر تجد متونها اقلامها» ويؤازر الوشمُ المجدد أيضاً الكتابة المجددة في ترسيخ معنى الاحياء والبعث. ولا ينفصل هذا كله عن الأطفال في قوله «أطفلت» او قوله «اطلائها» فالطفولة تجديد يوازي تجديد الكتابة وتجديد الوشم، ففيها جميعا يلتمس الشاعر الاحساس بالبعث والإحياء. ولقد استخدم الشاعر في هذا القسم إيقاع التثنية في قوله «جودها فرهامها» وفي قوله «ظباؤها ونعامها» وكأنه يكر بهذا الإيقاع، وقد حمله مضموناً جديداً، على إيقاع «محلها فمقامها»، «غولها فرجامها» و «حلالها وحرامها».

لكن الشاعر ينهي النسيب بقوله:

فــوقفت أســـالــها وكيـف ســـؤالُـنـا         صمــــاً خــوالـدَ مــايـبيـنُ كــلامُــها
عَرِيَــتْ وكـان بها الجـميـعُ فـأبكـروا         منــهـا وغـودر نـؤيُـها وثُمـامُــها

يعود لبيد بهذين البيتين إلى إثارة الإحساس بدمار الوجود ونضوبه الذي بدأ به نسيبه. وفي هذا السياق تكتسب كلمة «عريت» أهمية خاصة لأن العري كان قد ذكر في أول كلامه حين قال «فمدافع الريان عري رسمها»، مما يؤكد أن البيتين الأخيرين عودة للأبيات الثلاثة الأولى حين كان الشاعر معنياً بتعميق الإحساس بالدمار وعرى الوجود ونضوبه. إن الواقع العاري هو الحقيقة الماثلة أمام عين لبيد، منها بدأ وإليها عاد، وكأن الوجود الحافل بمعاني الخصب والبعث والاحياء لم يكن الا مجرد حلم جميل أفاق منه الشاعر على جمود الحياة متمثلاً في «الصم الخوالد» التي يسألها الشاعر فلا تجيب. إن لبيدا يحلم أحلاما عظيمة، شأنه في ذلك شأن الحارث الذي كان يحلم بالنور والدفء متمثلين في هند. لكنه أيضا مثل الحارث يتشكك في إمكان تحقق هذا الحلم.

وعلى الرغم من ذلك كله فإننا لا نستطيع تجاهل أثر حلم لبيد العظيم على رؤيته للواقع العاري. تجسد هذا الأثر في كلمتي «نؤى» و «ثمام» فالنوءى، نهير يحفر حول البيت ليحميه من مياه الامطار. أما الثمام فهو شجر رخو يسد به خلل البيوت. في هاتين الكلمتين نلمح معنى الحماية للبيت من الغرق او التدمير. كما أن البيت في حد ذاته يضاعف هذا المعنى والكلمتان تتعلقان به. يضاف إلى ذلك أن «الثمام»، وهو نبات، يذكرنا بالايهقان، أي يذكرنا بمعنى الخصوبة. أما الإحساس بالحماية، فهو عنصر مشترك آخر لأن هذا الإحساس تضمنه كلام الشاعر عن الظباء والنعام والبقر، فهي جميعا لا تنفك في كلام الشاعر عن معاني الأمومة والرعاية للأطفال. يظهر ذلك خصوصاً في قوله «والعين ساكنة على أطلائها». ويبدو من النص أن كلمتي «ثمام» و «نؤى» تمثلان أهمية خاصة فقد جاءا على الإيقاع الخاص الذي اتبعه النص في «محلها ومقامها» و «حلالها وحرامها» وغيرهما، وكأن النص ينبه على أهمية دلالة هاتين الكلمتين «نوءيها وثمامها».

لا ننكر مع ذلك أن المعنى الايجابي المرتبط بهاتين الكلمتين يمثل مجرد أثر خافت تخلف عن حلم الشاعر الصاخب بالوجود الثرى بامكانات الحياة والتجدد.

فقد خلت الديار من ساكنيها وتوحشت الأماكن التي كانت مأهولة بالسكان. وقد عبر الشاعر عن معنى شمول الخراب بقوله «محلها فمقامها» التي تعمق الإحساس بالخراب بعد أن أضاف إليها الشاعر «غولها فرجامها». ويلاحظ هنا أن الشطر الأول يعمم فكرة الخراب. بينما يخصص الشطر الثاني هذه الفكرة لأن «الديار» و «محلها فمقامها» اكثر عمومية من تعيين الاماكن في قوله «منى» وقوله «غولها فرجامها» فالدمار إذن عام وخاص .

ثم يستمر الشاعر في تزكية هذه الدلالة قائلا :

فمَدَافِعُ الرَّيّانِ عُرِّيَ رَسْمُها      خَلَقًا كما ضَمَنَ الوَحْيَ سلامُها
دَمَنٌ تجرَّمَ بعد عهْدِ أنيسها      حِجَجٌ خَلَونَ حلالُها وحرامُها

وينبغي على القارئ هنا يضم «حلالها وحرامها» إلى قوله فيما سبق «محلها فمقامها» وقوله «غولها فرجامها» لأن هذا كله بسبيل شيء واحد هو تكثيف الإحساس بالدمار الشامل من حيث المكان في قوله، محلها فمقامها وقوله «غولها فرجامها»، ومن حيث العمق الزماني في قوله «حلالها وحرامها» ويقوم الإيقاع هنا بدور هام في تزكية الدلالة لأن قوله «محلها فمقامها» ثم قوله «غولها فرجامها» ثم قوله «حلالها وحرامها» هي بما بينها من تناظر إيقاعي واضح تغذي بعضها بعضا، وتبدو بمثابة أصوات وأصداء.

بيد أن الشاعر يتخذ بعد هذه الأبيات وجهة مناقضةٌ لما كان فيه، إذ يبدأ في إثارة الإحساس بالخصب والنماء وتعمر الأماكن بعد أن كانت قد خلت وتأبدت:

رُزِقت مرابيعَ النجومِ وصابَها      ودقُ الرواعدِ جودُها فرِهامُها
من كل سارية وغاد مُدْجِنٍ      وعشيةٍ متجاوبٍ إرزامُها
فعلا فروعُ الأيهقانِ وأطفلت      بالجَهْلتينِ ظِباؤُها ونعامُها
والعينُ ساكنةٌ على أطلائها      عوذًا تأجَّلُ بالفضاءِ بِهامُها
وجلا السيولُ عن الطلولِ كأنها      زُبُرٌ تُجدُّ متونَها أقلامُها
أو رَجْعُ واشمَةٍ أُسِفَّ نَؤُورُها      كِففًا تعرضُ فوقهن وشامُها

ولاتحتاج هذه الأبيات الى تأويل فهي تكاد تعبر عن معاني الخصوبة وتولد الحياة تعبيراً مباشراً. إن هذه الابيات تنفي ماقبلها. ويتمثل هذا النفي في الإلحاح على أن الخصب يشمل الأمكنة «لجهلتين»، وأبلغ من ذلك استخدامه لكلمة الفضاء التي توحي بمعنى اتساع الأمكنة وشمولها. أي إن فكرة الدمار الشامل في مفتتح المعلقة تنفيها هنا فكرة العمران الشامل. اما زمن الدمار الشامل متمثلا في قوله هناك «حلالها وحرامها» وقوله «حجج» فيناهضه تنوع زمن الخصوبة في قوله «سارية» و«غاد» و«عشية» وفي اشارته لوقت الربيع في قوله «مرابيع النجوم». ولئن كانت الكتابة في الأبيات الأولى توحي بمعنى الذهاب والفناء لكونها متآكلة ترتبط بالرسوم العارية، فإنها في السياق الثاني توحي بمعنى

لقد أعمت عزة الشاعر وقومه عيون أعدائه وكأنها شمس الحقيقة الساطعة التى تعشى كارهى الحق اولياء الشك والخلط ولهذا جعل الشاعر من نفسه وقومه جبلاً أشم يتأبى على محاولات السحاب (العماء) أن يطمس حقيقته. وتسمية السحاب بالعماء توحى بمعنى التباس الرؤية، أى لا ينفصل السحاب فى هذا الموضع عن معنى فقدان البصر والبصيرة (٢٣).

إن استقصاء الحقيقة وتبديد الشكوك معنى يوجه الشاعر فى معظم مايتضمنه خطابه من تفاصيل. من ذلك مثلا ذكره «النبش» و «النقش» حين قال:

أيّما خُطَّة أردتُم فَأَدُّوها الينا تُشْفَى بها الأملاء.

إن نبشتم مابين مِلْحَةَ فالصاقب فيه الأموات والاحياء.

ونقشتم فـالنقشُ يَجْشَمُهُ الناسَ وفيه الإسقامُ والإبراءِ.

ففى النقش والنبش محاولات لاستقصاء الحقيقة وإظهارها على الباطل، وكلها محاولات لتبديد «العماء». ومن هذا الوادى ايضا استخدام الشاعر لكلمتى آية وآيات :

أيها الناطقُ المبلّغُ عنّا        عند عمرو وهل لذاك انتهاء
من لنا عنده من الخير آياتٌ      ثلاثٌ فى كلّهنّ القضاء
آيةٌ شارق الشَّقيقةَ            اذ جاءت معدٌّ لكلِّ حيٍّ لواء

ومضى الشاعر بعد ذلك يفصل القول فى تلك الآيات التى تكشف الحق وتزيل الشك والالتباس .

ولقد عاد الشاعر بعد ذلك فرأى خصومه فى ضوء فكرة "التعاشى"، وهذا يشبه مافعله قبل ذلك حين رآهم فى ضوء فكرة الترقيش، فيقول :

فاتركوا الطَّيْخَ والتعاشى وإما        تتعاشوْا ففى التعاشى الداء

إن الداء الذى يخاصمه الشاعر من خلال اعدائه هو الشكوك متمثلة مرة فى التعاشى وأخرى فى الترقيش. لذلك فإن الفخر والهجاء لا يكفيان ولا يصحان فى الإبانة عن مثل هذا الشعر. إن التفكير الشعرى منصرف فى هذه المعلقة الى محاولة البحث عن الحق والهداية، ومحاربة الشكوك والأوهام. وينبغى ألا نفصل هذا كله عن رؤية الشاعر لهند فى أول القصيدة، وقد رأينا كيف وحد الشاعر فى نسيبه بين الوجود الشعرى لهند وفكرة النور والاهتداء. المعلقة إذن جهد متصل لو نظرنا الى النسيب بوصفه التجسيد المثالى لافكار الشاعر، وباقى القصيدة بوصفة التجسيد الواقعى للأفكار نفسها .

يعلن لبيد فى بداية نسيبه عن إحساس بالدمار الشامل :

عفت الديار محلها فمقامها        بمنى تأبَّد غولُها فرجامُها(٢٤)

بوصفها تمثيلاً للنور والاهتداء لم تفارق عقله فما يزال مهموما بالبحث عن الحقيقة وإزالة الشكوك. وقد بدأ الشاعر خطابه عن الناقة وأنهاه بذكر الهم فقال أول هذا الخطاب : -

غيرَ أني قد استعين على الهم اذا خف بالنَّوىِّ النجاء

بزفوف ............

ثم قال في آخر هذا الحديث عن الناقة :

أتلهَّى بها الـهـواجـرَ إذ كلُّ ابن هم بليـةٌ عَـمْـيَـاء

يرتبط الهم في البيت الاخير خصوصاً بالإحساس بالحيرة والضلال الذي يشبه ضلال ناقة عمياء. إن هذا البيت، واضح الدلالة على أن هم الشاعر هو هم من مزقته الشكوك، مما يضفي على رحلة الناقة معنى البحث عما يزيل الشكوك. ولم تنته هذه الرحلة بنهاية حديث الشاعر عن الناقة، بل مضى الشاعر في إتمام هذه الرحلة من خلال مايسمى اصطلاحا بالفخر والهجاء. وخطاب الشاعر في هذين الموضوعين يسوده نوع من العقلانية التي لاتتسق مع ماتوحي به الكلمتان من معاني الطيش والنزق والتهور. إن خطاب الشاعر يشع بمعنى الرغبة الصادقة في إظهار الحق وتبديد الشكوك. ولن تتناول التفاصيل التي تدل على هذا المعنى، بل نكتفي بإيراد أمثلة يمكن أن تعين القارىء المهتم على قراءة مايسمى بالفخر والهجاء قراءة مختلفة عما نعهده .

بدأ الشاعر خطابه عن خصومه قائلا :

وأتانا من الحـوادث والأنبـاءِ خطبٌ نُعْنى به ونساءُ

إن إخـواننـا الأراقمَ يَغْلون علينا فى قـيلهمْ إحْـفـاء

يخلطون البـرىء منا بـذي الذنب ولا يَنفع الخَـلَـيَّ الخلاءُ

يلاحظ هاهنا ان الخلط في قـوله »يخلطون« هو مـحاولة طمس الحق أو إخفاء الحقيقة، فلم يكن غريباً بعد ذلك أن يجمع الخصوم أمرهم ليلا :

أجـمعـوا أمرهم عشـاءً فلمـا    أصبـحـوا أصبـحـت لهم ضوضاء

والعشاء عدو الوضوح لأنه من العشى وهو اختلاط الرؤية، كما أن هؤلاء الخصوم هم أعداء الشاعر وخصومة الشاعر للأعداء هي خصومة للترقيش :

أيهـــا الناطق المرقِّشُ عنـا    عند عمـرو وهل لذاك بقاء؟

والترقيش كما يقول الشارح هو التبليغ بما يثير الريبة والتشكيك(٢٢). لا ينخلع الوجود الشعري للاعداء إذن عن معنى الشك والريبة وطمس الحقيقة، بينما يقترن وجود الشاعر وقومه بفكرة الحقيقة الساطعة فيقول عن عزة قومه :

قبل ما اليـوم بيَّضَتْ بعيون الناس، فيها تَغَيُّظٌ واباءُ

وكـأن المنون تَرْدى بنا أرْعَنَ جـوْنـاً ينجـابُ عنه العماء

| | |
|---|---|
| فـتـنـوّرتَ نـارَهـا مــن بعــيــد | بخَــزازَى هيــهــات منك الصِّــلاء |
| أوْ قَـدتْها بين العَقيقِ فشَخْصين | بعـودٍ كـمـا يلـوح الضـيـاء |

تتراءى هند للشاعر فيما يشبه الوهم أو الحلم. يثير هذا النص الشعور بالشك ولكن بأسلوب مختلف عما فى نص عنترة. بحيث بدت تجربة الوهم عند الحارث مباينة لتجربة الوهم عند عنترة. استحالت المرأة عند عنترة إلى رياض وخصب وماء صاف لم تطأة قدم، أما في حالة الحارث فان النزعة الصوفية تتجسد تجسداً مختلفاً. انها تتجسد في النور والضوء والنار والدفء. المحبوبة في هذا النص هي البصـيـرة والرؤية والدفء. وهي لذلك حلم لا يتحقق رغم وضوح رؤيتـه ومثـوله أمام عـيـني الشاعر. نار هند قريبـة جداً فهي «بعـيني» الشاعر وهو تعبير يشى برغبة الشاعر في التوحد مع تلك النار التي تظهر ظهوراً واضحاً لانها في مكان مرتفع. أما قول الشاعر «تنورت نارها» فأبلغ في التعبير عن تلك الرغـبـة الدفـينـة في التـوحّـد مع الـنار والنور. فـفي الفـعل «تنور» يوحّدُالشاعر بين النار والنور والذات الباحثة عنهما. إنه فعل يوحّد بين الذات الباحثة عن المعرفة وموضوع المعرفة.

إن اسلوب الحارث في نسـيبه يتشابه مع أسـلوب الأحلام والرؤى. ووجه الشبه بينهما هذه العبثـيّة او اللامعـقوليـة لأن هنداً ليست بعـيدةً من الناحية الفيزيقية، فـهى تلـوّح له بالنار السـاطعـة التي يراها الشاعر بوضوح. لكن هنداً رغم قربها هذا تبدو بعـيدة، بل مـسـتحـيلة. ولا يقدم النص سـبـبا واحـداً يمنع الشاعر من بلوغ غايتـه، وغاية نور هند ونارها. صـحـيح أن الشـارح يقول إن الحروب وغيرها عـاقـته عن هند ونارها(٢١). وهو تبرير مقبول بشرط ألا تفهم الحرب فهما واقـعيـاً أي بشـرط أن تكون الحـروب مجرد تمثيل لفكرة العقبات التي تحول دون الشاعر وهند. وهي عوائق لا نعـرف من كلام الشـاعـر شـيـئًا عن طبيعتها. هي عوائق غامضة مسكوت عنها في كلام الشاعر. يحيل الشاعر هنداً إذن إلى ما يشـبه الحقـيقـة العليـا، أي النور والنار، ولكنه يقرر أنه لا سـبـيل إلى الاصطلاء بتلك النار المحبوبة «هيهات منك الصلاء».

إن الشاعر في هذا النسيب يقدم هنداً الحلم بأسلوب الأحلام نفسها، ولعل هذا مـا دعـاه إلى تغـيير اسم المحـبوبة الذي هنف به في أول كلامه وهو أسماء، إلى هند. إن كثافة الأحساس بأساليب الاحلام تبدأ منذ لحظة تغيير الاسم من أسماء إلى هند. أسمـاء صـيـغت صـياغـة واقـعـيـة إلى حد بعـيد، أما هند فـقد صاغ الشاعر كلامه عنها صياغة تقـرب بينهـا وبين الحلم شكلاً ومضمـوناً. بعـبارة أوضـح، فإن هندا هي حلم الشاعر، مثلها مثـل عبلة عنترة، ولكن الـكلام عن هذا الحلم صيغ بأساليب الاحلام. هذا ما يجعل الحارث مختلفا عن عنترة.

ولو نظـرنا فيما يسـمى بالفخر في معلقة الحارث لوجدنا آثاراً لبحث الشاعر عن نار هند ونورها بما تمثلانه من رغبة في الاهتداء إلى الحقيقة.

هذا الجهد، لكن الصياغة التي يبث الشاعر من خلالها هذا الإمكان تثير الإحساس بالتوتر والترقب، بل والشك. فالمحبوبة «شاة قنص» بما يثيره القنص من ارتياب وتحفز، والرامي إما أن يصيب أو يخطىء. في القنص تتساوى احتمالات الفوز والخسران. والمحبوبة، على كل حال، محاطة بالأعادي، مما يذكرنا مرة أخرى «بالزائرين» في أول كلامه. وفي ظني لو أن الشاعر اراد أن يغلب احتمال الفوز بالمحبوبة على احتمال الخسران لانهى القصيدة بهذه الأبيات، لكنه لم يفعل، بل مضى في كفاحه أو صلاته الشاقة لآخر القصيدة، مما يستبقي الإحساس بالشك في أمر الوصول إلى المحبوبة، لهذا استمر عنترة في إكمال «شعائر» القتال، وبذلك ظل النص مفتوحا قابلا لأكثر من احتمال.

ومعلقة عنترة على طولها النسبي شديدة التماسك لو تناسينا مايقال عن انقسام القصيدة إلى نسيب وغزل وفخر ووصف للناقة والفرس، لأن النص كله مبني على فكرتين لا تنفصل إحداهما عن الأخرى، فكرة المرأة / الحلم وفكرة المجاهدة من أجل بلوغ هذه المرأة. وقد تجسدت فكرة المجاهدة من خلال ذات الشاعر وناقته وفرسه. ان هذه العناصر الثلاثة تنتظمها جميعا فكرة واحدة رغم تباينها الظاهري.

كانت الأمكنة من مثل الجواء وعنيزتين وغيرهما بمثابة عوائق تحول دون الاتصال بالمحبوبة. أما الاماكن عند الحارث فترتبط «بالعهد»:

| رُبَّ ثَاوٍ يُمَلُّ مِنْهُ الثَّوَاءُ | آذَنَتْنَا بِبَيْنِهَا أَسْمَاءُ |
| فَأَدْنَى دِيَارِهَا الخَلْصَاءُ | بَعْدَ عَهْدٍ لَنَا بِبُرْقَةِ شَمَّاءَ |
| فَتَاقٌ فَعَاذِبٌ فَالوَفَاءُ | فَالمُحَيَّاةُ فَالصِّفَاحُ فَأَعْنَاقٌ |
| فَالشُّعْبَتَانِ فَالأَبْلَاءُ | فَرِيَاضُ القَطَا فَأَوْدِيَةُ الشُّرْبُبِ |
| اليومَ دَلُهَا وما يُحِيزُ البكاء | لا أرى مِنْ عَهِدْتُ فيها فَأبكي |

يبكي الشاعر في هذه الأبيات على ماض جميل يرتبط بهذه الأماكن التي كان يعهد فيها المحبوبة، وقد ذكر العهد مرتين. ومن الواضح في هذا السياق آن الأماكن تكتسب في قصيدة الحارث معنى مختلفا عما في قصيدة عنترة، الذي مثلت له الأماكن معنى العوائق والحجب دون المحبوبة، أما الأماكن عند الحارث فترتبط بعهده بأسماء، ولذلك توالي ذكر الأماكن، كما لو كان ذكرها استبقاءً لأسماء.

ولكن الحارث يتشابه مع عنترة من وجه آخر، فهو مثله يثير الإحساس بالتوتر الناجم عن رؤية الشيء وتأمله والاعتقاد بإمكان بلوغه من جهة، ثم تقرير استحالة بلوغه من جهة أخرى. إن اسماء التي تحولت إلى هند، وهو تحول ذو دلالة، تبدو قريبة بعيدة في آن واحد:

| أخيرًا تُلْوى بها العَلْيَاءُ | وبِعَيْنَيْكَ أوقدَتْ هِنْدٌ النَّارَ |

إن الاشارة إلى الفرس السابع بأنه «مكلم» أي ملىء بالجروح تذكرنا بما قاله عن الناقة من انها كالفحل «المكدم» أي الذي كدمته الفحول، فـفي الحالتين نجد انفسنا بازاء كائنات شعرية (١٨) تجسد معنى المكابدة الشديدة. وقد عاد الشاعر في أبيات أخرى إلى فرسه ومعاناته حين قال :

| | |
|---|---|
| أشْطانُ بئـــر فـــي لَبــانِ الأدهم | يدعــون عنتـرَ والرِّمـاحُ كـــأنها |
| ولَبـانـه حتّــى تَسـرْبَـل بالدم | مــازلتُ أرمِيهـم بثُـغـرَة نَحـرِه |
| وشكا إلـيَّ بعَبْـرة وتَحَمْـحُـم | فـازْوَرَّ مــن وقْع الـقَنا بَـلَبَـانه |
| ولكان لو علم الـكــلام مَكلِّـمِي | لو كان يدري ما المحاورة اشتكى |

لا ينفصل الفعل البطولي عند عنترة عن معنى الصراع الذي تتكافأ أطرافه وهذا ماقاله الشاعر نفسه عن خصومه :

| | |
|---|---|
| لا مـمْعْـن هربا ولا مـســتــسـلـم | ومــدجّج كــره الـكـمـاةَ نِـزالَـه |

وهو أيضا يقول عن خصم آخر :

| | |
|---|---|
| بالسيف عن حامي الحقيقة معلم | ومـشَكٍّ سـابـغَة هـتـكت فـروجهـا |
| هتـاك غـايــات التجــار ملـوم | رِبذٍ يــداه بالقِـداح إذا شـتــا |
| أبــدى نواجذه لغيـر تبـسـم | لمــا رَآنِــي قــد نـزلـت أريــده |

ويقول أيضاً عنه :

| | |
|---|---|
| يُحذى نِـعـالَ السِّبْت ليس بتوأم | بطلٍ كــأنَّ ثيــابه فــي سـرحـة |

أسهب عنترة إذن في الحديث عن خصومه مجسدا من خلالهم فكرة الخصم البطل مما يعمق الإحساس بشدة المغالبة والمجاهدة.

ويلاحظ إن الشاعر في غمرة تجسيده لهذا القتال الشديد يعود الى ذكر المحبوبة فيما يبدو أنه قطع للسياق، بل قد تبدو هذه الأبيات التي يذكر فيها هذه المحبوبة مثل جملة معترضة لا موضع لها، إذ يقول عقب الأبيات السابقة :

| | |
|---|---|
| حَرُمْت على وليتِـهـا لــمَ تحرم | ياشاة مــا قَنَـص لمن حلــت له |
| فتجـسَّسي أخبـارها لي واعلمي | فبعثت جاريتي فقلت لها اذهبي |
| والشــاةُ ممكنــةٌ لمن هــو مــرتـم | قـالت رأيت من الأعـادى غِـرَّةً |
| رشــأ مــن الغــزلان حُـرٍّ أرثَـم | وكـأنما التفتت بـجيـد جَـدايـة |

وكما قلت لا يبدو لهذه الأبيات موضع بين مـاقبلها ومابعدها من حديث عن القتال واثبات للبطولة، لولا أن التفكير الشعري لا يفصل الإحساس بالمجاهدة عن الاحساس بالمحبوبة، فكان ذكر المحبوبة بين الفينة والفينة بمثابة تنبيه لهذا المعنى ولفت النظر اليه .

ولقد يبدو من كلام الشاعر الأخير أن المحبوبة أصبـحت «ممكنة» بعد كل

بفكرة الصراع الذي ترك آثاره على جسد هذا الفحل الذي امتلأ جسمه بالكدوم من جراء صراعه مع الأخرين. البطولة والمعاناة إذن فكرتان أثيرتان لدى الشاعر، وهو لا ينحاز لإحداهما على حساب الأخرى، وكأنه يريد أن ينسج منهما معاً موضوعاً واحداً.

غير أن صلاة الشاعر الشاقة من خلال الناقة لم تكن إلا مجرد مرحلة في صلاة تستمر حتى آخر القصيدة، وهي صلاة من أجل المحبوبة التي مازالت تحتجب عن الشاعر وتمتنع عليه. وقد وجه الشاعر كلامه لها عقب كلامه عن ناقته قائلا:

إن تُغْدِفي دوني القناع فإنني   طَبٌّ بأخْذِ الفارس المُسْتَلْئم

يعود بنا هذا «القناع» إلى المحبوبة المستحيلة التي تشبه حلماً بعيد المنال يتشكك الشاعر في امكان تحققه. يعيد هذا القناع تمثيل فكرة الموانع أو الحجب التي جسدها الشاعر بأكثر من طريقة في نسيبه. بعبارة أخرى فإن هذا القناع تعبير رمزي آخر عن فكرة الموانع كما أنه يذكرنا ببداية القصيدة مما يحيل المعلقة على طولها إلى عمل شديد التماسك على عكس ما يذهب بعض النقاد حين ينظرون في الشعر الجاهلي .

لم يكن كفاح الشاعر من خلال ناقته كافياً لبلوغ المحبوبة، فهي مازالت تُغْدِفُ القناع دونه. ولهذا استأنف الشاعر صلاته الشاقة من خلال عرض مجاهدته هو، وهي مجاهدة جسدها الشاعر من خلال نبرة اخلاقية بطولية فيقول :

ولقد شربتُ من المدامةِ بعدما   ركَّدَ الهواجرَ بالمشوفِ المُعْلَمِ
بزجاجة صفراءَ ذاتِ أسرةٍ   قُرنَت بأزْهَرَ في الشمالِ مُقدَّم
فإذا شربتُ فإنني مستهلكٌ   مالي وعرضي وافِرٌ لم يُكلم
وإذا صحوتُ فما أقصِّرُ عن ندى   وكما علمتَ شمائلي وتكرُّمي

ومن المهم هنا أن نشير الى أن تعاطي اللذة متمثلةً في الخمر يقتضي "التضحية" بالمشوف المعلم لان المشوف المعلم ليس مجرد مال، بل هو "موضوع" يوحي بمعنى الشيء الثمين الذي يضحي به الشاعر في سبيل لذته. وهذه التضحية تتسق مع المعاني الاخلاقية التي ساقها الشاعر بعد ذلك ،

وينبغي أن نتذكر دائماً أن نضال الشاعر خلال المعلقة كلها لا ينفصل عن حلمه بالجنة أو عبلة، فهو مايزال يذكرها كل حين موجهاً كلامه اليها سائلاً إياها:

هلّا سألتِ الخيلَ يا ابنةَ مالكِ   إن كنتِ جاهلةً بما لم تعلمي؟
إذ لا أزالُ على رحالةِ سابحٍ   نَهْدٍ تعاوره الكُماةُ مُكَلَّمِ
طوراً يُجَرَّدُ للطِّعانِ وتارةً   أوي إلى حَصِدِ القِسيِّ عَرمرمِ
يخبرْكِ من شهد الوقيعةَ أنني   أغْشى الوغى وأعَفُّ عند المغنمِ

فنقول أن الشاعر سيؤدي من خلال المعلقة طقوساً قاسية (١٣) أو صلاة متصلة من أجل بلوغ «دار عبلة» أو جنتها. لقد أجمل الشاعر في هذه الأبيات الثلاثة ماسوف يمضي بقية القصيدة في تفصيله. فالناقة مثلاً تتجسد في لغة تحيلها إلى قوة هائلة تقطع الطريق في همة وقدرة ولكنها في الوقت نفسه محاطة بالمخاوف تتناوشها قوى خفية. تسير الناقة سيراً واثقاً :

خَطَّارة غِبَّ السُّرى زيّافَـــةٌ     تَطِسُ الأكامَ بوخْدِ خفٍّ مِــيــثَم

كما أنها

شربت بماء الدَّحرُضَيْن فأصبحت     زوراءَ تنفر عن حِياضِ الدَّيلم

ولكنها رغم وثوقها وأنفتها تتناوشها المخاوف

وكأنما تنأي بجانب دفّهــا الــ     وحشِّي من هَزِج العشــيِّ مـؤوَّم
هِر جنيبٍ كلمــا عطفــت لـه     غضبي أتقـاهَا باليديــن وبالفم

تعاني الناقة في رحلتها إلى المحبوبة من صراع مع قوى خفية مجهولة عمد النص إلى تجهيلها. وقد فُسِّر قول الشاعر «هزج العشي» بأكثر من طريقة. فقيل إن الناقة تخاف إما الهر الذي سيأتي ذكره في البيت التالي وإما السوط. هذا ماقاله الزوزني(١٤). وأضاف صاحب الجمهرة تفسيراً ثالثاً قال فيه إن هذا المؤوم (وهو القبيح الرأس العظيمة) هو الحادي(١٥). وفي رأيي أن النص الشعري يعمد عمداً إلى تجهيل هذا الكائن القبيح الذي يعترض سير الناقة. إن النص يريد أن يعبر عن فكرة الإحساس بقوى شريرة مبهمة. وقد كان ذكر الهر عاملاً إضافياً لزيادة الإحساس بمعنى الشرِّ المبهم، لأننا، في الواقع لا نتصور صراعاً بين ناقة وهرّ. إن ظهور الهرّ في هذا المشهد يحيل إلى الشعور بالكوابيس التي تتراءى للخائف على شكل رموز مخيفة كالأفاعي أو الوحوش أو هذا الهرّ. هذا الهرّ إذن رمز أو تجسيد لفكرة الشر المبهم أكثر مما هو محاكاة لأمر يمكن أن يحدث في الواقع.

ولم يكن غريباً أن يأتي بعد هذا المشهد الذي ركز فيه الشاعر الإحساس بالصراع المرير مع قوى مجهولة أن يعرض الشاعر لمعاناة الناقة وتعبها وإحساسها بالمشقة، وكان ذلك كله ختاماً لكلامه عنها فقال :

بركت على جنب الرِّداع كــأنما     بركت على قَصَبٍ أجشَّ مُـهـضَّم
وكأنَّ رُبّاً أو كُحَيْلاً مُعــقّـداً     حَشَّ الوقودُ بـه جوانبَ قُمْقُم
ينباعُ من ذَفْرَي غضوبٍ جَسْرَةٍ     زيّافةٍ مثـل الفنيق المُكَـدَّم

فالشاعر يشبه أنين الناقة «من كلالها بصوت القصب المكسر» كما فصل في الكلام عن عرقها تكثيفاً للإحساس بالتعب والجهد الشاق غير أن الناقة مع ذلك غضوب موثقة الخلق تشبه في سطوتها الفنيق، وهو الفحل. ولكن هذا الفحل «مكدم». أي أن «الإرادة الشعرية»(١٧) تأبى إلا أن تقرن بطولة الناقة وقوتها

وراءها ضرباً من «اللامعقول» كما نقول في لغتنا المعاصرة. ولكن من هي عبلة التي تمتنع على الشاعر كل هذا الامتناع؟ إن أسلوب عنترة، الواقعي إلى حد كبير، قد يغري القارىء بالركون إلى القصة التي تروي عن حب عنترة لها، خاصة وأن الشاعر يشير إلى خلافه مع أبيها. لكننا في الواقع لا نتساءل عن عبلة «التاريخية»، وإنما نتساءل عن «الوجود الشعري» لعبلة(١٠). أما الإفصاح عن هذا الوجود فقد تضمنه قول عنترة:

| عذبٌ مُقَبَّلُـهُ لـذيـذ المطعـم | إذ تستبيك بذي غُروب واضح |
| سبقت عوارضها إليك من الفم | وكأن فارةَ تاجرٍ بقسيمة |
| غيث قليل الدِمن ليس بمعلم | أو روضةٌ أنفاً تضمن نبتها |
| فتركن كل قرارةٍ كالدرهم | جادت عليه كل بكرٍ حُرّة |
| يجري عليها الماءُ لم يتصرّم | سحاً وتسكاباً فكل عشية |

إن عبلة في هذا الشعر «رائحة تحس ولا تلمس، تدرك ولا يمكن تحديدها... إن المحبوبة عند عنترة... ترتبط بروضة بعيدة عن الأقدام، ولكنها ذات حياة جمة... وهي من أجل ذلك تصبح شيئاً أروع من مجتمع الناس... ولم يكن مايسمى التصوف معروفاً، ولكن كيف يستطيع القارىء أن يطمئن إلى استعمال فكرة أخرى بعيدة عن التصوف، وهو يرى أن المحبوبة بعيدة عن المجتمع، وأنها عبير، لا يحتويه حدود.»(١١) ان الوجود الشعري لعبلة يؤكد ما سبق أن ذكرته من أن عبلة تبدو كالحقيقة المتعالية أو الحلم المستحيل.

خلق الشاعر من محبوبته عالماً أثيرياً يفيض صفاءً وطهراً بحيث تكون الجنة هي أقرب مايمكن أن نصف به هذا العالم أو ذلك النعيم. ولم يكن الشاعر بعيداً عن فكرة النعيم والتَّنعُّم حين قال بعد هذه الأبيات مباشرة:

| وأبيتُ فوق سراةِ أدهمَ مُلجَم | تمسي وتصبحُ فوق ظهر حشيةٍ |

قال الشارح تعليقاً على هذا البيت «هي تتنعم وأنا أقاسي شدائد الأسفار والحروب»(١٢). ولا يشير عنترة صراحةً في هذا البيت إلى علاقة سببية بين عالم النعيم المرتبط بالمحبوبة وعالم الشدائد الذي يعيشه الشاعر. غير أن معاناة الشاعر هي في حقيقة الأمر نتيجة لجهاد الشاعر من أجل بلوغ عالم المحبوبة. انه يريد أن يبلغ «دار» المحبوبة كما سيقول بعد البيت السابق مباشرة:

| نهـد مراكلـه نبيـل المحـزم | وحشيتي سرجٌ على عبل الشَّوى |
| لعنت بمحروم الشراب مصرم | هل تبلغني دارها شَدَنِيَّـةٌ |

ذكر الشاعر في هذين البيتين والبيت السابق لهما ثلاثة أشياء. ذكر نفسه وفرسه وناقته. ومن خلال هذه العناصر الثلاثة سيمضي الشاعر بقية قصيدته في كفاح متصل، كفاح يتجلى من خلال خطابه عن نفسه كما يتجلى من خلال خطابه عن الفرس والناقة. ونستطيع هنا أن نستعير مصطلح مصطفى ناصف

يتصل بما قبلها فيفاجأ بأن مابعدها منبت الصلة بما قبلها. لا يبقي بعد ذلك إلا أن يكون التساؤل في حد ذاته هو الرابطة المنطقية بين سؤالي عنترة. إن إثارة الإحساس بالتشكك هو سرّ قوة هذا البيت وسرّ جاذبيته. وفي هذا السياق يكون لكلمة «توهم» وقع خاص، إذ تعزّز الاحساس بالشك. إن الشاعر متردّد بين «المعرفة» في قوله «هل عرفت» والارتياب في قوله «توهم».

لا يتشكك الشاعر في وجود الدار فحسب، بل يتشكك في إمكانية أن يقول الشعر، أي يتشكك في «وجوده» ذاته من حيث هو شاعر. لذلك كانت الدعوة المستحيلة للمكان أن ينطق ويفصح، إثباتاً لوجوده ونفياً للوهم، تالية للبيت الأول:

<div style="text-align:center">يادارَ عبلةَ بالجواء تكلّمـــي  وعمـي صباحـاً دار عبلة واسلمي</div>

يسعى الشاعر إلى يقين يدفع عنه الأوهام والشكوك ويحيله إلى حقيقة ثابتة. لذلك لم يكن غريباً أن يقول عنترة بعد ذلك :

<div style="text-align:center">فوقفـت فيهـا ناقتـي وكـأنهـا  فـدن لأقضـي حـاجـة المتلـوِّم</div>

إن لجوء الشاعر الى ناقته يرتبط بمعنى الاحتماء، فهذه الناقة «كأنها فدن» أي قصر، والقصر بناء ثابت الأركان يوحي بمعاني الأمن والحماية. إن حاجة الشاعر إلى الإحساس بالأمن والحماية إحساس طبيعي نتج عن الشعور بالضياع لفقدان الثقة في وجود دار عبلة، وفي وجوده هو بوصفه شاعراً. وهو استمرار لمطالبة الشاعر للمكان أن يتكلم، ففي الحالتين يتشوف الشاعر يقيناً أو ملجأ يحيمه من شكوكه واضطراب أمره .

أما «عبلة» أو «أم الهـيثم» فتبدو في هذه القصيدة كالحقيقة المتعالية يريد الشاعر أن يبلغها دون جدوى. إنها «وهم» يتراءى للشاعر ثم مايلبث أن يختفي. إن الموانع دون عبلة، حلم الشاعر أو وهمه، جمـة. هناك أولاً المانع الطبيعي، أو الفيزيقي، لأن عبلة تحل «بالجواء» بينما يحل الشاعر مع أهله في أماكن أخرى بعيدة :

<div style="text-align:center">وتحل عـبـلة بالجـواء وأهلنا  بالحـزن فالصمـان فالمتثلم</div>

وقد عاد الشاعر إلى هذا المانع وتعميق الإحساس به حين قال :

<div style="text-align:center">كـيف المـزار وقـد تربع أهلها  بعنيـزتين وأهلنـا بالغـيلم</div>

ولم يكن المانع المكاني هو العقبة الوحيدة دون «عبلة»، فهناك مانع اجتماعي يتمثل في إنها محاطة بأعداء اشتدّت عداوتهم للشاعر واتصلت بينه وبينهم الحرب والقتل :

<div style="text-align:center">حلت بأرض الزائرين فأصبحت  عسراً على طلابُك ابنةَ مَخْرم
عُلّقتُها عرضاً وأقتـلُ قومَها  زعماً لعمرِ أبيك ليس بمزعم</div>

إن قول الشاعر «زعما لعمر أبيك ليس بمزعم» يجعل من طلب عبلة والسعي

ماتزال نتائجها تفعل فعلها في مجالات البحث، لا في اللغة والأدب فحسب بل في سائر العلوم الإنسانية. وأغلب الظن أن كلام ابن خلدون عن اللغة والأدب ينطوي على نظريته المعرفية التي تفسر كلامه عن الموضوعات الأخرى التي لا تتصل باللغة والأدب اتصالاً مباشراً. بعبارة أخرى، فإن المبادىء النظرية التي صدر عنها ابن خلدون في كلامه عن اللغة والأدب يمكن ان تكون هي نفسها «الصورة الذهنية المجردة»، التي صدر عنها في بحثه لشتى الموضوعات التي تناولها في مقدمته أما الصورة الذهنية المجردة التي يحاول هذا البحث تلمس تجسيداتها فتتلخص في ميل الشعراء إلى «بناء» موضوع ما ثم «هدم» هذا الموضوع أو النيل منه، مما يشيع في الشعر روح التشكك .

يبدأ عنترة معلقته ببيت ينطوي على سؤالين :

هل غادرَ الشعراءُ من متردَّمِ؟ أم هل عرفتَ الدارَ بعد توهُّمِ؟(٢)

ولم يكن عنترة حالةً فريدة، فافتتاح القصيدة بسؤال الطلل أو التساؤل عنه شائع في الشعر القديم. يقول زهير في أول معلقته :

أمن أم أوفى دمنة لم تكلم بحومانة الدَّراج فالمتثلَّم(٣)

ويقول عبدة بن الطبيب :

هل حبل خولة بعد الهجر موصول أم أنت عنها بعيد الدار مشغول؟(٤)

ويقول ربيعة بن مقروم :

أمن آل هند عرفت الرسوما بجمران قفراً أبت أن تريما؟(٥)

ويقول النابغة الذبياني :

طال الوقوف على رسوم ديار قفر، أسائلها وما استخباري؟(٦)

وقد توالت أسئلة بشر بن أبي خازم حيث يقول مفتتحا إحدى قصائده :

أي المنازل بعد الحول تعترف؟ أم هل صباك-وقد حكمت-منصرف؟

أم مابكاؤك في دار عهدت بها عهدا، فأخلــف، أم في أيها تقف ؟(٧)

وهذا يشبه قول امرىء القيس :

ألا عم صباحا أيها الطلل البالي وهل يعمن من كان في العصر الخالي

وهل يعمن الا سعيد مخلد قليل الهموم لايبيت بأوجال؟(٨)

وهناك أمثلة أخرى كثيرة على هذا الاتجاه الى ابتداء القصيدة بالتساؤل(٩)، غير أن سؤالي عنترة يختلفان عن سائر الأسئلة. ووجه الاختلاف أن العلاقة المنطقية بين سؤاليه مفتقدة، إذ لا توجد علاقة بين السؤال عن الشعر (هل غادر الشعراء من متردم ؟) والسؤال عن الدار (أم هل عرفت الدار بعد توهم؟) هناك محاولة للربط اللفظي بين السؤالين في قوله (أم) غير أن هذه الأداة (أم) زادت من الإحساس بغياب العلاقة بين السؤالين لأن من يسمع (أم) يتوقع بعدها شيئاً

## نزعة الشك عند شعراء الجاهلية :
## بحث في الصور الذهنية المجردة

### محمد بريري

تسعى هذه الدراسة الى استخلاص مبدأ شكلي تدخل في بناء القصيدة العربية قديماً وحديثاً. وقد كان من الجائز أن يتتبع البحث الكيفيات المختلفة التي تجسد بها هذا المبدأ في الشعر العربي لولا أن هذا مما لا يحتمله المقام من حيث المساحة والوقت المتاحين. لذلك جعلت الدراسة من شعر المعلقات مادةً أساسيةً للنظر، ثم تناولت قصيدة «أبى الهول» لأحمد شوقي فيما يشبه أن يكون تعقيباً مختصراً يشير إلى اتصال الشعر العربي منذ بداياته في العصر الجاهلي بالشعر في عصرنا الحديث من حيث بناء هذا الشعر على مباديء شكلية أعمق مما يبدو على السطح.

لا يختلف ما أعنيه بمصطلح المبدأ الشكلي عما كان يعنيه ابن خلدون بمصطلح الصور الذهنية المجردة(1) التي ينسج الشعراء قصائدهم على منوالها. وينبغي هنا أن نؤكد على أن هذه الصور المجردة تتجاوز الإدراك المباشر لأي شاعر فرد. إنها أشبه بالعقدة النفسية التي توجه سلوك الفرد وتفسره دون أن يكون هذا الفرد مدركا لهذه العقدة أو واعياً بها. إن الصورة الذهنية المجردة، فيما يمكن أن يترتب على كلام ابن خلدون، شيئٌ من عمل الناقد الذي يعول عليه في استخلاص القوانين الداخلية للنصوص. وهي قوانين لا يدركها الشعراء ادراكاً واعياً لانهم معنيون في الأساس بتجسيد تجاربهم، ولا شأن لهم بالكلام المجرد (إلا في حالات الشعر الضعيف). وقد كان ابن خلدون حريصاً على تأكيد أن الصور الذهنية المجردة لا تتعلق بعلوم البلاغة والبيان والنحو لأن هذه العلوم جزئية تعني بالتفاصيل على حين أن الصور الذهنية ذات طابع كلى مجرد. ولا شك أن ابن خلدون كان في حقيقة الأمر يضع أسس علم جديد حين نظر في قضايا الأدب واللغة، ولكن الرجل لم يقيض له ما قيض لأمثاله من المفكرين والفلاسفة في الغرب حين عكف النقاد والمنظرون على الأسس النظرية التي أرساها «دي سوسير»، مثلاً، في كلامه عن اللغة فاستنبطوا علوماً ونظريات

٢٢ - انظر المصدر السابق ١٩ : ١٦، وأيضا الكامل في التاريخ، لابن الأثير - طبع بولاق، القاهرة : ١٢٩٠ هـ، ١ : ١٧٩.

٢٣ - العقد الفريد، لابن عبد ربه، (مضى ذكره في هامش : ٧)، ٥ : ٢١٣.

٢٤ - الأغاني، لأبي الفرج الأصفهاني (مضى ذكره في هامش : ٧)، ١٨ : ١٩ - ١٩، والكامل، لابن الأثير (مضى ذكره في هامش : ٢٢ ) ١ : ٧٩).

٢٥ - العقد الفريد، لابن عبد ربه (مضى ذكره في هامش : ٢٣)، ٥ : ٢١٣، والكامل في التاريخ، لابن الأثير (مضى ذكره في هامش : ٢٢) ١ : ١٧٨.

٢٦ - المؤتلف والمختلف، للآمدي (مضى ذكره في هامش : ١٩)، ص : ٧.

٢٧ - العمدة في صناعة الشعر، لابن رشيق، تحقيق محيي الدين عبد الحميد - مطبعة السعادة، القاهرة، ١٩٦٣، ١ : ٨٧.

٢٨ - طبقات فحول الشعراء، لابن سلام (مضى ذكره في هامش : ١ )، ١ : ٣٥.

٢٩ - الشعر والشعراء، لابن قتيبة (مضى ذكره في هامش : ٥)، ١ : ٣٧٩.

٣٠ - العمدة في صناعة الشعر، لابن رشيق (مضى ذكره في هامش : ٢٧) ١ : ٨.

٣١ - خزانة الأدب، لعبد القادر البغدادي، تحقيق عبد السلام هارون - طبع مكتبة الخانجي، القاهرة، ٤ : ٣٧٨ .

٣٢ - الأغاني، لأبي الفرج الأصفهاني (مضى ذكره في هامش : ٧) ١٩ : ١٥.

٣٣ - خلط بعض القدماء والمحدثين بين أبرهة هذا وأبرهة صاحب الفيل. انظر مثلا ابن قتيبة في الشعر والشعراء (مضى ذكره في هامش : ٥ ) ١ : ٣٧٩، جواد على في المفصل في تاريخ العرب قبل الإسلام - مكتبة النهضة، بغداد، ١٩٧٢، ٩ : ٤٤٣.

٣٤ - انظر نجيب البهبيتي في تاريخ الشعر العربي إلى نهاية القرن الثالث للهجرة - مكتبة الخانجي، القاهرة، ط. رابعة، ص : ٢٦.

٣٥ - الأغاني، لأبي الفرج الأصفهاني (مضى ذكره في هامش : ٧)، ١٩ : ٢١.

٣٦ - المعمرون والوصايا، لأبي حاتم السجستاني (مضى ذكره في هامش : ١٨)، ص : ٣، وأيضا الأغاني ١٩ : ٢١.

٣٧ - الأغاني ١٩ : ٢٠.

٣٨ - طبقات فحول الشعراء، لابن سلام (مضى ذكره في هامش : ١). ١ : ٣٦ - ٣٧، الأغاني لأبي الفرج الأصفهاني ( مضى ذكره في هامش : ١٤ )، ١٩ : ٢٢) المعمرون والوصايا ( مضى ذكره في هامش : ١٨ )، ص : ٢٦.

٣٩ - ١٩ : ٢٤ - ٢٦.

٤٠ - نفس المصدر ١٩ : ١٩.

أمين وآخرين – مطبعة لجنة التأليف والترجمة والنشر، القاهرة، ١٩٦٥، ٥: ٢١٣ – ٢٢٢، وبتفصيل مستفيض في كتاب بكر وتغلب، مطبعة نخبة الأخبار، ١٣٠٥ هـ .

٨ – للحارث وملوك كندة انظر: Gunnar Olinder. *The Kings of Kinda.* Lund: Gleerup, 1927.

٩ – منتهى الطلب في أشعار العرب، لابن ميمون، الجزء الخامس، نسخة جامعة ييل Yale. وفي أشعار بكر وتغلب قصيدتان، إحداهما حائية في ثمانية وعشرين بيتاً، والأخرى قافية، في تسعة عشر بيتاً.

١٠ – الحب المثالي عند العرب، للدكتور يوسف خليف، سلسلة اقرأ.

١١ – انظر عدة فصول بعنوان «الغزل والغزلون» في حديث الأربعاء، طبع دار المعارف بالقاهرة، وقد أعيد طبعه بعنوان: «من تاريخ الأدب العربي: العصر الجاهلي والإسلامي»، دار العلم للملايين، بيروت ١٩٧٥، ١: ٤٣٩ – ٥٣٦.

١٢ – من النادر أن تبدأ قصيدة في الرثاء بذكر الأطلال أو النسيب، وإنما تكون من بداياتها عن مصاب الراثي وصفات المرثي، وقد يتطرق الشاعر إلى الحديث عن الصيد، وفيه يقتل الحيوان تأكيداً لحتمية الفناء، كما في قصيدة أبي ذؤيب العينية (المفضليات، رقم: ١٢٦).

١٣ – الشعر والشعراء (مضى ذكره في هامش: ٥) ١: ٧٤ – ٧٥.

١٤ – طبقات فحول الشعراء (مضى ذكره في هامش: ١) ١: ٥٥، وانظر أيضا كتاب الأوائل، للعسكري، تحقيق محمد المصري – طبع وزارة الثقافة، دمشق ١٩٧٥، ٢: ٢٢٠، الأغاني، لأبي الفرج الأصفهاني، طبع دار الكتب المصرية، ٥: ٥٧، المزهر (مضى ذكره في هامش: ٣) ٢: ٤٧٧.

١٥ – ١: ٣٩. وللبيت انظر ديوان امرئ القيس، تحقيق محمد أبو الفضل إبراهيم – دار المعارف، القاهرة، ١٩٦١، ص: ١١٤. ويقال له أيضا: ابن حذام، وابن حمام.

١٦ – الشعر والشعراء (مضى ذكره في هامش: ٥) ١: ١٢٨.

١٧ – جمهرة أنساب العرب، لابن حزم، تحقيق عبد السلام هاورن – طبع دار المعارف القاهرة، ط. خامسة، ١٩٨٢، ص: ٤٥٦.

١٨ – المعمرون والوصايا، لأبي حاتم السجستاني، تحقيق عبد المنعم عامر – مطبعة عيس الحلبي، القاهرة ١٩٦١، ص: ٧١.

١٩ – المؤتلف والمختلف، للحسن بن بشر الآمدي، تحقيق عبد الستار فراج – مطبعة عيسى الحلبي، القاهرة، ١٩٦١، ص: ٧.

٢٠ – شعراء النصرانية، للويس شيخو – مكتبة الآداب، القاهرة، بدون تاريخ، ٢: ١٦٠، ديوان الشعر العربي، لأحمد سعيد أدونيس – دار العلم للملايين، بيروت، ١٩٦٤، ص: ٥٧٦، الأعلام، لخير الدين الزركلي – دار العلم للملايين، بيروت، ١٩٧٩، ٤: ٢٢٠.

٢١ – الأغاني، لأبي الفرج الأصفهاني (مضى ذكره في هامش: ٧)، ١٩: ١٥.

وإذا كانت هذه القافيَّة قد بدأت بالطيف، فإن بائيته التى نظمها فى نفس الوقعة تبدأ بذكر الطلل، يقول :

حـى داراً تغيـرت بالجنـاب        أقفـرت من كواعـب أتـراب

ولكن للأسف الشديد لم يصل إلينا من المقدمـة الطلليـة إلا هذا البيت، واقتصر أبو الفـرج من هذه القصيدة على عشرة أبيات يصور فـيها زهير هزيمة تغلب .

أرجو أن أكون قد وفقت إلى توضيح أن القصيدة الجاهلية بأقسامها المعروفة اكتملت لها صورة واضحة المعالم منذ أوائل القرن الخامس، إن لم يكن أواخر القرن الرابع، وإلى تبيان أن مهلهلاً لم يكن أول من قصد القصيد، وإلى الكشف عن بعض جوانب تتصل بابن حذام لم تعالج حتى الآن، وإلى أن زهير بن جناب هو أقدم شاعر مُطيل – حسب ما وصل إلينا – له قصائد طويلة ذات مقدمات طلليلة .

فإذا صح ما وصل إليه هذا البحث من نتائج فإن قصائد زهير بن جناب تدل على فن اكتملت مقوماته أو كـادت، ومن ثم فلابد أن القرن الرابع قد شهد بعض ضروب هذا الفن بصورة أو بأخرى .

### الهوامش

١ – طبقات فحول الشعراء، لابن سلام، تحقيق محمود محمد شاكر – مطبعة المدني، القاهرة ١٩٧٤، ١ : ٣٩ .

٢ – الموشح، لأبي عبيد الله المرزباني، تحقيق محمد على البجاوي – طبعة دار نهضة مصر، القاهرة، ١٩٦٥، ص : ١٠٦ .

٣ – المزهر، للسيوطي، تحقيق أحمد جاد المولى وآخرون – منشورات المكتبة العصرية، بيروت ١٩٨٧، ٢ : ٤٤٧ .

٤ – رسالة الغفران، لأبي العلاء المعري، تحقيق عائشة عبد الرحمن – دار المعارف، القاهرة ١٩٦٣، ص : ٣٥٣ – ٣٥٤ .

٥ – نقائض جرير والفرزدق، لأبي عبيدة معمر بن المثنى، تحقيق أنتوني بثان – مطبعة بريل، ليدن ١٩٠٨، ٢ : ٩٠٥، وانظر أيضا الشعر والشعراء، لابن قتيبة، تحقيق أحمد محمد شاكر، دار المعارف، القاهرة، ١٩٦٦، ٢ : ٢٩٧ .

٦ – مجالس ثعلب، تحقيق عبد السلام هارون – دار المعارف، القاهرة، الطبعة الثانية، ١٩٦٠، ١٢ : ٤١١، ونقل ذلك السيوطي في المزهر ٢ : ٤٧٧ .

٧ – الأغاني، لأبي الفرج الأصفهاني، طبعة دار الكتب المصرية ٥ : ٤١، ولوقائع الحرب : ٣٤ – ٦٤ من نفس الجزء، المعارف، لابن قتيبة، تحقيق ثروت عكاشة – دار المعرف، القاهرة، الطبعة الثانية، ١٩٦٩، ص : ٦٠٥، العقد الفريد، لابن عبد ربه، تحقيق أحمد

وقتل رئيسا منهم. فانصرفوا عنه خائبين، فقال زهير:

| | |
|---|---|
| ١ - أمنْ آل سلمى ذا الخيال المُورِّق | وقد يَمقُ الطَّيفَ الغريبَ المشوَّقُ |
| ٢ - وأنَّى اهتدت سلمى لوجه مَحَلِّنا | وما دونها من مَهْمَهِ الأرض يخفق |
| ٣ - فلم ترَ إلا هاجعاً عند حُـرَّة | على ظهرها كُورٌ عتيقٌ ونُمْـرَقُ |
| ٤ - ولما رأتني والطليحَ تبسمـت | كما انْهـلَّ أعلـى عارض يتألـق |
| ٥ - فحُيِّيتَ عنا، زوَّدينا تحيـة | لعل بها العاني من الكَبْل يُطلَقُ |
| ٦ - فـردَّت سلامـاً ثم ولَّت بحاجة | ونحن لعمري يا ابنة الخير أشوَقُ |
| ٧ - فياطيبَ ما ريَّا ويا حسن منظر | لهـوتُ به لو أن رؤياك تصدَّقُ |
| ٨ - ويوم أثالى قد عرفت رسومها | فعُجنا إليها، والدمـوع ترقرقُ |
| ٩ - وكادت تُبين القولَ لما سألتُها | وتخبرني، لو كـانت الدارُ تنطقُ |
| ١٠ - فيا دارَ سلمى هجت للعين عبرةً | فماء الهـوى يَرْفَضُّ أو يترقـرقُ |

وقال زهيرٌ في هذه القصيدة يذكر خلاف الجلاح عليه:

| | |
|---|---|
| ١١ - أيا قومنا إن تقبلوا الحق فانتهوا | وإلا فأنياب من الحرب تحرقُ |
| ١٢ - فجاءوا إلى رَجْرَاجَةٍ مكفهرة | يكاد المدير نحوها الطَّرفَ يصعقُ |
| ١٣ - سيوف وأرماح بأيدي أعزة | ومَـوْضونة مما أفاد مُـحَـرَّقُ |
| ١٤ - فما برحوا حتى تركنا رئيسهم | وقد مار فيه المَضْـرَحيُّ المذلقُ |
| ١٥ - وكائن ترى من ماجد وابن ماجد | له طعنة نجلاء للوجه يشهقُ |

وواضح أن القصيدة غير كاملة. فالبيت الحادي عشر هنا يسبقه قول أبي الفرج «وقال زهير في هذه القصيدة يذكر خلاف الجلاح عليه»، ولكن ما أعقبه من الشعر لا ذكر فيه لهـذا الخلاف، مما يدل على أن هذا القسم قد فُقِدَ. ولا أشك أن هذا القسم الأخير (من البيت ١١ - ١٥) قد فقد أيضا جزء كبيرٌ منه، فليس من المعقول أن يتحدث زهير عن نصر كهذا سبقته وقعة نكراء لرجل آواه وأكرمه في أبيات خمسة. ولو انتهت إلينا هذه القصيدة كاملة لكانت في الأغلب الأعم أطول قصيدة في هذا الزمن المبكر من تاريخ الشعر العربي.

وليس طولها فقط هو مبعث أهميتها، بل أيضا مفتتحها بالطيف والخيال، واحتواؤها على النسيب والأطلال وسؤال الديار. ففي الأبيات السبعة الأولى يحدثنا عن أن طيف سلمى ألم به في المنام قاطعا مفاوز وقفارا فأسعده زورها وتبسمها وحديثها، ثم أفاق على مر الحقيقة. فأني له سلمى وهذه ديارها قفر قد استبانت له فعاج إليها ووقف بها حزينا ساكبا دمعه يسألها عن أهلها الظاعنين. ولو كان في مقدور الديار أن تتكلم لأجابت هذه الدار عن سؤاله رحمة به وشفقة.

لما توقل في الكراع هجينهم    هلهلت أثار مالكًا أو صِنْبَـلا

وسواء كان هذا البيت من نَظْم مهلهل أو نظم أخيه كما ذكر المعري، فإن الذي يسترعي النظر هو أن هذا البيت على وزن وروي أبيات زهير بن جناب التي أوردتها منذ قليل. وواضح من بيت مهلهل أو أخيه أنه يعير زهيرا بهزيمته وأنه أدرك ثأرا من قتلوا، وأغلب ظني أن هذا البيت من قصيدة كتبها مهلهل بعد وقعة السُلّان التي ثارت فيها تغلب لنفسها لهزيمتها في معركة الحبي. وعندي أن قصيدة مهلهل هي مناقضة للامية زهير بن جناب، مما يزيد توثيق هذا الشعر صحة. والناظر في كتاب بكر وتغلب يجد أنه قلما ينظم شاعر قصيدة دون أن يرد عليه شاعر من القبيلة المعادية مناقضاً.

شعر الشكوى من الهرم: ذكرت قبل أن زهيرا عُمِّر عمرا طويلاً «حتى ذهب عقله، وكان يخرج تائها لا يدري أين يذهب، فتلحقه المرأة من أهله والصبي، فترده»(٣٧)، وشعره – كبعض شعر لبيد – فيه تبرم من طول الحياة، وماورثه ذلك من ضعف البدن وذهاب النظر:

ألا يا لقومي لا أرى النجمَ طالعـاً    ولا الشمسَ إلا حـاجبي بيميني

وعز عليه ذهاب الهيبة ؛ فقد كان زهير – كما قال أبو الفرج – «إذا قال : ألا إن الحي ظاعن، ظعنت قضاعة، وإذا قال : ألا إن الحي مقيم، نزلوا وأقاموا»، فلما أسن لم يستمع إليه أحد وخالفوه فقالوا غير ماقال ورأوا غير ما رأى :

أمير شقاق ، إن أقم لا يُقم معـي    ويرحلْ ، وإن أرحل يقمْ ويخالفُ

وقد أورد له ابن سلام(٣٨) قصيدة من شريف الشعر يذكر فيها مابنى من مجد وما خاض من قتال، ولهوه وشربه وصيده، وقيامه في المجالس خطيباً، ثم يختمها بهذين البيتين في وصف ما آل إليه بعد أن كان من كان :

والموتُ خــيــرٌ للفــتى    وليــهــلكْـنْ وبه بقــيـةْ
من أن يُــرَى الشــيخ البَجَـا    لَ ، وقد يهادى في العشـيـةْ

أما وقد نظرنا في موضوعات شعر زهير، فقد آن لنا أن ننظر في الشكل الذي صيغ فيه هذا الشعر. مابقى من شعر زهير قليل، وهذا القليل لم يصل إلينا قصائد كاملة وإنما أجزاء من قصائد ضاع أكثرها. ولننظر الآن في إحدى ماتبقى من هذه القصائد والخبر الذي ارتبط بها. جاء في الأغاني(٣٩) : قال أبو عمرو الشيباني : كان الجلاح بن عوف السحمي قد وطأ لزهير بن جناب وأنزله معه، فلم يزل في جناحه حتى كثر ماله وولده. وكانت أخت زهير متزوجة في بني القين بن جسر، فجاء رسولها إلى زهير ومعه برد فيه صرار رمل وشوكة قتاد. فقال زهير لأصحابه : أتتكم شوكة شديدة وعدد كثر، فاحتملوا. فقال له الجلاح: أنحتمل لقول امرأة ! والله لا نفعل. فأقام الجلاح، وظعن زهير. وصبحهم الجيش فقتل عامة قوم الجلاح وذهبوا بماله. ومضى زهير لوجهه حتى اجتمع مع عشيرته من بني جناب وبلغ الجيش خبرة فقصدوه، فحاربهم وثبت لهم فهزمهم

في بغيض وآخر من شعره في بكر وتغلب. أورد أبو الفرج أربعة عشر بيتا قالها زهير بعد ظفره ببغيض، وهم من غطفان :

| | |
|---|---|
| ١ - ولم تصبر لنا غَطَفَان لما | تلاقينا وأُحْرزت النساءُ |
| ٢ - فلولا الفضل منّا ما رجعتم | إلى عذراء شيمتها الحياءُ |
| ٣ - وكم غادرتم بطلاً كَمِياً | لدى الهيجاء كان له غناءُ |
| ٤ - فدونكم دُيونا فاطلبوها | وأوتارا ، ودونَكم اللقاءُ |
| ٥ - فإنا حيث لا نخفى عليكم | ليوثٌ حين يَحْتَضر اللواءُ |
| ٦ - فخلَّى بعدها غَطَفَان بسّاً | وما غَطَفَان والأرض الفضاءُ |
| ٧ - فقد أضحى لحي بني جنَاب | فضاء الأرض والماء الرواءُ |
| ٨ - ويصدق طعننا في كل يوم | وعند الطعن يُخْتبر اللقاءُ |
| ٩ - نفينا نخوة الأعداء عنا | بأرماح أسنَّتها ظِماءُ |
| ١٠ - ولولا صبرنا لما التقينا | لقينا مثل ما لقيت صُدَاءُ |
| ١١ - غداة تعرضوا لبني بغيض | وصدق الطعن للنَّوْكَى شفاءُ |
| ١٢ - وقد هربت حذار الموت قَيْنٌ | على آثار مَنْ ذهب العَفَاءُ |
| ١٣ - وقد كنا رجونا أن يمدوا | فأخلفنا من اخوتنا الرجاءُ |
| ١٤ - وألهى القَيْنَ عن نصر الموالي | حِلابُ النِّيب والمرعى الضواءُ |

الأحداث التي تذكرها هذه الأبيات مصداق لوقائع الحروب في كتب الأدب والتاريخ، فهي تذكر أن زهيرا بعد أن أوقع بغطفان «مَنَّ على غطفان وردَّ النساء»، كما نرى في البيت الثاني هنا. وتحدد موضع القتال بمكان يقال له بس، وهو مذكور في البيت رقم ٦. وتنبئنا – كما مرَّ بنا من قبل – أن بغيضا غزت صداء وأوجعت فيها ونكأت، كما نرى في البيتين العاشر والحادي عشر، وتخبرنا أن زهيرا لما أجمع أمره على غزو غطفان استمد بني القين بن جشم فأبوا، وترى ذلك واضحا في الأبيات الثلاثة الأخيرة.

ومن الأشعار التي قالها في بكر وتغلب وأسره مهلهلاً قوله :

| | |
|---|---|
| ١ - تبّاً لتغلبَ أن تساقَ نساؤُهم | سَوْقَ الإماء إلى المواسم عُطَّلا |
| ٢ - لحقت أوائلُ خيلنا سَرعانهم | حتى أسرن على الحُبَيّ مهلهلا |
| ٣ - إنا ، مهلهل ، ماتطيش رماحنا | أيام تنقُف في يديْك الحَنْظَلا |
| ٤ - ولَّت حُماتُك هاربين من الوغى | وبَقِيتَ في حَلَق الحديد مُكبَّلا |

مضى في صدر هذا الحديث كلام المعري في رسالة الغفران عن مهلهل وإتيانه بهذا البيت :

عمره»(٢٨). وقال عنه ابن قتيبة : «وهو جاهلي قديم ... وهو من المعمرين»(٢٩). أثبت - فيما أرجو - آنفا أن ابن حذام أسن من المهلهل، واقترحت العقد الثاني من القرن الخامس الميلادي لزمن ميلاده. ثم نقلت عن الآمدي أن ابن حذام كان مع زهير بن جناب في غارته على العدنانيين وأفاد ابن رشيق(٣٠) أن زهير بن جناب كان عم ابن حذام ونقل ذلك البغدادي(٣١) وهو قول صحيح عن مطلق عمومته، فقد نقلت قبل نسب ابن حذام عن جمهرة الأنساب لابن حزم، وهو : امرؤ القيس بن حمام بن مالك بن عبيدة بن هبل. ونسب زهير كما أورده أبو الفرج من ترجمته هو : زهير بن جناب بن هبل(٣٢). ويتضح من كلا النسبين أن زهير بن جناب ليس عمه مباشرة وإنما ابن عم جده مالك. وهذا يعني أن زهير بن جناب كان أسن من ابن ابن عمه بما يقرب من ثلاثين عاما. فإذا قبلنا ما اقترحته قبل من أن ابن حذام ولد حوال عام ٤٢٠ م، فإن عام ٣٩٠ م يبدو وقتا مقبولا لميلاد زهير بن جناب.

ويستشف مما ذكره أبو الفرج في ترجمه زهير أن ميلاده أسبق مما اقترحته ههنا. قال «قال أبو عمرو الشيباني كان أبرهة حين طلع نجدا أتاه زهير بن جناب، فأكرمه أبرهة وفضله علي من أتاه من العرب». وأبرهة المذكور ههنا (٣٤٠ - ٣٧٥) غير أبرهة صاحب الفيل(٣٣). وذكر حمزة الأصفهاني أن أبرهة الأول كان معاصرا لملك الفرس سابور الثاني (٣١٠-٣٨٠)(٣٤).

وإذا أخذنا برواية أبي الفرج عن أبي عمرو، فلابد أن زهير بن جناب كان آنذاك في تمام الرجولة وذكاء السن حتى يفضله أبرهة «على من أتاه من العرب». فإذا قدرنا أنه كان في الخامسة والعشرين من العمر، إذا افترضنا أنه قابل أبرهة في آخر سنة من عمره أو حكمه وهي سنة ٣٧٥، كان ميلاده إذن عام ٣٥٠ م، وهذا أمر مستبعد لأنه يكون قد جاوز الثمانين خلال حروب عدنان وقحطان. ولعل منشأ هذه الرواية يكمن في أن بعض العلماء يعتقدون أن زهير بن جناب عاش خمسين ومائتي سنة(٣٥)، وبالغ بعضهم في الإفراط فقال أربعمائة وخمسين سنة(٣٦) والذي لا شك فيه أنه عمرا طويلا حتى ناهز المائة، كما مر بنا وكما يدل عليه شعره. وليس من المعقول أن يكون «قائد قومه في حروبهم»، كما يصفه أبو الفرج، في السن العالية. ولو ذكرت لنا المصادر أن قومه أخرجوه معهم في هذه السن تيمنًا به كما نرى في أخباردريد بن الصمة وغيره - لقلبنا ذلك. ولكن ترجمته في المصادر تتحدث عن شجاعته، ونقيبته الميمونة، وظفره، وقيادته قومه وسيادته.

يعالج شعر زهير بن جناب موضوعين متمايزين : حروبه التي قاد فيها قومه ضد العدنانيين، وشكوى مريرة من كبر السن وماجره من هرم وضعف وسقام وفقد هيبة وسلطان.

شعر الحرب : نرى في شعر زهير - الذي نظمه عقب انتصاره على بغيض وهدم حرمهم، وفي شعره الذي قاله عقب سحقه لبكر وتغلب وأسْره مهلهلا وأخاه كليبا - مرآة صادقة لوقائع هذه الحروب كما حفظتها لنا كتب الأدب والتاريخ، مما يدل دلالة قاطعة على صحة هذا الشعر. ولنكتَفِ بمثال من شعره

مشهودا له بالحكمة والتجربة. ويؤيد ذلك من بعض الوجوه أن مهلهلا شارك في معارك قومه ضد القحطانيين، التى هاجت قبل حرب البسوس كما ذكرت فيما سبق. فبعد انتصار بَغيض على قبيلة صُداء اليمنية(٢١)، ازدادت بغيض قوة وثراءً، وعتت وبغت، وتطلعت إلى بناء حرم مثل حرم مكة لا يقتل صيده ولا يهاج عائذه، ففعلت. فبلغ فعلهم زهير بن جناب وهو يومئذ سيد بنى كلب فأغار عليهم في موضع يقال له بس، فظفر بهم وهدم حرمهم(٢٢). فتعبأت العدنانية للأخذ بثأرها وطرد اليمانية من بلادها وقادها عامر بن الظرب فأوقع باليمنيين وقعة منكرة عند البيداء(٢٣)، ولم أجد ذكرا لمهلهل أو أخيه كلَيب في هذه الوقعة. فاستطار زهير بن جناب سيفه وجمع قومه وأغار على بكر وتغلب عند ماء يقال له الحبي وأسر مهلهلا وأخاه كليبا(٢٤). ولكن القبائل العدنانية استطاعت أن تثأر لنفسها برئاسة ربيعة بن الحارث في وقعة السلاّن. ومن ثم بدأت القحطانية والعدنانية تعدان لمعركة فاصلة، فتجمعت كل قبائل معد تحت لواء كليب بن ربيعة – أخي مهلهل – وأحرزت نصرا حاسما على القبائل اليمنية(٢٥).

وليس من السهل تحديد الزمن الذي وقعت فيه هذه الحروب، ولكنها مع ذلك قد تسعفنا في تحديد زمن مهلهل. رأينا من العرض السريع لهذه الحروب أن وقائعها الأولى تخلومن ذكرمن مهلهل، مما يبيح لنا أن نستظهر أنه كان صغير السن خلالها. فإذا سلمنا أن حرب البسوس قد انتهت حوالى ٥٠٠ م أو ٥١٠ م على أكثر تقدير ك وأنها قد بدأت عام ٤٦٠ م أو ٤٧٠ م على أكثر تقدير أيضا، وأن حروب عدنان وقحطان كانت قبلها بزمن لا ندريه على وجه التحقيق، وأن مهلهلا كان يافعا خلال وقائعها الأولى، أقول : إذا سلمنا بذلك كله كان ميلاد مهلهل حوالى عام ٤٤٠ م أو قبلها بقليل أمرا غير بعيد. وتحديد ميلاد مهلهل على وجه التقريب يعين على تحديد زمن ابن حذام على وجه التقريب أيضا. اقترحت فيما سبق أن ابن حذام أسبق زمنًا من مهلهل ومعاصريه، وإلا لما أفرده امرؤ القيس بالذكر، فهم جميعا قد قالوا القصيد، وهم جميعا ذكروا الأطلال والنسيب، ثم نقلت عن أبى حاتم أن ابن حذام كان من المعمرين، عاش مائة سنة أو أكثر من ذلك قليلا. ويذكر الآمدي أن ابن حذام كان مع زهير بن جناب في غاراته على بكر وتغلب(٢٦)، ويؤيد ذلك ابن رشيق عن أبي عبيدة معمر بن المثنى(٢٧) أي أنه شارك في الحروب التي كانت بين عدنان وقحطان قبل نشوب حرب البسوس. كل ذلك مجتمعا يشير إلى أن مولد ابن حذام كان في العقد الثاني من القرن الخامس على وجه التقريب.

وأنتقل الآن إلى لب المقال، وهو زهير بن جناب. وقد اضطررت إلى هذا التمهيد الطويل لكي أصل إليه. فكان لابد من تحديد زمن بعض الشعراء خاصة زمن مهلهل وابن حذام حتى يسهل تحديد زمن زهير بن جناب، وكان لابد من تتبع مقدمات القصيدة والذين قصّدوها لنرى من كان له فضل السبق. وانتهينا إلى نتائج، أرجو أن تكون صحيحة المقدمات.

قال ابن سلام عن زهير بن جناب «كان قديما شريف الولد، وطال

أنشدوا خمسة أبيات متصلة من أول : قفا نبك من ذكرى حبيب ومنزل، ويقولون إن بقيتها لامرىء القيس»(١٧).

ثم نرى أبا حاتم السجستاني (– ٢٥٦) يترجم لابن حذام ترجمة مختصرة يذكر فيها نسبه وثلاثة أبيات رائية(١٨). وبعد قرن تقريباً يورد الآمدي (– ٣٧٠) ترجمة له، ويذكر نسبة كما ذكرها ابن حزم بعد : امرؤ القيس بن حمام بن مالك بن عبيدة بن هبل بن عبد الله بن كنانة بن بكر. ثم ينقل عن بعض الرواة أن امرأ القيس هذا هو الذي أشار إليه امرؤ القيس صاحب المعلقة في بيته الذي مر بنا آنفا، وأنه يسمى أيضا : ابن حذام. ثم يذكر له ثلاثة أبيات على روى الراء، وهي مختلفة عن الأبيات الرائية التي أوردها أبو حاتم السجستاني، ولكن كلتا القطعتين على نفس الوزن والروي، مما يشعر أنهما من قصيدة واحدة، ويبدو أن ما أورده الآمدي هو مطلع القصيدة، فأول هذه الأبيات هو

لآل هِنْـد بـجـنـبـيْ نَـفْـنَـفٍ دارُ    لم يَـمْحُ جِـدَّتَـهـا ريحٌ وأمطارُ

ثم يقول عن هذه الأبيات : «وهي أبيات في أشعار كلب، والذي أدركه الرواة من شعره قليل جداً»(١٩).

مما تقدم نرى أن مافات ابن سلام استدركه آخرون، كل يضيف شيئا يسيرا إلى كلام من سبقه. فابن حذام إذن شخصية حقيقية، وليس وهميا اخترعته مخيلة الرواة. فإن صح ذلك – وهو صحيح إن شاء الله – فالسؤال الذي يطرح نفسه الآن هو : متى عاش ابن حذام؟

نحن نعرف على وجه اليقين أنه عاش قبل زمن امرىء القيس. وقد مر بنا أن مهلهلا والمرقش الأكبر والحارث بن عباد والفند الزماني، كلهم قد كتب القصيد، وأن المرقش الأكبر خاصة قد أحكم المقدمة الطللية، وإن كانوا كلهم قد ذكروا تبكاء الديار. ولكن امرأ القيس لا يذكر أياً منهم، وإنما يخص ابن حذام دونهم بهذه المزية. فإن قلنا إذن إن ابن حذام سابق عليهم في الزمان لم نبعد. ويقوي هذا الفرض أن أبا حاتم السجستاني ذكره في المعمرين وأنه عاش مائة سنة. وظني أن ابن حذام. كان شاعرا له ذكر قبل أن تكتمل للمرقش أو المهلهل الأداة، بل لعله كان كذلك قبل أن يولدا.

تعيننا الحروب التي وقعت بين القحطانيين والعدنانيين قبل البسوس على تكشف جوانب عنصر الزمان وأسبقية الشعراء. وظني أن حرب البسوس انتهت خلال السنوات الأولى من القرن السادس، ربما عما ٥٠٠ م، وليس في عام ٥٢٥ أو بعده كما اقترح بعض الباحثين(٢٠)، ومات المهلهل في الأسر قبل انتهائها. ونحن نعلم أن حرب البسوس استمرت أربعين عاما، فيكون ابتداؤها إذن حوالي سنة ٤٦٠ أو ٤٧٠ على أكثر تقدير. ونحن نعلم أيضاً أن مهلهلا كان قائد تغلب ورئيسها منذ اليوم الأول لوقائع حرب البسوس. ولا يعقل أن يرأس غلام حدث قبيلة قوية مثل تغلب وهي مقدمة على حرب مريرة ضد قبيلة لا تقل عنها قوة، وهي شقيقتها بكر. ولا جرم إذن أنه كان آنذاك رجلا مكتمل الرجولة ومحاربا

فشعر الحارث بن عباد مثلا – وقد مر بنا منذ قليل – وأن احتوى على هذه الأقسام، لا يمهد كل قسم لتاليه بل ينتقل فجأةً دون تمهيد كما حاولت أن أبيّن.

٢ – اللغة في شعر المرقش محكمة عالية، لا تقل – بل أظن ظنا أنها تزيد – عن لغة مهلهل رقةً وسلاسة.

٣ – إن المرقش – حسب الأشعار التي وصلت إلينا – سبق شعراء المعلقات في الإتيان ببعض الصور والتشبيهات، مثل رَوْد الوحش قفر الديار عند زهير ولبيد، ونضرة النبات وسؤال الديار الصُّمّ عند لبيد، وتشبيه ما بقي من رسم دارس بخط القلم في جلد أو رقٍ أو كتاب، كما تجد عند امريء القيس وغيره.

فإذا كان ذلك كذلك فـهل المرقش الأكبر إذن أو بعض معاصريه أولَ من قصّدوا القصيد وأحكموا شكله المعروف؟

نقل ابن سلام احتجاج بعضهم لامريء القيس بأنه «سبق العرب إلى أشياء ابتدعها واستحسنها العرب، واتبعته فيها الشعراء: استيقاف صحبه والبكاء في الديار، ورقة النسيب ...»(١٤). غير أنه كان قد أورد قبل هذا البيت لا مريء القيس.

عوجا على الطلل المحيل لعلنا      نبكي الديار كما بكى ابن حذام

وعلق على ذلك بقوله «وهو رجل من طيىء لم نسمع شعره الذي بكى فيه، ولا شعرا غير هذا البيت الذي ذكره امرؤ القيس»(١٥).

ويمدنا ابن قتيبة (– ١٧٦) بأشياء قليلة – لم يعرفها ابن سلام – عن ابن حذام، فنقل عن ابن الكلبي (– ٢٠٤) أن «أول من بكى في الديار امرؤ القيس بن حارثة بن الحمام بن معاوية وإياه عنى امرؤ القيس بقوله:

ياصاحبَّي قفا النواعجَ ساعةً      نبكي الديار كما بكى ابن حُمامِ

ثم نقل عن أبي عبيدة معمر بن المثنى (– ٢١٤): «هو ابن كذا ولعلها حذام»، ثم أنشد البيت الذي أنشده ابن سلام. ثم زاد: «وهو القائل:

كأني غَداةَ البَيْنِ يوم تحمّلوا      لدى سَمُـرات الدار ناقفُ حنظلِ»

يعني أن ابن حذام هو قائل هذا البيت، وهو البيت الرابع في معلقة امريء القيس.(١٦)

ويؤكد ابن حزم (– ٤٧٦) هذا الكلام مضيفا إليه، ففي معرض حديثه عن بني كنانة بن بكر قال: «ومنهم بني عدي، وزهير، وعليم بني جناب بن هبل بن عبد الله بن كنانة بن بكر المذكورين، وهم بطون ضخمة، وعمهم عبيدة بن هبل، بطن، من ولده: امرؤ القيس بن الحمام بن مالك بن عبيدة بن هبل، وهو ابن حمام الشاعر القديم الذي يقول فيه بعض الناس: ابن حذام ... وهو الذي قال فيه امرؤ القيس: نبكي الديار كما بكى ابن حمام.

قال هشام بن السائب: فأعراب كلب إذا سئلوا بماذا بكى ابن حمام الديار؟

١٦ - يَهْلِكُ والدٌ ، ويَخْلُفُ مَــوْ لـودٌ ، وكل ذي أب بَيْتَـــمْ
١٧ - والوالَداتُ يَسْتَفِدْنَ غِنىً ثم على المقدارِ من يَعْقَمْ
١٨ - ما ذنُبنا أن غَزا مَلك من آل جَفْنَةَ حازِمٌ مُرغِمْ

تبدأ الميمية الأولى «الخَيَمْ» بالحديث عن الأطلال، إلى أن يتبين الشاعر من الدار العافية أثافيَّها والأماكن التي كانت تقوم فيها خيامها، دار كانت تحل بها أسماء فأضحت وحشاً يباباً. يختلط الماضي البعيد الحي بالحاضر الماثل المحل في ذهن الشاعر فدمعه على الخدين سَحٌّ سَجَمٌ حزناً وألماً وصبابةً، ويجَيل النظر حوله فلا يرى إلا الوحش ترعى ما كان يوماً عامراً. ولكن كيف السبيل إلى السلو من ألم الفراق ولذعة الحب ووحشة المكان ! هذي ناقته القوية كفيلة أن تحمله بعيداً علّه يتسلى حب أسماء. بذلك يتخلص الشاعر من «الأطلال والنسيب» إلى «الرحلة» في يسر وسهولة .

تبدأ الميمية الثانية «كَلَّمْ» أيضاً بالأطلال والنسيب، ولكن بطريقة مغايرة لما في الميمية الأولى «خِيم»، فالشاعر هنا عارف للديار متبين لها، يسائلها فلا تجيب، هل أصابها صمم؟ كلا، ولو كانت الديار تتكلم، لحكت له هذه الديار عن أسماء وأهلها الظاعنين. وإذا كان الشاعر في الميمية الأولى قد رأى ما بقي من آثار الديار لا يعدو الأثافي ومبنى الخيام، ففي هذه الميمية الأولى قد رأى أن مابقى من آثار الديار سوى شيء يسير كخَط القلم في رقعة من الجلد. إذا لم يكن في الميمية الأولى من معالم الحياة إلا بقر الوحش التي تسترِيد المكان، فمعالمها في الميمية الثانية نبت جميم ندى، ونور ناضر حسن. ولكن هل هذا هو ما أشجاه؟ أم أشجاه تذكر النساء بكرة راحلات. فهذا تخلص لطيف في البيت الخامس إلى وصف «الرحلة» ولكنها ليست رحلته هو كما في الميمية الأولى، وإنما رحلة النساء - يستعيدها بعد حين - واصفا جمالهن في البيت السادس. ولكن هل هذا ما أشجاه حقاً؟ لا، إن الذي أشجاه هو مقتل ابن عمه، وهذا تخلص ثانٍ لطيف جدا ليبدأ رثاءً(١٢) ابن عمه ثعلبه بن عوف - الذي قتله مهلهل في إحدى وقائع حرب البسوس - وينتهي بالبيت السابع عشر. هذا الرزء الفادح يذكره بخطب جليل نزل به وبقومه، فقد أوقع بهم ملك من آل جفنة. وهذا مرة ثالثة تخلص في غاية اللطف من موضوع إلى آخر، فإن حزنه وكمده لمقتل ابن عمه لا يقل عن ألمه وهمه لغزو ابن أخته قومه، ويستمر هذا القسم حتى تنتهي القصيدة بالبيت الخامس والثلاثين. ومن هذا العرض لكلتا القصيدتين يحق لنا أن تستظهر ما يلي :

١ - إن المرقش الأكبر - وهو معاصر للمهلهل - لم يقصد القصيد فقط، بل استقر في شعره شكل القصيدة بأقسامه المختلفة من أطلال ونسيب ورحلة، كما نقله ابن قتيبة وعرفه وحاول تفسيره(١٣). وبلغ المرقش في ذلك مبلغا ليس لمهلهل نصيب كبير منه. والناظر في شعر مهلهل في «كتاب بكر وتغلب» يرى صحة ذلك. وأنا أزعم أنه - أعني المرقش - أحكم ذلك خيرا من معاصريه جميعا،

| | |
|---|---|
| ٥ - بعد جميع قد أراهم بها | لهم قباب وعليهم نَعَمْ |
| ٦ - فهل تُسلِّي حبَّها بازلٌ | ما إن تُسَلِّي حبها من أَمَمْ |
| ٧ - عَرْفاء كالفحل جُمالِيَّة | ذات هبَابٍ لا تَشكِّي السَّأمْ |
| ٨ - لم تقرَأ القَيظَ جنيناً ولا | أصُدُّها تحمل بَهْمَ الغنمْ |
| ٩ - بل عَزَبَتْ في الشَّول حتى نَوَتْ | وسُوِّغَتْ ذا حُبِّك كالإرَمْ |
| ١٠ - تعدو إذا حُرِّك مِجدافُها | عَدْوَ رَباع مُفرِّد كالزلَمْ |
| ١١ - كأنه نضعُ يمان ، وبال | أكرُع تَحْنيف كلون الحُمَمْ |
| ١٢ - بات بغَيْبٍ مُعْشب نَبْته | مختلط حُربُّثه باليَنَمْ |

وواضح وضوحاً لا لبْسَ فيه أن تشبيهه للناقة - الَّذي يبدأ في عجز البيت العاشر - بالثور الوحشي ينتهي فجأة بعد بيتين ونصف، وأنا مقتنع بيقين أن بقية هذا القسم مفقود، وأنَّ أقساماً أخرى تليه قد فقدت أيضا. ولو انتهت إلينا القصيدة كاملة لرأينا أنها تفوق قصائد المهلهل لغةً وأسلوباً وإحكام قصيد، ومن حسن الطالع أن ميميته الأخرى (رقم: ٥٤) قد وصلتنا كاملة. وأنا مضطر كل الاضطرار أن آتي بنصفها هنا حتى يتابع القارىء تحليلها وحتى تسهل المقارنه بين مقدمتها ومقدمة الميمية التي أثبتها آنفا :

| | |
|---|---|
| ١ - هل بالديار أن تُجيب صمَمْ | لو كان رَسمٌ ناطقاً كلَّمْ |
| ٢ - الدار قَفْرٌ والرسومُ كما | رَقَش في ظَهـــر الأديم قَلَمْ |
| ٣ - ديارُ أسماءَ التي تَبَلَتْ | قلبي ، فعَيْني ماؤُها يَسجُمْ |
| ٤ - أضحت خلاء ، نبتها ثَئدٌ | نَوْرٌ فيها زَهْوُه فاعْتَمْ |
| ٥ - بل هل شجتْكَ الظُّعن باكرةً | كأنهُنَّ النخلُ من مَلهَمْ |
| ٦ - النَّشْرُ مسكٌ ، والوجوهُ دنا | نيرٌ ، وأطرافُ البنان عَنَمْ |
| ٧ - لم يُشْجِ قلبي ملحوادث إلاَّ | صاحبي المتروك في تَغلَمْ |
| ٨ - ثَعلَب ضرَّابُ القوانس بال | سيف ، وهادي القوم إذا أظْلَمْ |
| ٩ - فاذهب، فدًى لك ابنَ عمِّكَ، لا | يَخْلُد إلا شَبابةٌ وأدَمْ |
| ١٠ - لو كان حيٌّ ناجياً لنجا | من يومه المُزَلَّمُ الأعصَمْ |
| ١١ - في باذخات من عَمَاية أو | يَرفَعُـه دون السماء خِيَمْ |
| ١٢ - من دونه بَيْضُ الأنوق وفو | قَه طويل المنكبَيْن أشَمْ |
| ١٣ - يَرقاهُ حيثُ شاء منه ، وإ | ما تُنسهُ مَنِيَّتُه يَهرَمْ |
| ١٤ - فغالَه رَيْبُ الحوادث ح | تى زَلَّ عن أرياده فحُطِمْ |
| ١٥ - ليس على طول الحياة نَدَمْ | ومن وراء المرء ما يَعلَمْ |

وتبدأ السينية، رقم : ٧ بذكر الطلل العافي، وما بقي فيه من آثار من رحلوا : وتد وأثافي ونؤي. ويصف ما فعلته الرياح والأمطار ببقايا الديار، فيقف يسألها :

وقفت بها أرجو الجوابَ فلم تُجب       وكيف جواب الدارسات الخوارسِ

وفي الأبيات الثلاثة التالية يتذكر من كان بها يحل من أمثال الدمى. وفي البيت الحادي عشر يتحول إلى تغلب، يقول :

بني تغلب لم تنصفونا بقتلكم       بجيرا ولمّا تُقْـتَلوا في المجالس

ويتهددهم ويتوعدهم ويذكرهم بظهور بكْرٍ عليهم كلما التقوا .

## المرقش الأكبر

إذا كان شعر المهلهل والحارث بن عباد، إلا قليلا، متصلا بحرب البسوس، فإن شعر المرقش الأكبر يكاد يكون مناصفة بين وقائعها وبين ألم الحب الممض، فقد كان المرقش من الشعراء الذين أطلق عليهم في العصر الجاهلي اسم المتيمون. أفنى المتيمون حياتهم كـالعذريين في العصر الإسلامي – في البكاء علي صواحبهم اللاتي لم يتح لهم القدر الزواج منهن، أو أتاح بعد برهة ثم غدر، ففاض شعرهم حسرة وأنينا، كما بين أستاذنا الدكنور يوسف خليف في كتيب نفيس(١٠). ولا يقدح في صحة شعر هؤلاء وهؤلاء ما نحلوه، وما صاحبه من أخبار لا تكاد النفس تصدق بها، فشعر المرقش في صاحبته أسماء كشعره في حرب البسوس سواءً بسواء وصدقاً، فليس شعرهم في جملته موضوعا كما حاول بيانه أستاذنا الدكتور طه حسين(١١) رحمه الله.

أثبت المفضل في اختياره اثنتي عشرة قصيدة ومقطوعة للمرقش الأكبر، رقم : ٤٥ ( سبعة أبيات )، رقم : ٤٦ (اثنا عشر بيتا)، رقم : ٤٧ (عشرون بيتا)، رقم : ٤٨ (أحد عشر بيتا)، رقم : ٤٩ (اثنا عشر بيتا)، رقم : ٥٠ (سبعة عشر بيتا)، رقم : ٥١ (أحدعشر بيتا)، رقم : ٥٢ (ثمانية أبيات)، رقم : ٥٣ (ثلاثة أبيات)، رقم : ٥٤ (ثمانية أبيات).

ولا شك عندي أن بعض هذه المقطوعات أجزاء من قصائد لم تصل إلينا كاملة. وعندى أيضا أن بعض القصائد فقدت منها أقسام أو أبيات من أقسامها المختلفة، مثل المفضلية رقم : ٤٩، ولسهولة المراجعة أثبتها هنا :

١ - هل تعرف الدار عفا رسمها       إلا الأثافيَّ ومَـبْـنَى الخِـيَمْ
٢ - أعرفها داراً لأسماء فـالـ       ـدمع على الخدين سَحَّ سَجِمْ
٣ - أمست خَـلاء بعـد سُكّـانها       مُـقْـفِـرة مـا إنْ بها من إرَمْ
٤ - إلا من الـعـين تـرعى بهـا       كالفارسيِّين مَشَـوْا فى الكُمَمْ

يالقومي فشمِّروا ثم جِدّوا     وخذوا حذَركم ليوم القتال

وتمضي القصيدة على هذا النمط في تحضيض قومه وتهديد تغلب، ويتكرر فيها هذا الصدر المشهور أربعا وأربعين مرة :

قـــربـــا مـــربط النعـــامــة مـــني

وواضح من مطالع القصائد الأخرى – ماعدا الثانية والأخيرة – أنها تبدأ بذكر الأطلال حينا والنسيب آخر. وبعض هذه القصائد قالها ابتداء، وأجابه المهلهل عنها، مثل اللامية (رقم : ١ هنا)، ثم الرائية (رقم : ٢ هنا)، أجابه المهلهل عنها برائيته المشهورة التي مطلعها :

أليلتنـا بذي حُســمُ أنيــري     إذا أنت انقضيـتْ فـلا تَـحُوري

فأجابه الحارث عنها ثانية برائيته (رقم ٣ هنا)

فى الرائية رقم : ٣ ذكر الأطلال فى بيتين ثم النسيب في بيتين، ثم انتقل دون تمهيد إلى ذكر الحرب والفخر بقومه وانتصارهم على تغلب :

فســائل إن عَرَضْت بني زهيــر     ورهطَ بنــي أُمامــة والغَــوير

وفي القصيدة الميمية رقم ٤ يذكر الأطلال وطمس الرياح لها في بيتين ونصف متخلصا بذلك إلى النسيب، فيقول في البيت الثالث :

أقْوَتْ وقد كـانـت تحل بجودها     حورُ المدامع من ظبـاء الشــام

وينتقل فجـأة في البيت السابع إلى ذكر وقاع بكر مع تغلب وكندة وكيف فلت بكر جموعها، ويتوعـد تغلب، ويؤكـد أنه لن ينسى قتل بجير، وأنها حرب لا هوادة فيها .

وفى القصيدة الدالية رقم : ٥ لا ذكر للأطلال فيهـا، وإنما بيداها بالنسيب، ثم يصف جمال صاحبته وتمكنها من قلبه في عشرة أبيات، ثم ينتقل دون تمهيد في البيت الحادي عشر إلى وقائع بكر مع تغلب، يقول :

سل حي تغلب عن بكرٍ ووقعتهـم     بالحِنْو إذ خسروا جهراً وما رَشَدُوا

وفي سبعة وثلاثين بيتا يفخر بقبائل بني بكر وانتصاراتهم على تغلب .

القصيدة اللامية، رقم : ٦، يبدأها بالكلام على الطلل، ويصف بلاه وأثافيَّ السفع، ومافيه من وحش وطير وجر الرامسات ذيولها فيه من شمَال وجنوَب وصبا، ويستغرق ذلك أربعة عشر بيتا، ثم يبدأ في البيت الخامس عشر تذكر صاحبته التي عمرت بها تلك الدار يوما، فيقول :

يوم أبدت ســلامُـة وجهــا     مستنيرا وعارضا مصقـولا

ويصف ملاحتها وشبابها في عشرة أبيات، ثم كعادته ينتقل دون تمهيد إلى ذكر تغلب وحروب قومه معها، فيقول في البيت السادس والعشرين :

ســفهت تغلب غـداة تمنت     حــرب بكر فـقتِّلوا تقتيــلا

## الحارث بن عباد

فارس بكر غير مدافع، استعظم قتل كليب أخي المهلهل في ناقة، وأبى أن يدخل في أمر تخطأ فيه قومه، حتى وقع حادث جلل، قتل المهلهل بجيراً، هو ابن الحارث، أو ابن أخيه عمرو بن عباد. فقال الحارث : نعم القتيل قتيلا أصلح بين ابني وائل. فقد ظن مهلهلا أدرك به ثأر أخيه وجعله كفاءً له. فقال له قومه : بل قال مهلهل إنه بشسع نعل كليب، فغضب الحارث ودعا بفرسه وقاد قومه. احتفظ لنا كتاب بكر وتغلب بعدة أشعار للحارث منها ثمانية أقلها طولا تقع في ثمانية عشر بيتا، وها هي مطالعها حسب ورودها في الكتاب :

ص : ٦١ - ٧٤، مائة بيت :

١ - كل شيء مصيره لزوال     غير ربي وصالح الأعمال

ص : ٦٩ - ٧٥، ثمانية عشر بيتاً :

٢- كأنـا غُـدوة وبنـي أبينـا     غَـداة الخيـل تُقـرَعُ بالذُّكُـور

ص : ٧٢، ثمانية عشر بيتاً :

٣ - عَفَت أطلال مية بالجفَير     إلى الأجياد منه فجوّ بير

ص : ٧٤ - ٧٥، ستة وعشرون بيتاً :

٤ - حى المنازل أقفرت بسهام     وعفت معالمها بجنب برام (ثُرام)

ص : ٧٦ - ٧٨، ٨٤ بيتاً :

٥ - بانت سعادُ وما أوفتك ماتعد     فأنت في إثرها حَرّانُ معتَمد

ص : ٨٠ - ٨٢، خمسون بيتا :

٦ - هل عرفت الغداة رسميا مُحيلا     دارسـاً بعـد أهلـه مـأهولا

ص : ٩٦ - ٩٧، أربعة وعشرون بيتا :

٧ - عفا منزل بين اللوى والحوابس     لمرّ الليالي والرياح اللّوابس (الروامس)

ص : ١٠٩ - ١١٠، واحد وعشرون بيتا :

٨ - ونهيت جساسا لقاء كليبهم     خوف الذي قد كان من حدثان

والقصيدة الأولى (حسب ترقيمى هنا) على طولها تخلو من المقدمة الطللية والنسيب. وذلك فيما أرجح لأنها خرجت مخرج الرثاء. وقصائد الرثاء، إلا نادرا، تخلو من هذه المقدمات. استهل الحارث لاميته برثاء بجير، ثم ختم الرثاء بإيعاد تغلب :

ثَكِلتني عـن المنيَّـة أمّـى     وأتاهـا نعـي عمّـي وخالـي

إن لم أشف النفوس من تغلب     الغدربيـوم يذل بَرْك الجمـال

| | |
|---|---|
| إنمـا النـاس ظـلامٌ دونهـم | فــإذا مـا أظلـم النـاس أنـاروا |
| نحن للناس سـراجٌ سـاطعٌ | وضـرامٌ يُتَقَّـى منـه الشـرارُ |

وإذا كانت نزار كذلك، فهي حرية أن تسود وأن يرضخ لها سادة الناس، فيذكِّر قحطان بما نالته نزار منها في غير معركة :

| | |
|---|---|
| إذ قــتلنا بالحِــمَى ســاداتكم | وأجـرناكم ، وفي ذلك اعتبـار |

ثم يوم خَزازَى :

| | |
|---|---|
| كم قــتلنا بخَــزارَى منكـمُ | وأسـرنا بعـد مـا حل الحِـرار |

ثم انتصارهم على مذحج :

| | |
|---|---|
| ونجت منـا فـراراً مَــذْحِجٌ | هربـاً ، والخـيل يعلوهـا الغُبـارُ |

وبعد كل هذه الدوائر التي دارت على قبائل قحطان، كان لابد لقحطان كلها أن يعلوها قتام الذل، وتشينها معرة الإسار فتنقاد خاضعة في صغار :

| | |
|---|---|
| أسْمَحَتْ قَحطانُ في أرْساننا | خَبَبَ الأعْيـار تتلوهـا الصغـارُ |

ويطيل في وصف ماعانته قحطان من حر القتال، وماأنزلته بها نزار من ذل وهوان، وينذر قحطان بأن لا سبيل لها على نزار :

| | |
|---|---|
| لن تـنالوا مـن نزار مــثلمــا | منكــم نالـت مـن الـذل نـزار |

ويبين لهم سبب عجزهم عن نيل مثل هذا المرام، فيعدد مفاخر نزار ويسهب في بيان فضلها وأمجادها وعراقة نسبها وحميد حسبها :

| | |
|---|---|
| نحن أولاد مَــعَــدٍّ فى الحَصـى | ولنـا مـن هاجَـرَ المجـدُ الكِبـار |
| ولدت أكـرم مـن شُـــدَّ بــه | عُـقَـدُ الحُـبْـوةَ قِـدْمـاً والإزار |
| إن إســمـاعـيـل مـن يَفْخـربـه | يُلْفَ في دار بهـا حَلَّ الفَخـار |

ثم يختم هذا الفخر بوعيد لا لقحطان فقط، بل لكل من يتوثب لقتال قومه :

| | |
|---|---|
| أيما قــوم حللــــنا بهــم | للـردى فـيهـم رواحٌ وابتكـارُ |

مـن هذا العرض الموجز الوافي – إن صح التعبير – يتضح أن قصيدة الفند، إلى جانب طولها الذي لا تدانيه كثير من القصائد الجاهلية التي وصلتنا، تبين عن مرحلة متقدمة في تطور القصيدة الجاهلية في شكلها المعروف، فهي وإن خلت من النسيب والرحلة، فقد بدأت بالأطلال، ولعل موضوع القصيدة أملى على الشاعر أن يتجاوزهما، كما تجد في معلقة عمرو بن كلثوم مثلا، حيث بدأ بالخمر التي تلائم روح الفخر الذي يسود القصيدة، وأعقب الخمر بالغزل، لا النسيب.

## الفند الزماني

احتفظ لنا ابن ميمون بثلاث قصائد للفند(٩)، أولها رائية في ثمانية وسبعين بيتا، وسأخصها بشيء من التفصيل بعد قليل، والثانية نونية عدتها عشرون بيتا ومطلعها :

أقيـــــــدوا القــــــوم، إن الـظـلم لا يـرضـاه دَيّـانُ

وقد اختار منها أبو تمام في حماسته تسعة أبيات (الحماسية الثانية، الجزء الأول). والثانية لامية في واحد وعشرين بيتاً ومطلعها :

أيــا تمــــلــــك يـــاتمــل           ذات الــدل والـشّــــكــــل

فواضح أن هذه قصائد لا مقطوعات، وأكاد أجزم أن قصائد أشباهها قد فقدت. وتبدأ قصيدة الفند الرائية بالبكاء على الأطلال، يستهلها بقوله :

أشجــاكَ الربـعُ أقــوَى والديار           وبكــاءُ المرء للـربـع خَـســـارُ

ولكنه لا يطيل الوقـوف، ويزجر نفسه على بكائه، فلن يغنى البكاء شيئاً، وخليق به وهو الفارس المجرب أن يكون صبورا غـير جزوع، فلا يصدر عنه ما يشين رجولته وجلده، فيقول في البيت الخامس :

أيهــا البــاكي عـلى مـا فــاتــه           أقْصِـرَنْ عنك، فبعضُ القول عارُ

ويستمر في مخاطبة نفسه مبيناً لها أن الجزع لا يجدي عنها شيئاً كما لم يجد قـومه نقيرا بعد مـا حل بهم ما من انكسار وقهر في معـترك القـتال، فيقول مخاطبا قومه :

فـاجـزعـوا للأمـر أو لا تجـزعـوا           قد تداعَى السقف وانهار الجدارُ

ويصف في عشرة أبيات كيف كان هذا التـداعي وذلك الانهيار. ويختلط حديث عن قـومه بحديث عن نفسه، فكلاهما جزع لما حاق به، وكل منهما عانى مرارة الهزيمة في ساحة الوغي وباحة الهوى سواء بسواء. ولكن ما باله ينساق مرة أخرى في هذا الحديث، فمافات لن يعيده تذكره، ولن يغير كنه وحقيقته، آن له إذن أن يجابه الواقع :

إنما ذُكُــرك شيـئــاً قـد مـضـي           حلم ، لو يَـرْجِـع الحُلـم ادَّكــــارُ

وإذا كان قومه - وهو فيهم وَسَطٌ - قـد هزمـوا مرة، فقد كانت لهم وقعات أذلوا فيها أعداءهم القحطانيين وظهروا فيها عليهم، فيبدأ ببني تيمة معيرا :

يابنى تيمة قــد عـاينـتم           وقـعــة منا لهــا نـار شَنَـــارُ

ويتبجح بما أنزلوه بهم وما أذاقوا قحطان من قهر ومذلة، وأنى لهم بنزار وهي نار تحرق ما تلقاه ونور للناس به يستضاء :

جـــمـــع اللـه نزارًا فـنـفـى           بهم الناس جميعـاً فـاستناروا

قصد القصيد» (٣). فهو يرى أن العصبية دفعت مختلف القبائل إلى عزو ذلك الفضل إلى شاعر من شعرائها .

ومن هذه القلة أيضا أبو العلاء المعري. يسأل ابن القارح فيمن يسأل من أهل النار – المهلهل : «فأخبرني لم سميت مهلهلا؟ فقد قيل : إنك سميت بذلك لأنك أول من هلهل الشعر أي رققه. فيقول : إن الكذب لكثير. وإنما كان لي أخ يقال له امرؤ القيس، فأغار علينا زهير بن جناب الكلبي، فتبعه أخي في زرافة من قومه فقال فى ذلك :

لما تَوقَّل في الكُراع هَجَــــينُهم  هَلْهَلْتُ أثار مـــــالكًا أو صِنْـــبَلا

هلهلت : أي قاربت، ويقال : توقفت. يعني بالهجين زهير بن جناب، فسمي مهلهلا. فلما هلك شبهت به، فقيل لي «مهلهل». فيقول : الآن شفيت صدري بحقيقة اليقين» (٤). فواضح أن أبا العلاء ينكر أن يكون المهلهل هو أول من أرق لغة الشعر، وأنه لم يلقب بهذا اللقب لفعله هذا، بل لشيء آخر تماماً. بذلك بطل عند المعري تفسير ابن سلام وما استتبعه من تلقيب، كذلك مقال ابن الأعرابي، وهو تفسير سبقه إليه أبو عبيدة، قال «وإنما سمى مهلهلا لأنه هلهل الشعر، بمعنى سلسل بناءه» (٥) .

وفوق ذلك تجاهل المعرى مسألة سبق المهلهل غيره من الشعراء إلى تقصيده القصائد، وإطالة المقطوعة من عدة أبيات إلى ثلاثين بيتا كما ذكر الأصمعي (٦).

وقف عمر بن شبة والمعري عند حد الإنكار ولم يجاوزاه. لم يقل أى منهما إذا لم يكن المهلهل هو أول من قصَّد القصيد، فمن يكون؟ وسوف أحاول فيما يستقبل من الصفحات أن أجيب على هذا السؤال حسب المادة التي أتاحتها لي المصادر .

من المعروف أن شهرة المهلهل شاعرا فارسا قد ارتبطت بحرب البسوس التي استمرت أربعين عاماً وانتهت في العقد الأخير من القرن الخامس – وهو ما أرجحه – أو العقد الأول من القرن السادس خلال حكم الحارث ملك كندة الذي توسط لإنهاء هذه الحرب الطحون، وباستثناء أشعار قليلة للمهلهل فإن معظم شعره نظمه في حرب البسرس ولم أجد إلا قصيدة واحدة عدتها أحد عشر بيتا قالها في وقعة السلان التي حدثت قبل حرب البسوس كما سيأتي بيانه بعد قليل. فإذا صح أن المهلهل ذاعت شهرته بوقوع حرب البسوس – وهو صحيح إن شاء الله – فإن بعض معاصريه أمثال الفند الزماني والحارث بن عباد وسعد بن مالك والمرقش الأكبر وابن أخيه المرقش الأصغر يستحقون جميعاً أن يشاركوه هذه المزية التى اختصه بها أكثر العلماء. وأكتفي هنا بالنظر في شعر ثلاثة من هؤلاء الشعراء مثبتا أنهم أيضا قد قصدوا القصيد وأن قصائدهم قد استكملت الشكل المعروف بأقسامه المختلفة من أطلال ونسيب .

# زهير بن جناب
## رائد مجهول

### عادل سليمان جمال

استقر في أذهان الباحثين منذ أوائل القرن السابع الهجري إلا قليلاً منهم أن المهلهل بن ربيعة هو أول من قصد القصيد. وسوف يحاول هذا البحث أن يثبت بطلان هذا الاعتقاد السائد. لأن هذا الأمر لو كان صحيحاً لوجب ألا تكون قبل المهلهل قصائد. لكننا سنرى، من ناحية، أن بعض معاصري المهلهل ليسوا من أصحاب القصيد فقط، بل تماثل قصائدهم قصائد القرن السادس في ابتدائها بالأطلال ثم النسيب ثم الرحلة ثم الموضوع الذي قصده الشاعر، ومهد له بذكر الأطلال وماتلاها. وسنرى من ناحية أخرى أن شاعراً مثل زهير بن جناب، وهو قبل المهلهل، له أشعار لا يمكن أن تكون بحال من الأحوال في عداد المقطوعات، وسنرى أيضا أن بعض أشعاره التي انتهت إلينا بلغت من النضج والكمال ما بلغته قصائد القرن السادس .

قلت في فاتحة الحديث أن أكثر العلماء إلا قلة يرون أن المهلهل بن ربيعة هو أول من هلهل الشعر، أي سلسل بناءه، كما قال ابن سلام(١)، وفصل ذلك ابن الأعرابي فقال : «المهلهل مأخوذ من الهلهلة، وهي رقة نسج الثوب، والمهلهل : المرقق للشعر، وإنما سمي مهلهلا لأنه أول من رقق الشعر»(٢). ومن هذه القلة التي خالفت هذا الرأي عمر بن شبة، فقد نقل السيوطي عن كتابه «طبقات الشعراء» مايلي : «للشعر والشعراء أول لا يوقف عليه، وقد اختلف في ذلك العلماء، وادعت القبائل كل قبيلة لشاعرها أنه الأول، ولم يدعوا ذلك لقائل البيتين والثلاثة، لأنهم لا يسمون ذلك شعرا. فادعت اليمانية لامرىء القيس، وبنو أسد لعبيد بن الأبرص، وتغلب لعمرو بن قميئة والمرقش الأكبر، وإياد لأبي دؤاد. قال : وزعم بعضهم أن الأفوه الأودي أقدم من هؤلاء، وأنه أول من

## مقدمة

وفي السنوات الأخيرة من حياته كان منهمكاً في تأليف «سيرة نبوية» يركز فيها على استراتيجية الغزوات وتطور النظم الإسلامية في حياة النبي عليه السلام، كما كان مشغولاً بكتاب آخر يتتبع فيه، بالدارسة الجادة وبالموضوعية اللتين اشتهر بهما، تاريخ حركات التطرف في الإسلام قديماً وحديثاً، ولكن موته المفاجئ حال – بكل أسف – دون أن يرى هذان الكتابان النور.

أما منجزاته في مجال تطوير الجامعة الأمريكية وتجويد أدائها إدارياً وعلمياً فهي محل تقدير كل من عرفه من أعضاء هيئة التدريس بالجامعة ومن الأداريين. ولا يتسع المجال لرصد كل ماقدمه لخدمة الجامعة ونكتفي هنا ببعض الأمثلة: فحين عين البروفسور جونز في الجامعة عام ألف وتسعمائة وستين ألغى ماكان يعرف بمعهد الآداب الشرقية، وكانت تغلب عليه النزعة الدينية وأقام على أنقاضه ما يعرف الآن بمركز الدراسات العربية ببرامجه وأقسامه العلمية والعصرية، سواء في مجال الأدب العربي ولغته، أو في مجال التاريخ العربي والإسلامي أو في مجال الفنون الإسلامية معمارية وزخرفية، أو في مجال تعليم العربية لغير الناطقين بها. إلى جانب وحدة البحث العلمي في حقل الدراسات العربية. ثم استقدم الأساتذة المتخصصين والمتميزين من أوربا وأمريكا ومن مصر للقيام بأعباء كل هذه البرامج.

وقد انتخب رئيساً لأعضاء هيئة التدريس بالجامعة أكثر من مرة وكان عضواً مؤثراً في لجان التخطيط المستقبلي للجامعة على المدى البعيد، وكان رئيساً لمجلس الجامعة ورئيساً للجنة لائحة الجامعة عدة مرات، ورئيساً للجنة النشر بالجامعة عدة مرات وعضواً فاعلاً في لجنة التعيينات المؤقتة والدائمة والترقيات، وفي المجلس الأكاديمي للجامعة ... إلى مناصب وأعباء كثيرة أخرى.

وبحكم معرفته الواسعة بالحضارة العربية وبالمجتمع المصري الذي أحبه، وبتوقد ذكائه ودبلوماسيته الفائقة في مواجهة أكثر المواقف حساسية كان المنبع الرئيسي الذي يستقى منه رؤساء الجامعة المشورة والنصح والتوجه السليم في الاوقات العصيبة التي مرت بها الجامعة وكان لهذا النصح أثره في الوصول بالجامعة الى بر الأمان.

أما عن علاقة جونز بزملائه فكانت تقوم على الود الخالص للأصدقاء والاحترام المتبادل مع الجميع. وبعد، فلا يسعني إلا أن أتقدم بكل الشكر والامتنان إلى المسهمين في هذا الكتاب من أصدقاء الدكتور جونز وتلاميذه، ومعارفه، الذين لولا إسهاماتهم لما رأى هذا الكتاب النور. كما أشكر قسم النشر بالجامعة الأمريكية، وبخاصة مديره الأستاذ مارك لينز (Mark Linz) الذي وجدنا منه كل العون والتأييد، وكذا مساعده الأستاذ نيل هيوسن (Neil Hewison) كما أتقدم بموفور الشكر إلى زملائي الذين بذلوا معي الكثير من الجهد والوقت في جمع هذه الدراسات وفي إعدادها للطبع، وهم بحسب الترتيب الأبجدي: الدكتور / برنارد أوكين، الدكتور / ثابت عبدالله، والدكتور / محمد سراج. وإلى مساعد البحث النشيط والدقيق الأستاذ ويليام كوبكي (William Kopycki) والله الموفق.

التدريس على بحوثه ومنشوراته العلمية التي جاءت نتيجة لذلك أصيلة وعميقة وجديدة، وبخاصة إذا تذكرنا أن جونز كان قارئًا نهماً لكل مناهج التجديد وأدوات التناول في مجال البحث العلمي أيضاً.

وهكذا أخذت أبحاثه في مجال تخصصه الأساسي – العصر الإسلامي المبكر – تتوالى وتحظى بالتقدير، سواء في مجال السيرة النبوية، أو في مجال نشأة النظم الإسلامية، كالقضاء والخلافة وغيرهما، أو في مجال التحقيق. وقد نشرت له جامعة أكسفورد في عام ١٩٦٦ م النسخة التي حققها تحقيقًا علميًا متميزًا من كتاب «المغازي» للواقدي (المتوفي سنة سبع ومائتين للهجرة)، وتقع النسخة في ثلاث مجلدات. كما نشر عددًا من المقالات والأبحاث في هذا المجال، ومنها «تاريخ المغازي من واقع النصوص» The Chronology of the Maghazi - A Textual Survey، و«ابن إسحاق والواقدي: حلم عاتكة وغزوة نخلة وقضية السرقة العلمية» Ibn Ishaq and al-Waqidi: The Dream of Atika and the Raid to Nakhla in Relation to Plagiarism) وقد نشرتا في مجلة كلية الدراسات الشرقية والأفريقية بجامعة لندن (BSOAS)، ومقالات: «غزوة»، و«ابن اسحاق»، و«حسن البنا»، في الطبعة الجديدة لدائرة المعارف الإسلامية. والسيرة النبوية مصدرًا للتاريخ الاقتصادي للجزيرة العربية لدى ظهور الإسلام Al-Sirat Al-Nabawiya as a Source of the Economic) History of Arabia at the Rise of Islam)

وقد نشرت في The Findings of the First International Symposium on the History of Arabia (Riyadh, 1977).

والفصل الخاص بأدب المغازي في المجلد الأول من تاريخ جامعة كمبردج للأدب العربى. The Cambridge History of Arabic Literature

ثم ما يلبث النشاط العلمي للبروفسور جونز أن يمتد إلى مجالات متنوعة، فهو يكتب المقال الخاص عن: مصر في دائرة المعارف البريطانية (بالاشتراك مع د. ليلى الحماصي) وهو ينشر: «الجبرتي» والبيان الفرنسي الأول» (Al-Jabarti and the First French Proclamation) وقد نشر في The Findings of the 150th Anniversary Conference on Al-Jabarti (Cairo, 1974)

وهو يترجم رواية «زقاق المدق» لنجيب محفوظ ترجمة رائعة، لكن ترجمة تريفور لجاسيك Trevor Le Gassick لنفس الرواية تسبقه بكل أسف إلى النشر، وهو يشترك مع كاتب هذه السطور في إصدار أربعة مجلدات من سلسلة أعلام الأدب العربي المعاصر في مصر وهي طه حسين (القاهرة، ١٩٧٥ طـ ٢، ١٩٨٢)، وإبراهيم عبد القادر المازني (القاهرة ١٩٧٩، طـ ٢، ١٩٨٥)، وعبد الرحمن شكري (القاهرة، ١٩٨٠)، وأحمد أمين (القاهرة، ١٩٨١)، وفي مقالات عديدة.

الجامعي في مقاطعة ويلز أيضا في كل من مدرسة جورتون الحكومية (Gowerton Grammar School)، ثم في كلية ويلز الجامعية (University College of Wales, Aberystwyth) لكنه حصل على درجة الليسانس بامتياز مع مرتبة الشرف الأولى، في اللغة العربية وآدابها من كلية الدراسات الشرقية والأفريقية (SOAS) بجامعة لندن عام ١٩٤٩، كما حصل من الكلية نفسها وفي التخصص نفسه على درجة الدكتوراه عام ألف وتسعمائة وثلاثة وخمسين. وعقب حصوله على الدكتوراه مباشرة عين محاضراً بالكلية التي تخرج فيها، حتى عام ألف وتسعمائة وستين ، حين انتقل إلى الجامعة الأمريكية بالقاهرة أستاذاً للدراسات العربية بها ومديراً لما كان يسمى في ذلك الوقت «معهد الآداب الشرقية» (School of Oriental Studies). وظل يعمل في تلك الجامعة حتى وفاته المفاجئة في صيف عام ألف وتسعمائة واثنين وتسعين عن نحو واحد وسبعين عاماً.

وعلى منجزاته في ميادين ثلاثة ترتكز المكانة الكبيرة التي يحتلها مارسدن جونز في أعين كل المشتغلين الجادين بالدراسات العربية والإسلامية :

١ – براعته الفائقة في مجال التدريس كأستاذ متميز ذائع الصيت دولياً.

٢ – كتبه ومقالاته وبحوثه العلمية المتميزة.

٣ – إسهامه الهائل بالأفكار والأفعال، في بناء السمعة الأكاديمية والعلمية التي تتمتع بها الجامعة الأمريكية بالقاهرة اليوم.

فأما في مجال التدريس فمن العسير على كل من تتلمذ على الدكتور جونز من طلابه المتخصصين وغير المتخصصين أن ينسى مهارته التي لا تبارى في التعريف بالجوانب المركبة والمتشعبة للحضارة الإسلامية، لا من خلال مراجع ثانوية تشيع فيها غالباً أفكار عامة مشوبة بسوء الفهم، وانعدام الدقة في معظم الأحيان ، وإنما من خلال دراسة أمهات المصادر العربية، التي كان جونز يؤمن إيمانا راسخاً بأن إتقان قراءتها يعد أساساً لا غنى عنه لأي فهم سليم وعلمي ومنصف لظهور الإسلام وتطوره فكراً وأنظمة وأساليب حكم.

وكان يستهجن الاتجاهات المعاصرة في دراسة الكثير من الغربيين للإسلام دراسة تقوم على تلك المراجع الثانوية ، وتكاد لا تعرف المصادر العربية الأساسية التي ينبغي الرجوع إليها.

ولقد نجح جونز، بتطبيق منهجه هذا نجاحاً منقطع النظير مع طلابه، وبخاصة في مرحلة الدراسات العليا. ولا شك أن الطلاب الذين أشرف جونز على رسائلهم الجامعية قد افتقدوا برحيله الإحاطة التامة بجوانب البحث العلمي الأصيل ودروبه ومناهجه، والاستعداد الدائم والمتحمس لتقديم العون والمشورة والنصح والساعات الطوال كلما شاءوا.

وقد انعكس مذهب جونز في اعتماد أمهات المصادر العربية منهجاً في

# مقدمة

## حمدى السكوت

يضم هذا الكتاب خمس عشرة دراسة تتناول جوانب متغايرة من الحضارة العربية والإسلامية كتبها أصحابها تخليداً لذكرى عالم كبير له بصماته الواضحة في مجال الدراسات العربية والإسلامية، هو الدكتور مارسدن جونز مؤسس مركز الدراسات العربية بالجامعة الأمريكية بالقاهرة، ومدير هذا المركز لسنوات طويلة.

ويعكس تنوع هذه الدراسات وتباين تخصصاتها مدى سعة اهتمامات الدكتور جونز نفسه وتنوعها. كما يعكس انتماء المسهمين في الكتاب الى جنسيات مختلفة، عربية وأوربية وأمريكية، مدى اتساع دائرة صداقات الدكتور جونز ومكانته، مع أن من أمكننا الاتصال بهم من هؤلاء الأصدقاء لا يشكل سوى عدد محدود من بينهم.

ولما كنت قد أتيح لي العمل مع هذا العالم الجليل زهاء ربع قرن من الزمان، نعمت فيها بصداقته وتعلمت منه الكثير ، فإنه ليسعدني أن يكلل جهدي – وزملائي – بالنجاح في إخراج هذا الكتاب التذكاري إلى دائرة الضوء، تعبيراً متواضعاً لا يكافىء درجة امتناننا العميق لما قدمه هذا العالم الجليل من خدمات جلى للثقافة العربية والإسلامية.

دعنا أولاً نقدم هذه السطور عن الدكتور «جونز» نفسه

ولد جون مارسدن بومونت جونز (John Marsden Beaumont Jones) (١٩٢٠ – ١٩٩٢) في العشرين من ديسمبر من عام ألف وتسعمائة وعشرين في مقاطعة ويلز بالمملكة المتحدة. وتلقى تعليمه الثانوى وقسطا من تعليمه

## قائمة المساهمين

أرنولد جرين: أستاذ التاريخ بجامعة بريجهام يفج، يوتا.

برنارد أوكين: أستاذ الفن الإسلامي بالجامعة الأمريكية بالقاهرة.

برنارد وايس: أستاذ الدراسات العربية والإسلامية بمركز الشرق الأوسط بجامعة يوتا.

كارولين ويليامز: محاضرة بكلية ويليام اند متاري، فرجينيا.

جورج سكانلون: أستاذ الفن الإسلامي بالجامعة الأمريكية بالقاهرة.

بسكال غزاله: ماجستير في الدراسات العربية من الجامعة الأمريكية بالقاهرة.

بيتر جران: أستاذ التاريخ المساعد بجامعة تمبل، فيلادلفيا.

روجر ألان: أستاذ اللغة العربية بقسم دراسات الشرق الأوسط والدراسات الآسيوية بجامعة بنسلفانيا.

ثابت عبدالله: أستاذ مساعد لدراسات الشرق الأوسط بجامعة اوكلاهوما.

حمدي السكوت: أستاذ الأدب العربي بالجامعة الأمريكية بالقاهرة.

جورج صليبا: أستاذ تاريخ العلوم بجامعة كولومبيا، قسم لغات الشرق الأوسط وثقافاته.

محمد مصطفى بدوي: أستاذ الأدب العربي الحديث في جامعة أكسفورد.

عادل سليمان جمال: أستاذ الأدب العربي بجامعة أريزونا.

رؤوف عباس: وكيل كلية الآداب وأستاذ التاريخ الحديث، جامعة القاهرة.

محمد بريري: أستاذ الأدب العربي المساعد بجامعة القاهرة، فرع بني سويف.

محمد سراج: أستاذ الشريعة الإسلامية بكلية الحقوق، جامعة الاسكندرية، وأستاذ زائر بقسم اللغة العربية بالجامعة الأمريكية.

چورج صليبا
الإتجاهات الحديثة في دراسة تاريخ علم الفلك العربي ١٠٥

*Arnold H. Green*
Family Trees and Archival Documents:
A Case Study of Jerusalem's *Bayt* al-Dajani  95

*Peter Gran*
Egypt 1760-1815: A Period of Englightenment?  73

*Pascale Ghazaleh*
Bedouins and Mamluks in the Sinai Trade  61

*Thabit Abdullah*
Some Observations on the Decline of Basra's Trade
in the Late Eighteenth Century  53

الفنون والعمارة

*Caroline Williams*
The Visual Image of Nineteenth-Century Cairo:
The British Discovery  39

*George T. Scanlon*
Medieval Egyptian Wooden Combs:
The Evidence from Fustat  13

*Bernard O'Kane*
The Gunbad-i Jabaliyya at Kirman and the
Development of the Domed Octagon in Iran  1

*Hamdi Sakkut*
Preface  ix

List of Contributors  vii

# المحتويات

| | |
|---|---|
| ز | قائمة المساهمين |
| | **حمدي السكوت** |
| ط | مقدمة |

## الأدب

| | |
|---|---|
| | **عادل سليمان جمال** |
| ١ | زهير بن جناب، رائد مجهول |
| | **محمد بريري** |
| | نزعة الشك عند شعراء الجاهلية: |
| ٢١ | بحث في الصور الذهنية المجردة |
| | **محمد مصطفى بدوي** |
| ٤٩ | الثوابت في الأدب العربي الحديث |

Roger Allen
Hadīth ʿĪsā ibn Hishām by al-Muwaylihi:
Thirty Years Later     117

## الشريعة

| | |
|---|---|
| | **محمد سراج** |
| | منهج التجديد التشريعي في الأحوال الشخصية في مصر |
| ٧١ | في القرن الأخير |

Bernard Weiss
Amidi on the Basis of Authority of Juristic Opinion     111

## التاريخ

| | |
|---|---|
| | **رؤوف عباس** |
| ٨٥ | المصريون والسلطة: رؤية تاريخية |

حقوق النشر محفوظة لقسم النشر بالجامعة الأمريكية بالقاهرة، ١٩٩٧
١١٣ شارع القصر العيني
الاقاهرة - مصر

جميع الحقوق محفوظة. ممنوع إعادة طبع أى جزء من الكتاب أو حفظه بعد تصحيحه أو نقله فى أى صورة أو بأي واسطة إلكترونية أو ميكانيكية أو تصويرية أو تسجيلية أو غير ذلك بدون التصريح السابق من صاحب حق النشر.

رقم دار الكتب: ٩٦/٧٣١٢
الترقيم الدولى: ٨ ٤.٠٢ ٤٢٤ ٩٧٧

تم الطبع في مصر

# دراسات عربية و إسلامية

مهداه إلى الدكتور مارسدن جونز

أشرف على إعدادها

ثابت عبد الله

برنارد أوكين

حمدي السكوت

محمد سراج

قسم النشر بالجامعة الأمريكية بالقاهرة

دراسات عربية و إسلامية